Also by Jay Kirk

Books
*Kingdom Under Glass: A Tale of Obsession,
Adventure, and One Man's Quest to Preserve
the World's Great Animals*

Film
Director's Commentary: Terror of Frankenstein

Avoid the Day

A NEW NONFICTION IN TWO MOVEMENTS

JAY KIRK

HARPER ● PERENNIAL

NEW YORK ● LONDON ● TORONTO ● SYDNEY ● NEW DELHI ● AUCKLAND

HARPER ● PERENNIAL

Parts of this book were previously published as "Bartók's Monster" in *Harper's Magazine*, October 2013.

Illustration on p. 94 from Joseph Strauss's "Motivic Chains in Bartók's Third String Quartet." *Twentieth-Century Music* 5/1 (2008) p. 30, reproduced with permission.

Illustrations on pages 187, 216, and 366 by Michael McGloin.

HarperCollins books may be purchased for educational, business, or sales promotional use. For information, please email the Special Markets Department at SPsales@harpercollins.com.

FIRST EDITION

Library of Congress Cataloging-in-Publication Data has been applied for.

ISBN 978-0-06-235617-8

20 21 22 23 24 LSC 10 9 8 7 6 5 4 3 2 1

For Julie

Alla ti e moi tauta philos dielexato thymos
—HOMER

I am the absence
of field.
This is
always the case.
Wherever I am
I am what is missing.
—MARK STRAND

1

FROM THE CLIFFS, PANNING DOWN, BEHOLD THE STILL-
ness of the valley in the predawn darkness. Pierced now by the
northbound *Montrealer*. The locomotive's headlight like a shot
of morphine sliding through the sleepy forest canopy, a rapid
wedge of illuminated treetops flying ahead like a ghostly manta
ray escorting the train to its rendezvous point at the tiny depot
just over the bridge where the tracks cross the dogleg of the
Dog River. From our craggy outlook, also now behold a more
sinuous thread of light. A car coming from the opposite direc-
tion, winding downhill, arriving at the depot just ahead of
the train. A woman steps out of the car, in a thick winter coat,
despite it being late July. Her driver, clearly unhappy to be play-
ing chauffeur this early in the morning, steps forward to smoke
as they wait. The woman stands by the car—let's say it's a 1939

Ford Deluxe—looking more flamboyant or nervous would be hard to say. The driver listens to the pulse of crickets and burble of river until the volcanic approach of the locomotive obliterates the meadow and the river and everything for miles around as it comes seething into the depot. The woman hurries forward to greet a younger, clearly frantic woman helping a wispy half-dead-looking man who only groans, but with the same peculiar accent as his employer. The driver drags the luggage off the Pullman, hauling several boxes as heavy as if packed with earth. He's used to hauling heavy things now for this woman. She actually had him haul a piano up to the second-floor guest room in preparation for this mysterious guest, even though there was already a grand piano in the downstairs parlor. The two women practically have to carry the foreign gentleman to the car where he collapses on the back seat, clutching at his shoulder in agony. And his employer snaps for him to go, to hurry, as if they were trying to beat the rising sun. As they climb back up the steep hill, past the chauffeur's own place, a barn at the bottom of the private drive, the composer looks pale and catatonic in the rearview mirror, flinching at the branches that scrape like talons against the window. Seeing the great house at the top of the hill, lit up like a riverboat on the Danube, is reminiscent to the composer of the mountain sanatoriums he had gone to since a child for a lifetime of unspecified ailments. Though, of course, the driver cannot know that. And the house is not a sanatorium. The woman, Agatha Illés (later Fassett), had bought it out of her own nostalgia for the Hungarian countryside. She hoped Béla would feel the same. She had not known him in Budapest—of course she had known *of* the great Béla Bartók, who was a virtual myth and cult in his native land, however

vaguely known here—but had only come to know him and his young second wife, Ditta, in New York, as a member of the émi-gré community. Agatha had fled Budapest several years ahead of the Bartóks, on the eve of Nazi occupation, and had helped them settle and find a furnished apartment, and in the process had become close friends with Ditta. This being the Bartóks' first summer as exiles, and knowing how New York rattled Herr Bartók's fragile nerves, Agatha had invited them to come to Vermont. She knew Béla to be difficult, aloof, imperious, and some-times even cruel, but she was shocked to see him in the state he had arrived. Ditta, she thought, did not seem entirely herself either. Ordinarily, it daunted her how the master's eyes seemed to look right through her, but as he entered her house now his senses seemed somehow turned perfectly inward, so that he did not appear to take in much of anything, and without uttering a word—he had not spoken since hobbling off the train—he went to his room and did not show his face again for two days.

After Ditta returned to the kitchen, she told Agatha how it had come on so suddenly. Just a few hours after leaving Penn Station such a change had come over him. The excruciating pain in his shoulder attacking without explanation. How he had become so panic-stricken when he couldn't move his arm at all. She said she had never seen him so frightened. He hadn't slept a wink on the train. He had writhed, in utter torment, clasping his shoulder and neck in agony until he had fallen into this awful stillness, this eerie apathy. She did not know if it was the war or the result of work. Not that he had com-posed anything so far in America. He was focused now on the manuscript he had been busy preparing for the past twenty-plus years—the ethnomusical work of peasant songs collected

on his field outings in Transylvania, the pages of which he had carried all this way to Vermont in those monstrous boxes. He had still not finished transcribing and deciphering their contents. But as the songs had been the source and inspiration for his own profound transmutation as an artist, if their code remained undeciphered, the same code he had worked into his own eerie compositions, he might never fully grasp the internal meaning of his own work. Ditta only hoped this time away in the country would improve his mood and health. So far he had not been able to work in America. New York City drove him mad. She told Agatha how Bartók was at his best in nature, how he had always been at his most wholesome, his most natural self, where he could be his *most real*.

He did not reappear at all that day, nor the morning of the next day, nor at lunch or dinner. Once when Agatha peeked in to check on him she saw how he had managed to hang a blanket over the window to block out the light. In the gloom, the boxes sat heavily where Matthew had dumped them in a corner of the room . . . It was not until midnight of the second night that Agatha heard him banging on his wife's door. She came out into the hall where she heard him insisting that he heard a strange noise. Something outside his window. A voice crying . . . Crying out *to him* from the woods, he said, imploring his wife to hear it as well. Soon the housemaid, Martha, was awake, too, and appeared with a lamp. They all stood in the upstairs hall, in the sputtering lamplight, straining to hear. But the women heard nothing. He said he thought it might be a cat. The women still heard nothing, but it occurred to Agatha now that she had not seen one of her cats, a gray Persian named Lulu, in over a day.

Bartók insisted the women follow him at once.

And so Agatha, Ditta, and the housekeeper had gone stumbling through the dark, following the pale figure of Herr Bartók, in his slippers and old flannel bathrobe, tapping his cane over roots and fallen branches.

He stopped after a bit, his elegant nostrils flaring in the dark woods. He leaned on the cane, with eyes closed, studiously breathing in the night fragrance, ears pricked. "It's coming at regular intervals," he said, turning his head to the side as if counting, taking in its tempo. "It's as though she needed time to rest before her next cry." When the women insisted they still heard nothing, Bartók shrugged, disbelievingly, and said he supposed that meant he was stuck as their guide, "since the deaf cannot lead the deaf."

And then he sprinted off again, receding into the trees, backlit by the women's dancing flashlight beams. When he paused again, turning his head this way and that, his skin glowed in the moonlight with the pallor of carbon monoxide. Only a few years earlier, when casting about for the right model for the fictional composer in his new novel, *Doctor Faustus*, Thomas Mann had arranged for a meeting with Bartók, noting that the Hungarian's head was so translucent it looked "carved from a cube of ice."

Geschnitzt aus einem Eiswürfel.

He would ultimately settle on the more approachable Arnold Schoenberg, father of the twelve-tone technique and the Second Viennese School.

Bartók's eyes blazed now from this cube of ice in the dark. He looked around as if he heard not only one cat, but as if they were surrounded by a whole chorus of cats dancing around them in the air. He clenched his shoulder with his hand.

"Don't tell me you can't hear it now," he said, before abruptly turning down a passage of slanting pines, moving farther into the chamber of dark woods. "This way," he urged. "This way."

When they next halted, the women could finally hear something. There it was. The distinct meow of a cat. They jabbed their flashlights up into the dark slash of branches, until they saw the gray speck and feline eyes. Lulu mewled back down at them piteously.

"What are you going to do next?" Bartók said, evidently seeing his role in the rescue operation as complete. "That tree must be at least five stories high. How will you ever get her down?"

In the end, Agatha sent Martha back to wake her grumpy caretaker, Matthew, to make him drag out a ladder to fetch Lulu. By now, he had been putting up with the rigmarole of preparing for the maestro's arrival for weeks.

"Of all the city-crazy things," Agatha later reported the old Vermonter had grumbled in her memoir about Bartók, after she had had him haul the piano to the second floor, presumably with help. "Even my old grandmother wouldn't have done a thing like that. She was crazy, good and proper, and proved it too by dying in the nuthouse in Waterbury."

The town of Waterbury, three short train stops away, was synonymous with the Vermont State Hospital (formerly, Vermont State Asylum for the Insane), and his grandmother presumably was a resident when fever therapy and daily enemas were still the favored treatment for neurasthenics, schizophrenics, and shell-shocked veterans from the Great War, and so on.

While they waited, Bartók sat on a fallen tree. Ditta and Agatha huddled beside him in a mesh of moonlit shadow. The master's face was as cold as the papery white birches that glowed

around them like crooked ghosts. His long fingers stroked the skin of the dead tree. "This old birch must have been dead for a long time," he said in his slow baritone, tilting his head, as if to hear some indistinct and faraway burrowed thing. Even the cat had gone silent. "Under the thin bark I can hear regiments of invading bugs. Grinding, eating, scurrying. Drilling their way through layer after layer of this white body—gnawing out its very heart."

It was inconceivable that at this same hour, four thousand miles away, in the Ponary forest, death squads were digging pits in broad daylight to fill with the residents of Vilna. That his own country had become collaborators to this darkness. An abomination. A jackal to Germany's lion.

Then the apparition came floating toward them, the rungs stuttering in the forested moonlight, as Martha returned with Matthew, who carried a wooden ladder perched on his shoulder. A hammer dangling from his belt. As the caretaker approached, he growled as if he had been called out in the middle of the night by very stupid or even insane children, but just before he got to the tree where the cat was stranded, Bartók quickly stood and made his exit into the woods ...

One had to wonder how such a strange creature could have had such success collecting songs from the earth-made peoples he sought in the wilds of Transylvania. He was so feeble, so aloof, so off-putting, with such a wan and acrid personality. How the easygoing peasant folk must have received him without snorting in his face one can only guess: a klatch of bemused grandmothers, pausing from their work to regard this strange dink from the city, with his thin white hair and odd manners, come all this way just to meekly, icily, ask if they would sing for

his pleasure. He was as pale as a winter parsnip. He had the complexion of a garlic clove. As obsessed as he was with tempo, you could have spent half an afternoon frisking his skinny frame before you found a pulse. More than anything he looked like a man grimly in need of a transfusion. One of his closest friends would describe his voice as "gray and monotonous." Though, to be fair, he didn't really have friends. Bartók's colleagues at the Academy, in Budapest, who sometimes detected the sweetish faint odor of chloroform on his person—he carried a vial in his pocket to euthanize beetles and other six-legged beasties that caught his eye, while wandering the countryside on his peasant hunting expeditions—found him bland, one of those almost offensively mild persons. Sullen, puritanical, anemic, timid, like some mute and slippered monk shuffling the catacombs. Though, surely, a few of the *bábas* noticed the thick wrists beneath his threadbare cuffs. Wrists like a butcher's from chopping away hours at the piano.

Though of course, they marveled at the machine he brought to suck the songs from their bodies. *Szörnyeteg*, they called it. The "monster." His Edison phonograph. This was the machine Bartók had used to record peasants singing and then integrated the *essence* of those folk songs into his own serious compositions. He dragged it over the rutted roads of Maramureş, and Székely Land, lashed to an oxcart, on the hunt for fresh plasma. When the bumpkins were gathered round he would load one of the wax cylinders, set the stylus on the groove, and demonstrate the apparatus like a colonial officer showing the natives how the Gatling took the belt before mowing them down in their huts. Once he'd gained the trust of the hill folk, he would wait until the end of the day, for the village maidens to return

from picking apples, or haycocking, or whatever it was peasants did when they weren't singing and getting drunk. Rapt, he sat across from them in the sputtering lamplight. When they opened their mouths to sing, he lowered the arm, and the needle bit into the turning cylinder . . .

Like Rumpelstiltskin, he hurried back to Budapest, and his unpadded headphones, to spin these bales of dung-flecked straw into chaotic threads of Lydian gold. Instead of shooting syphilis into his veins, like the fictional Leverkühn in *Doctor Faustus*, in a bargain for genius, he had infected himself with a virus far more ancient, the ancestral Magyar strains. But when audiences suckled on the usual Viennese milk heard his compositions, they fled in horror. If anyone still needed convincing that the ancestral Hungarian, the Magyar, was, indeed, a "breed of Satan," here was proof. Perhaps it was his presence as much as the barbaric music. The gaunt sickly weakling—*Herr* Bartók—was transformed into a terrifying soul onstage. However meek in real life, here in the theater, behind his piano, the pale maestro leapt about the keys like a panther, like Menelaus crouching through the dark, spear in hand, creeping up to the wall. And then, between movements, during that excruciating pause when some old fuck might be permitted his long withheld cough, you realized to your dismay that the blazing gaze of the master was turned upon you . . . The audience had fallen away into darkness, it was only you and the maestro. And during this brief unreal moment it felt as if you had become the subject of a new arrangement stirring in the composer's mind. As if the whole time he had been playing, he had been hunting, stalking, and only now, when it was too late, did you realize that he had smelled your blood.

THE NEXT MORNING, AFTER poor Lulu's high-wire escapade, like all future mornings, Bartók hadn't come downstairs until lunchtime. According to Agatha's memoir, *The Naked Face of Genius: Béla Bartók's American Years* (Houghton Mifflin, 1958), he seemed cheerier, and the strange shoulder pain seemed to be gone. Noticing a wooden spoon, he took it down from its hook to fondle the sturdy handle. He seemed mesmerized by the simple kitchen implement.

"Ah, it has been a long time since I've seen a spoon like this," he said (again, according to Agatha). He gazed into its ladle as if into the pool of a Florentine baptismal font. "Just the thing for stirring goulash in a huge cauldron at harvest time, or on some other great occasion—like a gypsy wedding." Then, as if spotting something wrong with the spoon, he veered course. "No, that's all wrong—not gypsies. They have no use for a tool like this."

He hung it back on its hook, disenchanted.

He shook his head. Revising his memories, or vice versa. "They hardly ever boil their food. It's too slow to suit their temperament. A quick roast over a roaring fire—pigs that die suddenly and no one knows how—a chicken that just happens to fly into their hands, *that* is their tradition. They have no other way."

He knew the Roma well.

"Did I ever tell you, Ditta, the story of the chicken bones and the gypsy girl?" he asked his wife as he sat down and began carefully examining the bread set before him. When she said that he had not, he said it was on one of his earliest trips to

Romania. "A hot midsummer day. I was eating my lunch in the yard of a run-down little inn on the outskirts of a small town at the very edge of a forest. It wasn't much of an inn, but it was a resting place for occasional travelers and their horses." He buttered a piece of bread as he spoke. "The yard was completely deserted and I was eating there alone. Only a little cat came to make friends with me, rubbing herself against my legs. She was not after food, she merely wanted my companionship, for when I put down a plate of chicken bones for her, she just sniffed at it politely and then walked away." He lifted the butter knife in surprise. "Suddenly, I saw a young gypsy girl coming out of the woods, as silently as a shadow—almost before I could realize what was happening she scurried right up and snatched the bones from the plate and darted back into the woods. Without thinking, I jumped up and ran after her as fast as I could." He chewed the bread uncertainly and shook his head as if still tortured by his choice to take pursuit. "Even as I was running I was disturbed and filled with sadness, for I feared she might think I was chasing her to punish her for stealing the bones. I knew no matter how fast I ran I could never catch up. I would never be able to reassure her and take away that look of a frightened animal."

He set the bread down as if suddenly disgusted. "It was a compulsion, an urgent desire to comfort her, to tell her something, or to give her something . . ."

After he had given up on the gypsy girl, he said, and was walking back to the inn, he had noticed how exposed the roots of the trees were, as if the earth had been washed away in a flood, leaving behind a network of tangled arteries, and how he had then been set upon by a great flurry of black flies that

pursued him and buzzed about his head as he made his way back. With this, Bartók set down his napkin and practically leapt from the table. Story over.

Moments later he could be seen out the kitchen window. Fronds of silver fern and Queen Anne's lace riffled around his spare frame as he crouched to inspect a pinecone. He sat for a long time, on the hillside of the lawn, holding the cone to his ear. He turned it slowly in his long hands, examining the strobilus from every angle, before prying it apart, one scale at a time, and staring at its symmetrical innards. But at the first sign of a storm, as the sky turned dark above the mountains, he scurried back to the dim sanctuary of his room. And was not to be seen for the remainder of the day.

THE FOLLOWING DAY AT lunch, when he was passed the breadbasket, he turned fiercely to Agatha. "How many different kinds of tasteless sponge do you parade in this house under the name of bread?!"

She tried to make light of it, saying that she only had the newfangled electric oven, which she agreed was no proper way to make bread, not like in the old country.

"That electric machine, or generator, or whatever you call the thing that keeps thundering all night like an angry Vesuvius!" He winced and swallowed one of the aspirin he had lined in a row beside his water glass. "It does something to the night, it upsets the balance, injects a foreign element, distorting the vibrant rhythm and harmony of the summer darkness. With that constant rumbling in my ears I find it impossible to follow even the most simple line of thought. I have abandoned entirely

the idea of working here, that is, of doing real work. Luckily I have enough other things to keep me busy."

Shortly after this, Herr Bartók demanded that he be provided with some bacon so he could cook for himself in his room. "But I mean a solid piece of it, not one of those paper-thin tasteless slices that you call bacon here. Then I could prepare a little supper for myself, toasting the bacon and a piece of bread over the chimney of my lamp as I used to do when I stayed in so many faraway country places. Oh yes, many times that used to be my evening meal and it was a good meal, too."

From then on, according to Agatha's wondrous talent for recollected dialogue, he kept a package on the sill of his room, in brown paper, and the aromatic alchemy of lamp oil and bacon could be smelled at all hours of the night.

He gradually expanded the ambit of his timid excursions beyond the lawn to include short walks down the private drive to the main road, stopping to inspect, or so it appeared to Agatha, every single tree and leaf, as if he were entranced by each new alien form of life. He would return from these short wanderings with clumps of moss or wild apples stuffed in his pockets. Or perched on his finger a ladybug: a new insect he had never seen and which he regarded as an exotic discovery.

One day, together, they went down the hill to Matthew's barn, where, on the way, anticipating a visit to a member of the authentic New England peasantry, Bartók spoke on the beauty of rustic, pastoral things, swishing his cane, jacket flung rakishly over one shoulder. A simple sprig of straw, for Bartók, was alive with intensity. "For me, straw has other associations, too, the warm, steaming beds of animals sheltered in barns and stables against the cold of winter. Straw alive with

fermentation—a smell so active that it actually verges on *becoming sound*!"

But when he actually laid eyes on the place, he was aghast. Agatha reports a kind of "horror" came over his face. Admittedly, Matthew was more idle tinker than true farmer. But when Bartók saw the muddy animals stranded amid the dilapidated tractors and rusted car parts jacked up around the yard on old tree stumps, he said: "Take one look at those poor beasts, those winter-wounded bodies. The summer sunshine is never long enough to smooth and heal their ravaged hides before the merciless cold is on them again. And now I will be forced to think of them every day this coming winter, every day I will feel through my own body the horror and torment of their existence, never knowing the hour when their icy hovel will finally collapse on them some bitter windy day."

And so on.

On a longer hike, Bartók saw fit to condemn the sonic quality of the New England ground beneath their very feet. "What a cold landscape this is. The soil is cold, stony, hollow, unyielding." He tapped the ground with his cane. "Hear that sound, how hard it is? Stone upon stone. No life in the depth of it."

But then, coming to a highland pasture, he thrust the cane into a mound of helpless dung. "There is life feeding on this dead heap," he exclaimed, poking and stabbing it, waiting for Agatha and Ditta to get closer, as crickets snipped past his head in the air. "See how the worms and bugs work busily, making little tunnels and passages, then soil enters, bringing with it stray seeds. Soon pale shoots of grass will appear, and life will complete its cycle, teeming within this lump of death." As he continued to jubilantly maim the *pile of shit*, he uttered the

Hungarian with insolent glee. When he saw it embarrassed Agatha, he pounced.

"What a pity," he said, wiping the cane in the meadow grass, "not to be able to feel the strength and purity of real words. How *vulgar* substitute words are, by suggesting they cover something ugly or evil. These words are accepted naturally by people who live in close connection with the earth. Words with special power and beauty, used by people who work, rest, and make love on this soil, and call every part of their bodies by these direct and inevitable names, names used with both gusto and tenderness. Those who try to change these words, covering their real meaning, are the ones who cast ugliness upon words and meaning alike."

He then launched into one of the more ribald folk songs he had picked up on one of his excursions to his authentic and radiant pure lands—hitting the vulgar reprise with sadistic joy. One has to credit Agatha for documenting these repeat humiliations inflicted on her by her celebrated houseguest.

She was so undone by the composer that he had even put her off how to walk.

"Oh, you again," he called out as she tiptoed past his door. "You always make me feel there is a burglar in the house. Can't you walk just normally?"

"I can't," she said. "I really can't. Something won't let me. I wish I could fly whenever I have to go by your door."

"I wish you could too," he said, turning back to the wispy, onionskin pages of his Romanian folk songs that still confounded him. The papers were heaped in bundles and piles across the table and unmade bed, their true code perhaps forever undeciphered. "Although the flap of your wings would no

doubt irritate me exactly the same. All rhythm has its natural law—this kind of restraint is nothing but a mockery."

From then on, Agatha wrote, she tried to walk "with as much freedom as I could produce, but he recognized my step in spite of my new style."

It's really no wonder she shoveled so much sawdust into his mouth in her memoir. Nor can you blame Agatha for enjoying a little schadenfreude of her own when some unannounced company from New York arrived and she got to witness the cringeworthy spectacle of the master reduced to a quivering, inept jellyfish. He was never prepared for such invasions on his membrane.

"Don't let them in!" he said to Martha when she came to announce the visitors waiting in the living room. "Please, tell them anything you like, just keep them away!"

"Béla, please see them," Ditta begged. "Just for a short while. They've driven all the way from New York. Going and coming, it takes two days, and they came only to see you. Can't you give them just a little time?"

Seeing no way out, bewildered and discombobulated, his voice was tense and meek. "I can't help it if they have two days to throw away. I haven't even a minute to waste."

Finally, though, seeing that Ditta would not help him out of this corner, he stood and walked stiffly into the next room, his face at once transformed into the aloof mask that would befit a stoic taking the hemlock.

"It still amazes me," Ditta confided to Agatha, "how he is completely without conception of what an everyday conversation is."

No matter how he abused her, however, when Agatha saw

Bartók coiled before the blazing fire on the night of a storm, drawn into himself, inert and gloomily shapeless, clenching his shoulder with a haunted and hunted look, she felt sorry for him. Coming to America had been a kind of death for Bartók. In America he was just one more invisible old man. No longer famous, he was ill, poor, and even, for the first time in his life, without a piano. The one he had used exclusively for tours in America had been recalled for lack of payment. Now that he knew what it was to be truly uprooted, as he huddled before the hissing fire, with rumbles of mountain thunder going off in the distance like mortar rounds, his confinement was complete. The one immutable thing they shared in common, Agatha knew, more than being Hungarian, was that of being a refugee. She understood why he stared at the roof over their heads as if it were only the flimsiest, most laughable of illusions. No matter how much he liked to romanticize the bucolic glories of his youthful excursions, where he had roamed so much out of doors, exposing himself to the raw and direct, to the wild venerated *real*, the source of his life's work, and his genius, the one thing he would never be able to take for granted again, as an exile, was sanctuary from the elements. The asylum of shelter. Only a refugee could really know this elemental fear. The idea of the elements had lost its romance.

BY LATE AUGUST, HOWEVER, as the nights were getting cooler, Bartók seemed to be taking more kindly to Vermont. While out on a country drive one weekend, seeing the tourist signs for the famous nearby granite quarry, Bartók announced that he would not be entirely opposed to visiting the Rock

of Ages. This was the pit that had dredged up the stone for millions of monuments and gravestones and mausoleums in America and had yet managed to advertise itself as if it were an amusement park. Agatha was reluctant. It was overcast and looked like rain, but Bartók insisted that his finely calibrated senses could detect no hint of rain in the air. "It's too cold for rain," he said.

So they drove on, Agatha opening up the flathead V8, but with the radio silent since Bartók would not stand for it.

After checking in at the Visitors Center and poking over the chintzy souvenirs and postcards of beetle-size men scuttling about the terraced shelves, workers eating out of lunch pails on steep subterranean cliffs evocative of stranded Arctic explorers posing for the final group shot before they succumbed to cannibalism, they walked out past the silent compressor plant and its cold brick smokestack into a landscape preternaturally still and muted. Especially now that it was Saturday and work had shut down for the weekend. It all felt as though it had been mined not only of its precious stone but of any habitable planetary atmosphere. The sky was a ghoulish lead ceiling. Dead spectral trees stood coated in a marmoreal haze of ashy pulverized rockdust. Running alongside the first pit was a line of flatbed cars loaded with enormous white granite slabs, a Hadrian's wall mounted on iron wheels, destined for the mill turbines and the bright wet blade powerful enough to cut halfway through the Devonian. Cantilevered and cruxed around the rim of the quarry stood fir-timbered tower cranes, derricks spooled with heavy lift cable fit for a god-size neck, and the shack where the hoist engineer lowered the dented gondola that carried the men down to its most arcane depths.

But today the great pits were empty of men. Agatha and Ditta, shivering in their coats, found the deserted rubbled landscape dismal, but the stillness seemed to give Bartók tranquil composure. He walked around the great empty pit, a limp jacket over his frail, birdish shoulders. The gloomy hushed landscape seemed like a balm, and he was eager to travel deeper into the quarry, as if each next pit, each new abyss, held more promise than the last.

At one of the deepest pits he got down on hands and knees and lowered himself onto his stomach to peer over the edge. Down at the wee equipment that had been tarped for the weekend, the tiny cranes, tiny tractors, tiny doll-size outhouses perched on the bowel-wrenchingly immense ledges. While the petrified women stood by, too terrified to object, he reached into the negative yawn of space to snatch at one of the dangling rope ladders. As he swayed the rope back and forth, it clattered, sending small echoes down the canyon wall. No doubt, it was the cold exacting precision of the quarry's operation that pleased him most. The cascade of extreme and fretful perspectives. The staccato pilot holes stitched across the blast lines. The symphonic shelves, like calving icebergs, sheared as cleaved bone. Tense diagonals of cable and rope. The pure cuboid interior.

At one point the women lost sight of Bartók. He did this sort of thing from time to time. Went missing. Vanished. Ditta started to grow uneasy, but soon enough they found him after going a bit farther into the interior. He was standing at the edge of an abandoned, flooded pit. Here they had come to the outermost reach of the quarry. A place long mined of all possible meaning. Shoes perched on the brink, the composer was contemplating the black mirror that twinned the white cliffs.

The gravity of the chasm seemed to hold him mesmerized. As if he were somehow telepathically linked, through the heft of iron in his blood, the veins of his arms, to the underground vein of billion-year-old rock beneath his feet.

They had gone farther than planned. And now, seeing the darkening sky, and the certainty of rain, they decided to turn back. By the time they could see Agatha's car, they were exhausted, but at least they had been spared the rain. Before getting to the car and escaping this depressing gray landscape, however, the silence of the quarry was broken by the high wail of an air-raid siren.

They stopped in dead fright. The Valkyric howl came down from the sky at the same time it seemed to blare up from the depths of the pits. And then the employee who worked in the Visitors Center came running out to escort them to the shelter.

Reassuring them that it was only a practice, he left the trio in the cramped dim space, a storage closet or the like, a back room. They stood pressed against the cold wall, waiting out the torturous mechanical scream. It ascended in a long and winding sinister bend. Pitched to an inhuman minor third—a centrifugal B♭ and D♭—the wail hurled out to its most extreme and upward apogee, whereupon it began its hellish reentry, falling back endlessly on itself before starting up again.

Agatha could see, through the vibrating haze of fear that blurred apart his dim outline, how Bartók was disintegrating. Trying and failing with all his will to withstand some malevolent shift in the laws gluing together the universe. As if the siren signaled a violent hypercorrection in Earth's orbit—a sudden acceleration in its turning, so that outside the blank room where they were imprisoned all had been jarred and swept out

into the rush of space, and the debris of the former world was whirling about the smoking planet now in a thick belt of pulverized mountains, cities, cathedrals, battleships, and scraps of the locomotive outside, already loaded with the slabs of rock that portended the world's end, streaking around the wasted globe in an exploded-view schematic of piston rods, crankshafts, staybolts, spindle nuts, and a fiery gust of rivets and superheated steam vapor leaking into the vacuum of space . . .

The very sanity of the world derailed.

Then, abruptly, the noise ceased. And the man from the Visitors Center reappeared and showed the disoriented trio out to their car, chuckling. "Well, here we are, all still in one piece!"

They drove back home in silence.

It was only at dinner that Agatha realized Bartók had not spoken a word since the siren. He had retired at once to his room when they had come home from the quarry. But now, in the flicker of candlelight, he looked more than his usual ill at ease. His skin had a yellow pallor. But most disturbing was the expression of simple terror on his face.

"What's wrong, Béla?" Ditta looked at him, truly scared. "Was it the air-raid drill? It was only a practice, not a real one."

With apparent effort, he turned to regard his wife, trembling. And then, in one of Agatha's eeriest transcriptions of the maestro's words, Bartók whispered . . .

"For me it was a real one. Real and terrible. All the stones of the quarry were falling, shaking houses, shattering windows, burying people and animals." As he spoke, the hollow gravity of his pupils, each like a dank and drafty drainpipe, tugged at the candlelight. "A single stone, alone, wiped out civilizations—and that siren was deafening millions." He closed

his eyes and the candle guttered. "Piercing their hearts as they ran under the falling bombs in the merciless crushing finality of destruction. There *is* a war. The bombs *are* falling. This very minute, like the minute before, somewhere, always somewhere, and there is no escaping from it anymore . . ."

And then he announced that he would be leaving as soon as possible, the next day. Ditta pleaded with her husband to stay, not to leave, to take a few days to recover his nerves, but there was no changing his mind. He insisted that he wanted to go alone, as well, and that she could return to New York in a few weeks' time. In the end it was only two notes, an interval of unimaginable discord, B♭ and D♭, that had undone the master of noise.

The next day he did not remove himself from his room until it was time to go to the station. To catch the southbound 10:24 that was late and did not leave until nearly midnight. Over the mountains, the stars blazed. They waited in the cold night air at what was not much more than a shed. At Bartók's insistence, Agatha had not recruited Matthew to play chauffeur, so the women, instead, had to lug his suitcases and heavy boxes into his roomette when the train arrived. He would get a porter at Penn Station. Fortunately, this was a few months before one of the patients in Waterbury, a deaf and dumb lunatic named Edwin, would escape and try to sabotage trains on the same line by chopping the ties with an ax. This, after Edwin had set fire to the hospital's dairy barn, killing six calves, a cow, and three bulls—the smoke billowed over the asylum for days. He was presumably spared the tortured music of his sacrifice.

2

"All the manuscript had been burned, and the blue flames
were flickering amongst the white ashes. The cylinders of
your phonograph too were thrown on the fire, and the wax
had helped the flames."
Here I interrupted. "Thank God there is the other copy in
the safe!"
—*DRACULA*, CHAPTER 21, DR. SEWARD'S DIARY

BÉLA BARTÓK MEMORIAL HOUSE, BUDAPEST. EMBEDDED
in the papier-mâché hills are little electric peg lights that blink
awake when you press one of the buttons. The buttons are ar-
ranged on a brass panel, with each blink corresponding to a
village where Béla Bartók collected. The mountains are built
low to the floor, so you have to get down on hands and knees,

like a child, really, to see, though I am the only one down on hands and knees, trying, with great difficulty, to reach up for a button while simultaneously framing the shot. My device, an iPod Touch, has a chrome mirror backing, so I am able to see myself contorted into this inane position in pursuit of documentation.

It's the sort of info-diorama you might see at a tourist center in the Poconos. The mountains themselves, on first glance, look more or less topographically sound. Otherwise it is a bald and artless simulation, without so much as a fake tree. A lot like my father's old model train layout in the basement, I think. With a notable degree of verisimilitude, he had made a simulacrum of our sad little mountain town, only a few miles down the road from where the master had spent his ill-fated summer in Vermont. But my father, who was installed in our own village as resident shaman, aka United Methodist pastor, put more of his creative energy into the mechanical details. Water tanks. Crossing signals. Gravel conveyors. Loading bunkers. Maintenance shops. But no fake shrubs or flower beds, no dead tree fall, no foliage, no serene cows enjoying the shade of a spreading elm along the riverbank. No *pastoral*. Just some raw mountains and a few river cliffs carved hastily out of high-density pink foam substrate with a steak knife.

The model train track circled the little church where he preached, the funeral home, the cemetery, the IGA, Lions Club, the little diner where he wrote the first drafts of his sermons, and the train station, of course, with little plastic gray men waiting with briefcases and newspapers, and even a complex of redbrick buildings and tall wrought-iron fence that stood in for the sprawling campus of the asylum, only a block

south of our house. In some inexplicable way, my father's model eerily captured how the town, designated as a containment unit for toxic psychic waste, was diseased through and through, caught as it was in the disturbed radius of the state hospital.

Everywhere you turned were heavily sedated casualties, residents of the halfway homes that lined Main Street, zombie courtiers with day passes from the castle on slow Thorazinic walks around the block. More than once on my way out the door in the morning I had to step over a patient nodding off on our porch.

I remember the sour electric smell of the train's motor. The bouquet of electro emissions, ozone, in my nostrils.

One detail my father had not failed to include: the smokestack behind the hospital I imagined was used for disposing of the incurable. It was only the generator, of course, that produced heat for the sprawling campus, and juice for electroshock treatments, but still, I kept an eye on it. It towered behind the wall of maples that bordered the field behind our house. The field where I compulsively dug holes, odd, solitary, morbid child that I was. Most of the field had gone fallow and was only a cloddy inarable meadow, except for one tiny corner that my mother had brought to life and kept cultivated as a garden.

Far out in the field, I spent many hours digging these foxholes to hide from the external world. They were deep enough that sitting at the bottom of one, I was sometimes able to suspend the solipsistic illusion of being the only survivor from some bloodless rapture, orphaned under a lid of autumn sky. After the leaves dropped, the smokestack was as stark as the steeple of my father's church across the street. Such were the gothic parameters of my childhood.

After service, still in his robes, before he changed, my father would descend to his private dungeon, with a mason jar of bourbon, to amuse himself by arranging the tiny figurines that wandered the grounds of the asylum to do perverse things behind 7 North, or the B Building.

I remember climbing around like a cat on this elevated stage—the platform was built high up off the basement floor, adjusted to my father's giant height—and delving into the parallel universe of HO track and switch towers, peering into the tiny pink-grated windows of the asylum, down the bore of the smokestack, as if I were soaring over the real world shrunk down, with the dizzying freedom of a sparrow, until one day I got too close to the edge and fell, cracking my chin on a very unsimulated concrete floor in an orgy of blood and pain. As I fell I thought I could see cinders raining down on papier-mâché forests . . .

I can still feel my father sweeping me up, his drink crashing to the floor, then fleeing with me in his arms, hurrying across the yard and weaving through the fussy flower gardens kept by our neighbor the dentist, dodging the quarry of fountain-sized holes that my brother's dog, Clyde, had dug in his petunias, and dancing around this flowery obstacle course, slipping and stumbling, the worn heels of his wingtips, always polished Saturday night while watching the game with a near-final draft of his sermon at hand, crumbling over the craters, pausing once to take a swipe at the dog, with one foot, and nearly kicking my brother—whom I can now also see, fuzzily, lying half in/ half out of the hole, snorting moronically as dirt sprayed him in the face from between the dog's hindlegs, my brother who was a fraction off, grazed maybe, in some hard-to-define way

slightly out of tune—but as blood gushed down my chin I felt as safe as I have ever felt, held aloft in my father's flowing arms, embraced by his comforting hugeness, the scent of Old Spice and Johnnie Walker Red and snuffed church candles reposited in the billowing robes, as soft as the folds of animal pelt.

The dentist could never keep up with the devastation incurred on his yard by our dog. I still remember how the dentist's fingers tasted of soil as they probed my bloody mouth. I'd bitten clear through my lower lip. I remember the laughing gas: as if I were a gypsy moth the dentist had caught laying my ravenous eggs in his Night Gladiolus, before dropping me in a vial of chloroform. I fluttered drunkenly upward . . . batting at the fluorescent panel as my legs kicked out in the air beneath me.

Piped into his office was classical music.

"*És az utolsó. Most. Vége.*"

"Yo, we're going upstairs."

This is the voice of my guide and translator, Bob. He and the Hungarian docent are already ascending, though I'm still down at floor level taking pictures of the toy Carpathians.

As we climb up to the second floor, the docent, who wears a leather jacket, and buckles on his shoes, points to the banner in the stairwell embroidered with the entire score of Bartók's Third Piano Concerto, his final piece, written in exile in New York City. The stairs go up one more flight, but then dead-end at the wall. The guide explains how this is because after the Third Piano Concerto, see, *that was it?* In fact, even after the ambulance had been dispatched to his fifth-floor apartment on West Fifty-Seventh Street, Bartók spent his last frantic moments trying to get down the final seventeen bars. The EMTs had to drag him away from the unfinished score. So the story goes.

The dead-end stairs seem pretty heavy-handed, but the docent is clearly proud of the symbolism. Regardless, I'm not interested in the Third Piano Concerto. My business here concerns the Third String Quartet.

On the next flight is a lot of the weird furniture Bartók brought back from Transylvania. He furnished his whole house with the stuff. It's all painstakingly carved: geometric stars and hexes and other hill-folk glyphs, somewhat oversize.

Upstairs, Bob and the Hungarian are standing in front of a cabinet, laughing. The docent points at a small box behind the glass.

"Our latest exhibit," Bob translates. "Bartók's last butt."

I look in the case. "The last cigarette he smoked?"

"This is new," Bob says.

I regard the little twist of yellowed butt, set like an engagement ring. The docent talks quickly. Bob translates. "In 2006 they were doing a complete renovation here and called in somebody to work on the piano, this famous instrument restorer. He took the whole thing apart and found that inside."

Idly, I wonder which string it was found under. Perhaps Bartók put the butt there on purpose for some kind of special effect.

"They checked—it's a Tisza Mayfly brand cigarette. *[Hungarian]* And that's what Bartók liked to smoke. *[Hungarian]* So somehow or other it got between the strings of the piano. *[Hungarian]* It was brought as a gift to his son."

"That's really beautiful," I say.

"Igen, igen."

Here and there are photographs of Bartók with his wife and children, one of the master in a polka-dotted ascot and sus-

penders, playing a giant crank instrument with strings and a kind of primitive keyboard.

"Hurdy-gurdy," Bob says. He takes his camera out of his leather fanny pack to get a picture. "Last traditional player died seven years ago."

Bob is originally from Teaneck, New Jersey, via the East Bronx. His dad was a cop. But he's lived in Budapest for the past thirty years. He knows a lot of random shit, like that Yoda's particular syntax was inspired by a Hungarian tech on the set of *The Empire Strikes Back*. But his main thing is klezmer. Not the honky-wonky clarinet-heavy wedding band American klezmer. His specific niche: Carpathian klezmer. He spent years tracking down the sacred-original stuff in Transylvania. Mostly his hunting days are over now. But he does have a band.

Inside another case we regard Bartók's cuff links, stamps, a well-worn pocket metronome. If you read accounts by his students, you quickly learn how he put tempo, almost cruelly, above all else. He demanded a precision impossible to duplicate and would shame those who could not master it. Whereas some composers leave tempo at least somewhat up to later generations for interpretation, Bartók's scores strictly dictate exactly how each note should register in time. For instance, on the autograph manuscript of his Third Quartet, he designated that each quarter note must be equal to 88 beats per minute, then changes it twenty short bars later to 76 BPM. A very subtle shift.

We wander over to a roped-off room. It is the master's studio.

There is his coffin, black and shellacked. Did I say coffin? I meant piano. Black and shining, the track lighting sends streams, like rivulets of thawing ice, dribbling across the lid.

The room is otherwise sparse. A leather chair by the window. The window is like any window. But the only thing of interest to me is the machine on the desk in the far corner.

"Is *that* the actual phonograph he collected with?" I say, sticking my head into the room past the velvet rope.

"NO NO NO."

"Don't lean over it," Bob says. "They've got a sensitized alarm system."

The amplifying horn is octagonal, painted tin. The headphones rest beside it. His son, Peter, writing in his book, *My Father*, describes how his father's study was always inexplicably filled with flying insects. Covering the window, crawling on the walls. He wondered if, somehow, "perhaps the bugs felt safe near him."

"Is it possible that I could get closer?"

"Gramofon . . . Igen?"

Bob grunts. "Uh-huh."

I dictate into my phone: "Ornate octagonal horn. Tin? What model number?"

Bob looks at me. "Did you want to go closer for a photo or something?"

Yes, I do. I am drawn to it like a winter moth. Though it doesn't appear they are going to let me. The thing is, it was this machine, more than anything else, that allowed Bartók to become Bartók. His whole method relied on this advantage: to go out into the world, collect bits of direct experience, make faithful transcriptions, then feed it to his inner gargoyle. I feel it somehow holds the secret to my entire investigation.

As a young man, Bartók had not shown great promise as a composer. He was a superb performer, was thought to have a

brilliant future as a pianist, but there was no burning inspiration to his early creative work. Of course, he was set back by the strange bouts of illness that had plagued him since childhood. The terrible skin affliction that had encased him head to toe for the first five years of his life. The child had avoided mirrors with lust. This vile virulent membrane had divided him from everything but the affection of his mother. The exanthem was cured by arsenic when he was five, but the sense of confinement never left. "Nothing could speak more eloquently of my innocence at this time than the belief that I could make my boundaries disappear," he said once in a rare, unguarded moment. "For only much later comes the discovery that one remains confined, to a lesser or greater degree, forever." During his second year at the Royal Academy of Music in Budapest, in 1900, he began to spit blood and was forced to take a half year's absence to recuperate in South Tyrol. Aside from this deferred year, his main obstacle was no different than for any other young composer of his time. Like most of his contemporaries, he was starving for something new, feeling, in general, that Western music had shot its diatonic wad. For a while he followed the path blazed by Strauss who espoused "new ideas must seek new forms" and who would do away with the stale fetters of the sonata, reordering and transforming themes, and for a time, Bartók, too, began to generate a handful of interesting, alchemical pieces with inversions, rotations, retrograde-inversions, motivic permutations that gave off the overall tonal impression of dangerous laboratory experiments.

But it wasn't until the summer of 1904, while Bartók was at a summer resort in Gerlicepuszta, a village in northern Hungary (now Slovakia), when he would overhear a nanny cooing

a lullaby and discover his true master. He was there to work on his Piano Quintet. But, then, one day, while composing, he was interrupted by a voice from the next room over. At first it must have perturbed him immensely. He was always fanatical about working in absolute silence. In his studio, he muted out his family with a thick leather blanket. In exile in New York, many years later, he would leave the shower running as a kind of white noise machine. But now, he set down his pen and sought out the girl. Surely, she was flustered, faced by this fanatical wraith of a man, demanding to know what it was she was singing, and she must have been apologetic, no doubt thinking she had disturbed him, for certainly the nanny had had to listen to his terrifying piano from morning till night. (But it was surely excruciating for Bartók as well, who had so much difficulty breaching his own boundaries, the ones he had felt since he was a child and the loathsome, itchy red blossoms that had kept him confined and isolated from other children, that had created that original sense of separation he had never gotten over, but now, however painful, however difficult, he violated his own boundaries to reach out, to go out of bounds, and when the young woman realized the gentleman was not scolding her, but just curious, she told him it was only a simple song she had grown up listening to her grandmother sing.)

He heard the music of chopping wood. Mud. Geese. Thatched roofs. Men with folksy tools: scythes, mattocks, hods, and weird twisty pitchforks. Black pines and roots growing out of stream banks. Peasant women embroidering at dusk.

Somehow Bartók found the courtesy and charm to persuade her to sing it again so he might copy it down in his journal. The song was about an apple that had fallen in the mud. It

really could not have been simpler. Bartók looked at it there, this apple in the dark mud, like a shining clot of blood, and he picked it up, and turned it this way and that, and he scribbled down the melody to better understand the shape of this thing which he could not yet grasp. But where did the tree that dropped apples such as this grow? The girl told him she was from Transylvania. Her name was Lidi Dósa. And then, eager to get back to her charge before her employer returned, and perhaps just as eager to separate from the strange man, she departed and they never met again.

The encounter left Bartók wandering, confused, in a strange new orchard. Transylvania? It was a backwater, not a place one would ever think to turn for inspiration. More to the point: it was impossible that such music could still exist. Everyone knew—this opinion most confidently championed by Franz Liszt—that if there was anything resembling a traditional Hungarian folk music, it was the *verbunkos* preserved by the more romantically in-vogue gypsies, and that the dissipated peasants themselves had long ago left their songs rotting in the weeds. And yet a few years later Bartók would set out there with a sack of wax cylinders and a phonograph tied to an oxcart, in pursuit of this ancient form that in one afternoon had reshaped his entire mind.

It was by using his machine, like a meat grinder, to record the scabbed and melancholy folk songs he had scavenged in the hills, melding his high theoretical mind with that raw open music, that made for the elixired hybrid Bartókian style. The Transylvanian ballads and *colindes* and *hora lungă* that he listened to under his scratchy headphones, during all-night sessions in his parlor, until his ears were nicked, like a cryptographer

possessed, had transformed him into a new kind of composer, in some ways nearer to meek shaman than aspirant to the tradition of Vienna. It was an angelic, grotesque metamorphosis.

He was still deciphering these new "codes" when he brought his boxes up to Vermont to stay with Ágota (Americanized as Agatha). I had once tried to visit the old house, where he had stayed with Ágota Illés, just down the road from Waterbury, but it turned out that the local fire department had burned it down in the late sixties to chase off a coven of hippies who had been squatting on the abandoned property. Local farmers had evidently grown tired of late-night bongo circles keeping awake their cows. Standing in the empty meadow, however, I had quickly grasped that if Bartók had ever peered out his heavy drapes (his guest room had been in the northeast corner of the upper wing), he would have had an unimpeded view of the green peak that cast its shadow over my own childhood village, which my father had so painstakingly sought to replicate in miniature, right down to our ramshackle train depot, just two stops north of Riverton, where the pale maestro had arrived that July night back in 1941.

But now the docent won't let me see the machine. I am most intrigued by its power to generate such perfect replicas. You never read of him ever having trouble with the machine either. No malfunctions due to dust from the long crooked dirt roads gumming up the governor shaft or fine brass gears. It operated with perfect fidelity. My search for clues is not helped by the fact that the docent is unfamiliar with the bizarre circumstances under which the autograph manuscript of the Third String Quartet had gone missing. When I tell the story, or what I've sorted out, at any rate, over the course of my investigation,

which sounds even more farfetched and sordid as I try to relay it, he only regards me with frank suspicion. As if I'm making the whole thing up. I think it's why he won't let me take a closer look—but maybe that's only because he gets upset when I try to let myself over the velvet rope of the master's enshrined studio to get at it myself.

At the very least I figure I can copy down the serial number. Bob looks at me like I asked to take the thing apart on the floor, or get a blood sample off the needle.

"*Igen, igen, Amerika, Bartók.*"

I ask the Hungarian if he is a musician himself.

"*Igen, igen.*"

"Yeah," Bob says.

"What do you play?"

"Pianist." Bob answers for him.

"Pianist?" I say. "Huh. You ever get to play that?" I nod at the piano on the other side of the rope.

"*Kicsit, kicsit.*" Little bit, little bit.

"When no one's looking I bet."

The docent shrugs, smiles, looks sheepish.

I give Bob a pleading look.

"Yeah yeah yeah yeah—I asked." Bob crosses his arms. "He says that machine was, when he got it in the beginning of the 1900s, it was, like, you know, the master supercomputer. They weren't mass-producing these."

"*Kollekcióban.*"

"Do we know who manufactured this?"

"He doesn't know," Bob says.

"Is there a name on it, or . . . ?"

"He has no idea."

"Maybe it's an Edison?"

"He can tell you the typewriter's a Remington."

Bob is clearly ready for a cigarette. He listens to the guide and shrugs. "It might have been brought from Vienna."

I recall reading a letter that Bartók had written to his son, Peter, in June 1945, three months before his death, that began: "Waiting, waiting, waiting, and—weeping, weeping, weeping, weeping—this is all we can do. For news has slowly begun to trickle over here and these are rather alarming." He had just read a newspaper account from Budapest that included an interview with his old friend, and fellow composer, Zoltán Kodály, who said that all Bartók's wax cylinders had been destroyed when Russian soldiers had looted the National Museum.

It makes me think of the time I stood in my father's neglected orchard, watching him burn all his papers. He had decided to do so on a violent whim, piling the back of his pickup with the dumped drawers of his filing cabinets, and I didn't try to stop him as he pitched handfuls of his sermons into the fire. The last time I saw him, a week ago, he was still in the hospital. Still somewhere in the hangover of anesthesia after they'd torn open a hole in his stomach in a vain attempt to remove the tumor. But the black apple was stuck; it could not be plucked without killing him. He looked and sounded a million years older than he had before surgery and he still hadn't really absorbed that it had been a failure, but I did not have the courage, or the time, really, to tell him. Even undead, my father still retained his giant's stature. Perhaps I was afraid. During that last visit he had risen from the bed and was standing in the middle of his room in his flimsy gown, reeling and stammering, while two nurses hurried to wipe the shit smeared all down his back,

this while a team of seven or eight doctors, oncologists, nurses, and orderlies labored together, with undisguised trepidation, to form a kind of group fulcrum, as if they were doing some ridiculous team-building exercise, to lower my father's gigantic yet impotent bulk down into the chair by the window. I remember his look of bewilderment, his failure to make the usual disarming jokes with the staff, and my own feeling of imminent collision with what I knew might soon enough be processed as reality.

"Well, Dad, I've got to be going to Transylvania. Big magazine assignment. See you in a couple of weeks!"

In the elevator on the way out of the hospital I made a quick note to myself: *you really can't avoid this, you know.* And then I looked at the little plastic box of flies my dad had pressed upon me with some urgency before I'd left the hospital. A last gift from a dying father to his son. They were angling flies he'd tied himself over the years. A collection of his greatest hits. But by the time the elevator doors opened, the benzo under my tongue had dissolved and the next thing I knew I was in Budapest at a bar with my New Jersey Virgil watching Serbian girls do Jäger shots.

Bob and the docent talk in Hungarian so I can't understand what they're saying, though I can make out the words *dokumentum, fotográfia, gramofon, Amerika.*

"Yeah, you'd have to be a psychologist," Bob says, in his indirect method of translation. "Here comes this city person, and the peasant that's just going to sing for him has no idea what he wants, or how he wants it, you know? He just says, sing what you sing, and then—you'd have to be a psychologist to understand the relationship."

The docent looks infuriated at the idea of how messy it would be to get inside Bartók's mind regarding the peasants.

"There's all these stories about him and the peasant girls." Bob and the docent shrug simultaneously, as if to say no one much believes it.

"When he got married," Bob says, "one of his Academy colleagues came up and said, 'Béla, I hear you have married again! Congratulations!' and Béla answered, 'Do not involve yourself in my genital situation.'"

As dry as pocket lint.

We fall silent as a crowd of women come chattering down the stairs. Then we look at a few more cases. Bartók's glasses. A child's toy one-stringed fiddle, matches, keys, pencils, ink... A kind of forked instrument for drawing staves on composition paper, the handle of which is a stern little figurine of Wagner. Then we walk over to two framed glass boxes that lie flat like jewelry cases and examine the contents. It is Bartók's insect collection.

When I ask what his specialty was in bugs, was it just beetles, or other insects, too, the docent, without really seeming to consider my question, says it was just anything. Nothing special. Just bugs.

Briefly, I try out my new digital magnifying lens app, which, really, is crap, but it does have a cool distorting effect, so, magnified eight times, the shriveled bugs look like giant quarter notes pinned to their vertical stems. I picture the composer sticking the wriggling notes to the staff before plinking out each tone on the piano.

On our way out, we stop in the garden to look at a bronze sculpture of a deer, or, at any rate, a surrealist's version of a deer. It kneels, bolted to a concrete plinth, in a patch of white-puff dandelions. It has an exaggeratedly long neck and a tiny head

but with these gigantic circumferential antlers swooping out like enormous stylized pincers. The earliest history of the origins of Hungary are forever lost in the fog of myth and legend, much of which came down through epic song. The deer (aka "Miraculous Deer") is one of the origin beasts of Hungarian mythology. Two sons of the Scythian kings Gog and Magog, the brothers Hunor and Magor, were hunting in the forest when they saw this white stag. It was clearly supernatural. A god. Its antlers rays of light. Great flares shooting out the side of its head like the condensation ring of a mushroom cloud. Led on by the magic stag they lost it somewhere around the Sea of Azov, or at any rate, en route to the Sea of Azov, when they ran across these two princesses, radiant daughters of the king of the Alans, got married, and thus were born the Hun and Magyar peoples, even though as modern ethnographers know, despite deliberate and tenacious misinterpretation by some myth-loving Hungarians, there has never been any relation, outside of myth and a similar-sounding name, between the Huns (see, Attila the) and the Hungarians (aka, Magyars). The deer is a nod not only to Bartók's love of Hungarian folk tales and mythology but also to his mysterious *Cantata Profana*. In that rare operatic piece he employed the use of mythical stags. The story briefly: One day, long ago, there was an old man who had nine sons whom he had failed to adequately prepare for life. They had no skills other than hunting in the mountains. And so that's what they did, spending their share of the endless tedium of days wandering the forest, poking around, looking for deer poop, and whatever else it is feckless hillbillies do, until this one day they come across an enchanted bridge, cross it, and on the other side are transformed into nine magnificent

stags. They know their antlers will never fit back in the door of their home so they pretty much just decide to stick with being stags. Then, their father, the old man, gets to worrying, though it seems probable that they were just somewhere getting drunk, but he goes out looking for them, comes to the bewitched bridge, wisely does not cross it, but when he sees these nine impressive stags he lifts his old rifle to shoot the really big bruiser, who talks back to him in this baritone voice and says, Dad, it's us, don't shoot, or we'll rip you a new asshole with our antlers for real.

> *Our antlers will impale you*
> *And throw you and hurl you*
> *Hurl you past the valleys*
> *Hurl you past the mountains*
> *We shall smash your body*
> *On a dreadful rockface*
> *Treat you with no mercy*
> *Our beloved father*

Bartók had begun work on his *Cantata Profana* around the same time that he had finished the Third String Quartet. They are intimately connected.

As we're leaving, Bob finishes recounting a final story the docent was telling on our way out about Bartók walking in the park one day with his wife, I didn't catch which one, when a big wasp flew past—*zzzzzzzzzzt*—and, either fearful of the bug, or just testing her husband's entomological savvy, she says, "Béla, what was that?" And he goes: "G-sharp."

3

AT THE INSTITUTE FOR MUSICOLOGY, HOUSED WITHIN the walls of the Erdödy-Hatvany Palace, we are met in the rather daunting lobby by the director of the Bartók Archives, a slight and courteous man who introduces himself as László Vikárius. I had read some of his articles online, such as "Bartók's Late Adventures with Kontrapunkt," as well as a rather unnervingly complex piece on rhythm patterns in the *Cantata Profana*. In his office, several flights up, there's a large double casement window thrown open onto the surrounding view of skeletal spires, river, general Gothic verticality. A pleasant breeze flutters the papers stacked around the room and on his desk.

He pulls around several chairs for us to sit.

It turns out Mr. Vikárius is just as unfamiliar with my story about the missing autograph manuscript as the unhelpful

docent at the Bartók House. Naturally, I want to tell him all about it, but, as I begin to fill him in on the sordid details, I detect, behind his polite exterior, something skeptical. Given my neurotic tendency to distrust my own memory and perceptions, this fills me with dread that I'm somehow trafficking in a fraudulent narrative (he's the Bartók expert, not me!), and I feel myself beginning to compensate by pumping up my story a bit, investing myself a little more in its telling than is perhaps required. I'm aware I'm doing so but can't seem to put the melodramatic tone I've taken in check, no more than I can stem the wild arm gestures I find myself making as I outline the basic shape of the story: that shape being, if you solely focused on my arms, and were perhaps sequestered from the scene by a panel of soundproof glass, something akin to a deranged preacher recounting the breaking of the seventh seal. I didn't bother going into the background detail, of course, about how I had first come upon the story, that being one distant evening now, more than a year ago, when I had taken myself out to a chamber music concert as a kind of reward for having crossed the three-month milestone of not getting drunk as a lord every night. It wasn't just booze but the pills too. The alcohol had worked for the same reason the pills worked. They acted like a toe I could keep wedged in the door of my unhinged amygdala, to keep out the salesman of doom shoving his fiendish wares against my chest till I could no longer breathe. I think the pills, at bottom, were to fend off my terror of other people, or rather, to be more specific, the *other minds* of other people.

It was a phobia, I guess, like being afraid of one's own intestines.

The problem was I had begun taking the benzos preemptively, whenever I had to travel, or leave the house, or make a phone call, or interact with other humans, or anytime I became aware of a physical sensation that struck me as suboptimal. They were great for erasing unwanted thoughts and for indeterminate fear in general. I took them to go to the park, I took them to be a better husband, I took them the instant I foresaw a traffic jam. I took them to face my own father's terminal diagnosis, and to quell the steady pulse of shame that was, I believed, my rightful inheritance.

But, yes, at the time, going to see some classical music seemed like the sober, clearheaded thing to do, a way to remind myself that I was still, on occasion, fit for society. I forget who the quartet was now—Emerson? Takács?—but they were performing Bartók's Third String Quartet, along with the Fourth or the Sixth; or maybe it was the Second, any one of which I have to admit I prefer to the Third.

Not that preference has anything to do with it anymore.

Anyway, since I'd arrived early, and was trying to avoid the champagne bar, I decided to sit in on the preconcert talk, which was being given in a small classroom off the mezzanine. There I found awaiting the lecture a group of nine or ten extremely frail and elderly white-haired people, because, aside from the two or three obligatory Chinese students, this is the only demographic that goes to see string quartets, even the avant-garde stuff like Bartók.

As for myself, I was wearing a flamboyant, long silver cashmere scarf and was aware of radiating from my inner being the pure, wakeful energy of the newly sober forty-year-old. I was

really in touch with the moment, gratefully aware that perhaps I was capable, after all, of carrying on a healthy and accepting relationship with reality, as opposed to the avoidant approach I'd practically mastered.

And I don't just mean the booze and pills. It was almost as if I'd been suddenly deprogrammed from a faulty cult of my own making. That cult having something to do with the rigors of my trade: this being the work of collecting and cataloging so-called experience, mine and others, mostly others, for what was an admittedly vampiric job. That is, I was a magazine journalist, specializing in narrative nonfiction. It was my job to go out in the world to try and have some kind of original experience, to capture and arrange and shape it all into some pleasing form, but in the process of listening to the tapes, reviewing notes, revising, rearranging, reconstructing, I would notice how the meaning of the original experience had a tendency to slip, to mutate, to become *unfixed*, and so I would go back and reread the transcripts, listen to the tapes again, noting shapes and shades I had not picked up the first time around, in the actual moment, each time discovering new interpretations, new layers that contaminated and mutilated the previous understanding, until I could no longer trust my ability to determine what events had any significance, to decipher any meaning that would not immediately decay before my eyes.

Who was I to speak on behalf of an immediacy that could never exist? Just the thought that anyone could possibly expect me to faithfully regurgitate my experience of the world made the bile rise in my throat.

In short, I had developed an acute allergy to experience itself. It had been a long time coming. I had long suspected that

my instruments for recording these experiences were little more reliable than a Xerox on the fritz. Mine maybe more than others. Memory being, of course, the defective machine spitting out its trickster distortions. The original memo—if there ever really had been one—was lost. The problem, no doubt, was that I had given myself over to thinking too much about the *idea* of experience. Maybe, at first, this was because I mainly got paid in experience. Go here, go there. Stay here, stay there. But gradually I began to question whether the sort of experiences I was having were real, or only staged, and, then, stickier questions, like how did one thing count toward experience and another did not, how could anyone believe that *any* experience was a thing that one could collect, catalog, and classify, as you might one species of beetle or another, and how much *conscious* attention was necessary to register experience as experience anyway, and how did consciously registered experience measure up to the other inward-bound seismic impulses, the more subterranean forms of id-munching, and so on and so forth.

But then one day I woke up and found I'd been happily deprogrammed in my sleep. I was free. I no longer wanted to be an unenlightened avoider but saw I might fully embrace this direct experience thing. All experience did not need to be in the service of making a pleasing copy. Every minute during that golden period seemed, how do I put it? Like I was experiencing each new moment at the ecstatic point of its *origin*. How else can I put it? I think that's probably sufficient.

Anyway, I had come to be present for this music with no other intention than to enjoy my new clarity. To reward myself with a little uptown R&R. Certainly, I hadn't come fishing for stories or material that I could later mediate and distort with

pedantic overreflection. So imagine my shock once our guest speaker, Richard Wernick, the relatively lithe septuagenarian and Pulitzer Prize–winning composer, began to speak.

At first he spoke of the golden ratio, and how Bartók had put it to use in his compositions, even drawing some neat diagrams on a blackboard for our edification. He mentioned the peasant music thing and how Bartók had transmuted the influence into his music, quite notably in his fiend of fiends, the Third String Quartet, smugly surprising us all by saying how that most demonic of pieces had actually premiered in Philadelphia, just a few blocks from where we were sitting, despite the long-standing and official, yet incorrect, story of a London premiere. Bartók's composition had evidently won a competition, in 1928, put on by an outfit called the Philadelphia Musical Fund Society; he co-won it with an Italian composer named Casella, and they had split the six grand; but if Wernick told us what Bartók went and spent his half on I wasn't listening because I was ogling one of the violin students, or maybe I was just spacing out on the silvery tassels of my scarf now.

But then our lecturer chuckled. Was this a prepared aside? Or did it truly only occur to him in the moment? Now, of course, I wish he'd completely forgotten it, or that I had remained focused on the student's shapely white-stockinged calf, but it was too late. He had already dropped the distraction bomb on us.

This bomb had to do with one of his former colleagues at the University of Pennsylvania, a man by the name of Otto Albrecht. Otto, it seemed, was a kind of musicologist, or ethnomusicologist, or marginal bibliographer of musical texts, it wasn't quite clear, but the gist of his job seemed to be that he

went around collecting autograph manuscripts of classical masterpieces, with the intention of publishing them in some kind of enormous academic tome that he'd been working on for like thirty years. It was called *A Census of Autograph Music Manuscripts of European Composers in American Libraries*. That would have been reason enough to go back to spacing out, but since this guy Otto was always on the make for scores—I took it his job was kind of like being a detective, a tweedy bounty hunter, so that kept my interest—he well knew that Bartók's Third String Quartet had debuted here, and that this Philadelphia Musical Fund Society (kind of a dopey, provincial, difficult outfit, you got the sense by the way Wernick spoke) was supposed to have the autograph manuscript (condition of the prize), but they didn't, or at least *said* they didn't, and so Otto, as I gleaned, had spent the next forty-four years of his life looking for the manuscript without luck, until, on the eve of his retirement, and in the midst of a lot of hubbub about a new music library being built in his name, something had tipped off the old man that this PMFS had been totally duping him the whole time—it wasn't clear what they had against this Otto fellow—but when he found out he went kind of berserk.

As Wernick told it, Otto found out they'd been keeping it hidden away in a bank vault. So he'd gone to the bank and bribed a security guard to let him inside. Then—then—he had *stolen the manuscript*. Sort of like Bartók stole it from the peasants, and, I suppose, sort of like I'm stealing the story now for my own reckless purpose.

But now I'm in Budapest, recounting the story for László Vikárius, still so excited by this part that I am actually raised up in my seat—in a sort of cheerleader's half squat—skipping

over certain details to get more quickly to the touchdown: this being when Otto had dashed back across the city (from his alleged bank heist) to interrupt an ongoing Music Department meeting, busting through the door, and, as I approach the climax, I thrust my arm into the air as if I myself become Otto E. Albrecht brandishing the rescued, pilfered manuscript—only pausing briefly to pantomime, for the benefit of my audience, the varied expressions of shock on the faces of the other faculty around the table—here is Lawrence Bernstein, scholar of Renaissance music, tears welling up with awe and admiration at the returning hero; and George Crumb, avant-garde darling and composer of *A Haunted Landscape*, with its own Bartók-influenced sonic rivers of droning time, cosmic plainsongs, descants, and guttural caterwauls summoning the shaman from the tomb, ironic distortions, parade of grotesques, et cetera, smiling broadly; and Richard Wernick, with both hands to his cheeks, like Macaulay Culkin, though, of course, I have no idea whether these are appropriate expressions to any of these men, but in the moment they feel dramatically correct—and then, standing on my tiptoes to make Otto's final gesture of slapping the manuscript down on the table, and shouting, "I *FOUND* IT GOD-DAMMIT!"

Mr. Vikárius sits still, hands wedged between his knees. All look at the floor where I have hurled the invisible manuscript, *ta-da*. Bob watches me nervously, fidgeting. When I see László is not as exercised about this as myself, I confess, lamely, how there's another version but it's not quite as interesting.

He says he knows of George Crumb, of course, but not this particular affair. He is not at all familiar with my story. In fact, I get the sense he does not know why this has brought me here.

If so, he may have a good point. In my raconteurial fervor, I'd been just about to launch into an inventory of the five boxes I'd found in Otto Albrecht's archives, at the University of Pennsylvania, but, then, recalling how the first item I had uncovered had been the results of a urine test, I shut my mouth.

Bob steps in and tells him how we're going to be traveling through some of the same villages where Bartók himself went, including trying to track down Lidi Dósa's old village.

Mr. Vikárius warms at the mention of Bartók's muse. He says meeting the Transylvanian nanny was a small miracle for Bartók, as it led to the great discovery. "It was quite a revelation," László says. "It was an accident that he heard this Lidi Dósa."

"Do you know if she has living descendants still?" Bob asks. "We'll be driving through Kibéd. I thought we'd stop and ask if there's anybody who remembers if the family's still there."

The plan is to meet up in Transylvania with Bob's friends Jake and Eléonore in two days. They're driving from Moldova, where Jake is working on a Fulbright studying links between Romanian folk music and klezmer. Bob speaks very highly of Jake, says he's the best klezmer fiddler in the world.

"I don't know about any relatives, but there might be," László says.

"We could just ask in town," I say.

"Ask the priest," Bob says. "He knows everybody. A town that size—I've been to Kibéd, everybody knows everybody."

László grimaces. "But let me tell you that it *might* be not so easy to go around and find someone. Or it might be *too* easy to find someone who appears to know something?"

Bob gruffly lets him know that he's peasant village street

smart enough to get us through any deliberate attempts at disinformation.

László returns to the subject of Bartók's meeting Lidi Dósa. And how it led to the accidental discovery of this autochthonous trove of alt-melodies. Just as groundbreaking, László says, was Bartók's discovery of *pentatony*.

Until then, a scale completely alien to Western ears.

"When he first reports on this discovery, he mentions that he had found this *ancient* scale, which he had considered extinct." Bartók, he says, also referred to it as a *defective* scale. "He didn't have the right name for it. It was so new."

"Defective scale," I say.

"More ancient types of scales," László says. "They are often pagan in origin."

He went on to explain how this was true, as well, for instance, when it came to the original source material for the *Cantata Profana*, a Romanian form Bartók had collected, and spent much time obsessing over, called *colinde*.

"Christmas carols," Bob says.

"Christmas carols, yes, exactly," László says. "I see you are quite familiar with the topic. But, of course, the colinde are more accurately called *winter solstice* ceremonial songs . . ." Even Bartók recognized, well before the advent of ethnomusical studies, that the colinde he had collected had little to do with the star of Bethlehem, and possessed much older astral roots, possibly reaching as far back to some pagan solar cult.

The colinde's rhythm patterns can be heard in the Third String Quartet, as well as the *Cantata Profana*. Very likely because both had been composed during a wild creative outburst following a long period of monkish study when Bartók had been

down in the hole with the Romanian folk songs: the very same that twenty years later, during his getaway in Vermont, he was still torturing into a five-volume manuscript for publication.

The general explanation why nobody outside the hinterlands knew this music still existed, the ancient scales and so on, as I understand it, was due to the isolated geography of Transylvania—the same isolation that had preserved the music in the first place from culturally polluting effects of the Ottoman and Habsburg occupations. Even today, it's a nine-hour train ride from Budapest to Cluj-Napoca, the urban hub of Transylvania.

I picture Bartók traveling by oxcart with his phonograph lashed down inside a crate and ask if it would be possible to see some of the wax cylinders?

"Oh . . ." Vikárius casts around the room. "They are—*no*." He laughs. "I think that that is not possible now."

From what I understood the canisters were here in storage. Sadly, Bartók had gone to his grave (weeping, weeping, weeping, weeping) believing they had been destroyed in the war, even though the damage later proved less significant than initial reports.

I imagined them lined up in a cool dungeon beneath the building. But László says that it is not possible to access those particular vaults. Not today. But then he swivels in his chair toward his computer and says that if I want he can show me a few digital images. On the screen I see the words *Edison Blank*. It looks like a can of Calumet baking powder.

When Bartók went on his first excursions to Transylvania, he had to be very careful with the cylinders. They were extraordinarily fragile. They had to be stored inside tin containers, and these in turn were stored inside padded boxes. The padded

boxes were stored in larger boxes to protect against the sinister roads. Since Edison had changed the formula from stearic wax and ceresin to a harder resinated wax, at least one no longer had to worry about cylinders melting in the farm-day heat. I recall listening to one of these early recordings at the library, and how in that moment I felt an almost unbearable suspense during the first few brief seconds of running tape, so to speak, in the silence preceding the music. The hundred-year-old dead air being gently etched for posterity. A sound like a kind of grinding cosmic background radiation. You can imagine the black wax canister turning. Bartók at the crank, waiting for his singer to gather her nerve, as the needle runs in the groove, the machine picking up the quiet apprehension of the country, the sound of its own turning, a bird, minuscule curls of wax falling to the ground and lugged off by ants to be archived in their underworld grottoes.

When Bartók returned home he would spend hours, days, and years listening deeply and transcribing his recordings. It was critical to listen over and over, to get at all the shades and gradations.

"All the ornamentations and the melismatics and stuff," Bob says. "You wouldn't be able to accurately notate that on one hearing."

László nods. "And the original rhythms—there's a logic behind them you can't hear the first time through."

Bartók identified two basic rhythms in Transylvania. *Parlando* (or *parlando-rubato*) and *tempo giusto*. Parlando being a looser kind of rhythm—a free rhythm based on natural speech. Rubato, meaning to rob, to steal from one note and carry it over to the next. Tempo giusto refers to a stricter dancelike rhythm with the exacting time of a steady heartbeat.

Considering how long and repeatedly Bartók would have to listen before he fully assimilated the peasant idiom into his system—he often listened until the cylinders broke or were ruined—he was fortunate that Edison had included, on his latest version, the invention of a pause button. It was this innovation, no doubt, as much as the gramophone itself, that enabled Bartók to make his close studies: to focus on the smallest intervals, to eavesdrop on these fragments of sonic experience.

I am still disappointed that I can't fondle one of the actual canisters, for the acquisition of tactile details and what all, but then László rummages around in his desk . . . "if you are interested, and I'm sure you are . . ." and then swings back around in his chair.

"Bartók made short transcriptions," he says, holding something small and old and leather-bound. "He had such small-size music books, which he could carry in his pockets."

"These are his originals?" Bob asks.

I now wish I had been given more warning. Something about the weight of the object in my hand, the density of its authenticity, makes me feel as if the gravity in the room has shifted. Maybe it's the jet lag. Maybe I just need a drink.

"These are, yes, this one is original. Especially with vocal music, he notated on the spot." László points at the quick mosquito notes in the master's own hand. "You see here? He put down the melody and made some remarks. He carried around these books wherever he went for his search for new material."

László says again how unique the rhythms were that Bartók discovered. How he took this rawer thing and put it into his own music and how the first city audiences to hear it found his humping thrusty peasant rhythms too "barbaric."

But isn't this how the blood flows? With pulsing and barbaric and interminable fury. Melody is only a flimsy negligee, barely concealing the eternal nakedness beneath. Why not rip off the lace and put one's mouth direct to the wound—feel the blood pulse straight from the source?

As much as I would like to be unafraid to come into such contact with that kind of raw direct experience, I now find that the nonvirtual presence of the diary balanced on my thigh, and the growing desperation for it to be gone, is triggering all the usual symptoms. It is hot on my leg, as if it had sat out too long in the sun. I feel the sweat begin to seep from my scalp. My mind is playing, in scattered, rapid, broken sequence, through all its defective scales. I have been synchronized, against my will, with some demonic metronome. I feel the raw droning in my own abducted blood cells. And then before I can stop it, I realize I am standing up from my chair and walking over to the window—or, rather, I perceive part of me doing this, like that hokey special effect you sometimes see, or used to see, on TV, where a character is nodding off in a chair and then his sleeping ghost peels off from his body, stands up, and walks away from the oblivious prattling wife, cue laugh track, and this is what I now view myself doing. I watch my pale clone wander across the room while Bob and László discuss how Hungarian nationalism (currently on the rebound) may have put Bartók in a mind-set of receptivity vis-à-vis the peasants, whereas prior to this new sense of national identity, as Bob puts it, *they just weren't considered, they were invisible.* Then I watch myself jump out the window.

4

I WAKE FROM A DREAMLESS SLEEP WITH FLIES CRAWLING over my face and the C-minor screech of train wheels. I swat off the flies and sit up in abrupt panic to see Bob across from me, hunched over the little foldout table, in our private berth, hacking at a log of salami. He's working with one of those kung fu butterfly knives, cigarette dangling from his lips. When he's finished slicing, he completes his task with a quick but elaborate sequence of one-handed flips to close the knife, pockets it, and then gives me a hunk of cheese and bread and says we're about to cross into Romania.

We eat in silence while the landscape rattles by and I unsort myself from sleep, trying to remember why I'm here.

"I don't think they really give a shit if you smoke," Bob says, wiping off his fingers, and then standing to flick his ash out

the open window. Insects cling to the dirty pane. "You're not supposed to smoke, but this is the train going east. This is a second-class old commie train."

I make a note to take a few pictures of the engine for my dad, a lifelong trainspotter. Whereas some men collect images of birds, or folk songs, my father took up photography to collect pictures of diesel-electric locomotives. There is a family story about a time he took one of his camera safaris to a train yard. I was young enough that I don't actually remember, I just know the story from being told it so many times, though, of course, I remember many other numerous occasions where I tagged along on one of his trainspotting outings. The time in question he had evidently become so distracted, and I had so dawdled behind, that at a critical moment we had become separated when he had gotten past the track, and I was left on the other side, just as a train passed, one of those very incredibly long freight lines, hundreds of cars long, and he was left unable to get to me, and, of course, I was over there, stuck. I imagine he was left more traumatized by it than I was. But I have wondered if this is the source of my own fear. It's possible it could be the moment. I often wonder about the origin of my own fear. The point of separation. I assume this must be it.

Bob continues talking as if I had not been asleep.

"He didn't try to break the thing in pieces and then fit them in the box. He made the box fit the original." It takes me a minute to realize he's talking about Bartók. But, at the moment, it is hard for me to summon even a hemiquaver of interest.

Bob's not usually a tour guide. His klezmer band, Di Naye Kapelye, tours a good deal. On the side he teaches fiddle workshops and writes the occasional piece for *Time Out Travel*. In

his spare time now he's trying to back up all the old cassette recordings of the musicians he recorded on his self-styled ethnomusical sprees into Transylvania.

"To be safe I burn CDs and make digital files of my recordings, which Bartók never had to do." When Bob and I first made contact, he was finishing up a Scholastic children's book about fishing for catfish in Hungary, which are obtained, he informs me, with a slingshot and maggot balls. Bob is more genteel, himself, and, like my father, prefers fly-fishing. He ties his own flies, too, and says some of the best fly-fishing he's ever done is in Slovenia, though the really big trout are in the rivers left mined in Bosnia. As of yet, he hasn't risked his life for such extreme angling. He wrote another young reader called *Transylvania: Birthplace of Vampires*.

> *Many people are surprised to learn that a place called Transylvania actually exists. Transylvanians are often just as surprised to learn that many people think that their homeland is a fictional creation filled with monsters.*

Bob first came to Hungary a few times as a young kid, in the 1960s, then again in 1972 when he was fifteen. He got turned on to the revival *táncház*, or dance house movement, a weird dance heavy on kicking and boot smacks that I had reviewed to my mild dismay on YouTube.

"It blew everybody away. It was like hearing raw folk music for the first time, you know? I said, *this* is the stuff I want. My uncle was like a very peasanty butcher and would take me around to people he knew who played music. The next-door

neighbor played the sitar, another neighbor played the flute, the garbagemen were gypsies, they had violins in the back of the garbage truck. He bought me a violin, and he bought me these three records that were Hungarian folk music. I went back to the States and I just fell in love with it."

When he returned a year later, Bob slipped over into Romania where he met nomadic gypsies, stayed with peasants, and got arrested a few times as a spy. Once because he needed to use a toilet in a bakery. "When I came out, my friend was flirting with the girls there, so the next thing you know, the Securitate is there and we're under arrest for taking pictures of young girls." When they were released, his friend said he had to get back to school in September. "I said, fuck that, I'm staying here. I stayed for three months basically hanging out in gypsy bars."

He came back to stay in 1984, when he was thirty-one. He got work teaching English and married a girl from Székely Land, the region of Transylvania where Lidi Dósa lived. Bob says he knows a lot about the Székelys, and not only because he used to be married to one, but because he currently lives upstairs from a Székely family, who are forever doing what they love best, this being to arbitrarily drill holes in the walls in an eternal but fruitless quest to make the apartment buzzer work.

"Oh, and they sometimes eat coffee beans by the handful."

By nature, Bob has an anthropological slant. While in college, at BU, he'd been working toward a degree in African Language Studies, studying Yoruba, and then, briefly, Eastern Algonquin, "which was at that time probably spoken by twenty people," but, as he puts it, the Indians were too busy feuding over tribal recognition politics to get interested in a language revival so he came to Hungary instead.

At the moment, his big-money scheme is to write a gypsy-vampire detective story, set in Cluj, which is where we're ultimately headed. He shares a bit of the plot. "The murders are suspicious in that there's *blood* involved, so people get superstitious when the gypsy cop goes out. Bring in these weird Hungarian and Romanian nationalists, accusing Israelis of stealing kidneys. Turns out that in fact it's a *vârcolac*. A werewolf."

Getting back to my own detective work, I ask Bob if he can clarify the historical and confusing role of the gypsy musicians.

He lights another cigarette and lets out a long stream of smoke. "After the Turks had abandoned Hungary and Transylvania, the gypsies, who had played Turkish music, without any chords, now played music for a new military patron class, which was the Habsburgs—the Hungarian nobles—the occupying forces. And they did this with the new modern Western instruments, the violins and stuff. You had to have money to go to a fine inn to pay for those good musicians. The local gypsies would play for both the local nobles in the countryside and to the peasants." The interesting thing, he says, is that, depending on how close you were to upper-class society, the closer you got to *harmony*. The melodies were harmonized, resolved, whereas the music played by peasants in Transylvania put more of an emphasis on rhythm. And that's what the gypsies did as well. They were more concerned with getting the rhythm down for dancing. "So instead of going up to a minor and then to a seventh and then something—and then condense—you're basically doing a rhythmic drone with the major chords of the melody in there." His teeth smoke. "And it became an entire style."

"That rhythmic drone," I say.

"Yeah."

He said he's taught classical musicians, trained in conservatories, who wanted to learn how to get that sound. "And they're fixing the melodies! The melody doesn't *want* to be fixed. It's got this incredible tension, you know? You completely harmonize it, you make it banal. And that's what we were talking about with Bartók. He knew how to set a folk song to classical music but still maintain the spirit of the folk song."

We look out the window and see some peasanty-looking abodes and he says once we're in Transylvania proper I'll see the giant homes some gypsies now build after stints working abroad. Mostly construction in Italy or France.

"They build these McMansions to show off their wealth and then don't bother to live in them but camp out in their backyards with the chickens because they're disgusted by the idea of indoor plumbing." He brushes ash off his lap. "They hate the idea of shit and pisswater going over their heads. The New York gypsies can't stand the idea of *gadjos* shitting over their heads so they won't live in high-rises but move out to Queens where they can buy all three floors and shit in the basement."

He says this as if it's the summation of years of anthropological work.

The men, he says, are unfailingly polite around women, even if they are just as vulgar as most men in unmixed company. They don't say, "I have to piss," if a woman is around, they get all genteel, Bob says, in a fake-genteel voice, and say, "I must go water the horses."

A few minutes later, I drain my beer, and excuse myself to do same. As I lurch from car to car, in search of the toilet, I push through one heavy-hinged door after another, anxiously leaping across each rattling vestibule, and then stagger down

what seems like an endless series of long cars occupied with sleeping Finno-Ugrics, Scythians, Thracians, Taurians, Minyans, and Pechenegs, piles of bodies huddled under coarse but colorful blankets, or maybe tapestries by the look of it, but with no toilet in sight I keep going, over yet one more violently shaking platform, and another, each like a swinging suspension bridge that connects the cars only but tenuously—a bond weak enough that I begin to wonder midleap whether I'm really on the same train when I cross over, and it seems to go on like this forever, car to car, until finally I find the train's solitary shithouse. As I dribble all over the seat and floor and various parts of the wall, jostled and hurled about, I recollect how the first item I had uncovered in Otto Albrecht's archives, while searching for clues, had been the results of a urine test . . .

When I had first approached the keepers at the university, where I suppose I should mention I hold a small, untenured position, I was told that any archival material they held on Otto Albrecht did not exist in a suitable manner for a professional researcher. That is, his effects had been dumped off in five cardboard boxes and had remained untouched since the day they'd arrived. I assured them I was anything but professional and promised, furthermore, that I would try not to embarrass anyone for having failed to get around to paying the basic bibliographic courtesy of indexing the correspondence of a man whose name adorned their very own music library, two flights below.

The boxes were housed on the sixth floor, in the oak-paneled reading room of the Rare Books Department. When I first arrived, I remember greeting the strange pale redheaded creature, a work-study, reading behind the desk. On the wall behind him was a self-portrait of the poet William Carlos Williams. Dark

brown eyes, pixie mouth, spikelets of black hair. I had forgotten, until that moment, that WCW had gone to Penn, the same year he had met his classmates Ezra Pound and H.D., in 1905, the same year Bartók made his first trip to Transylvania. He had come to Penn, as I recalled, to go to the dentistry school.

> I saw a child with daisies
> For weaving into the hair
> Tear the stems
> With her teeth!

The self-portrait was from 1914. He had signed it with a Chinese ideograph. Seeing it then seemed like a sign, given Bartók's and Williams's shared goal to produce direct raw impressions and a mutual passion for working out those impressions with new forms, more naked and earthbound rhythms. *The dancers go round, they go round and around, the squeal and the blare . . .*

As for me, I found the redheaded work-study a bit offputting. I knew him but I wasn't sure how. Was he a former student of mine? No, he said. Did he barista at the café I sometimes frequented? No, he said. I couldn't place him for the life of me. I questioned him a bit further, but in the end was left with the sure impression that he did, in fact, know exactly where it was we knew each other from, but would not say for some inexplicable, dark reason, perhaps because I too am a ginger-haired man and we tend not to trust one another. But mostly it gave me an unsettling sense of déjà vu.

I made a series of increasingly feeble guesses until, at last, they brought out the first box, and I had to give up.

The box itself was just a generic, ratty cardboard box. Not so much as identified with an inventory number. It was surprising nobody had accidentally hauled it off to the incinerator, except that it was so large and unwieldy. It gave off the fragrance of basement and had bits of ancient yellowed Scotch tape stuck to its outside, random scribbles, intriguing dents. Each dent seemed like some kind of statement I had yet to decipher, but, of course, this was only because I had not yet made a figurative dent into the contents of the box itself and so far had only sat staring at its bulging, mysterious freight.

The aide said there were four more just like it. Then the head archivist, John, a guy who looked a bit like Mike Mills from R.E.M. in a suit and tie, came out, intrigued that somebody was here investigating the string quartet, and wanted to know if I knew that the autograph manuscript itself was actually here in the archives, which he assumed I knew, and which, of course, I did, and that if I wanted to examine it now he would be happy to have it brought out for me.

He said they had adopted a very liberal attitude about the collections, to hopefully encourage students to interact and make use of the textual reliquaries that the university had in storage. They weren't even making them wear white gloves anymore. Anyone, including myself, was free to fondle to their heart's content. I found the mere thought of it lascivious. Almost perverse. The idea repelled me. But it was more to do with my fear of coming into such direct contact so soon.

I told him, abruptly, that sure, I'd probably get around to looking at the manuscript itself, but I had enough now. Ten minutes later an aide brought out the first dismal box.

I sat looking at the naked neglected box for maybe twenty

minutes thinking I should have put fewer coins in the parking meter so I'd have a better excuse to leave. Occasionally, I glanced over to see the redhead staring, as if he were waiting to see how long it would take for me to give up.

At last I tentatively opened the lid.

I never imagined anything could be this jumbled. No objective truth could reside here. The papers were not so much as lumped into folders. The contents were entirely uncataloged. A total clusterfuck. Evidently, the boxes had come straight from Otto's last known address, Apt #D110, at Pennswood Village ("Incomparable Senior Living in Bucks County"), and were dumped on the library steps. There was no way to start other than to lift the first piece of paper, on top, the aforementioned urine test. The date on the slip was December 30, 1983. Just nine months short of Albrecht's death. The lab technician had scribbled: "Satisfactory and requires no action at this time." On the back of the slip, in what I presumed to be Otto's handwriting, were scrawled four names: *Boismortier. Debussy. Ysaÿe. Villa-Lobos.* All composers. The second document I examined was a letter written in German, dated December 15, 1938, from somebody named Trapp, "Lieber Herr Professor," and it was at that point that I began to pack up my belongings. There was no way I was going to find a smoking gun here. I probably really should have left, but now I was afraid of letting the redhead think he had gotten the better of me. So I cleared my throat, sat back down, and proceeded to go through what I thus designated as Box #1.

From the disorganized and nonchronological yet somewhat repetitive nature of his correspondence—Dear Mr. X: "Could you give me the total number of pages, the height and

width of the page, any title on the title-page or at the head of the first page of the music, an indication whether it is the first draft or the finished score . . . and any signature and date at the end of various movements"—I was still able to glean fairly quickly the nature and method of his work.

As I gathered, the old man's job really was a bit like being a spy or detective, involved a lot of international travel, required a good deal of charming private collectors into coughing up lists of the manuscripts in their possession, and a lot of waiting around for photostats.

Albrecht sought out both autograph manuscripts and facsimiles of the European composers where they existed in America in all the expected places—the major libraries, prestigious depositories—but he also made amazing discoveries in surprising nooks. He had tracked down an Alban Berg concerto in Minneapolis. Mahler manuscripts in Hollywood. Mozart's Coronation Concerto in Charlotte, NC (!). The first draft of *Das Rheingold* in Titusville, PA (!!). In Baltimore, he had even found Beethoven's final work: the long-lost original to the finale for his String Quartet no. 13, written as a replacement for the *Große Fuge*.

In effect, Otto Albrecht was a manuscript hunter. I imagine him, fleetingly, as a torrid, restless Van Helsing type.

But to be sure, a lot of it seemed like maniacally dull work, but probably better than what I was doing myself; that is, going through the old man's correspondence (much of it in German, which I can't read). There must have been around two thousand sheets of paper in Box #1 and not a single reference to Bartók. Though it did occur to me how Otto's work was not so different from Bartók's—both men were in the business of

seeking out, verifying, and making painstaking copies of what they deemed to be the authentic original thing.

It took me all of one day to go through Box #1. Seven hours with no payoff. Nothing about a bank robbery.

The next day, I returned and went through Box #2, where I also found very little of use, only lists of "lexica," not lists of words alone, but lists of *volumes* that cover the lexica of musicology. There were old tests from his Music 600 Class. Here's from the final exam, December 1969:

> *(1) For each of these centuries (16th, 17th, 18th, 19th, 20th) name a composer for whom no critical edition of his complete works has been undertaken, and indicate why you think such an edition desirable.*
> *(2) Give the provenance, the present location (library and city) and indicate briefly the importance for musicology of the following manuscripts: Bamberg Ed. IV. 6; Squarcialupi Codex; Egerton 3307; Codex Calixtinus; Koch collection no. 22; Diputacio 887.*

I found correspondence regarding the Friends of the Otto E. Albrecht Music Library. He seemed to be very busy taking donations (Otto himself is on record for having donated $15 to his library) and gifts, including a substantial collection of recordings and books from one Mrs. Ethelwyn Smith—among the rpms being a performance of Bartók's opera *Bluebeard's Castle*. This is the first mention of Bartók whatsoever. Given the nature of the story—new wife, dungeon filled with blood-spattered jewels and bodies of murdered ex-wives—it's curious to know that Bartók dedicated this opera to his young *first*

wife, Marta (not Ditta). I get excited when I then come across a piece of correspondence regarding Otto's discovery of the autograph manuscript for Bartók's Piano Quintet in Iowa City. The very piece Bartók had been composing when he'd been interrupted by Lidi Dósa! Otto notes, in this letter, how, due to noble smuggling efforts during the war, no less than 90 percent of Bartók's manuscripts resided in the United States. But then the trail goes cold. The next half bushel of correspondence begins with a list of rare books and music recently stolen from the library that runs up to $10,910, and another letter from the director of Buildings & Grounds addressing this rash of thefts. "I have had the guards and janitors pay particular attn to the Music Building this past week and have come to the conclusion that until something is done within your dept toward security, you will continue to lose property due to thefts. Within the past week, our cleaning lady has reported four occasions she has found one or more exterior doors propped open when she came on duty at midnight. On each occasion the guards had locked all exterior doors at 10 PM. This would indicate that somebody in the Music Department is setting this building up for another job."

When I find another document titled "Memorandum on the Alleged Conspiracy in the Music Department," I briefly get excited, but the intrigue has nothing to do with Otto or the Bartók manuscript, only events leading up to the appointment, tenure, and rapid resignation of the evidently much loathed chairman of the department during the academic year 1968–1969, which resulted in Richard Wernick stepping in as new chair.

Another letter from Otto, this one written from Germany, in 1936, says how he and "mother" (his wife) had gone to the

Berlin Olympics and actually seen Hitler come out for the jav-
elin toss. Reading this, and seeing that javelin sail, watching
it through the new Zeiss field glasses Otto had bought for his
son as a gift the day before, one can't help but urge the spear
to fly clean through the Führer's sternum and pin him like a
cockroach. Wernick had let me know, over one lunch meeting,
the sordid detail that Otto's wife had been institutionalized
shortly after this trip.

From what I could piece together so far, she had been in-
stitutionalized after giving birth to their youngest son. In all
likelihood, her confinement was for what we now know and
treat as postpartum depression. But Mrs. Albrecht had lived
out the rest of her life in the asylum, leaving Otto alone to raise
his three sons by himself—just thinking of it makes me briefly
conflate Otto with the fictional father in Bartók's *Cantata
Profana* and the three by three sons transformed into magnifi-
cent, if testy, stags.

John, the archivist, had come back out as I was packing up
for the day to say I might want to contact Marjorie Hassen.
She was the most expert on the whole Third Quartet mystery,
he said. She worked in the library's Music Department. When
I called her, Marjorie told me she thought that Otto's wife
had committed suicide but wasn't sure. I told her I had looked
at old 1972 newspapers, for stories about the heist of a string
quartet, but found nothing. There were no police records for
any arrest warrants on Otto Edwin Albrecht or anything like
that. She laughed in a friendly way and said my story might be
a good bit less exciting than I had hoped, that she had heard it
was a tug-of-war more than bank heist. She says, yes, a bank was
involved, but that was later, after Otto had gotten his hands

on the manuscript, made his copy, and they had caught wind of what he'd done, and they'd gone and hid it on him again in a vault at Girard Bank. She said how the Philadelphia Musical Fund Society had started out as a pretty cool noble organization, helping destitute musicians, with a strong mission to present more challenging work to the public, like Bartók. But she said they had also been very amateur and sloppy, not to mention inexplicably secretive, and at the time of Otto's investigation the archivist, who was a priest, was a guy by the name of Father Dorsey, a priest who was also evidently a true pack rat, a diagnosable hoarder. One suspicion had always been that some of the archives, and so perhaps the Bartók masterpiece as well, had just been lost under the priest's couch.

It was disappointing there had probably been no bank heist. But then, of course, I wondered, how had Otto gotten it from the priest? One can easily imagine him being royally pissed off enough, after chasing the quartet for forty-four years, to deck the priest if he'd discovered it was only being guarded by dust bunnies. Marjorie says with a laugh, yes, another rumor she had heard was that quite a "tussle" had ensued over the manuscript. One only hopes none of the pages were torn during this tug-of-war.

—m—

I FOUND MY NEXT possible clue from a letter (in Box #2), from one of the younger members on the faculty who had been at the meeting when Otto ran in with the manuscript—a scholar of Renaissance music named Larry Bernstein. Bernstein had written to Otto from Budapest, in 1979, to describe some of the manuscript hunting he had been engaged in himself, but

the quarry he was interested in was primarily the orchestral scores of Joseph Haydn composed while he had lived under the palace roof of Prince Nikolaus Esterházy, one of the potentates in the Austro-Hungarian Empire. I knew from Wernick that Bernstein was one of the few living people who would remember Otto well. They had been close friends. If anyone would be able to shed more light on the mystery, it would be Larry.

So, before moving on to Box #3, I looked up Bernstein in the campus directory. He seemed quite friendly over the phone and said he'd be happy to meet, though he assured me he would have little to contribute toward my "investigation." Since the two men had been close friends, I hoped he might be able to tell me more about Otto's wife.

Bernstein and I scheduled to meet the following week at the Music Department, near the corner of Thirty-Fourth and Walnut. I was already running fifteen minutes late when I arrived. Though he had clearly been waiting, he did not seem perturbed, or maybe I should say that anything I might have read in the moment as perturbed I just as quickly wrote off to a touch of shyness. He was a good bit older than I'd imagined, and it only occurred to me then that, being an emeritus, he had probably only made this trip to campus in order to meet me.

I told him again how grateful I would be for anything he could tell me about Otto, since, really, so far, in terms of character, I had little to go on if I were ever going to write about the man. I asked about the day when he had burst in with the Bartók manuscript, and he was more than glad to oblige and slowly began recounting the famous moment until I had to cut him short when I realized that I had neglected to get coffee this morning. Interrupting him was a lousy thing to do, I

know, but continuing through the interview uncaffeinated, at nine o'clock in the morning, was undesirable in the extreme. I apologized profusely and explained how it was all my fault, of course, on account I was running late, and how I especially wanted to speak to him about one piece of correspondence that I found of possible intrigue, the single nugget of gold I thought I might have, though it was barely legible, this being an awkward exchange between Otto and John Y. Mace, Esq., evidently the lawyer for the PMFS. I only had Otto's end, which said: "You told me you were embarrassed by the incident of the Bartók manuscript and that you were having difficulty in meeting the cost of the work. I certainly agree with you that Father Dorsey should not be allowed to contribute to that expense. I am glad, however, to help the Society out of its financial difficulties by enclosing my personal check for ten dollars to help defray the cost of the photograph." There was also reference to an invoice that Otto had apparently sent but which the Society had lost, and so they were requesting a new copy of the invoice. They couldn't even hold on to an invoice, how could they be expected to be trusted with one of the twentieth century's finest compositions? But, anyway, I wondered if Bernstein might be persuaded to continue our conversation over a nice Americano? There was a Starbucks a block away. It would be on me.

He paused a moment before saying that, no, he did not feel he required coffee, but that if I needed to supplement myself before we continued, then of course, I should feel perfectly at liberty to go fetch a cup.

I knew now that I had committed a faux pas. On the other hand, I really did want to be fully conscious for our interview, so after promising to dash to the café as quickly as possible, and

securing numerous assurances from him that it really was okay, I rushed down the street and across the intersection, having thus set my interview on pause.

Fortunately there wasn't a line and I was able to get my coffee in no time. Yet, as I came back outside, and was waiting at the crosswalk, I felt a dirty needle of journalistic dread creep up my spine when I saw Professor Bernstein hurriedly shuffling away from the Music Department Building.

The old man was wearing his coat and hat, briefcase in hand, bustling up the sidewalk. Before the light changed I darted across and saw that he was carrying my bag as well, which he now handed back to me with an awkward apology, saying, with a strain in his voice, that his wife had suddenly taken ill. He had to go immediately. I asked what had happened!? He only shook his head before stepping off the curb to wave down a taxi. Naturally, I didn't believe him for a second. I knew I had blown the interview. Yet I also felt it was in awfully poor taste to use his wife's health as an excuse to ditch me. But then a more casual paranoia began to insinuate its way into my thoughts. What if he were only somehow protecting his late friend Otto? What if the real reason he was giving me the slip was to conceal something much more dastardly about the circumstances regarding the case of the Third String Quartet? Or worse? As I watched his taxi speed away, I was left wondering, once again, what it was all about, if anything.

5

When we finally meet up with Jake and Eléonore, at the hotel in Satu Mare, they're eleven hours late. Bob and I waited at the station for a while, where they were supposed to pick us up, but we finally gave up and took a taxi to the hotel. They seem haggard when they arrive, well after dark. Jake had evidently opted for what he thought would be the shorter national road (N17), despite Eléonore's insistence that they stick to the safer European road (E58), advice that would have seemed worth heeding as they were soon bottoming out in potholes the size of koi ponds; by now Eléonore said she had been begging Jake to turn back, but he pushed on until Eléonore made him stop to speak to a police officer who told them, with a smirk, that the road only got worse, and at the rate they were going (it had taken them one and a half hours to travel

9 miles) it would take a full extra day to get to Satu Mare. So they turned back to the highway and then nearly hit a gypsy kid who was jumping into the road to scare drivers.

When they join us on the patio for drinks, Eléonore is still shaken, and says she was angry with Jake for not listening, but the way she says it, in her light whispery French accent, it is hard to imagine her ever being truly mad. She looks, I decide, like the writer Nathalie Sarraute.

The next morning we pack up the car, violins and bags jammed under the hatch, and all of us crammed into Jake's '96 VW Golf. It's claustrophobic pinned behind Bob's somewhat forbidding and pedantic bulk, but I feel well compensated by getting to have Eléonore as my backseat companion, with her faint but pleasing French girl accent (*et* stink). She keeps a secret stash of chocolate and every once in a while breaks off a square and slips it to me when I must appear faint.

As we travel farther north my mood lifts as it always does in the mountains. It is all pretty indistinguishable from Vermont. Same vibe mountains. Same piney reek of bracken and fir. Same dangerously elevated levels of oxygen. Ditto yokel vibe. Granted, with added medieval trappings: the Van Gogh haycocks, the bored peasant women sitting on rickety stools silently casting hexes on we who pass. There are fewer cars and more horse-drawn wagons piled with loads of twiggy/crappy-looking hay, driven by brawny, sun-poached men in funny little hats. Never make fun of the funny little hats, Bob says. They're a symbol of male virility. As of yet, we see no forbidding castles. We are in rural Maramureş. The most remote corner of Romania, quite possibly the most remote corner of non-Arctic Europe. It was in large part this extreme remoteness,

and profusion of bad roads, that allowed the region to resist collectivization during the communist era, and to preserve its traditional customs and rituals. At least until Romania entered the EU and Romanians started finding work abroad. The returning money is evident in the suburban fantasy palaces replacing some of the old stone and wooden cottages. We pass a few of the McMansions Bob had already warned me about, all pink stucco balconies and tacky clerestories. I see one with driveway gateposts crowned by two painted concrete (photo-realistic) German shepherds.

"I fucking hate dogs," I say, not realizing I had said it out loud.

Eléonore takes pictures out the window. "The old women are so beautiful," she says. I think all the old women look like they're in eternal mourning, grim crones, but the confiding pianissimo of Eléonore's voice makes it sound true.

Oddly, I find myself wanting to tell her about my father, and how I had gotten drunk with his moderately likable dog the night following his botched surgery, but I keep this confession to myself, feeling that it is somehow shameful to share one's dead, perhaps especially when they are not yet actually dead.

As for Jake, I confess feeling a bit awkward having this virtuoso chauffeuring me around Transylvania. It seems it should be the other way. But he's supereasygoing, a master at circumnavigating the potholes that can take up an entire lane—which strike me as if some giant beagle had come down from the mountains and dug them up willy-nilly in its stupid instinctual hunt for bones—and despite what I sometimes interpret as Jake's slightly menacing mien in the rearview mirror, a slight but innocent defect only due to a childhood harelip.

Nonetheless, we hit it off soon enough over Milan Kundera. I had brought *The Book of Laughter and Forgetting*, which turns out to be Jake's favorite novel.

Kundera, I tell him, leaning forward between the seats to better study the canine curl of his lip, wrote that Bartók had a "sad . . . hypersubjective soul." And that this "soul's sorrow could find consolation only in the nonsentience of nature." That is, Bartók preferred insect larvae, trees, rivers, streambeds, bosky meadows, termite hills, and so on, to the frivolity of people and their questionably employed sentience. Fortunately for Bartók he had his machine. The nonsentient monster-machine that let him extract what he did need from people.

Here in the *Avash*, Bob says, the men specialize in a form of music that involves taking the fiddle and winding string around the neck so that there's almost no fret left to play on, and the sound is very plinky, and they accompany these melodies with songs that are more obscene primal scream with almost nothing approximating conventional melody whatever, a phenomenon Bob demonstrates by pretending to plink an invisible fiddle and screaming out the window in a high cutthroat falsetto.

This, just as we are passed by a swaying top-heavy truck heaped with Romanian cowshit, and the smell is so intense, so carrion-like, as if it must be a truck loaded with dead rotting cows rather than just their reeking shit, and I make this distinction as one who, having grown up in a rural dairy-heavy region, ordinarily has no objection to the bouquet of manure, but in this case I join Eléonore in a shriek laced with obscenities as a feculent-thick gust swarming with flies fills our vehicle.

In the town of Săpânța, which, like many villages, consists of not much more than a single crooked street, we stop at the

Merry Cemetery. If anything this far-out counts as a tourist stop, this is it. There are dogs barking nearby and doves cooing from a little falling-down chapel. We walk around the graves, which are not stone but wooden steles painted bright primary colors and illustrated with cartoony images of the dead.

Bob translates the narrative underneath one of a guy holding a hammer and sickle. "I loved the Party. But I believed in God. And I was thus judged in 1975." He shrugs and digs around in his fanny pack for his giant bottle of ibuprofen. "Often it's who I was, or what the village really thought of me, and how I died."

There's another of a man walking into the woods with a rifle under his arm. A factory worker standing too close to a buzz saw. A soldier getting accidentally shot by his own men. A miner in an explosion. A little girl being struck by a taxi from the next village over. Another soldier getting himself decapitated. A peasant drinking himself to death at his kitchen table. An idiot on drugs roller-skating by the railroad tracks. A whole gamut of final endings under the category, as Bob puts it repeatedly: "shit happens."

Jake and Eléonore walk hand in hand from one grave to the next, and Jake translates one story of a man playing violin for a couple of lovers that does not make any sense, really, except to Eléonore, who says that it is "very sad."

We next move to a grave of a young woman immortalized in nothing but red panties, the implication seeming to be that she died and went to hell for being a slut. The horny gaze of two swarthy seraphim hover on either side of the dead girl. I suppose one must appreciate the refreshing lack of piety of the cemetery. I get the underlying wisdom. We are all prophets

and buffoons, et cetera. Sublime grotesques. I can't help but imagine if my father were buried here, the artist might render him in his collar and robe, scotch in hand, a *Hustler* unfolded across one knee. There is such a photograph, taken years ago by a friend of his on a lark. This, several years before my mother left him for another woman and moved into a lesbian commune in Florida. It was the drinking. It was his cruelty to my brother. And, of course, things like grabbing her at cocktail parties and announcing to everyone, as often as not with a gratuitous thrust of his hips, that "tonight's the night!"

I think he would have quite liked the ribald peasant folk here, just as in our mountain town he got along better with the merry sinners than with his more dour and pious congregants. He was at his best swapping lewd jokes with the butcher behind the meat counter. Flirting with the floozy receptionist at the nursing home. Bullshitting with the gravediggers in the cemetery. My dad got along best with the down-and-outers. The drunks who lived down by the river who tinkered on busted snowmobiles and lawnmowers. The radiant fat-witted women with steaming red arms who cooked for church potluck suppers. My dad was a bit of a repressed satyr. He never, in my life, not once, let any female of any age cross the street in front of our car without grading her tits. At the rehearsal dinner for our wedding, when my wife offered to top off his wine, he said, in his fake genteel, "Yes, my dear, please, but just a cunt hair." He was always sending me *Onion* headlines like "Dead Teenager Remembered for Great Handjobs." He loved the grotesque. The mean. He picked on my prim brother mercilessly. He even pissed on his foot once, just for a joke. Or actually,

make that my foot. My father was a profane man. A walking sermon joyeux.

COME EARLY EVENING, WE arrive at our pensione in Poienile Izei. It's down a long dirt road, deep in the countryside. In the front yard is a gazebo and a tree covered with pots and pans, which, according to Jake, means a girl of marrying age lives here. Beneath the tree is a swinging bench upholstered with tattered sheep or goat skins, and outside the barn across the yard is a wooden cage of bunnies.

"Ooh," Bob says. "I hope we're having bunnies for dinner. Cute things always taste good."

After we get cleaned up, we reconvene in the dining room where our hosts have put out a feast on the long wooden table. Bob takes pictures of all the food to blog about later. He's on the Atkins diet but is making exception for the heaped plates of *plăcintă*, a delicious cheese-stuffed fried pastry; *mămăligă*, basically polenta, but mixed with cheese and crumbled bacon; and *ciorbă*, tripe soup with meatballs. It's not cute but it does taste good.

The house is simple and clean. There's a woodstove in the corner, with a sorry little cactus on the hearth. A plain linoleum floor. Hanging from the back of the front door are handmade woolen bags made by the owner's wife from wool shorn from their sheep. A picture of Mary and Baby Jesus hangs on the wall next to a poster from a local tourist agency. The poster shows a few sites of unlikely interest, like the village of Sarbi, where the main attraction is a carver who makes miniature

ladders out of plum wood, which he then inserts into bottles of *pálinka* (plum brandy), like model ships, as if there is any way one could climb out of a bottle of plum brandy.

The one that gets us talking is *"Fenomen inexplicabil!"* The photo on the poster shows what looks like a rental car on a desolate road. Jake and Bob and Eléonore are all familiar with it, *f. inexplicabil* being some paranormal locus where the road goes uphill, yet if you stop to get out of your car, and put it into neutral, the car ascends on its own. You can see a clip on You-Tube* of men running alongside their vehicles, hazard lights blinking, a few with wives or grandmothers left in the back seat, as if what you are watching is an abduction taking place in slow motion by an invisible driver . . .

One car has no less than five crucifixes on the dashboard. One guy on YouTube even puts a two-liter Coke bottle on the road and it too steers its way uphill unassisted. Bob says he himself has experienced it. His whole band will attest to its authenticity. I assume, since there's clearly no other scientific explanation, that it must be a wormhole or tear in the planet's magnetosphere.

Bob picks up my 64GB iPod and asks how many hours of recording I can get. The digital recording app I have gets thirteen hours of uncompressed recording time per gigabyte (depending on the quality setting). Considering that the cylinders Bartók used got four minutes each (that being doubled in 1908 from the previous two-minute cylinders after Edison figured out how to double the number of grooves on a cylinder from

* http://www.youtube.com/watch?v=lXSfr4RE_DY

100 grooves per inch to 200 grooves per inch), that would be the equivalent of 1,950 wax cylinders, at 7,800 minutes, which would require how many oxcarts and how many trips from Budapest to Transylvania, I do not know.

Bob himself no longer burdens himself with machines. Over the years he made several collecting expeditions to Transylvania to get to the underlying original-original holy-holy stuff, and he used to always bring a Sony Walkman. He went through about six Sony recorders. Once in a bad situation he had to buy a Panasonic to make a last-minute recording of a peasant fiddler who knew some Jewish tunes he wanted from the 1930s. Bob says he finally stopped bothering with machines altogether. In the end, Bob felt like the machine interfered with the purer experience of just becoming a musician.

"We didn't really know what we were getting into when we started taking klezmer music," Bob says, pouring some pálinka, the high-test moonshine our host has stilled from plums in his own orchard. "We've learned since. Jews didn't really care much about their folklore. They cared about their high culture, you know? So we didn't have a Bartók or anybody studying our own. It never was a national symbol for Jews. Not like Irish music for Irish, and Greek music for Greece, or Hungarian music for Hungarians. For us it was this necessary evil you had to have at weddings."

"Necessary evil?"

"Yeah." He pours me a glass. "You have a commandment to make the bride laugh as she leaves her family."

One time the Jewish Music Study Group at Budapest's ELTE University loaned him a Marantz to go to the village of

Ieud to record the late Gheorghe Ioannei Covaci and his family, who, according to Bob, had the greatest repertoire of Jewish instrumental music of any gypsy family in Transylvania.

"I carried it in my backpack and got to Ieud via trains, hitchhiking, and walking. After a couple of weeks I was in agony. It was heavy, especially with the big microphones. A pain to set up. I think this is how I screwed up my back. And when I got to Ieud, Gheorghe's son, Ion, the accordionist, had an eggplant growing out the side of his face." Bob makes a grotesque hand gesture over his face. "An abscess. So I gave Ion money to go to the hospital in Sighet—and as gypsies are wont to do, the whole family, minus eighty-five-year-old Gheorghe, accompanied Ion to support him in his hospital stay, leaving me with no orchestra to record. But I got to sit with Gheorghe for a month, learning style and tunes and recording some pieces."

In this way he built his repertoire—by going straight to the source. Jake has done a lot of the same. There is a savage nobility to their hunting.

"The other bands are all working with material that comes from gramophone records. *My* band is the only band who's only really worked off stuff we've recorded." Bob pours another shot. "In order to be legit, we've got to get down here in the mud." He drains the glass and then stands to go outside for a smoke.

After a little while a neighbor shows up with a guitar and then our hosts, both mister and missus, reappear dressed in traditional peasant garb. The host has a violin. When they start to play it's all rather startling. The violin is beautiful and strange yet somehow at odds with the guitar, which the neighbor plays

with a rough senseless kind of derelict rhythm. The neighbor is several heads taller than our hosts, lanky, gold of tooth, and ruddy of face—he beams like a drunken butcher. He holds his guitar not at all like a guitar but propped sideways on his hip, with the neck straight up, the headstock nearly grazing the low ceiling. I make out two chord changes tops. The guitar is actually missing a few strings but he beats on it as if trying to bludgeon the smaller man's wimpy, scurrying melody. In truth, his strumming sounds like roof work.

Despite this indelicate violence of the guitar, the wife, who wears a rose-patterned skirt and a green-and-black headscarf and little booties at the ends of her bare calves, which are each as thick as a piglet, sings with her fists on her hips and in an instant her high lonesome voice dispels what I had not until this moment registered in myself as homesickness.

The host's gentlemanly wattles grab at the belly of the violin.

The woman's song has a kind of defiant pride and when I feel her spittle fleck my cheek, I feel happy for this small if accidental intimacy.

The men's outfits are far more interesting than the woman's. They both wear those little hats we're not supposed to make fun of, and white peasant blouses cinched at the waist with giant wide black leather belts that, not to be funny, nor to make fun, but only to accurately describe, really do look very S&M (i.e., three buckles), but which, in reality, I suppose must be some kind of back support for lifting sheep. With admiration for early cinema's surprising regard for wardrobe research, I recognize the outfit as that worn by the fearful peasant coach-drivers who refuse to take von Wangenheim across the bridge to the

castle in F. W. Murnau's *Nosferatu*. What Murnau could not capture in black and white, however, are the dazzling multicolored ribbons on the hats, or the mint-green hearts, each the size of a locket, embroidered around the flowing flared cuffs of the mad guitarist's sleeves.

Soon, Jake and Bob get out their violins, too, and the small kitchen is reboant with music. Eléonore sits close beside me with a glass of pálinka and translates the woman's song. The words have to do with how the world is big, but she doesn't have any room in it. *Mare-i lumea si nu-ncap.* And how when you're doing well in life people really aren't glad for you. *Cam așa.* This is kind of the way it goes, she sings.

When Jake plays, they watch with amazement. As do I. That this American boy in the leather jacket can play this music, their music, not just Romanian music, *foarte frumos*, so very beautiful, but their music, the style of Maramureș. With the sphincter-clenching *rhythm* of Maramureș. They request something that might be traditional American music. Jake hesitates, laughs. You can sense our hosts wondering if we have such a thing, and then Bob lifts his fiddle to his shoulder and starts in on some chicken-in-the-breadpan-pickin-out-dough kind of barn lick, something from *Hee Haw*, and the woman cries *bravo, frumos*, so beautiful, and the drunk with the guitar smiles widely to reveal his terrible gold teeth and says it reminds him of the movies. He says that Bob's playing is *bărbătească. Da*, the other man agrees, *bărbătească, așa!* It is very manly, this *Hee Haw* music.

I try to imagine the old vampire here, in his woolen suit, eating intestine soup and turning down pálinka, teetotaler that he was, but how, really, the peasants probably never would have

invited him inside their home, asking him to wait outside instead with the rabbits and his weird machine.

The more pálinka I drink, the more I feel put off by the guitar and its dull monotony. It's not unfamiliar. A self-pitying feeling that I will never get in sync with the living. That *they* are in rhythm—whereas I am not. A sense that I have misplaced something critical: I'm not sure exactly *what* it is I think I've lost except I'm tempted to use a word like *instinct*—a word I take to mean having the talent and heart to live in the present flow, as opposed to conducting most of one's living as forensic investigation. Though, to live it postexperientially, at least you get to separate the subjective-feeling part from the thinking part and the (elusive) meaning part: all those clues that never seem to synchronize in the living moment. What's agitating is the belief that if they could be synchronized—if I could harmonize the thinking and the feeling and the meaning parts, experience them simultaneously—then I might get closer to recovering at least the illusion of that lost thing. Of course there's also a healthy fear that if I did somehow suddenly Experience Ultimate Reality as a fully woken being, I would go stark raving batshit crazy.

At some point I go outside to call my father in the hospital. As I listen to it ring, I am sitting on the swinging bench, under the tree of moonlit pots and pans. The crickets in the surrounding orchard are in a serene frenzy. I have no idea what time it is and I'm not surprised when I don't get an answer. As I hang up, I find myself wishing again that I had brought the box of flies he'd given me. I think how, more than anything, this is how I best remember him, my father most at ease: sitting at his desk, late at night, listening to the radio, a drink beside

him, tying flies. I can see him hunched over, bifocals perched on his nose, with a kind of scholarly calm, winding thread around the small barbed hook fixed in the jaws of a small titanium vise. Composing these miniature lethal decoys: it was all about proportion and balance. Winding the black thread around several strands of pheasant tail fiber and shank, getting the hackle just right. The vague magick names of the tools and material: bobkin, barbule, hare's ear. A strand or three of peacock herl. White calf tail, fox tail fur. Winding the thread to hold the tension. My father trims the floss, ties off a knot at the eye, maybe stopping every so often to take a sip, jot down a note for his next sermon. Quiet, rhythmically, he winds the thread around the hook. Marabou Damsel Nymph. Woolly Worm. The Royal Wulff. Tighter and tighter, he winds the string, winds the string.

When Bob and the guitarist come outside, I wander over to join them in the gazebo. Jake and the old couple are still inside playing, Eléonore is sitting at the kitchen bench looking melancholy or maybe just tired.

We sit across from one another in the dark and I can see the guitarist's gold teeth gleam dully in the moonlight, like the pots and pans drooping from the branches of the tree. It's chilly, and the air feels like a New England night.

Bob tells me, after the neighbor rattles on a bit drunkly, that the man is glad I came here to hear the pure authentic Maramureş music. He is proud of his music, and proud that Bartók sought it out, and borrowed it for his own nobby high-art purposes, but less happy now that it is being stolen and commercialized, made less pure by less pure hearts. He says they come with computers and steal their beautiful Maramureş music. He

says how he's heard himself pirated on the radio, heard his own music mixed and dubbed into popular music for the *discotecă*.

"Our tradition is being lost," he says. "But it will not die."

It's the sort of contradiction embodied by one of the key forms that Bartók discovered in this very region: the hora lungă, which can be heard in the tenor stag's inhuman lament in the *Cantata Profana*'s metamorphosis aria. One of the defining characteristics of hora lungă is its indeterminate content structure. It is so ill-defined, so nonconstrained, that it can remain what it is and yet be something else at the exact same time. The musician who takes up the hora lungă is free to roam, to compress, distort, stretch, quicken, or altogether break the rhythm, shatter the box, chase the hens out of the coop, and yet somehow it will always come back to being hora lungă.

Its boundaries are no boundaries.

Handing me a cigarette and his lighter, Bob says there's a special word in Romanian that describes the feeling of loss that sometimes overtakes you: *dor*. It's a kind of homesickness, a sadness, a longing for something lost, like one's homeland.

I watch the VU meter on my recorder as he speaks. The light bars, like antlers, buck and stab in the dark. Sadly, later, I will find that this whole conversation was lost itself. My nonsentient machine ate it.

The half-moon above the dark hill looks like a dictionary tab with the letter rubbed off. Looking at the pots gleaming in the tree, it occurs to me we never did meet the presumed girl whose virgin soul was for sale here. Maybe, I think, she has been locked away the whole night, which makes me think of Otto's wife, locked away in her asylum room like one of Bluebeard's doomed wives. I imagine Otto putting her in the car,

driving her to the hospital. As I picture it: in a 1938 Buick. I don't know if I have the car right, but that's the year. I imagine him taking a detour, out into the country, and coming to fenomen inexplicabil. Perhaps there is music on the radio. Let's say Beethoven's String Quartet no. 13, the *cavatina*, fifth movement. To amuse his wife, Otto stops and gets out, puts the car in neutral, and she stays inside as he runs alongside. They are both laughing. But then it starts to go faster, and he tries to catch up, he runs as fast as he can, but then the car just drives off, speeding over the hill with his wife looking back at him out the rear window.

6

THE NEXT DAY, IN SIGHET, WE STOP OFF TO SEE AN OLD woman Bob knows whom he once paid a hundred euros to clean a dress. He and his girlfriend, Fumie, had been traveling through on one of his own collecting expeditions, and somehow she besmirched her dress. Bob doesn't say how. I'm sure it's innocent. When we get to the old woman's house she and several of her friends, all clad in standard old lady regalia—layers of aprons and floral-print skirts, ratty sneakers, tan and polka dot headscarves—are out in her yard, in the middle of preparing for some kind of church supper, and right away the old woman and Bob—the old woman's name is Nitsa—are laughing about the dress, oh yes the dress! They all remember the dress! There's a table set up on the lawn outside the kitchen door where Nitsa is molding balls of rice and her friend beside

her is chopping peppers and the other women stand around a giant cooking pot with the rice and cabbage that is big enough to boil a dwarf. The friends know about the dress too! What a classic moment! You washed it. A hundred euros. The dress! Yes! Bob introduces me to Nitsa, says how I'm interested in Bartók. She wipes off her hands, reaches somewhere down into her aprons, and comes back holding a photograph of Bartók, as if she's a wizard who reads minds, or maybe Bob called ahead, I don't know. But it's odd to think she has this picture under her aprons, the size of a school picture, pressed against her humid flesh. She holds it up close to my face and I can smell the old woman on the photograph. Onion. Paprika. It's a photo of Bartók as a young man, but already he looks like Jim Jarmusch, circa *Ghost Dog*.

All the women's arms are slicked to the elbow with oil and rice and tiny cubes of minutely diced vegetable matter. The oldest, who looks to be about two hundred, sits for the most part silent and motionless on a red box beside the giant pot that itself is balanced on a small stool. Her heavy forearms are crossed over her lap, creased palms turned up, here but yet not entirely here, somewhat like myself, you could say, watching but not watching. The others chatter and bicker while they work, tossing pinches of different spices from glass jars with screw-top lids, answering Jake's and Eléonore's polite questions about what it is they're preparing anyway.

"*Orez, varză verde, ceapa verde, paprica, morcovi, piper, cimbru . . . Nu carne.*"

No meat. They are making *sarmale*, stuffed cabbages. Bob says it's for a potluck for the dead. There's a ritual in the cemetery where villagers bring dishes, the priest blesses the food, fol-

lowed by a feast. I think of the cemetery where we stopped this morning to see a UNESCO-preserved wooden chapel where there was one old woman on her knees stabbing a giant knife into the dirt around a grave, chopping weeds and stuffing them into a tattered plastic grocery bag, and then the insane pornographic images painted on the walls inside the church, sinners being punished by devils armed with red-hot pokers and hammers and stakes and a lot of ultraviolent ass-play, and I'm starting to feel like maybe Transylvania deserves its reputation.

Bob says if we're lucky Nitsa will invite us in to hear her sing. She knows some of the songs Bartók came to collect. The photo of Bartók, it turns out, is a calling card from a French filmmaker who came through a few years ago making a documentary about Bartók that was never released. It's quite possible Bartók had stood in this same yard, watching a group of peasant women with tough fat arms glistening in the afternoon sun. Eléonore is walking around the barn, taking pictures, her long calves encased in mint-green leggings. She looks at me looking and smiles. There is nothing I would like to do more than take her behind the haycock and stroke her mint-green calves, if only because it might soothe the stabbing sensation in my brain. The old women try out her name and possible Romanian variations. El-ee-nora. *Eleonora.* Leana! They try different Romanian diminutives. *Elena.* E-*lee*-o-no-ra. E-le-o-no-ra. Ileana. *Lenaea.* Eléonore looks over and says, in her soft French whisper, "*Ileana, e bine aşa. Ileana, da.*"

All around us in the yard, the sound of field insects and their serenade. It is erotic and terrifying if you listen too closely.

It occurs to me, again, as I watch a rooster waltz across the yard and snatch up a grasshopper, that there is something

vaguely buggy to Bartók's music. Especially in the Third String Quartet. The chanty rubbery harmonics. Pizzicato of grass blades plucked. To check out this hypothesis, I slip on my headphones to play a few measures. But as soon as I hear the familiar opening bars, the acid chisel making its first light graze against the metal lathe, the influence of the music hijacks the whole scene, which I guess I knew it would, and everything goes lurid and ominous.

Right away I forget about my hypothesis and get derailed by the soundtrack-enhanced spectacle of the eldest peasant woman's face. Somehow the music has profoundly slowed the projection of this two-hundred-year-old woman into my brain, and she now comes to me as if she were a video installation, put here for my exclusive contemplation, very much as if she had been set on pause. The music has a kind of pressure, a barometric pressure; it gives me the bends, it yaws and rolls, it makes me seasick, and the deeper I sink into the old woman's creases and grooves, intriguing dents, gripped by the horror wending into my ears, the more I hear what János Kárpáti, in his analysis of the Third String Quartet, called the primordial figure emerging from the "static harmony" of the *Prima parte*.

The figure, as described by Julie Brown, in her monograph, *Bartók and the Grotesque: Studies in Modernity, the Body and Contradiction in Music*, is more that of absurdist monster or chimera, a hybrid grotto-dwelling creature, a distorted fusion of the mechanical and animalistic.

"In Bartók's Third String Quartet we might understand the eruption of the *Seconda parte* into glissandi, and particularly the extremely wide, contrary-motion glissandi, to be a type of string grotesquerie," Brown writes. "Just as the human

body can be washed, clothed and contained within norms of social decorum only to erupt in defecation, urination, sex and disease, so the beautiful violin can be mastered and practised to high art standards only to erupt into glissandi, fiddler style and earthy scraping sounds. Sonic eructations might be compared with gross bodily functions and linguistic vulgarities."

To glimpse the mechanical wheels and pinions under the bloody pelt, one need only look at the arcane diagrammatics in the journal article "Motivic Chains in Bartók's Third String Quartet," by Joseph N. Straus (*Twentieth-Century Music*, Vol. 5, March 2008, p. 30), in which the author attempts to categorize the endless intestine-convoluted ways Bartók created linked motives (i.e., chains) where "the last note or notes of the first become the first note or notes of the next, and the two are related by one of the four traditional serial transformations."

Theodor Adorno, the same Adorno who put forward that "art is the negative knowledge of the actual world," also refers to the alchemical, mixed media nature of the work in his early review of the Third String Quartet: "What is decisive is the formative power of the work; the iron concentration, the wholly original tectonics, so precisely suited to Bartók's actual position. Hungarian types and German sonata are fused together in the white heat of impatient compositional effort; from them truly contemporary form is created."

Adorno's praise is especially interesting considering how, at the time, he was a fawning disciple under Alban Berg, whose own *Lyric Suite* is thought to have been an influence on the Third String Quartet. Bartók began composing it just a few months after attending a festival in Baden-Baden, where Berg first played his *Lyric Suite*. Bartók had performed his own

Avoid the Day

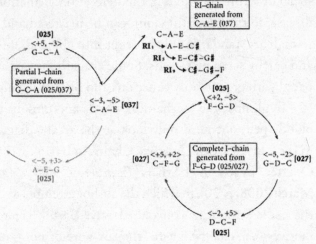

b. Chains of trichords

recently completed Piano Sonata, then reported to his mother in a letter, July 22, 1927, that earlier that evening, he had witnessed a demonstration of the new film technique of synchronizing voice to image. The big surprise came after dinner when the spectral image of Schoenberg himself was projected on the wall. Who remembers what he was talking about, but his voice and mouth movements were perfectly synchronized. It was uncanny. Bartók thought the sound quite superseded that of the gramophone.

He was less enthusiastic about the medium, years later, when his son, Peter, convinced him to go see *Fantasia* in New York. He was unimpressed with Disney's own "experimentation with three-dimensional sound." This was in 1943, when Bartók was dying, impoverished, and living in exile on West Fifty-Seventh Street. They went to see it at the Little Carnegie Theater. They got through Bach's Toccata and Fugue, and

the *Sorcerer's Apprentice*, but after a bit of Beethoven's Pastoral Symphony, Bartók turned to his son and said: "We will go now." At first Peter thought it was because his father was ill, but on the walk home his father revealed he was upset because "a small segment was missing from the Beethoven symphony, it was cut from the film. My father could not tolerate tampering with artistic creations. 'Why did they do that to Beethoven? If the piece was too long for them, why did they not pick something else, shorter? How could Stokowski permit it?'"

Suddenly Bob is in my face, making the exaggerated, muted charade motions of a person removing headphones. He is yanking me out of my private theater—just as Papa Bartók rudely yanked his son out of *Fantasia*—but I remove the headphones and follow him and the others inside the house. We go down a long dark hallway, a passage that at one point turns off down another dark passage, past a room with the unmistakable quiet of sleeping bodies, the men who are otherwise nowhere to be seen, perhaps, following Nitsa, passing through a kitchen with blue talons screeching under a teapot, and finally out of the dim maze into a sunlit room, the most spellbinding I have ever seen.

It is the center of Nitsa's house. A room filled with vibrant upholstered pillows and handmade carpets and tapestries of sheer floral pandemonium.

"It's like a bad acid trip," Bob says. It sounds like an exaggeration to say so, but you nearly can't tell where the floor leaves off from the psychedelic rugs hanging on the walls. It gives me instant vertigo and is disorienting enough that I pop a benzo.

"It's called the clean room," Bob says. "In Romania it's the room that shows stuff off. You can greet people and bring them in for coffee, like, before you go to church. It's not really used

for much. This is like the living room that has the plastic over everything."

All the tapestries are handmade. And when they make them, they always make two. A copy is always made. Bob points to one and says that he himself owns its twin.

In the center of the room, on a table with a basket of hand-painted eggs, Nitsa sets out five glasses, and then goes to the closet and comes back with a plastic jug. Evidently it's moonshine time. If I'd known, I might not have popped a tranquilizer, but on the other hand, that's never much stopped me in the past.

At first she refuses to sing, despite Jake's and Eléonore's pleas. This is something Bartók complained about, how suspicious the peasants could be, and how nobody wanted to sing and he'd have to cajole and beg and then they'd want money.

But after a few more glasses, she begins to sing a song about a dying brother, performing for Jake and Eléonore who cuddle on one of the weird upholstered benches.

"This is the real folk shit," Bob murmurs my way. "This is like hearing Robert Johnson." He says it's actually a colinde. The same solstice-ritual type ballads Bartók would have heard in the homes of hunting families.

The pálinka is wonderful, even if my eyes get a bit crazed by all the demanding patterns until I find a place to rest them on a painting of Jesus. He's in a scarf-draped frame, wearing a powder-blue robe, has a Vandyke beard, and seems to be resting his eyes on me as well. He points to his heart, which floats just outside his chest, clinched by a chaplet of thorns, like it's an ankle monitor. After a little more pálinka, I can feel my own parolee's heart loosen. Free to wander on my leash but not too far.

As Nitsa sings I watch a fly crawl across our savior's face,

which somehow makes me feel inexplicably ecstatic. The Easter eggs on the table sparkle in the sun that pours through the curtains and flashes off the chrome back of my iPod. The drapes that only a moment ago seemed to be emoting something like a melancholy desire.

Nitsa pours more and then starts to sing to her glass. *Palincuta te iubesc, mai dorule mai . . .* "Dear Pálinka, I love you, hey my dear hey, but I drink you until I live, hey my dear hey! Because if I die I won't be drinking you, but the ones who are left will drink, hey my dear hey . . ."

She stops, pours more, we toast and drink. I suspect this is how all Romanian grandmothers look. That this is what every Romanian grandmother is like, a living stereotype, one more grandmother in an eternal motivic chain of grandmothers, though, of course, no one knows how far back you would have to go to find the original.

Eléonore asks if it's made with apples.

"*De mere, si de poame,*" Nitsa says. Apples and berries.

"*Mulţumesc.*"

"Thank you!"

"*Cu plăcere.*"

"*Foarte tare.*"

"Very strong."

"*E foarte tare?*"

"It is very strong!"

Then Eléonore suddenly disappears with Nitsa for a costume change. The old lady has whisked her away and when they return Eléonore is blushing and decked out in full traditional regalia: embroidered peasant dress, black felt vest, white blouse with flared sleeves, and so on.

"*Ţărăncuţă*," Nitsa says.

Bob looks at me. "*Ţărăncuţă*. Peasant girl."

"*Cu bujori în obrajori.*"

"With peonies in her cheeks." She is our little Lidi Dósa.

"*Să te văd!*" Nitsa says. Let me see you!

"Bravo!" Bob says, taking pictures. Grinning, Jake starts to take pictures too.

"*Frumos!*"

"I feel like a circus *fenomenul*," Eléonore says, frowning at Jake.

"You have no choice," Jake says.

"I'm going to look like a clown." Her voice is barely audible.

"*Eşti foarte bine!*"

Eléonore is suspended, as if floating on a pond of psychotropic lily pads. There's fennel for you, and columbines . . . They say you can't tell whether you are falling up or down when you're drowning.

Stumbling back out to the car, my head hissing, I trip over the rooster and for a moment consider swooping it up and bringing it with us. This is the mood pálinka puts me in, the kind where one adopts stray animals. I am also in the mood to share, evidently, in hypersubjective overdrive, thus the theme of lost animals sends me into a reminiscence about my erstwhile pet, or rather, my brother's erstwhile pet, Clyde; the two of them were attached at the navel. It was never my dog. It was my brother's dog, the unwanted mutt my father gave to the state hospital as sacrificial surrogate.

The blood of the innocents fills the moat around the labyrinth.

As Jake resumes steering us around the obstacle course of

potholes, Eléonore breaks off dark squares of chocolate and listens to me ramble on like a moron about how my father, who was committed to nothing, who had no calling, had still committed Clyde. One day, Clyde was just gone. The solution to donate out family pet to the asylum had been my father's, all on the flimsy pretense that Clyde would not stop digging apart the dentist's yard, and from that day forward the only time I ever saw Clyde was at the end of a leash, leading one of the village *strigoi* on a Thorazinic walk. My brother howled from his room whenever Clyde appeared, sometimes lingering in front of our house for what seemed forever, his dog mind clearly trapped in abject confusion, head lowered, once or twice harmonizing in return with his own pitiful wrenching yowls. After a while, he no longer seemed to recognize us, and it naturally made me wonder if he was really in fact our dog, or whether they had done something to him, removed his brain, or scraped it clear of memory, or perhaps he was only a convincing facsimile.

I can hear something distorted in the way I'm speaking: a little trancy as I talk about Clyde, savage exhumer of the dentist's Night Gladiolus. This slurred story being a chapter from my most intimate folk oeuvre, a way to signal my gothic origins to new friends. The mad pastor for a father. A childhood in the shadow of the asylum.

I do not tell my klezmerite friends how when my brother once ran away to the hospital to save Clyde I got slapped for saying to let him stay since he was a "retard freak" who belonged there. Agreed, I could have put it more diplomatically.

Nor do I tell them my truest belief. That Clyde's institutionalization was only my father's unconscious at work, his darkest desire to have my brother committed. The dog was a

surrogate. The asylum was right there, they were low on business, there were plenty of empty beds. My brother obviously reflected back some unwanted distortion, some *thing* my father could not abide, some hideous defect buried deep down that he had fought his entire life to conceal but that my brother, his impoverished seed, brought out into the light, like some feeble weed poking through the hard earth. Every time my father looked at my brother, he saw nothing but his own contemptible weakness.

Being invisible myself—and therefore safe—I was not a problem. But my brother was too visibly, too obviously, a copy of the defect.

He had come into the world as blue as a forget-me-not. The umbilical cord twisted about his neck. My spiritual belief wants me to think that this was only the compassion and mercy of my mother's womb, trying to spare my brother yet one more cruel round of samsara, so he might return to a kinder, better world, but I had also dreamt the kind of dream that one desperately wishes they could forget, that it was my father who had gotten there first, while my mother was still under, and before the doctor arrived with his scalpel, and had taken the cord in his fists and twisted the slippery rope around my brother's throat . . . But was caught red-handed, literally, smeared with gore, as he garroted his infant son . . . Or perhaps this was only my father's nightmare: one I had accidentally eavesdropped on, picked up on the wrong dial one night. In any event, with my brother locked away, my father would have been spared the constant reminder, the defective face in the mirror. But of course that would have been awkward, so the dog was sacrificed.

7

BOB, SMOKING, IGNORES MY GARBLED NARRATIVE, WHILE working to unwrap one of the meatball sandwiches our hosts from the pensione had packed us that morning. I register my rambling in Jake's brow in the rearview mirror. He is listening, murmuring uh-huh, mm-hmm, but something in the mirror makes me think what I sometimes think, which is that when I fell off that train table as a child I never stopped falling. Somewhere, many miles down, I am still falling through the basement floor.

The car fills with the smell of meatballs as Bob gives Jake directions to the village of Dragomireşti. In Dragomireşti, there's an ancient fiddler whom Jake and Bob are eager to see by the name of Nicolae Covaci, the brother of Gheorghe, the

man Bob had spent a month playing with after his orchestra had disappeared due to the nephew's eggplant-sized abscess.

Bob says that Nicolae is "like a Rosetta stone of folk music."

Nicolae is a gypsy, but he's also the last link to the old Jewish folk music that was unique to this area. Both he and Jake have come to study by his side.

"They were rounded up mostly in 1944," Bob says, "and sent to Dragomireşti, before being sent to Sighet to be taken to Auschwitz."

Bob says that in Sighet there's a monument where all the soap made from Jews killed at Auschwitz is buried.

"*All* of it?" he mutters to himself. "Shampoo? Conditioner?"

I haven't mentioned it yet, but Otto Albrecht actually had a fair amount of contact with Nazi Germany. After the war he helped de-Nazify the publishing industry there. He also had a role in helping the von Trapps escape to America, which, again, interesting personal note here, Maria von Trapp ended up just a few miles up the road from my home, where she started a ski lodge, and where her eldest daughter, Rosemarie, would receive electroshock. It's strange to picture one of the sweet von Trapp girls stuck behind the pink bars of our asylum with all those other bogeymen of my childhood. Before the war, in 1936, when Albrecht had gone to the Berlin Olympics with his wife, the reason he was there in the first place was for a research trip he liked to refer to as his "adventures in the Third Reich." This was something I first came upon in Box #5. The main object of his visit seems to have been to hunt down libretti set to Goethe. While conducting his research at the Berlin State Library (then the Royal Prussian State Library), one day the director, Georg

Schuenemann, invited Otto to come downstairs into a small room with three safes...

"He opened them and invited me to take out whatever I wanted to look at. They contained nothing but original manuscripts of Bach, Beethoven, Mozart, Brahms and nearly everyone else you could name. For two hours I read through the B minor Mass, the St. Matthew Passion, the 4th, 5th, 7th and 9th symphonies of Beethoven, his letters to the Unsterbliche Geliebte [Immortal Beloved], his last Quartet, Op. 135, the Op. 111 piano sonata..."

He makes no mention of Bartók's Third Quartet, but, of course, why would we expect for him to find it in a Nazi vault in Berlin?

We are now well up in the hills, and by now my bladder is about to burst from the pálinka, so I'm glad when we arrive at the village. In the street where we park, a few urchins are kicking a ball that looks like a half-rotten cantaloupe.

We walk down a kind of mazey path between overgrown gardens to get to the old gypsy's yard where we're greeted by an even older woman wearing pink crappy-looking sandals who silences the dog and roosters. After a minute, another older woman wanders out and looks around, dazed; then the old man, Nicolae, comes out and sends one of the women back to get his violin, while the other drags out chairs into the dirt yard.

Nicolae accepts a cigarette and light from Bob and chats a bit in Romanian with Jake, who clearly regards the old man with enormous deference. He is an extremely small, toothless old man in a faded plaid shirt, grubby denim pants, and a deeply

waled green wool hat—he is so skinny that the twine cinched around his waist looks like a piece of rope tied around a log.

His skin is the color and texture of his violin, varnished and chipped.

An ancient cat creeps bonily around the rock-strewn yard, wisely keeping its distance from the rooster. There's an outhouse that looks as if it's been here for six hundred years. It stands off by a copse of spindly trees like a coffin, upended, recently exhumed. A ratty floral skirt stirs on the clothesline.

Bob asks about another fiddler from this region who is now evidently dead. They talk about Gheorghe, his brother, also dead.

As the old man tunes his violin, the first old woman drones, "Only the old man is left. Only he's left. He is ninety years old. Ninety years. Now he's ninety." Then she points to the other old woman who comes back out from the house dragging a banged-up-looking guitar and who takes a seat on a stool by the woodshed with a look of sublime indifference. "She is eighty years old. Eighty. He's ten years older."

The old man smokes his cigarette as he and Bob hand off and look over each other's violins, then Eléonore films the old man while he and Jake take up, playing some ancient klezmer lament, while Bob looks on with an expression of boyish veneration. It is amazing to watch the old man play. To watch his hands. They are thick, his cuticles dirt black. He wears a chunky watch that somehow doesn't get in the way as his fingers hunt up and down the worn frets. It is such leaping slender music. Every once in a while he pauses to grin or let out a rusty, protracted cough.

Bob watches the old man's bow almost hungrily.

When Bob joins in, he leans into his fiddle, swaying on his bow, and as they get deeper into the jam, he says to me out of the corner of his mouth unimpeded by a Marlboro, "Hora lungă. Bartók shit."

The old man stops for a minute, takes the guitar from the old woman, tunes it, or something that looks like tuning, and hands it back.

The woman with the guitar sits on the stoop with the fatigued air of somebody only recently roused from a coma. She wears a mossy shawl around her head, and a layer of dull sweaters, in the midst of which I notice a hole directly betwixt where one supposes are her breasts. It gives me a shiver to contemplate. Beneath her skirts are dusty gray ankle socks and rotten boots.

The guitar is cradled in her lap like the one-eyed skull of some extinct and slow-moving arboreal ungulate. Not to mince words, but at the indeterminate, arbitrary moment she takes up strumming the thing, it is horrid. Far more monotonous than the drunken neighbor the night before. She holds the broken neck and bangs away. Just the barest rhythm on three open strings. A chopping *thungk thungk thungk thungk thungk thungk*. At first it is just boring, but then starts to have an untoward effect on my afternoon hangover.

Before I say just how untoward, I should take a moment to properly describe the fully heathen condition of the old woman's guitar. It really is the beatest gonest guitar I ever did see. It looks like something that might have been salvaged from the junkwharf on a river, under a bridge, after a flood. The fretboard is nailed on, and the neck itself is wired onto the body with what I imagine is a busted string, which may say something about

the priority accorded the placement of said strings. The body is patched with pieces of bile-green plastic, maybe cannibalized from an old jerry can.

Whereas the guitarist at the pensione had two chords, here, there are no chord changes. There are *no chords*. Just an unsteady wham on three witchy strings. She is the cosmic brute steady. The braying uncooperative mule of time. Another bestial image comes to my mind of a very dull-witted rabbit. A rabbit that has been cornered, and in its panic hurls and thuds itself against a wall, and if the guitar is the rabbit, the violin is the old man clumsily trying to get a snare around its neck, and, listening, one can only root for the old man to snare it as quickly as possible, or, that failing, for the rabbit to finally break its neck by hurling itself against the wall, you don't really care which, only that it stop. Needless to say, it does not.

The old lady's ramming away makes me recall my visit with George Crumb. I'd gone to visit him at his ranch house outside Philadelphia one afternoon to talk about the day Otto Albrecht had shown up at the faculty meeting waving the autograph manuscript, and we had talked about Bartók, a major influence on Crumb's own avant-garde compositions, but also the poetry of Lorca, the influence of which can be heard in Crumb's *Songs, Drones, and Refrains of Death*, in which Crumb sets a series of the Spaniard's death-poems starting with "The Guitar."

> The weeping of the guitar begins
> Useless to silence it
> Impossible to silence it.

Crumb said he had visited Lorca's home in Andalusia and become overcome with déjà vu. This is how close he felt to the poet. Crumb wasn't really able to tell me that much more about Otto, except to verify he had been there the day Otto burst into the department meeting, frothing and haring about with the stolen manuscript, even if, by now, I admit I was no longer convinced it was stolen, per se, but perhaps only ecstatically borrowed. On the other hand, the thing that stays with me now was what he had said about Lorca, for whom the guitar was always a motif for the "primitive voice of the world's darkness and evil."

Which is exactly how the old woman's guitar strikes me now. Here is the dark origin of something. Some pagan evil-id thing. Some kind of fetid sulfurous spring. The black gaping mouth-hole of the guitar is chewed open, like the old woman's maw herself, which, by my careful count, is home to only one solitary tooth, though quite sharp.

As she bangs away, the same *thungk thungk thungk*, it hacks away at the last tenuous sinews of my already nearly dismembered sanity. Watching the old gypsy fiddler, I forget for a moment who I'm watching, and I realize I'm starting to confuse Bartók and Otto Albrecht. Which is the hunter? Which the hunted? It must be that I am no longer reliable. I can't even keep the subjects of my own story straight. One thing for sure, I cannot take this old woman's guitar anymore. I bum one of Bob's cigarettes and excuse myself, muttering that I must go "water the horses."

It takes a few moments inside the outhouse for my eyes to adjust, so I can only bumble forth in the dark to unencumber

my full bladder without seeing much more than the vague adumbration of the hole. I can still hear the music, but from in here, it's amusing to think that the *thungk thungk thungk* and sawing violins are the sound of my friends hewing planks for a coffin, and that I am already inside the box. When I finish pissing I just stand there smoking for a minute, not ready to go back, when I notice that somebody has graffitied in the faintest lettering on the wall, uncannily in my own handwriting, the words *furor poeticus*. Have I already been here, without my knowing it?

Then, after I smoke for another minute or so, I turn to the other presence, who, at first, I was trying my best to ignore, because, of course, it's not real, but my eyes have now adjusted to the half-light of the shitter. He sits there, a slender figure, legs dangling over the hole, with jacket and pants folded neatly beside him, hands propped on the ledge of the stained boards, as if contemplating jumping. I try to convince myself, at first, that it is just a stain in the wood: an old man-shaped stain braced as if in the midst of some violent letting go. Whatever it was, no doubt, his presence was an unreliable distortion of my pálinkared mind, my reason doubly compromised by the effects of the evil guitar—of this vision's absolute unreality there must be no question, but, nonetheless, as the dimensions of his form resolve, it does not make him any less convincing, nor less naked. I do recall reading that Bartók was an occasional nudist, so this detail is less startling.

His pupils are the size of pinpricks, as if he'd just pulled away from peeping out a crack or knothole; beside him, a notebook with a few fresh notations. When he notices me, he only clenches the side of the hole tighter. Perched on the edge, legs

dangling lower in the hole, as if he must be slipping, he seems unbothered by the fumes of afflatus that waft up from beneath. I can see how his skin is slightly bluish, like an old mimeograph, and that he's trembling, either because he's cold or afraid or sick, I'm unsure. His teeth gleam red in the crepuscular crap-scented light. I wonder if he's had one of the hemorrhages I recall his son writing about.

Then again maybe what's really happened is that he was caught at sunrise and had to hide out here till sunset.

Even though I know it is all mad, that none of this is actually happening, I listen to the master's ghost begin to tell me about how, in 1918, after he had nearly died after contracting influenza during the epidemic, that he had developed inflammation of his middle ear and it sounded like insects scratching and digging at his eardrums. For a time he heard every note on the piano a fourth higher than usual.

This gives me the opportunity to ask about the possible influence of insects on his composition, but he only says how that sounds like something his son would have said: his son who once made the mistake of referring to his father's music as "atonal," when Bartók said his music was always tonal, *never* atonal, and it occurs to me that I had not really thought of him as a father before.

As if reading my mind, he shows me a box. It's a small cardboard box. It fits easily on his wispy lap.

Inside is a large, dead beetle the size of a fist.

His son, Peter, who kept a close correspondence with his father, and knew how near the end was—by now Bartók was down to eighty-seven pounds—had sent it to him from Panama, where he was stationed with the US Navy. He had caught

it in the jungle, prepared the beetle himself, and arranged it in the paperboard coffin. This was just two months before Bartók died. A last gift from a son to his dying father. I think of my own father tying flies, and wonder if he would like such a gift, and I want to ask the master if he knows where I might procure such a thing, without making it sound as if I'm trying to trick him into giving me his, but as soon as I open my mouth he vanishes down the hole.

When I look down into the pit my mind does an involuntary cinematic form dissolve with the guitar hole, so it seems as if that hellish thrum, the ceaseless rabbit-bang of the old woman's guitar, is coming up from the shithole. Putting my face closer, staring into the darkness, I wish that I could go after him, and for a minute I imagine doing just that, if only I had some means of rappelling, and for whatever reason what comes to mind is a Pegasus—and here I specifically have in mind the black, red-eyed stallion from *Fantasia*—because if I had a Pegasus I could cut open its belly, quickly disembowel it over the hole, which is not something, by the way, that bothers my conscience, nor should it yours, if you consider how Pegasus is really a sinister creature, a winged monster sprung from the spurting neckhole of slain Medusa, so it's not like we're talking about killing a unicorn; but thus equipped with the ropy guts tied around my waist, I could descend, Rapunzel-like, spelunking far below the rich archaeological strata of graves, kicking through eons of peasant excrement, until I came out into some dripping Hippocrenic cavern, whereupon I would realize that the old man's trail had gone cold, that I had lost sight of my chimera, my gift bearer, and left with no other option than to catch a ride out on an underworld tributary, back toward Bu-

dapest via the Tisza, which runs west to the Danube, where I suppose I would float for a day or two until I looked up and saw that I was drifting under the Széchenyi Bridge, and the white spires of Parliament, and, far above, the castle turrets and green flying horse of Saint Stephen, and—it breaks my heart to say so—still suspended in the smoggy air outside the Erdödy-Hatvany Palace, the figure of my poor defenestrated soul left dangling outside László Vikárius's window.

I sit out the remainder of the jam session, enduring the painful stabs of sunlight that veer off the screeching bows and varnish of Jake's holy violin.

The cylinders of your phonograph too were thrown on the fire, and the wax had helped the flames! Van Helsing stared on gravely.

Eléonore is playing the flute. I did not realize until this moment that she was also a musician.

After a few more songs with Nicolae, Bob says, "We should start saying thank you before we kill him."

And when I hear this, I almost want to cry for the old man, I really do. But, nonetheless, I start scanning the ground for a rock big enough to do the job.

8

You might be wondering if I'll ever get back to the whole case of the missing auto manuscript quartet thing. But, for that, I have to go on a minor digression. Back to the Rare Book & Manuscript Library at the University of Pennsylvania. Back where I had first gone rummaging through Otto Albrecht's unindexed boxes—back whenever that was. This is where the autograph manuscript, good ole Streichquartett No. 3 (Sz. 85), still lives today. It had ultimately come to rest here like an asylum seeker caught in limbo, with a whole other separate sordid history of haggling and favor-dealing that I am not going to bother with now. It is true I hadn't bothered to examine it yet myself and had even squeamishly rebuffed the archivist's offer to fondle the naked manuscript on my first visit.

But it was here where I found myself once again, and this

time I had not come alone. I had brought one of my students, Zoe K., enlisted to help me on my ill-defined project, which, at this point, I still envisioned as a kind of narrative nonfic epic, starring the two star-crossed protagonists, Otto and Béla, two men linked to history via a major and majorly mislaid opus of modernist angst, a story that spanned the twentieth century, all painstakingly reconstructed by yours truly out of correspondence, personal interviews, a few lost memoirs, and a good helping of inferential deduction. All pointing, of course, to some larger resonant meaning and/or theme about why it was an important story for today, life in the age of informational transmutation.

I just needed to land some good scenes.

On her own initiative, Zoe K., my overachieving research assistant, who had so far excelled at digging up arcane scholarly articles on the source readings of the *Cantata Profana* and other stuff I would probably never read, had sought out and befriended a violinist who had put in real hours on the Third. A student at the Curtis Institute, the violinist was also named Zoe. I'll call her Zoe M. But my original Zoe—Zoe K.—believed it might be useful for me to infiltrate the mind of somebody—in this case, Zoe M.—who had actually had authentic insider experience with Sz. 85.

So, on the appointed day, Zoe K., myself, and Zoe M. went to the archives to pore over the manuscript together.

"This is the closest I've been to anything like this," Zoe M. said, after the archivist, John, had brought out the acid-free coffin containing the source of all future joy and grief.

When he set down the box, he gave me a look like, *you're really still on this?* The box itself was almost too new. It looked

hardly touched, virginal, a rectangular, taupe, clinical affair. There were no signs whatsoever of prior handling. Surely, we must have been its first visitors in twenty years.

"Did you ever get in touch with Marjorie?" John asked.

I tell him yes, though I don't go into her preposterous theory about a tug-of-war, or epic Grecian wrestling match, between the manuscript hunter and an archivist-priest, who kept it stashed under his couch. Or, honestly, if I had just misremembered something she had said after she'd burst my bubble about the bank heist.

"Turns out it's a bit of a Rashomon," I say.

When he opens the box, my nose is attuned, but there is *nothing*. The manuscript is scentless. It is weirdly neutral. It is, scentwise, invisible. It is too clean, especially for something shut up this long.

When Zoe M. beholds the pages, carefully spread out for us, she is visibly flushed. "We don't need gloves or anything?" she says.

"Not at all," John says. The way he says it sounds almost sadistic. Then he leaves us alone with the thing.

The score has eighteen staves per page. Across the first, the title page, is scrawled in the master's hand: *III. Stringquartett dedicated to the Musical Fund Society in Philadelphia by Béla Bartók*. It's written in what appears to be pencil but I think (here is inferential logic at work) must be faded ink. The paperstock itself is identified in the bottom left corner as Protokoll Schutzmarke No. 5, 18 linig, with a lion rampant holding a partly scrolled shield. Exactly 4.3 inches above the top of the lion's head is a tear that is a half inch in length, and the bottom right-hand corner, where one would seize the manuscript with

forefinger and thumb to turn, is slightly curled and stained dark. As Zoe M., the young violinist, takes a gentle hold of the corner, my mind reels at the statistical odds whereby what I assume can only be the engrimed whorls of the master's fingers might actually now be in synchromystical collision with her own whorls. Would she be able to sense such a thing? I notice on the second page, fifth staff, erasure marks, but it's hard to make out the words. The bottom right corner is also torn off at a 42-degree angle and the page itself looks roughly handled. The reverse side of the page is blank but for seven hastily sketched stray notes speared between the second and third staff.

Zoe M. says she's only seen things like this before under glass. "I wonder if this is his own writing or if he had a copyist." Her fingers hover timidly over the first bars of the *prima parte*. "It's very nice."

Since last time I'd been here the reading room had undergone a renovation. I noticed the self-portrait of William Carlos Williams had been taken down and I tried to remember whether or not it had shown the dentist-poet with teeth bared.

Zoe M. hummed quietly to herself as her eyes worked over the manuscript. Her own teeth were a dazzling button white. "The *sul ponticello* ricochets here . . . and then here, it's like the viola and cello are egging each other on." Zoe M. runs a fingernail precariously over a few more bars. "And then . . . this part just soars. They're moving up a register. It's just getting louder, higher, bigger, and then it's just, like, this floating down."

Zoe K. asks if any interesting imagery or phenomena goes through her mind when she plays this particular quartet.

Zoe M. shrugs and then stares spacily across the room. "As a musician, the way you think about these things is pretty

abstract." She says how she sometimes maybe senses faint humanoid figures in the impressionable mist of the tritones.

I nod at Zoe K. to note it.

Zoe M. examines it more and lingers at the end where the master had dated its completion. "Budapest, 1927." Then, carefully, she turned back to the first page.

It was hereabouts that Zoe M. made her disturbing discovery.

"The tempo is different."

I ask what she means.

She looked bewildered.

For a moment it is horribly silent except for a grad student hammering living hell out of his laptop. Zoe M. reaches into her bag and pulls out her own marked-up practice copy, studies it, does a few more double takes.

"This says moderato 88," she says. "That says moderato 76."

Her finger hovers, where the original moderato clearly is "76."

I say as how I don't think that sounds very likely.

She points at it. "Yup. That's not what he wrote. He wrote seventy-six."

She shows me where it differs on her own score, which is heavily defiled with arrows, coaching accents, and other squiggles. See, she says, it's the metronome marking that was changed from the original.

That slight shift, slight decrease in speed, she says, is a change in mood. A shift from 88 to 76 will register as a subtle temporal shift. *Attenuto*. A relaxation . . . A slackening . . . Each mood has its own speed and frequency. This is why Bartók was so specific about tempo. Feeling was a measurable thing,

closely coupled to time. How is it possible that the authorized copy—published by Boosey & Hawkes, Bartók's longtime official publisher—could be different from the original? She has no idea. Zoe K. scribbles, noting Zoe M.'s mildly catastrophic expression.

I figure it's something to investigate another day. But then a few pages later, she discovers yet another tweak: the *tranquillo* has also been changed from the original 66 to 76. Also sped up.

We had discussed the enormous significance of tempo for Bartók earlier that day, when we had first met at the Curtis Institute, where the two Zoes had reserved a rehearsal room for us. Bartók himself had turned down a job teaching composition at the Curtis when he came to America, just as he had refused to teach composition at home out of fear it would pollute his creative powers, even when it meant flirting with destitution.

To show us a few of the infinite ways that Bartók had pursued conflict at every level, as she put it, Zoe M. had played different sequences of the quartet. Zoe K. and I were perched on a couple of decidedly non-ergo desk chairs, trying to follow along on the small study score of the Third (the Boosey & Hawkes).

"Bartók, in his quartets, was *extremely* specific about what tempos he wanted," Zoe M. said, half mumbled, violin tucked under her jaw. "That's actually one of the most difficult things about playing Bartók."

She showed us, especially, at the beginning of the *seconda parte*, how the metronome markings were constantly changing. *Moderato. Sostenuto. Quasi a tempo, tranquillo. Più andante. Piu lento.* Sometimes all within the span of only a bar or two.

She also demonstrated how Bartók put melody and har-

mony in conflict—first playing one of his more or less straight Transyltucky-style licks, then contorting her fingers and slitting the violin's belly to simultaneously release a spume of entangled notes, both dissonant and concussive, that sets our teeth on edge. Chord blocks jammed against melody to create the rude interruptive quality of thought itself.

"Whoof," says Zoe K., my young apprentice.

I tell the violinist she looks as if she's in a trance.

Zoe M. pauses. "There's something primal, almost, about playing Bartók." She wipes a drop of sweat that trickles down her throat. "You just really *dig into* your instrument, and these rhythms are so—there's a certain swing to them."

Like the swing of an ax, or a shovel.

At first, Zoe M. tried to get out of going back with us to the archives. She had rehearsal in a few hours, she said, but Zoe K. applied her quiet charm, letting her know, demurely, how we already had the manuscript placed on reserve, and how she would be able to actually touch it, that we could be looking at it within fifteen minutes if we went right now, and promised to get her back in time for rehearsal.

In the end, she yielded, and the three of us squished into the back of a taxi. It was on the ride over that I blushingly confessed to my two young Zoes how I had not actually made time to see the manuscript yet myself, a fact that neither Zoe finds too shocking. The taxi had let us out at Thirty-Fourth and Walnut, the exact same corner where Lawrence Bernstein, professor emeritus of Renaissance music, had ditched me in his own getaway cab.

IN THE READING ROOM now, Zoe M. keeps looking at her distressing discovery. The purity of the copy is now in question. Perhaps the mimetic itself was now in question. Something had been lost—or added—in the transmission.

The whole situation gives me a feeling of extreme, physical distress. Like my teeth have become trapped in a bench vise.

"That's too bad, you know." Zoe M. seems genuinely disheartened.

"76 to 88 is not a *big* difference," she says without conviction. She can't fathom how such an error could have been allowed. Why a distortion had been introduced. This minuscule scratch on the wax tube.

I make a note to look at the reproductive technology used to make the first copy in 1928. Mimeo? Litho? Cyclostyle? Rapid roller damp leaf? But the publishers themselves, Boosey & Hawkes, with Bartók griping over every draft and revision— you can read the correspondence in BB's published letters— would never have dared allow such a thing. A medieval monk would have been flogged in half for such a nod.

Understandably, Zoe M.'s upsetting find has put me on high alert. Who would have tampered with the author's original intent on such a fine point? Does she think it could have been an act of deliberate sabotage? Zoe M. thinks, more likely, a performer thought they knew better. But she can't get over it. It's as if our attention were meant to be drawn to this particular detail. But why? Who would plant such a thing? And? To what end? It's impossible to believe it could be mere accident.

An error of such magnitude—to my thinking—could never have happened by accident. It too strongly bears the mark of a *will*. Even a competing will. But to think it could have been

done on purpose, or that anyone could have harbored such a distorted motive—who would have even had access to it to do such a thing?

But wait. But wait.

I pull my attaché back out and find the manila envelope, skipping over the photoduplication price list (1972 prices)—microfilm negatives: $.07 per exposure; box & reel: $.25 per set; photostats: $3.00 for one 9″ x 14″ glossy print—until I find what I need. It's a photocopy of an empty envelope with an address. Obtained during my first trawl through Otto's clusterfuck archives. Now a possible clue. It's an address in Olney. Not the nicest part of Philadelphia. Zoe K., my assistant, seems to be making furtive glances in my direction, taking notes, having learned when I am on the cusp of some epiphany.

And I am then scooting my two Zoes out the door, giving Zoe M. ten bucks, putting her in a cab back to the Curtis, and then stepping out to wave down another taxi. Zoe K., who is off to meditation class, thrusts into my hands, at the last second, a thick dossier marked "maybe of interest," in her practical and serene handwriting. She hands it off just as I tell my driver: "200 West Tabor. Saint Albans Parish. Make it snappy."

9

I quickly tuck away Zoe's package, in the cab, assuming it must be details I had asked her to go after on the old photo lab at the university library. It was the last errand I had put her on, to get details for the scene where Otto is waiting on his forgery, to look into the technology angle. Maybe see if she couldn't get her hands on a manual from the manufacturer. Were there any photographs of the old photo lab itself? Did the exit face the street? That kind of shit. But the top letter was one I had already seen, one about an invoice, or a lost invoice, and the need for a new copy of the invoice, so I assumed this meant she had not gotten to the photo lab yet. I found myself mildly irritated since what she had given me was redundant, and I still had no details about electrostatic polymers. I tuck it away and try to focus on the matter at hand.

The question is: At what point was the defective tempo introduced? One could start out logically and think, *aha*, it could only have happened at Boosey & Hawkes. So when the manuscript was in London. One can imagine simple human error on the part of a copyist, perhaps hungover on G&Ts, perhaps just inattentive. And yet, Bartók himself would have signed off on any final galleys. He sometimes traveled to London for this express purpose. The point is, it positively did not happen prior to publication of the score. Which means that the published score, which Zoe M. uses, and which all professional string quartets use, must actually be the composer's original intention. Meaning that the autograph manuscript had been tampered with at a later date.

So why do I now suspect the priest? Father Dorsey, the archivist of the PMFS who had hoarded so many of its treasures . . . Because it *had to have been* the priest. His reasons are unknown; maybe it was just a crime of opportunity. But, for whatever sociopathic reasons, I surmise he had altered the autograph manuscript while it was in his possession. It is a hunch, I admit, but a firm one, and one I admit repulses me. It fills me with a sense of telepathic apprehension verging on terror. It's too irrational. Surely there must be some cognitive bias at work here. My thinking is distorted. You're making this too much about your father. The priest is a surrogate. But yet the arrows on the compass all point north toward St. Albans. Which is why I have decided to visit the scene of the crime as immediately as possible. It's the only place I can imagine any confrontation taking place.

I don't know why it hadn't occurred to me sooner. A small change in the tempo, but however small, all alterations

regarding matters of time must be taken seriously. The other members of the Society didn't even know the priest had it. It had never *been* at the bank! Because he couldn't resist a good relic. Because he was a pathological hoarder. A deeply covetous man. I remember the look of shock in Zoe M.'s eyes when she had seen the changed tempo marking. Did the priest think he knew better? Had some devious angel been whispering in his ear?

Once Otto figured it out, I think he would have gone for the element of surprise. He would not have wanted to tip off the thief by making an appointment. He would have gone straight to the priest's. Jumped in a cab one day, on instinct, just as I had, following his bloodhound intuition. After forty-four years, obviously his patience had run out. Maybe the priest got a strange call one night that sent him back over to the church office, where he found the old manuscript hunter waiting in the dark behind a glowing cigarette. Would the priest have recognized the face there in the shadows? Surely, introductions would not have been necessary. He would have known why Otto had come. Did the priest keep a gun in his desk drawer? Did he make a run for it? Was that when the alleged tussle ensued?

I imagine all it took was the dignified calm of the righteous. The priest would not have been able to retreat behind the peacock feathers of his holy raiment. And, without another word, as I pictured it, after a handful of threatening impotent gestures at most, but probably only hostile embarrassment, the priest would have knelt on the carpet, in his full liturgical vestments, rumpled cassock, and aching back, to retrieve the item from where it was stashed beneath the sofa.

The rest would have taken place quickly. The priest, unable

to look Otto in the eye as he handed it over. Then Otto, victorious, beating a quick retreat to his waiting taxi, demanding to be driven as fast as possible back to campus, dropped at the corner of Thirty-Fourth and Walnut, that unholy intersection, and then headlong into the faculty meeting already in progress to bask in the gobsmacked amazement of his esteemed peers.

I have no question this is the way it went down. Of course, I have no real idea, not for sure. Nothing truly substantiating. But it follows if there had been a crime, there had to have been a scene of the crime.

On the TV in the cab is a commercial for one of those DNA home test kits. Get a buccal swab in the mail and discover your primal origins. It shows a map of Africa, the migration route of our ancestors out of the continent, like a diagram for an emergency exit from a plane, red lines spreading out like a staph infection, jumping over the strait from Djibouti to the Arabian Peninsula, and onward to the Levantine Corridor. I can just imagine our ancestors on their first night of self-imposed exile, making a fire in the foreign desert, watching the flickering shadows stabbing at the strange dragon blood trees, probably too afraid to even dare pull out the bone flute, which, obviously, would have settled their nerves. And yet their hunter-priest, in his animal pelt robes, keeping up his patter, trying to put the qualms of the second-guessers to rest, threatening anyone who dared suggest they go back home with the animistic wrath of various bull-horned deities. By this point, the Doubting Thomases might have even had his number, may have figured out his ulterior motives for convincing everyone to flee, but the priest was good at providing stories, plenty of stories, always more stories. Vengeful gods. Better food elsewhere. He

excelled at convincing the others with his propaganda. Visions, he said, that came to him on his long agitated walks. Signs delivered from the animals. The real reason, of course, being that he could no longer sit still with his agitated, inhospitable thoughts. Leaving was a way to cure his restlessness, but he was too cowardly to go into the desert alone, without protection. Only a priest, a seeker, on the run from time itself, would have suggested such a reckless expedition, the results of which, as everyone now knows, would be catastrophic for all involved. No question it was his constant badgering to go on a road trip that had led to the journey in the first place. He had consolidated his base by first appealing to the hunters who were more superstitious and apolitical, easier to manipulate, who did not object to a good hike. And once the hunters were in, everyone else pretty much had no choice.

The blame had always lain with the priest.

Out the window I watch trees decorated with plastic Easter eggs go swimming by like polliwogs. Shitty brick rowhouses. We cross Rising Sun Avenue. Pass a Vietnamese mallplex. Chan Kwan Tat. Seng Hong Oriental Market.

The blame, in my instance, definitely lies with the priest. *The thief.* Why on Earth would he have done such a thing? What sick motive? It's impossible to understand, unless he felt about the quartet the way I do.

Unless he had made the same discovery that I myself had made, about the Third String Quartet, not the manuscript, but the quartet itself, and it was this discovery that had driven him to his criminal act of obsession. That the Third String Quartet was not, in fact, primarily, a piece of music. I know that sounds insane, on first blush, but if you listen carefully, and you do not

even have to listen all that carefully, once it's been pointed out, it is easy to discern that the main concern is not the music itself, but the main concern is what the music is protecting, circling it like a ring of vultures. Hiding at the center of the quartet is an immense emptiness. It is quite discernible, as I said, once it's been pointed out. It is right there, vast, centripetal, absolute, like the hollow core of a planet. The quartet is a vessel, containing a stillness far more sacred than any music ever composed or improvised. The music is only a ring that Bartók had drawn around the void, to protect it, this empty space the master had dug out of the night. This terrifying nothingness at the center of the dissonant spiral that goes round and round in remote orbit, like a ring of dark and wheeling, albeit horribly insane, birds.

I really do think it must be, because of this, that the priest had become obsessed with the manuscript. He had fallen under its dark enchantment. It had turned a key in his mind, and, like a jealous bluebeard, he had kept it locked up tight, made the manuscript his unwilling lover, his prisoner, victim to a priest's late-night whims. I know if the shoe was on the other foot that I would have been tempted. It gave him power and it held him in its own quiet power. A power he did not understand, and had no mastery, no comprehension of its arcane spells: black notes he chanted at night, dressed up for the part, to indulge in his forbidden ritual. That the manuscript was kept a secret only increased its power over him. And then, drunk on this illusion of power, and maybe drunk as well, one raw lonely night he had shoved aside his odious sermon, fetched the manuscript from its hiding place, and spread out the taboo pages. Then, with his pen, the same one he had been troubling over the meaning of Paul's letters to the Thessalonians, he defiled the tempo. His

adrenaline must have been flying. But was it the mere thrill of transgression, to deface? Or was it a compromise, since he understood, as I did, that the real time signature was hidden at its center, which was no time at all, but there was no time signature for that great emptiness, that great absence at its center. But once the act was committed it was too late to take back. But the change was so subtle he believed no one would ever possibly notice. One fraction patiently counterfeited. Just one minuscule act of vandalism against time. All things considered, it really was nothing, but in that instant *the meaning* of the original—insofar as the measure of time has any meaning—was forever altered. Desecrated for the erotic pleasure of putting a hand in the sacred text himself! To reach inside the masterpiece and feel its profane organs pulsing. He defiled it in his lust to feel that unholy power. So monstrous! But it was the priest's one chance to play God and he'd snatched it without blinking.

The taxi has pulled over. The flaming cross on the sign gives me a familiar, delinquent pang of déjà vu. As a Protestant apostate.

It's no longer Episcopal. I realize, as I get out of the cab, that I may be ten, twenty, even thirty years late. I go up the steps where there's an intercom over one of the heavy dungeon hinges and press the buzzer.

EGLISE DE DIEU PAR LA FOI.

GOD'S CHURCH BY THE FAITH OF PHILADELPHIA.

The marquee does not say St. Albans. The flame is more Pentecostal. But it's clearly an Episcopal cathedral. There is a minivan parked in front. I only make my driver wait another minute, to double-check the address, before I pay and get out, and I'm left standing on the curb.

The street is more or less deserted except for a street department worker in an orange vest half a block down, in front of the funeral home. Mann Funeral Home. He's spray-painting neon orange bars on the street, each parallel line separated by about three feet. Each time a car passes, the man patiently steps back to the curb, and waits, spray can on hip. Once clear, he steps back out, straddles the center of the road, and tops off each bar with a simple arrowhead, circumflex, caret, however you like, all pointing in the direction of the church side of the street. It must be his job to keep an eye on the symmetry.

The cathedral is beautiful, even if the yard is a bit of a shambles, covered in strewn litter. Being a weekday, chances are nobody's here. There is only the minivan parked in front. If it's a cleaning person, I might be able to slip inside, they won't know who the hell I am. Then I have the quite unpleasant idea of running into the priest, inside the dark sanctuary, and me screaming: "But I thought you were dead!"

It's a stupid, ridiculous thought.

Besides, the marquee says "Reverend Edner Antoine."

I note the phone number and then just stand there, checking out the stone fortress, the sunlight splattered across the massive slate roof (rooves) through the sycamore leaves, the massive doors, the cathedral's sturgeon-scaled spires, the fussy Gothic trim and flouncy stonework. I can't make out any meaning in the stained glass. I walk up the front steps to the doors, which are planted in an arch of heavy stone, but of course they're locked, so next I walk around to the back and come to a barbed-wire fence. Train tracks over that. Asian gangster graffiti. I check the other entrances, a back door, a fire escape. I am, of course, being a PK, practiced in the art of sneaking into

churches. And out. I remember once sneaking down the fire escape with my high school girlfriend, after one of our assignations in the Sunday school on the second floor, when we had to beat a quick retreat after we heard somebody enter the church downstairs. Our only choice was to creep down the escape like teenage sex ninjas, only to then come even with the window of my father's office. And, there at his desk, my father, filing the barb off a hook for a catch and release. It was already dark, and snowing, so we could see him but he could not see us. He was so intently focused on his fly that I do not think he would have seen us even if it had been full daylight. I remember being just high up enough that I could see the snow on the graveyard, and maybe that was what led to the thought that I was invisible, suspended just outside his window in the snowing dark, as if I were already dead, while he was still inside where it was warm, in serene concentration, but it was this temporary power of invisibility that allowed me to see his true face for that one moment. If only he had known he had nothing to hide.

But this church is locked tight. I will not be getting in to conduct any literary forensics today. Pacing the lawn, I find a CD somebody must have pitched out their car window. I turn the disc over in my hands, examining it, but any clue as to a recording artist has been effaced. Then I take one last stab at the symbols in the front window but it's just another dead pattern. A great blank hole.

When I dial the number on the marquee, I wonder again how I'll react if the old man himself answers. I find myself almost anticipating it. The bizarre intensity of that moment when the priest will answer and where I will realize—*Oh my God, you're alive! You're alive!* And he'll be, like, *Of course I'm*

alive, my son, I've been waiting for your call. Why'd you take so long?

But then I hear the voice of a Haitian man.

"Hello?"

My heart sinks.

"Oh, uh, hello. Who is the father here?"

"'Scuse me?"

"Who . . . is the, uh, reverend?"

"The reverend? Who's calling, please?"

"I'm calling to find out if this is still the Episcopal church?"

"Um, no. It's not Episcopal church. It's another denomination."

"Oh."

There follows a long pause where I'm kind of hoping he'll just hang up on me.

I clear my throat. "Was this church formerly known as St. Albans?"

"Yah. Used to be St. Alban."

"What is it now?"

"Now it's Pentecostal church."

"The same minister?"

"No, it's another organization. Different from Episcopal."

"Who is the minister now?"

He carefully enunciates: "Reverend Ed-ner An-toine."

"Are you Reverend Edner Antoine?" I stare at a latex glove snagged in the shrub.

"Yes, I am."

"Did you know Reverend Dorsey?"

"I met him long time ago, maybe ten years ago."

"Hmm."

"Yeah."

"Is he still there?"

"No. I don't know where is he. I don't know. I have no idea."

"I don't even know if he's still alive," I say.

"No. I don't think so, either." The reverend murmurs to somebody on his end. "When we was in process to purchase that place, I think he was in a nursing home or something like that. He was very old. But you are at the church now?"

"Yes, I am."

I say how I'm writing a book that Reverend Dorsey may or may not be a character in and how what I really need is to see the pastor's office. I tell him I can't write anything unless I've absolutely seen it for myself. I tell him that's why I need to come inside. Will he invite me in?

There's a pause.

Will he let me in?

"Okay," the man of God says, slowly. Something about my tone has evidently put him off. "I think that his office, that they transfer, they move everything. When we get the building we get the building empty. They's uh, no office there. And, uh, it's something different. There is nothing you can find about the Reverend Dorsey here now."

"Oh?"

"And now we working. We working some work now." I can hear the creak of floorboard over the phone, and I wonder if he has moved to a window to watch me. On the other hand, I don't know for sure he's really in the church.

"Hello?" I say.

"Maybe if you have to come, maybe we have to make an appointment," he says. "Because unfortunately we are busy doing something now."

"I'm just outside now. I was hoping I could come in."

"Oh, you want to come now?" He sounds nervous. "Because there is a machine making noise inside."

I listen for a minute but I do not hear any machine. Maybe it's on his end and he isn't in the church. I don't notice any signs of work, or trucks, either, except for the road maintenance guy who has moved almost out of sight.

"We're doing a job," Reverend Antoine says. "Since we bought the building we have a *lot* things to do here. They have no boiler here. And some part of it need to be repair. It's a very, uh, good building. And it's registered as a historical building so we want to take care of it. Mm-hmm."

I let it drop. "Can you tell me, is it the same carpet that he had?"

"The same what?"

"Carpet in his office," I repeat.

"Carpet?" he says. "No. When our church come here, they move practically everything."

"Oh," I say. I ask if he can tell me anything about Reverend Dorsey himself. If he ever met the man . . .

He says he spoke to him only once. Back then, Reverend Antoine's own church was in a house across the street from St. Albans, which, by that time, no longer had a congregation. The church was effectively dead. But Reverend Antoine would still see Father Dorsey show up every Sunday, alone, in full robes and miter, to ring the bell.

"They had no Mass in that building anymore. He just rang the bell and left," Reverend Antoine says.

The one time he spoke to Father Dorsey was when he found him behind the church, down on his knees, one Sunday after he had rung the bell. He was tending to the roses. The two clergymen only spoke briefly, but Father Dorsey seemed very frail under the weight of his sacred robes. "He was *okay.*" Reverend Antoine makes an indecisive murmur. "He was doing his activities." It was then that Father Dorsey had offered Reverend Antoine the use of the spacious backyard if their own church might have need of it for youth activities, since it wasn't being used otherwise.

"He was a very nice person. But his health was not too good maybe. That's the only time I speak with him, but we didn't have chance to speak again."

When I get off the phone I feel like an idiot for coming here at all. I don't know why I continue to pursue this story. I should have more contemporary interests anyway. The trail has gone cold. I'll never know any more than this.

10

EXTERIOR: A VILLAGE CHAPEL
TRANSYLVANIA—DAY

HERE LET'S INDULGE IN A CINEMATIC FORM DISSOLVE TO another church stoop. This one in Kibéd, Székely Land, hometown to Lidi Dósa, Bartók's accidental muse, the girl who got him started on his own peasant village raids. This was Lidi Dósa's place of worship. Reformed Church of Romania (see: Heidelberg Catechism), of the spa blue door and tin steeple, with no parables in the stained glass to misinterpret; it is not even, in fact, stained, only a plain round window over the entry. The window has no mystical significance, only the obvious functional: to separate the outside from the inside and vice versa.

Around us see the verundulant hills, et cetera, optically all more or less interchangeable with your standard New England vista. The stable, calming mountains, fatherly even. An apple tree towers beside the church, erupting from behind a neighbor's ornate carved wooden fence to give us shade. Or maybe it's a pear tree. The leaf shadows are more ovate than elliptical, so I'll say pear. And then there's this detail: your humble author, *c'est moi*, looking down in dismay at his phone at a text message of a polar bear.

My dismay has nothing to do with the bear. It's from my friend Darren. The picture is the whole message. A white-furred monster covered in blood. I don't know if it's human blood, or seal or reindeer blood, but it's set against a very welcome-looking desolation. I still don't really want to think about what the polar bear might imply, but I have an idea.

My real dismay is that my voice recorder app has just died. When I ask Jake to repeat whatever it was he was just telling me, something I want to remember, I don't even see the prancing digital antlers of the equalizer.

Bob is talking, per usual, dissertating, listing off the numbers of casualties taken in this area during the religious wars of the Reformation, how many Hussites had had their intestines removed with red hot tongs before they were beheaded over the wrong gloss on the question of theodicy, and how the gypsies here in Kibéd are Gabor, the Roma who live around this area, and the ones he and Jake are going to jam with in Cluj. They're the ones who look like the villains in a spaghetti western, he says, with the big black hats and the mustache. Oh, and P.S., he says, this town is famous for its onions. I've decided Bob is like a character out of a novel who's under the impression we're

still stuck in the information age or that anybody anywhere cares about this kind of shit. A town famous for its onions? What am I supposed to do with that? The Tartars this and the battle of Kurutz that. No one has told him information like this has already gone out of style. It has no currency. That, in fact, despite what anybody tells you, we are no longer in the information age. We have already moved into the more deliberate and artful age of mutually interchangeable data. It's all a mountain of raw material and you're free to use it depending on your preferred version of reality. Orient yourself toward objective truth however you like, so long as nobody ever knows your real secret. Regardless, none of this matters now since, like I said, my machine is on the goof. I'm nearly as lost without it as I am without my drugs.

It would be bad enough to have a dead recorder, but my writing arm is out of order too. It stopped working midway between Poienile Izei and Sovata, where I'd had a massage and a good soak but it had only helped temporarily. Naturally, given my dependence on this machine, for both memory and meaning, I see all this now, sitting on the church stoop, as if at a distance, or as if we're sliding across the village of Kibéd midway through a time-lapsed car accident, *ritardando*, one in which I have already been hurled through the windshield, and the dust and glass are suspended glitteringly around my airborne corpse, a helpless participant to my own unmediated and bloody spectacle. If anything happens, I won't be able to document it now, and that stress is making me reach for more pills, making the alternative method, that is, memory, even less of a backup. I think the arm trouble is the culmination of trying to keep up with Bob's logorrhea.

Then, as Bob had predicted, on cue, up the dusty road comes a pack of sparkling gypsies—on an afternoon promenade, *passeggiare*, old women, dewey-skinned daughters of the forest, the youngest streaming with ribbons in their hair (designating, says Bob, nonbetrothal, an accessory to the pots and pans), scarves red as pig's blood, and all the more enchanted by the fact that they do not so much as glance our way, as if we really are not there, three invisible klezmerites and gingerpated me, but then Bob goes and talks to a couple of the men who trail the harem. And we learn that the Dósa family does indeed still live here. They are the village butchers. We can go meet them, they will take us if we like, but it turns out we don't much really care. We're all more eager now to get on to Cluj-Napoca, the city that awaits. If there were anything worth getting I wouldn't be able to record it anyway.

Forgetting the polar bear for now, I hit up Bob for the ibuprofen he carries in his fanny pack. When this doesn't work, I figure it's at least 7 P.M. in New York, so I go for the pálinka we had bought yesterday on our way to Sovata, the little spa town. We'd picked up the moonshine at a flea market in the lot of some ramshackle logging operation. Bob was on the hunt for a new hat. He wants a replacement for the one on his head that's more or less identical to the fedoras all the men here wear, though, of course, most of the men here don't also sport a derelict ponytail-cum-dreadlock with Birkenstocks (one of his former gigs was reggae radio-show host). When he asks a guy manning a pile of cardboard boxes spilling over with rusty wire snippers, one-clawed hammers, bent hinges, and chain saw blades, the man says no hats, so Bob asks how about pálinka, and the guy says yeah and calls his wife over who's

sorting through a sack of carburetors, and he points for us to follow the woman, so we go down a muddy path, past a gang of men stripping bark off giant logs with crowbars, and a few skinny-ribbed dogs until we came to her hovel. Her clean room was more derelict and grim than Nitsa's but in the center is a rain barrel filled to the top with crystalline hooch. One fully expected to see goldfish stirring under the surface.

On the way back to the car Bob had warned me to "take it easy on that stuff," as I glugged one of the two-liter Coke Zero bottles she had filled with an oil funnel and sold us for a song. But it instantly vanished the pain. As if the bear had unclenched its jaws.

Then we had gone to Sovata. Sovata, the old Carpathian spa town. It was all very Magic Mountain. An idealized Hansel and Gretel Hapsburg-era escape, with just the right touch of neglect. From my balcony, I have a view of Lake Ursu and Strada Trandafirilor with its many twee balconied villas.

It was Bob's idea to come here, for my fucked-up shoulder, his kindest and bestest idea yet, and I'm grateful. I'd blown half my expenses at this hotel. I pay out the big resort bucks for everyone, to their shock.

Eléonore asks: "What is *Harper's* going to think of this?"

I want to tell her there's no future in print journalism, so it doesn't really matter what *Harper's* thinks. I need the magic heliothermic healing waters and four-star catharsis. Once they discover how hollow my story is at the center, they won't ever ask me to write anything for them again anyway.

I think I was starting to kind of hate Bob until this night in the hotel when we split the last bottle of pálinka and rapped about Michel Gondry films. We hit it off over *Eternal Sun-*

shine of the Spotless Mind. The aspect of erasure, of memory, whether and how memory determined meaning, the meaning of the Beck song on the soundtrack, "Everybody's Gotta Learn Sometime." For Bob—we were in his room—there was something essential and pure about what he regarded as "the authentic." That a thing was somehow best nearest its point of origin, undiluted. Bob had a general bias toward this point of view. He found it felt most legit, and I guess none of us can get by without that, without a sense of something legit. He believed in the reality of the first deposit, the first layer, the actual and verifiable, in the actuality and verifiability of the initial exposure, the beginning of a thing, the ground zero of any given experience. I didn't deny it, but I did feel it was a mistake to believe in preserving it in any kind of fixed way, given every grimy accumulation of memory and meaning, the way it was all recombined, subject to constant rearrangement, interpretation, redaction, adjusted for alternating levels of fear, new chains of causation and meaning started with each convolution, focal length adjusted for revised predictions, shifts in the hermeneutic code. It occurred to me at some point that I may have just been talking to the voices in my head. But, still, I ask him if he won't consider, for a moment, the example of the Third String Quartet and its Rashomon. At this point, he gives me a pretty big jeesh face, but I stumble onward. He was to be my confessor. The whole missing autograph manuscript part, I say, it was less than it really was. At least less than I had thought it really was. The story was supposedly the reason for bringing me here, *to him*, to all of this, to this room, on our picaresque adventures, I say, standing before the full-length mirror, not really believing I am about to blow up my own story in front of

this dude with werewolf toenails. His violin sat beside him on the bed in its battered case. He was teetering on the corner of the mattress, shaking his head. Before he can stop me, I go to my room to get the incriminating folder.

It's in my suitcase. The dossier that my assistant, Zoe K., had thrust on me before I'd rushed off in vain in a cab to go case Father Dorsey's parish. The correspondence she had dug up and marked, in her urgent conscientious script, "maybe of interest." Indeed I had read it. Of course I had read it. Even if not until a few days, or maybe a few weeks, after the stake-out. But after I had digested how much its contents fully contradicted the version I had built up in my mind, I must have quickly concealed it from myself. I had wished for the most violent, disorderly version, the more dramatic bank heist, or, at the very least, epic tussle in the pastor's den. But the new correspondence showed a far more cordial version. It was anti-climactic. There was no home intrusion, no wrestling match on the carpet of the pastor's office, no all-points bulletin for the arrest of Otto E. Albrecht. When I returned to Bob's room, I drop the folder at his feet. There was never a bank heist, I tell him. There might not even have been a tussle. In the stash of my research assistant's flagged material, I tell him, was a letter from Otto to the Musical Fund Society attorney, John Y. Mace, Esq., saying he regretted hearing that Father Dorsey had been "severely censured" for passing off state secrets. There were even phone memos in Zoe's stash that Otto had kept from his conversations with Father Dorsey, revealing that the priest had in fact been a good sport and gone along with his scheme. The priest had been more of an accomplice all along. I gave the dossier on the floor a less than gentle nudge

with my toe, and Bob pulled his foot away startled. Father Dorsey had even given Otto E. Albrecht his own key. Because the manuscript—this much was true—was in a vault. Just not in a bank vault. The priest had taken Otto right to it. Evidence of his collusion was right there among the other items I had either repressed or forgotten, but given my healthy pill habit it also wasn't entirely out of the question that I'd already solved this investigation once, only to pick it up again as a cipher.

Of course I might have been spared some of these inconvenient mundane truths if Zoe had only gone on the errand I had asked, which was to get more ekphrastics, I say. Sensory ekphrastic details on the old photo-laboratory services department: Where was it, were there any old images? What did the room look like? What kind of light? Did they have IBMs or Xerox? I wanted as many deets as she could get her hands on to better picture Otto, the dapper emeritus, nervously waiting on his forgery, playing with his cuff links, the tang of electrostatic chemicals clinging to the worsted wool of his now rumpled suit, making awkward small talk with the women who worked there in fuchsia chunky heels from Wanamaker's. When I pictured the kind of shoes Otto wore, they were the scuffed shoes of an otherwise natty older man who saw his wife only on her birthday and Christmas now. I picture him sweating a little, tapping his fingers uncharacteristically on the counter. Even if I knew better, now, I still had him watching the door for the cops. I wanted every possible specific about the moment the manuscript had come into contact with the radiant machine. Particulars. The more ekphrastic, the better. Did it throw off a lot of state-of-the-art heat in the spasms of reproduction? Did the room hum? Yeah, yeah, Bob says, I know what *ekphrastic* means.

I hold up a letter dated May 15, 1972.

Father Dorsey hadn't actually known where it was either. Not the original. He didn't even know for sure that it was the actual autograph manuscript. They had their archives spread out over the city, he told Otto. Some was in storage at the Free Library. Some in a vault at Fidelity Bank. They went looking together. At the library, in the walk-in vault in the Music Department, which today only serves as a place to store the booze for rental gala events, they found the parcel that contained the prizewinning scores of the 1928 competition: Alfredo Casella's downright cheery, piccolo-laced Serenata op. 46, and the Third String Quartet, op. Sz. 85, of Béla Bartók. Otto's expert eye quickly affirmed its authenticity. He told the priest that it was paramount that such a relic should be protected and preserved, how it was standard practice for libraries and archives around the world to make copies of their rare materials to guard against loss by theft or destruction, by fire or war, and that he had authority to offer sanctuary to the document in the library that would soon bear his name, but at the very least he urged the priest, he should be allowed to make a professional copy that he could distribute to the Library of Congress (where the Third's sister was archived along with the Fifth String Quartet), as well as the Bartók Archives in Budapest. It truly was a matter of preserving Western civilization. He also told Dorsey that if the Society were to insure it, they should put it at $75,000. Father Dorsey then entrusted it to Otto, who went to have a copy made at the photo lab—after, of course, taking his spry victory lap through the faculty Music Department meeting already in progress—and had it returned to Father Dorsey in less than twenty-four hours.

But then the Society's Historical Committee, a real group of Jacobins by the sound of it, had gotten wind of Dorsey's treasonous behavior and accused Otto of "all sorts of nefarious intentions," and the autograph manuscript was moved under cover of night to a new location (later to be revealed as Girard Bank, deed Box #54). The Society attorney, John Y. Mace, demanded that Otto promptly return the "illegal copies" he had made of the original score, with thinly veiled legal threats, in response to which Otto schooled him on fair use and copyright law, and then he had taken the opportunity to fill Mace in on the whole lengthy history of the fiasco, starting with the significance of the piece, and how he had personally been chasing it for forty-four years, and also how in its perverse secrecy and astonishing rudeness the PMFS had led so many other scholars up the garden path.

Among those frustrated in their efforts to consult the original had been the director of the Bartók Archives in Budapest, László Somfai; Boosey & Hawkes, Bartók's longtime London publisher, and copyright holder of the quartet, who were under the impression the manuscript was supposed to be in their own archives and required clarification; Victor Bator, founder and trustee of the Bartók Estate, who was to be in America on such and such date, and while here, desired to make an appointment to personally inspect any records associated with the prizewinning quartet, only to be told by the serving secretary, Willem Ezerman, DDS, that "My files cover only from 1944 onward, and precisely what my predecessor put away I must confess I do not know. Someday, when the bank has no holiday, *and I do*, I may dig out the dusty boxes, and see what's there. In the meantime, I'm afraid I can be of little help to you" (Letter dated

January 9, 1961). Peter Bartók practically groveled for a copy and, after numerous failed requests, had turned to Eugene Ormandy, who, in addition to being the volcanic conductor of the Philadelphia Orchestra, and a fellow expat from Budapest, was an influential trustee of the Bartók Archives. He responded by asking his lawyer to tell Peter to stop pestering him, and that he wanted to be left alone because he had agreed to serve as a trustee in name only and did not want to be at all involved in any such matters, or any matters at all really. A month later he resigned. As a result of what at times felt like a deliberate misinformation campaign, Otto let John Y. Mace, Esq., know, the definitive biographer of Bartók, Halsey Stevens, had been given the wrong venue, date, and performers for the work's premiere, thanks to the Society's perplexing obstructionism, and incorrectly placed the 1928 premiere in London, rather than in Philadelphia, at the Bellevue-Stratford. He still had the program. Zoe had found it. I had seen it with my own eyes. Otto himself had been there.

December 30, 1928. Four o'clock in the afternoon, in the Grand Ballroom of the Bellevue-Stratford Hotel. The Waldbauer-Kerpely Quartet performing Béla Bartók's Quartet for Two Violins, Viola, and Violoncello in C-Sharp Minor. Prima Parte. Seconda Parte. Ricapitalazione Della Prima Parte. Coda. All in under fifteen and a half exquisite minutes of crushing light that clearly moved the twenty-nine-year-old Otto deeply enough to spend the rest of his life chasing after it. Lest it get away forever. Or maybe only to prove to himself that it had been real, and, yes, to authenticate the original intent of the gift bearer.

I told Bob that as far as the altered tempo marking went, I had come to accept that it was highly unlikely that Dorsey was behind it and in all likelihood it had probably just mutated on its own. Which I did not consider at all infeasible.

One day I went to the Bellevue just to absorb the vibes. It now goes by Hyatt at the Bellevue. I got an Americano at the Starbucks in the lobby, window-shopped the carved maple salad bowls at Williams-Sonoma, and then slipped upstairs and found the Grand Ballroom. Pastel silver and mauve rococo. Vaulted ceiling. Gold chandeliers, chairs stacked in the center in a pyramid, empty but for the white-haired gentleman vacuuming in a far corner. Just outside in the hall were conference attendees in black lanyards milling about on a stretch break, standing around whispering about corporate encryption software. All encrypted data is worthless now, they were saying, unless you have the right encryption keys.

11

AT THE SPA HOTEL, I HAD AWOKEN AT FOUR IN THE MORN-
ing, still dressed, and then gone out onto my balcony to hear
AC/DC blasting from the hills still under cover of dark. The
local yokels partying hard. Dogs for miles around barking in-
sane. I had gone back to get my phone to record it, just to be a
dick, so I could play it back later for Bob as a sample of local
folk music I had collected. But when I try to play it back, it's
nothing but dead crickets. I stood there, on the balcony, until
the birds awoke and filled the valley with their evil screams,
and then I went back inside and finished off the last good slug
of *horincă*, got dressed, and took a pill on top of it to dull the
Mongol arrowhead grating like a motherfucker under my
shoulder blade.

It occurred to me that the pain in my shoulder was punish-

ment for all the terrible things I had ever done to my brother, and it was only catching up to me now.

Outside, it was wintry cold. On the walking path that goes around the lake, it also occurred to me that it was absurd to refer to birds singing. They aren't singing. They're screaming. Then I remember that I had read that somewhere else, in a French novel, I think. It was not an original observation, but I couldn't remember what novel. Whoever made the observation first was clearly mortally hungover.

For good measure, I popped another half milligram of Ativan to push down the shrieks.

I can't remember a lot these days, like I said, thanks to too many of these pretty little things, yet I am proud to report I can still recall its formula. For reasons unknown to myself, I have it memorized. $C_{15}H_{10}Cl_2N_2O_2$. My own habit shared a few protons with the master's choice: Veronal—$C_8H_{12}N_2O_3$—which he had begun taking, in 1930, for a recurrence of his childhood exanthem. To tranquilize the panic the itching caused him. Even if the two drugs are as different at the molecular level as an oxcart from a nuclear submarine, I still liked to think I could feel a little of the chemical serenity the master must have felt while composing the *Cantata Profana*—his underwater power ballad. The tent pegs for my own fluttery little heart are closer to the anxiolytic identified by name in *Dracula*: chloral hydrate. It's what Dr. Seward takes after staying up night after night with poor, undead Lucy, dictating into his phonograph between failed transfusions. This horrifying "diary"—and that is what he calls it, his "diary"—is kept on a newfangled Edison phonograph.

"I am weary tonight and low in spirits," Dr. Seward moans,

alone in the den of his private asylum. "If I don't sleep at once, chloral, the modern Morpheus—$C_2HCl_3OH_2O$! I must be careful not to let it grow into a habit."

When I first read this, I wrote it down in my own diary as *choral*, which made me think, how nice to have a vial of lullabies.

Anyway, hungover, but at least sedated, I decide to go for a walk before my friends awake. I briefly consider waking Eléonore to see if she wants to come along, but I don't dare knock on her door. How foolish do I want to seem?

To get to the stairs down to the lake, I cross the patio that the night before had been full of loud cheesy Slav-pop and thick biceped men in net shirts and Bono glasses, telecom entrepreneurs from Bucharest and Debrecen, with their bimbo mistresses, or secretaries from Ostankino. Once on the gravel path, I can objectively see that it is a lovely morning. I no longer hear the birdsong as screams of existential pain. But objectivity is also the problem. It is all *out there*. The lake, the birds. Sunlight needling the tips of the trees. I can't seem to internalize it. That's the problem. I can't cross the threshold.

I pass a couple of joggers. It's still quite early. Only drunks and joggers are up at this hour. It's very cold, and I have a rough cough, from too many of Bob's cigarettes, which I bummed too freely. If my machine were working, I'd be recording all the self-loathing thoughts bombarding me. To keep me honest. What if, for instance, I ended it all now by just walking into the lake. I could eat up the rest of my pills and put some rocks in my coat pocket. As far as my suicidal ideations go, it's more romantic than usual. Drowning myself in a lake in Transylvania. If I had my notebook I could jot something down, or at least try out a draft, but since my arm isn't working, and my means

of transcription are gone, I am forced to experience these unpleasant thoughts on their own terms.

Halfway around the lake, I stop, and it's at this pause that I see a fish leap. A solitary fish. It just explodes, up, from the still surface. I behold it as an act of extreme, almost violent, solitude. Something I clearly was not meant to witness. It leaps upward as if moving in reverse, as if it had launched from a perfectly static position, vaulted into the air, from just under the other side of the pane. As sudden as if defenestrated from another dimension, it hangs in the spangled air, briefly suspended over its own mirrored detour, before speeding back with a cymbal crash of blistered sunlight.

Waves converge, or as it may be, diverge, in broken eccentric rings, as if the entire moment had been carved by a woodcutter.

My father, man of God, never prepared me for moments of actual consecration. Not that I'm prepared to say this counted as such, but I can see how a mind more fertile, more receptive to the mustard seed, might. My reverend father only showed me how to put on the spectacle of holiness. He was a performance artist. He did his rain dance up on the pulpit each week, dressed in ritual garb, cut in half by the ecliptic of light that streamed through the stained glass, casting his invisible line over the gullible trout in the pews. I counted myself among those trout. But he taught me the art of deception, fiction, nothing else. Weirdly enough, to be fair, the one thing he did really teach me, with any passion, was the art of tying flies. How to think in miniature. How to build miniature decoys. How to wind and wind and wind the thread around the barb, how to pick the right feather, to factor in the season, the time of year, to mimic

the right phase in the life cycle of the pupae, the larvae. My father, master of nothing, except those miniaturist masterpieces, taught me to confect phony flies to float weightlessly on the surface of the water, but never to investigate the spoor beneath our feet, the sacred reality beneath our hooves.

I would do anything to have one of the sermons he burned.

When I finish the loop, I stop to read the sign at the entrance to the path, which lists all the pernicious diseases the waters claim to be able to heal. Ulcers, infection, angina pectoris, arterial hypertension, hyperthyroidism, advanced arteriosclerosis, epilepsy, infertility, VD, coronary insufficiency, and "repeated and abundant hemorrhages disregard of their nature and location." I do not see frozen shoulder. Nor intestinal cancer.

This must be the type of spa frequented by Herr Bartók. I know he went with his father at least once, as a child, for the "cold water cure." A regime of rubbing, dunking, freezing, lashing, poaching, thawing, swaddling—all meant to harden the child's fragile nervous system. When he was older, for a spell of shoulder pain, as it happens, he went to see Dr. Lajos Bilkei Pap at the Gellért Baths in Budapest. The Gellért Baths, with its unknowable source, was named after the bishop drowned there by heathens in 1047, following the Magyar Conquest, and had become a favorite place to bask for the sybaritic hordes of occupying Nazis. There, in addition to the usual mudpacks and poultices, he was subjected to diathermies (electromagnetic currents), histamines, radiographs, and solluxes—which, according to Wikipedia, have something to do with "visible" (?) radiation. The shoulder pain started in 1925. I'm pretty sure

my own is just chronic strain of the trapezius from trying to keep up with Bob's endless thoughts especially after my machine started to malfunction—and yes, I realize the whole hurting-shoulder parallel might seem like a way too patently false one to be drawing between myself and the master, another one of those phony coincidental gestures, false duplications, all to try and rope the reader deeper into my own distorted mise en abyme, but as they say in the suburbs, *it is what it is.*

"The symptoms," Peter Bartók wrote, "were the same as those in his arms and shoulders that emerged later several times. After fifteen years these appeared more and more often, so from a non-professional point of view it can be imagined that those were the first symptoms of his disease that turned out to be fatal."

A Freudian might suggest this was Peter's feeble way of dispelling his own subconscious, infantile guilt for having been born the same year—or perhaps the father's own subconscious anger making itself a nest in the fascia of the trapezius in some kind of psychosomatic reaction to the birth of the usurping son, however kindly a father Bartók would turn out, keen to play with the new baby in the yard for hours, pointing out bugs and creepy crawlies to his own pink-cheeked pupa. But I think it might be more productive to look at the master's work during this period.

The shoulder pain first arose while he was deep in the labor of preparing the manuscript of his collected colinde. The colinde, alone, making up volume IV (the ineptly named "Christmas Carols") in what would eventually be published as his great encyclopedic tome *Rumanian Folk Music*. Although

finished by 1926, due to a fiasco with the publishing house, the colinde would not be released along with the rest of the completed volumes of *RFM* until he was twenty-three years in the grave. They were an obsession that would consume him long enough he came to refer to himself during this period as an "ex-composer" but then reemerged in a creative explosion that gave birth to a small constellation of masterpieces, including the Piano Sonata (1926), the First Piano Concerto (1926), the Third String Quartet (1927), and *Cantata Profana* (1930). All bore the unmistakable stamp of this strange music of the solstice. It was as if he had eaten the sun and then vomited it back up.

The specific colinde that would become the germ for *Cantata Profana* was a ballad he had collected, in 1914, in Târgu-Mureş (formerly Maros-Torda), called "The Hunting Boys Turned into Stags." The abnormal influence of this particular ballad on Bartók is immeasurable. He actually collected *two versions*: in one, a more primitive earlier text, the stag is actually a lion. The lion being a symbol of the sun—and the sun, as always, being a symbol for anything you like. Bartók would assimilate both versions into his libretto for *Cantata Profana*, the only text he himself ever wrote for his choral works. Both tell of a father usurped. As I have pointed out, the colinde is loosely translated as "Christmas Carols," but as the text(s) in question make clear, it is far removed from the story of the manger and the three wise kings, evoking something more akin to a crazed fertility ritual along the frozen primeval plains of Transdanubia at the blackest hour of winter's holy terror. The darkest night, the coldest night, a night ideal for monsters, yet elected the holiest and most sacred. The solstice.

The first version. A young hunter finds himself on a moun-

taintop, as the sun has just set, and where the lion has chal-
lenged him to set down his bow and arrow to wrestle. However
cold and numb his fingers, the young man overcomes the lion,
binds it in silken cords, *fivefold and sixfold braided each as thick
as a man's wrist*, and drags it home, much to the surprise of
his proud mother, who we must presume was insane with fear,
given how clawed apart her son must have appeared, and no
doubt shocked to discover that lions inhabited her native cor-
ner of eastern Europe. It occurs to me somewhat nonexigently,
here, that I am experiencing some overlap in the play between
the wrestling match between the hunter and lion with Otto
Albrecht and the priest, Father Dorsey, and their own now
debunked tussle, even to the point where I get the functional
character roles confused so it's Otto wrestling the lion, and the
young son rolling around with the priest. Even though we now
know that this version is nothing but a fiction, it has already
been coded into my memory. As for the version where the
quarry is a stag, the version that most captured Bartók's fancy,
the hunter stalks it in exactly the same way as he did the lion
and is implored by the stag to set down his weapon and to wres-
tle like men. I don't think you ever hear about a wife or mother
in this version. But the feeling is—there is something of pro-
found sadness. Where is the mother? Is she dead? Has she left
them for a better life? Did the father have her institutionalized
against her will? It's hard to picture how they must live. This
old man and his nine sons. I picture it lonely and derelict. No
women surely, but many dogs. Dogs spread out everywhere
over the house, sleeping and stinking, splayed in the filthy
kitchen, piled one on top of the other by the cold hearth, on
the unmade beds, dog dishes wherever they got dragged last, so

many dogs you have to step around the bodies just to make it from one end of the house to another. In the yard, too, a weedy obstacle course of turd and bone holes and the skeletons of Xmas trees still entangled in dead colored lights, dogs sleeping under rusted-out cars, piles of stolen, rotting lumber . . . I picture a once decent house, now a hovel, a calendar on the refrigerator three years out of date, guns on the broken laundry machine, spare boxes of shotgun cartridges set on top of the microwave. Parts of a dismantled snowmobile engine on the kitchen table amid piles of food detritus, paper plates littered with chicken bones. Beer cans (Silver Bullet), empty tins of dip, bags of BBQ-flavored potato chips, everywhere. The old man asleep in a stained La-Z-Boy. Three fingers of plum brandy, a TV preacher on mute. The old man has sawdust on his clothes but he is no carpenter, he has no trade, it is only that the chair is positioned beneath one of the many holes in the ceiling where termites kick out their offal, who chew apart his house and dump the masticated splinters on the old man as he sleeps. He exists like this, in a near comatose state of stagnation, half buried in sawdust. And all the sons know how to do, we are told, is hunt, that is how ill-bred they are, how unprepared for the immediacy of the world. The kind of grown men who wear athletic gear seven days a week, who are always talking over one another at the tops of their lungs, always threatening to "gorilla up" to one thing or other, who will watch baking shows only because the hostess wears a low-cut dress, then drag their laptops off to the woodshed to look at images in private of other more degraded humans than themselves commit atrocities upon one another's rectal cavities. They were earthen, *sown men*, sons of the earth with shitty dental plans. They

were always fighting among themselves. The way brothers will. Constantly vying for power, there were fist holes in the wall, teeth embedded in the linoleum kitchen floor. A few of them even read psychology books on power and how to manipulate one another, but that's as far as their studies ever got them. In the main, they were the kind of sons who can't hold down a job, who stay home all day drinking homebrew and shooting up old TV sets and hubcaps strung from the sugar maple in the backyard. And yet, who sometimes experience, when they are alone in the woods, in solitude, in the wilderness, perhaps looking at the way the water collects in fairy pools at the rooted foot of an old mossy tree, the pristine cognitions of a poet, and all the ignorance and fear and hunger and self-contempt and the desire to sow their own self-contempt into their brothers falls away, as it will for any person left alone long enough in the forest, however fleeting and unrecorded, the curse lifts. But mostly they were obscene apes. The father taught them nothing other than the clod art of discerning the shape and coil patterns of one genus of animal crap from another. They do not even know the word *spoor*. They only point and call it as they see it. Bear crap. Turkey crap. When the old man wakes from one of his hypnagogic states, angry, disassociating, terrorized by thoughts of his own meaningless death, he swats off the ziggurat of sawdust on his groin, looks irascibly and a little afraid at the hole in the ceiling. He eyes the nearest dozing mutt with murder in his eyes, as if the dog could have anything to do with it, as if the canine were somehow in cahoots with the termites. The TV preacher in a brimstone boil. God's eviction of Adam and Eve, et cetera. Indeed, the old man wakes feeling vaguely, indefinably rejected, this being what

happens when he naps too long in the afternoon, wakes to a universe that feels somehow far too miserably personal, and yet has absolutely no need of him. The only thing for it is the jug. But his sons—his sons who he knows no longer love him, if they ever did—have taken the last of his hooch. Their guns are gone. So he sets out for the woods. The hunter sets out with his old rifle, through fields of stubbled rye, he enters the woods, passing familiar mossy boulders, the familiar give of pinecones beneath his unlaced boots. He follows a trail of crushed beer cans, like glinting bread crumbs, trudging up the mountain to chew them out, to curse his sons for making his burden too great, for crowding in on his uneasy daymares, and he seeks them to the bridge, a bridge that gaps no more than a trickle of stream, nothing mythical, no epic chasm here, just a span of planks greened by years and a crooked wobbly birch-branch rail, and that is when he sees them on the other side. Ashen mud caught in their fur, rain dripping off sodden withers, antlers wide as the trees, the ground gored by their sharp hooves. Already, they have become symbiotic with the forest. They have merged into the ecosystem. Insects flit about their twitching hides. Parasites swim in their gummy, long-lashed eyes. He can smell them on the damp breeze. He is worse than late.

They are gathered, he now sees, around some kind of cold mountain spring, drinking from a silvery pool. In his gut he knows it is heavily polluted with some kind of elemental agent of transformation and magic. The old man stands there, rifle pointed at the biggest one, ready to murder his eldest son, as drops of the morning's rain, now desisted, measure out the standoff in a steady spizzling *tick tick tick*. The stag looks back across the bridge, less with contempt than at a remove of mem-

ory, as if only a flicker of his previous form remains in a now acorn-sized amygdala, something tenuously filial, and the father at once realizes it is too late, that it is he who is being rejected, that that is what this is all about, that it is not his sons but he himself still stuck in this servile human form, he is stranded, and when he calls out, shouts, beckons, implores, begs them to turn back, even throws empty beer cans at them, the terror and despair in his voice must unsettle at least a crumb of the fading human memory, but then the eldest son, who *speaks with the tongues of the trees*, answers in his mortifying tenor:

> *Our beloved father,*
> *Go home from the forest,*
> *But we shall remain:*
> *Look at our antlers,*
> *Wider than your doorway,*
> *Our slender bodies*
> *Cannot hide in clothing,*
> *They must hide among the leaves;*
> *We must make our tracks not*
> *In your hearth's warm ashes*
> *But along the forest floor;*
> *We must drink our fill not*
> *From your silver goblets*
> *But from cold mountain springs.*

And once the aria ends (delivered in the quavering rhythms of the hora lungă), the stags return to the pool, which is, in fact, whether or not the father realizes it, the true and original substance, the pure source itself, dripping from their sleek

jowls. But by now the old man is already staring in horror as he hears the crashing echoes in the old Roman woods and the baying of dogs. Dogs! Suddenly roused by the scent of your fear, old man, they come hurtling up the mountain. The final metamorphosis will be the hunter become the hunted. Your own dogs come to rip you apart! Melampus! Ichnobates! Pamphagos! Dorceus! Oribasos! Nebrophonos! Laelaps! Theron! Pterelas! Ladon! Hylaeus! Dromas! Tigris! Leucon! Asbolos! Thoos! Aello! Harpalos! Melaneus! Labros! Arcas! Argiodus! Hylactor! To each goes a share of the hunter's tough and withered flesh . . .

But even as the old man beholds the tragic statement of his predicament, as the dogs slip about and trip over his burst entrails, he will also experience in this last flash of consciousness the undeniable ecstasy of being ripped apart by wild animals, the most mystical of all deaths, when the transfer of form is immediate, and he can witness his own metamorphosis, see his own blood lapped up as quickly as it splashes the ground, his own flesh consumed and made new before it has even begun to decompose, his once harmonious parts, cock and balls, hairy tits, fragile bones and yellow teeth, thrown in the acid bath of the roiling intestines, recombined, transcribed by the dog's jaws, with a mute chorus of green and glistening leaves, the silent sun-digesting organs, looking on impassively . . .

12

A basic feature of mythology is its determination to explore the flexibility of boundaries, whether social, cultural or species, in the creation of stories about our being in the world. In order to do this, human myth and storytelling relies heavily on the human body, drawing on its power as the original source of sensation and apprehension to help us frame questions and our attempts to answer them. From symbols focusing on a particular body part such as Adam's rib and Achilles' heel, to myths and stories involving beings with multiplied body parts (many Hindu deities), or involving various forms of bodily hybrids (centaurs), the body is a key site for the formation of mythology. The principle of metamorphosis is also central to such myth-making . . .
— JULIE BROWN, *BARTÓK AND THE GROTESQUE: STUDIES IN MODERNITY, THE BODY AND CONTRADICTION IN MUSIC*

13

BACK INSIDE THE HOTEL, I REMEMBERED THAT I HAD
scheduled a massage, and followed the signs, taking the lobby
elevator to the basement, painfully aware how my hangover
seemed to be concentrated in my shoulder now, but evidently I
made a wrong turn, and I can't find my way back to the eleva-
tors, or wherever it was I checked in, and I end up wandering
into an older, more decrepit part of the spa, down clammy stone
hallways, dim tunnels, dank grottoes. It smells like a dialysis
unit down here. A smell so decayed it actually smells sterile, as
if the grotto has cultured its own strain of antibiotic to nourish
a perfectly life-neutral environment.

 I come into a kind of underground pool area, more like a
flooded catacombs, arched peeling ceilings, a sunken ruins. It
is all vaguely Ottomanesque. Large rancid pools of green wa-

ter, the color of engine coolant, with old men and women sunk up to their rounded shoulders, leaning against the rotting submerged columns. The old men have fat wormy moles growing out of their foreheads and the women look downright Brechtian, in teal and gold bathing suits, big hoop earrings, and full scare makeup, bellies and wrinkled breasts floating askew. The water is the magical lake itself pumped indoors for its powers to melt tumors and pasteurize the black biles. Recalling how the waters are supposed to cure infertility, I consider dunking my head.

Somebody finally ushers me to a blank room, where I am told to take off my clothes and lie facedown on the table. A short time later, I hear the door open, and then, without a word, an anonymous pair of hands sets to my body. I can't tell whether it's a man or a woman giving me what feels like an unremarkable and fairly perfunctory massage, but before I get a chance to guess, or look, my nongendered masseuse finishes and exits the room—disappears without so much as a grunt. After, I quickly track my way back through the catacombs, going the way I came; I finally come out into the more modern end of affairs, a shiny cavernous atrium of chrome and ice blue tile, like the pleasure deck of a Norwegian cruise ship.

I do a few laps in the wave pool and then surrender myself to its mechanical peaks and troughs, letting myself be rolled and laved, undulated and sine-curved, rising and falling on the pitch of happy squeals of children bobbing with floaties on their skinny biceps. There is something forgiving in the monotony of the water's rhythmic caress, a merciful forgetfulness . . .

When I get out, I grab my towel, and head for the sauna.

There, I am surprised to find Eléonore and Jake already in the cedary dry swelter. I take a seat and the intensity of the heat gives my skin a freshly plucked sensation. Eléonore wears a modest laurel-green bathing suit; Jake's torso glistens, a silvery sliver of sweat in the slit of his beautiful lip. They are huddled together on the top bench, Eléonore's long bare legs drawn up, toes perched. At first I feel like an intruder, but they seem happy to see me. There is another woman they had been talking to, a little younger than myself, and Jake seems relieved to drop the strained bilingual small talk, though when the woman and I exchange glances it is an unspoken commiseration, for not being any younger than we are now in the presence of such radiant youth. On the lower bench, I am eye level to Eléonore's knee. No one has seen Bob yet this morning, and I enjoy a private brief fantasy that he might have died in the middle of the night, and my secret that I have no real story will die with him. Or maybe he just abandoned us, disappeared, got sick of my shit finally and decided I wasn't worth escorting around Transylvania anymore, hitched a ride out on a mule cart. Jake and Eléonore would just head back to Moldova, but, of course, being as nice as they are, they would make sure to get me to the train first. Actually, I think, they are so kind, as kind as missionaries really, they would probably offer to drive me the two days back to Budapest. If that happened, I tell myself, I would be noble and refuse. Or perhaps I would accept. It would depend. But how much more relaxed to go on without Papa. It's a childish, murderous thought . . .

When Jake asks how my arm is, I realize the pain has actually left my shoulder, it has thawed, but at the same time the spike-in-a-knot-of-pine sensation has also somehow migrated

to the vicinity of my heart, or my heart has migrated closer to the source of pain. Since my arrival the other woman had retreated conversationally from Jake and Eléonore. Though she still offered pleasant looks in their direction, perhaps only to maintain the bond forged prior to my arrival, to assure Eléonore the bond was still cherished and intact, ready to be renewed at any point the younger woman might desire, and it did now seem that Eléonore was looking back at her in a way I perceived to be reciprocal, but then again maybe it is only a wordless command to act, since a moment later the woman reaches for the ladle and pours water over the superheated rocks. The steam scalds my skin as Jake and Eléonore are enveloped. They vanish in a cloud of pale vapor. Like a cruel magic act, they make their quick escape. All but for the exquisite knee near my chin. This sweet pink islet is the only thing that remains, that gives me hope, a small but definite shore to kick toward, like a castaway carried on a piece of flotsam, a hatbox maybe, or a buoyant violin case, or another less fortunate man's bloated corpse. If only I can make it one day more without being dragged under and eaten by sharks, if the current remains in my favor, but then even the island recedes into invisibility in a thick bank of fog.

14

INTERIOR: A BAR IN CLUJ.

HE KNEW THE SHIP. HE HAD DONE THE TRIP BEFORE AS A hired videographer for the cruise line, when he had traveled to the Arctic to document the unforgettable experiences of rich ecotourists paying through the nose for a front-row seat to the end of the world. Darren was an old college friend. He had gone with the same cruise line, as videographer, to the Galápagos Islands and Antarctica. But the Arctic, Darren said, was way more mellow. "No Drake passage. No fucking penguins, which, honestly, depress the shit out of me. The North Pole is downright tropical by comparison. You'll love it, being a snow bunny from Vermont. The only thing to worry about are polar

bears. But only if we run into one on land, and then, I assure you, we'll be armed to the fucking teeth."

It was kind of amazing. He'd managed to leverage those connections to get us free passage on a five-star cruise to the Arctic Circle. The concept he'd pitched was for a travel show for the Travel Channel, even if it was on spec. Darren did a lot of travel shows. He'd only returned recently from Dharmsala to interview some Tibetan monks in exile. In Borneo he'd been bitten by an orangutan. It was what he did between making other semidisposable programming about professional wrestlers and forgotten glam rockers. Subjects that appealed to his Florida boy roots.

"Svalbard, baby. The Arctic Ocean. Two cabins. Airfare. Everything's covered. Five-star chef. When I went last time, I had the best meal of my life, swear to God. If you're lucky they'll serve the minke whale. All you need to bring is a nice pair of mittens and some muck boots for Zodiac landings. They'll provide the heavy firearms for cover."

Of course, I am still in Romania. Sitting at a bar in Cluj-Napoca, talking to Darren over Skype. My laptop is on the bar, which I have mostly to myself. There's a room off to the side with some old men and docile enough skinheads watching soccer. Darren's in his office in LA, where I can see on his wall the zigzag shield he got in Rwanda. Behind him on an editing screen is the frozen image of a Tibetan monk, shedding huge flames, smoke billowing from his head. The monk appears to be running down the street through a market area, in broad daylight, people close enough to catch their own hands on fire as he passes if they chose, camera phones raised to sample the

moment. It's past midnight in Los Angeles and Darren is sipping wine from a coffee mug. As usual, he is between fifteen projects—at the moment he's editing a documentary he and his partner had gone undercover to film in Tibet, which had gotten them banned from China. He claims the secret police poisoned him with strychnine. We had gone to Rwanda together, where I was on assignment, and he had tagged along to make a documentary in more or less the same postgenocide buddy adventure genre as his Tibetan trip, and where, given the volatile nature of our friendship, we had been removed from our hotel room and put up in an outbuilding after a late-night shouting match over Werner Herzog's *Grizzly Man*. Darren had objected to Herzog denying his audience the pleasure of hearing audio of Timothy Treadwell's final screams as he was being eaten alive and to Herzog "just sitting there like an asshole" with the headphones on, whereas I felt such extreme violence left implicit was powerful enough. This had led to him screaming at me how everyone knew going into the film that Treadwell got killed by the fucking bear and how it was the only reason anybody went to see it in the first place so "why doesn't he have the balls to play it?"

He holds up a brochure for Lindblad Expeditions. The name of the cruise line. A package called "Land of the Ice Bears." Explore the beautiful fjords of Svalbard on an ICE-C class ship with state-of-the-art stabilizers and claims about organic indigenous ingredients. There's a bow shot of a group of well-heeled looking senior citizens with expensive cameras revering a (what else) polar bear traipsing across the ice. There was a sommelier and a pastry chef. In addition to kayaks for exploring the surrounding habitat there was an ROV (remotely

operated underwater vehicle). Darren said how they paid professional naturalists to tag along to enlighten the passengers. How, with the ROV, they had discovered new species science didn't know about. Undiscovered monsters of the deep.

I look at the supernova of the monk: it's as if he is trying to outrun the flame that twists around his body like a sail in a tempest. "You are not fucking serious," I say.

"Deadly serious, hombre. Get your little butt home and pack your long johns. We're going to see Santy Claus."

We had discussed this cockamamie idea before, of course, but I hadn't believed anything would really come of it. For one, it was insanely expensive. An eleven-day $18,000-per-head cruise, which began with a flight to Oslo, then a four-hour charter flight to Longyearbyen (a mining commune boasting the northernmost church and northernmost whiskey bar on Earth), where we would then sail north into the high Arctic. The ship would come within just a couple hundred miles of the actual North Pole. Lindblad, Darren said, was picking up the entire tab. Though only now does he tell me, that in addition to leveraging his former connections with the company, and whatever tenuous interest he had from the Travel Channel, that he had also leveraged my magazine connections. He says he told the director of PR that I would probably do a story for *GQ*, and she was thrilled since a piece like that could really help lure a younger affluent demographic, though he assures me there's no obligation. Mostly, he said, all I really had to do was make my face and experiential impressions available for his crew, which was just him and his DP (director of photography, aka his buddy Mark). "You're great on-camera. You are! Just bring the Kirkitude!"

I say none of it matters because I can't go anyway.

He begins reading from the brochure. "They have their own spa deck, Jay. If all that other luxurious treatment makes you nervous, you can always just go get a massage."

He's playing me, I know it, but I have to admit it's kind of working. He is, after all, proposing a tailor-made fantasy of avoidance and escape.

"So how's Transyltucky? You gettin' a good story?"

"I don't know. I don't think so."

"You never know. You might just be sitting on one HBO will want to option. Maybe even a Netflix Original."

"Bartók?"

"Maybe a video-game concept. What's the interactive potential?"

"I don't see it."

"You're too pessimistic. Video games are big on unconventional narrative now. Especially if there's VR potential. You don't even play video games, so you don't know. But put some fucking vampires in it. Definitely."

I told him we should come back and do a documentary on Transylvanian grunge music, something Jake had turned me on to. He says he's been listening to Tibetan mix-ups while he edits. That and some Persian Lounge. "You'd dig it. It's like smoking a joint and going to mosque."

Bob, Jake, Eléonore, and I had arrived a couple days ago, but this was the first place I'd been able to find decent Wi-Fi to Skype. Cluj was a pleasant, medieval city, and for the past few days we had wandered around, poking around record stores, looking for fresh strawberries for Eléonore, and a new hat for Bob, and meeting up with Jake and Bob's gypsy musician friends, which

had led to several endless afternoons sitting around in cafés. But then, earlier today, while waiting outside a store for Bob to buy cigarettes, I had been examining a CD Jake had talked me into buying, a band called Zdob și Zdub, which he said fell squarely into the subgenre of Transylvanian grunge; the album cover was just three deeply moronified-looking sheep standing in a pasture, nothing meaningful about it at all, but it had unhinged me in a bad way, coming over me all at once while I stared at the unsettling shape of their skulls. A case of the shrieks I had barely kept internal, muzzled. Then I'd split without saying anything to Bob, I'd just taken off, peaced out, and eventually made my way to this bar somewhere along Strada Memorandumului near the pharmacy museum (Muzeul Farmaciei). And now I was counting out my remaining Ativan, getting worried I don't have enough to last out the trip and might have to cut it short.

"I got the fear, man. I got it bad," I told Darren, arranging my little Stonehenge of benzos. "I got it real bad."

"What brand? What make?" Darren asks, concerned. "Fear of humiliation? Fear of failure? The grim reaps?"

The running monk remains frozen in his robes of fire. Eyes closed, mouth opened in a crevasse of pain, one leg vanished in flame. The smoke shadow billowing from the holy man's head is clearly demarcated on the street. The sun, I note, makes no distinction between the pain contained in this shadow from any other shadow. The shadow of food stands, the pendant shadow of prayer flags strung over the market. The smoke birls upward like a volcanic eruption, a pyroclastic flow, it rises in a great black and gray plumage, a crest, a crown of indifference that would blot out the sun.

"No, just the pure stuff. No fight—just flight. Like my

brainstem is hatching a prison break. Like I wanna stow away on the next probe scheduled for Mars."

"You gotta go on the lam."

"I'm already on the lam."

"You gotta go on the lam from the lam."

"I gotta escape—I've got like a major need, *a need*, to escape the bio-collective."

"See, that's why we've got to get you to the North Pole, pronto."

"I don't know," I say. "My dad . . ."

"Listen, the ship has its own wellness deck. A full-time masseuse. A sauna. You can get a sea urchin clay mask and botanical essence massage. I know you love spas." Time stops, he says, it's transcendent. He says how I won't have a care in the world. "Seriously. North of the Arctic Circle, it's like Oz. You and me have two tickets to fucking Oz. Temples of ice. A little solitude."

"Except for all the people crammed on the boat."

"The ship only accommodates like 150 passengers. It won't be like a Disney Cruise. And they're just ecotourists. Affluent, well-educated—actually pretty nice people for the most part. They think their experience has some kind of moral value, I guess. But we'll be younger than most by twenty years. It's surprisingly easy to pretend they're not there." He sips his mug and nods. "You'd be surprised."

"Can't do it."

"Actually," he says, "think about it, man. We can even do a little indie thing on the side like we've always wanted—we'll have free run of the ship, full access, twenty-four-hour sunlight, we can shoot around the clock." He claps his hands. "And

plenty of rich, older women to hit up for funding! It will help you take your mind off things. Your dad. Everything..."

"I can't do it."

"You're coming," he says. "It's no longer optional."

"I can't." I lift a finger to my bartender.

"Look," he says. "Your dad would have wanted you to do this."

I remind him that my father's not dead yet.

"Sure, well," Darren says. "I know that."

He pours himself more wine while I sniff one of the pills. I don't mean crumble it up and snort it, I just mean give it a sniff. They smell like aniseed. "I dunno. I feel like I've made some kind of internal converting error. The experience-to-meaning ratios are way off. Not sure, but it feels critical."

"Your recall is distorted. Check your settings."

"I have. I will." I look at myself in the dull, almost black mirror behind the bar. The meniscus of my scotch looks like liquid silver. "But it's maybe more like a chemical bonding problem. Like the things I see and encounter and the meaning I attribute, or attribute later, confer, aren't, uh, cohering."

"Between meaning and experiencing," he says.

"That's the problem. I can't pin down any one meaning. It's gone quantum. Or maybe more like a copy error replicating out of control."

"You're picking up some discrepancies," he says. "My advice. Given the choice, take immediacy over any alleged or allegedly attributable *meaning*."

"I'm not sure if I can really separate..."

"I'm not sure you can afford not to..."

"Meaning and experience?"

"It's like splitting the Higgs from the boson."

"That's not . . ."

"Curds and whey, muchacho."

"Curds and whey what?"

"Vinegar and water."

"What are you saying exactly?"

He temples his fingers, considering. "Meaning is just a reflection, right?" He momentarily untemples his fingers to form air quotes. "A 'reflection' of experience. The clearer the reflection, in theory, the more perfect the copy. The more perfect the reflection, the closer the meaning and the original experience are to being identical and therefore, ultimately, pointless. The meaning might have its own dissonant beauty, its own value as art, but it's inaccurate, however minor the flaw. Meaning, to be properly considered, has to be separable. But if it's identical, it's indivisible, and therefore beyond the reach of a proper hermeneutics."

"Meaning . . ."

". . . is like a cheap belt. A handbag. Meaning: it's an accessory. Forget about it. What are you drinking anyway?"

I raise my glass. "Glenlivet."

He watches me wash down another pill with my scotch. "You know that's fucking retarded, right?"

"Yeah. I just don't know if I have enough lullabies here to make it the rest of the trip." I start to recount my pills.

"Take one too many and it's gonna be lulla-bye-bye forever . . . You're strung out, my friend. I can hear it in your voice. You sound like Béla Lugosi. You can get clean in the Arctic. You just need a little serenity. The cruise is only a week. Two if we stay over in Longyearbyen for some land shots. Go check out

the northernmost grocery store on Earth. There's some mines there the Nazis shelled, too; we could go explore the ruins."

I picture Kafka in his Praha jacket with an ax chopping the frozen sea; and then I picture great white icebergs of benzodiazepine melting under my renewed willpower. What better place to regain my lost visibility than in the land where the sun never set?

"A rehab . . . An Ahabian rehab at sea," I say.

"What they do." He's typing. He swivels back. The truth is, he says, he needs me. He needs me for the documentary. "You will be the face of the doc. You will. I'm gonna do a series of 'em. Calling this one *Holiday in the Arctic*. You were great in Rwanda when you weren't shitfaced."

"How goes *Holiday in Rwanda*? Done with that yet?"

"Still editing."

It's been four years. "The political situation has completely changed, you know that, right?"

"Well," he says, pivoting. "That's why you'll like the Arctic. Where we're going there is no political situation. There's no civilization. Never has been. Permafrost won't let it take hold. Nothing with roots can get any traction. There are no fertility gods north of the sixty-fifth parallel. No agriculture, no trees, it's neutral. It's almost impossible to generate metaphors there. As a writer, you'll feel a sense of relief almost immediately. It's totally degree zero. *Derrière le prétérit se cache toujours là un démiurge . . .*"

I concede it sounds nice.

"It is! It's sacred up there, man. You'll see. You'll be able to embrace the holy entanglement of it all again. Become one with the larger project of creation. It's not just a cruise. You're gonna experience something on the order of full metamorphosis."

He's overselling the ship a bit I think. But there's some up-lifting trance music playing in the bar now. The flocked green wallpaper is starting to look friendlier. I bum a cigarette off an unsteady older man wearing a Bavarian football jersey. The in-signia of the team is, I notice, a pinecone. On his end, Darren nods his head in time, drumming the air with his finger. "The Arctic will free your head. It'll make you feel like a Zen monk."

We both look at the monk ablaze on the screen.

He jerks a thumb. "Not this guy."

As the music continues to swell, and I feel more vibrant, I think, but, really, what about my father? I wonder foolishly if maybe I can bring him along, if we can sneak him aboard, as a stowaway, if Darren would go along with such a scheme, so at least my father can die somewhere where he too can embrace the holy entanglement of it all. He always made the same crack whenever I told him I was traveling somewhere. *Let me come, I'll carry your bags* . . . It didn't matter where I was headed. He said the same thing every time. Now I wish I had taken him up on it at least once. I think if I had ever said to him, before he got sick, *sure, come with me to the land of the ice bears, let's make this happen*, not as a joke, he would have jumped at it. He would have tried to make it happen. He had that kind of spon-taneity. But now it's too late. I can no more take him any more than he can take me where he's going. But I also knew that if I myself went to the North Pole, I might be able to keep some distance between myself and the truth a little while longer. The truth being, because there is no hiding it, that I was really just waiting for him to die. If only because I know how much easier it will be once there is only one of us around.

15

I EVENTUALLY GAVE UP MY STAKEOUT AT ST. ALBANS, OR God's Church by the Faith of Philadelphia, Eglise de Dieu par la Foi, after my call with Reverend Antoine. When I get off the phone I stand there for a minute, straining my ears, but I do not hear anything. Certainly no machinery from inside the church, as he had claimed. But I decide to give him the benefit of the doubt. The walls are thick stone. It's entirely possible the pastor isn't really lying to me.

When I get a text back from Zoe K., my assistant, I sit on the steps of the church to read the manual of the Edison phonograph she has already somehow found since I saw her an hour ago. It always amazes me how she can find things in ten minutes that would take me a week. Even though, true, I hadn't asked her to find this particular manual but the manual for

the 1970s era Xerox machine at Penn, I open her attachment anyway. "Directions for Setting up and Operating the Edison Standard Phonograph":

> Take out the padding under spring barrel (B) and while motor and gears are exposed and in full view, apply a drop of Phonograph oil to friction felts (K) which come in contact with brass governor disc (N) and to each center of the governor shaft (R) and other bearings. Be sure that there is no excelsior between the teeth of the gears, especially between the teeth of the fine governor pinion (M)....

It's really no help, so, discouraged, I start walking up the street to find a cab. But then I stop and look at the funeral home across the street. Mann Funeral Home. I know my dad had been buddies with our local funeral director, it was one of his regular coffee stops, they were natural allies, so I figure I might at least see if anyone here remembers Reverend Dorsey. Do my due diligence. It's likely they collaborated at some point during their careers.

I ring the bell and after a moment a little pooch comes and yaps at me through the curtain in the sidelight with its black gums and tiny yellow teeth bared.

When the door opens, an older couple is standing there. The old guy is wearing a well-handled Nike baseball cap and green plaid shirt tucked into corduroy pants. He looks to be about eighty. Her too.

I notice the woman has a phone in her hand and I realize they've probably been watching me snoop around the church. I

quickly say how I'm a reporter investigating something maybe to do with a dead pastor named Dorsey. I say he's probably dead.

"Father Dorsey?"

"*Reverend* Father Claypoole Dorsey." The woman corrects the man.

"So I have the right place?"

As the door opens wider, I can see, behind them, a pyramid of UPS boxes in the foyer.

"We never called him that," the man says at the woman.

"No," she says. "That was his full name."

"Yeah," the man says.

"Reverend Father Claypoole Dorsey," I say. "I take it he's no longer around."

"Oh yes," the man says. "He's alive."

"He certainly is," the woman says.

"No kidding," I say, taking an involuntary step back.

"Yeah. Al, where—what town?"

The man sounds steamed. "Well, you tell him. You tell him where he's at."

"He's up in Roxborough," she says.

"He's in Roxborough?" I say. I don't live far.

"No no," she says. "I can't think of the name of the place. It's—what is it, Al?—tell him."

"I don't know."

"You don't know?"

"No."

"It's, um, it's a nursing home," she says.

"Well, I'll tell you this much," the man says, peeved, "he has someone who takes care of him, his affairs."

"Right," the woman says.

"Name's John Rosso. Now I can get his telephone number for you, you call him, and—"

"Cathedral Village," the woman interrupts. "That's where he is. Cathedral Village in Roxborough."

"No!" the man says.

"No?"

"No."

"Not anymore?"

"They wouldn't . . . *take him in*," the man chides. "Because he didn't like the, uh, he didn't like! He wanted it done his way so he—"

Woman: "I know he wanted to go to Dunwoody and he couldn't get in Dunwoody!"

"Well, he couldn't get in Cathedral, either!"

"I thought he was in Cathedral."

"He's up in Mt. Airy somewhere," the man says crankily. "Up in that neck of the woods. But I can't honestly tell you."

"Well, here," the woman says. "Why don't you—"

"I'll get you the telephone number."

"Get him the telephone number!" she shouts at the man's green plaid back as he retreats to an office in the rear past the clock that looks like a giant metronome.

Then, after a beat, she says to me: "Come on in, it's fine."

"Are you sure?"

"Yes! I'm positive!"

"OK," I say, stepping in. "Thank you."

The place is a split level. A mashup of seventies architecture and drapey Victorian furnishings. On the wall are portraits of several gloomy-looking old men, who I take to be

former undertaker-patriarchs. Against the wall by the entrance is a display cabinet filled with Egyptian statuettes, QVC gimcrack. Perched above a stairway at the end of the long room, above the rail to stairs that descend, is a stuffed peacock. On the wall is what looks to be an original antique tourism flyer for the *Titanic*.

The pendulum tocks larghissimo.

The pendulum tocks shoegazer.

"Marjorie Mann, nice to meet you." She extends a bony hand. "We knew Father Dorsey *very* well. He had dinner with us at Thanksgiving and Christmas. And my parents used to sneak over there to go to the last Christmas Mass after we'd been to church at Saint James United Methodist. But, no, he was a *frequent* visitor. As a matter of fact, he was very good friends with my brother. My brother joined the Cincinnati because of James and everything else."

"The Cincinnati?"

She looks at me like I'm a dope. "Yes. The Society of the Order of the Cincinnati Fellow Officers of George Washington's Army and Descendants Thereof?"

"Oh. I didn't know anything about that."

"Father Dorsey comes from a very storied family in Maryland. The Dorseys were the—he said they were two-time losers. They backed the Confederacy, they had slaves. And, um, what other monumental event . . . I can't think right now."

"The Revolutionary War?"

"No! But he does have a sister who's alive. James, well." She steeples the fingers of one hand to her chest and adopts a conspiratorial whisper. "I never called him anything but Father Dorsey. He's a high Episcopalian. I believe it was *Reverend*

Father James Claypoole Dorsey." She looks at the window toward the cathedral. "He supported that church until he couldn't manage anymore. There's a little house over on Somerville Avenue, a twin, where he lived." She crooks a finger to have me understand it's around the corner. "I believe that was the church manse. I'm not positive. My brother would know."

She jumps when there's a loud violent clang in the back. It sounded like someone had dropped an old Bakelite phone.

I ask, "So what is the church now?"

"It's, uh, how shall I say it, it's an evangelical Christian group? They've been fixing it up. It was in *very* bad repair. I mean, the last year or two that he held Mass, there was no heat in the church." It's beautiful inside, she says, but a ruin.

"A peacock," I say, with a nod at the spongey-looking oviraptor perched over the stairwell.

"Oh my God, we have all kinds of stuff here." She says how it was one of the things that came out of Father Dorsey's house. She says there's even a taxidermied bear in the basement. "My brother collects everything. He'd collect you if he had an opportunity." Same as Father Dorsey, she says. He was a bona fide pack rat.

"Do you see all this?" She rolls her eyes. I glance at the giant cabinet with the QVC gilt Egyptian figurines. But she means the pile of unopened boxes in the lobby. "Do you know what Byers Choice dolls are?" she asks me. "Christmas carolers that are all different figures and stuff?"

I can, indeed, picture what she means. Such things seasonally adorn my mother's mantel. The same rosy-cheeked ceramic dolls, collars upturned, mistletoe besprigged, scrolled scores in hand.

"We have almost four hundred of them," she says. "This is a man who can never—" She searches for the right trope. "There was a commercial, years ago, you wouldn't know it. It was for Frito-Lay. And they'd open a bag, and they'd hand it to you, and say, 'bet you can't eat just one.'" She slowly mimes taking a potato chip out of a bag and offers it to me.

She shouts to somebody in the back named Craig, about what the church is now, and then she disappears briefly before returning. "My brother's dying of cancer in his brain and I asked him if he knew. Sometimes he knows things and can remember, and sometimes he can't, and his answer to me was some kind of goofy S-H-I-T. So, at any rate, um . . ." She shrugs. "I don't know any more than that."

The old man returns, holding out a slip of paper.

"John Rosso," he says. "This is his telephone. He's a professor. Teaches Greek and Latin. I see him about every two weeks. He was just here last Sunday, so I won't see him until probably Easter Sunday. But he takes care of all Father Dorsey's affairs. In other words, he's the honcho. The father, he is . . ." He extends a stout hand and waffles it in the air. "Right now, more or less dementia. Whether he can come in and out, to talk to, I don't know. But John can tell you a lot."

Marjorie shakes my hand again. "I've got to make breakfast for my brother. It was nice to meet you." She leaves through a door by the grandfather clock.

He shakes his head. "She likes to put her nose in too much stuff."

He shifts the bill of his hat. "But this is it here." He points at the number in my hand. "The father had so much stuff in there."

Then we stand there in dumb silence a bit too long for comfort.

I nod at the case. "Egyptologist?"

He scratches his shoulder. "I've been studying for about five years."

We stand together in front of the cabinet.

"It's nice." He shrugs. "I'm eighty-five and a lot of people say, well, what do you do *that* for?" He points at a glass pyramid. "When you start into this, it's like a narcotic. The more you learn, the more you wanna learn, and the more you realize how little you do know . . . But, basically"—he opens the glass door and the reflection triangles the room behind us—"I say go to the deities first."

The whole pantheon of gods and goddesses trapped beneath their individual bell jars, crowded onto glass shelves, mixed in with an assortment of sphinxes, black obelisks, golden ankhs. Snakes and falcons. Osiris with his crook and flail. Sacred scarab beetles: symbol of the solar god Khepri. Everything a symbol. All a substitute for some other thing. The scarab, the heart-shaped beetle, the symbol of the soul. The sun a ball of dung rolled by a beetle. A bird-faced god sinking into the underworld on a boat. Everything entrapped by symbol, a sign to look elsewhere, to something not itself, the eternal spasmodic deferral of meaning.

The juxtaposition between the Nile River deities with the *Titanic* memorabilia—framed menus from first class, replicas of the doomed ship's final radio signals, *come at once we have struck a berg*, even a laminated copy of the sheet music used by the quartet who played on deck up to the very final moment—

seems like yet another strange deferral of indeterminate meaning. Even before I factor in the uncanny name of the ship who first arrived to pick over the dead. The *Carpathia*.

"The idea is, you can look at a relief, or you can look at a stelae, and look, I'm no expert, believe me." He slowly scratches the side of his thumb. "But you say, who are these?" He shrugs, as if yielding to a more determined curiosity than mine. "That's Isis. This is Nephthys. They're sisters. And this is her son." He points at the spaniel-faced god. "Well, what happened was, her brother, Osiris"—he gestures for me to skip that, halt that thought, start over—"Isis and Nephthys. Isis married Osiris, right? Nephthys married her brother Seth, who was evil. She and Osiris, they had a son. Horus. What she did, she went to her brother Osiris, got him drunk. Got him drunk on beer. Disguised herself as Isis and got pregnant. And she had Anubis. Now, Horus is the Greek name. His real name, his mama's name, well, see—if I didn't like you I'd take your name and put a spell against you. So when a kid was born, his mother would give him a name, and she was the only one who ever knew that name. See? So they couldn't put a spell against you. So *his* Egyptian name was Hor. Just like Anubis, who's the jackal-head guy, his name was Impu." Points at Anubis again.

"Come down below here." He hikes a thumb at me to follow.

I follow him down the carpeted stairs, below the watchful strabismic peacock, downward until we arrive in a pitch-black space at the bottom where the man goes ahead and I am momentarily stranded alone in the dark and on the edge of mild

panic until he turns on the light and I discover myself to be in a bright windowless room.

It's a casket showroom.

The gleaming coffins radiate newness. They radiate a kind of perfect emptiness. The room smells like Sears.

Just outside is a sales table with some brochures, and on the wall above is a cartouche. We stand underneath it as he points.

"These are half brothers. Horace and Anubis. It tells you right up there." He points to the hieroglyphic square. "'Here is Anubis.' This here, their basic alphabet, and this can be either used as a *W* but it's pronounced with a *U. Impu.* And there is his determinative. A determinative is a helper. See, when you read hieroglyphs, you always got to train yourself to read in squares. And they were hell for symmetry. What was on one side, was on the other. So how do you know where to read?" I follow him down a narrow aisle of new caskets—hardwood, copper, bronze. "You always read in toward the mouth of the birds or the person. That's how you know."

As we walk down a narrow aisle between caskets, we pass one that he knocks on. The inside looks like a Porsche. "This here, my boss is going in this." The casket is called the Parliament. The price tag says $16,000. Solid black walnut. "He put the price up so high so nobody would buy it, 'cause it's his." He's got it on reserve.

He points to a wall of urns, one a painted gold mask of King Tut. Another urn emblazoned with the logo for the Philadelphia Eagles. And yet another urn that is a trio of brass dolphins springing from the brass sea. The price tag for the Tut urn is astronomical. He tells me a former Atlantic City casino

owner is the only one who ever prepaid for one of the King Tut urns. He won't say which former Atlantic City casino owner.

Up on the wall, next to an electric green casket called the American, another shelf with more figurines. It's a little shrine. With little doll-size canopic jars and a tableaux of Egyptian figurines in the middle of embalming another doll. This is what he wanted to show me. There is Osiris. He has green skin, he says, because green skin, or maybe it's just green, represents rebirth. Frankenstein green. It's all about rebirth. Reawakening. And that there is Anubis, the one in the middle of making a mummy, leaning over the little corpse pharaoh.

I ask who the person is that Anubis is embalming.

He shrugs. "Just somebody. It's not important who."

Next to Anubis is another figure taking notes on a piece of papyrus. A little scroll the size of a postage stamp. This one has the face of an ibis, I guess.

"See, this is the Hall of Ma'at where they judged you." He points to a miniature scale. Anubis, the dog-faced embalmer, would weigh your heart. If it was sufficiently light, your soul was free to roam in the underworld. You had to have a certain sangfroid to make it in the next world. "And of course, this is your personality. That's your 'baa.' Your personality. Your 'kaa,' which symbol is this." He presses his thumbs together to create the illusion of an *L* regarding itself in the mirror. "Well, that's your kaa. That is *you*."

He turns his hands, thus, as if framing my face for the camera.

"This is what they call the canopic jars, where they put the viscera, see. Now the heart they never took out cuz they thought everything emanated from the heart. So when they

made the incision, on the left side, they would take everything out through that *hole*, except your heart. Now, evidently . . ."

He scratches his shoulder, trying to remember what he was going to say. His nails are stained with what I assume is embalming potion. I start to ask what kind of hook they used to pull out the brain when he recovers his thought with a finger wag. "*Somewhere along the line*, somebody screwed up! Because, well, you know Ramses the Great, right? Well. He had so many damned funguses on him they didn't know what to do. So they took him to France. Gave him a passport, took him to France. Something like eighty different funguses just deteriorating him. So somebody come up with the idea, let's *nuke* him. Because that's what they do with surgical instruments, to sterilize. So they nuked him!" He adjusts the bill of his hat. "But first they did an MRI and found out his heart was on the wrong side."

I keep listening, waiting for the punch line. He looks at me as if, indeed, I have missed a pretty good joke.

"The embalmers botched it and sewed his heart back on the wrong side."

I keep staring at him, waiting.

He shrugs. "I'm just telling you."

There's no accounting for why it strikes him as meaningful.

Nor, I suppose, why I find myself worrying about his *Titanic* memorabilia, wondering how long the martyred quartet must have really played up to the end—conventional legend says the final piece was "Nearer My God to Thee," though I prefer to picture them playing something important at the final moment, like Alban Berg's *Lyric Suite*. Were they still clinging to their instruments as they went under? Did they keep saw-

ing away with numb fingers even as they sank past the black wall of the iceberg, like a sunken pyramid, in their black coat-tails, black tuxedos? Were they able to pluck out the last notes before their lungs exploded and their earth-bound human in-struments were transmuted inseparable from the eternal ocean?

But mostly I am just shocked that Reverend Dorsey is still alive.

16

JAKE WANTED SOUP. THIS IS WHAT ELÉONORE INFORMS me when she comes to knock on my door. The sun was already setting. I had been taking a late-afternoon nap after an early afternoon of casual drinking with Bob's gypsy friends, the ones he and Jake will be jamming with tonight at Café Bulgakov, near Unirii Square. The name of the band was Palatka, a pretty big act, as far as these kinds of things went, at least on the Eastern Euro folk revival circuit.

Jake and Bob, she said, had already gone ahead to set up.

I'm still groggy, momentarily stupefied to find Eléonore at my door, but I get my jacket. We go hunting for soup and finally find the kind Jake likes, the kind with sheep intestine, two blocks from the Bulgakov, and she carries the takeout down the street in a deliberate kind of way I would have a hard

time characterizing, yet it struck me as memorable. The Bulgakov was like a medieval fortress, and we had to wander around a bit, through a labyrinth of connecting rooms and corridors, where I seem to recall torches flickering on the walls, but that can't be right, and in retrospect I think it is an almost certain misperception. We finally found our friends in the cellar bar, down a narrow vaulted stairwell.

There was a band playing, something superficially rocklike, but more woodsy than folk, however electrified. Kids danced around us, or at least made the minimal necessary gestures of dancing. I was reintroduced to half a dozen people I'd already met earlier in the afternoon, including a man named Florin, the prima violinist. We could barely hear each other over the music. Palatka's band manager was there, too, kind of a snotty-looking guy named Raoul whom I immediately disliked. Jake slurped his soup, while the rest of us resumed drinking in a tight cramped circle pressed against the bar. The ceiling was a low, curved brick arch. We barely had enough room to properly hold our drinks as we watched the kids stomping around: one androgynous youth danced just inches from me, moving pale and sweatless. Between sets, Raoul, who was pressed against me to my right, holding a glass of pálinka the color of goat piss, shoved himself even closer, offering a damp hand that I declined, and slurred, h'mmm, one of those American names, h'mmm, Jay, ha ha ha, spitting on me, and I felt the disgusting heat from his body, his sour breath in my face . . . H'mmm. J'ay. J'ay. J'ay. One of those Am-er-ican names, *Annyira vicces!*

He wore sunglasses, even though it was night and we were in a basement. Everything about him was repellent and made me even more bored than I already was. He wore a straw hat

that looked as if he had personally plucked the straw himself, *en passant*, from the nearest, most crap-ridden bale of hay, assembling it absent-mindedly on his head, probably on his way over this evening. Bob, alas, still had not found his dream hat, even though he had sought it these two weeks like the Tarnhelm itself. Raoul wanted to tell me, in his spitty way, how one of our companions, a guy with a black walrus mustache and wide-brimmed black Gabor hat, named Lali, who was about six inches away from my left, in addition to being a member of Palatka, was a "famous" Romanian movie actor. From what I gathered he was in some road trip movie, a reality-based thing, the plotline of which, so far as I can follow from the antic reenactment to which I am treated, is all about Lali and his friend driving around Romania, eating cheese and getting in fender benders, making calls from pay phones, and bartering with old ladies for used VCR parts, when the story then takes a wild turn, and they somehow end up in Egypt, where they visit the pyramids, and toss cash at belly dancers, go video gambling, barter for trinkets, drive around some more, and then, at the climax, inexplicably, adopt a stray puppy who joins them until they manage to sell it to a group of nomadic camel herders—this scene, specifically, is reenacted for me with great care. There's absolutely no explanation for how the story jumps from Romania to Egypt. To me, the leap seemed like a fundamentally flawed part of the narrative structure. The whole time Raoul keeps pushing up against me and is close enough that, between sets, when it becomes relatively if only momentarily quieter, I can hear his internal music rising up from a stained trench coat. It was transmitting from under the coat. The music is so wee, I felt I might have only been registering it as an auditory halluci-

nation, and I pictured a crippled little homunculus with a tiny, almost invisible violin, no doubt harboring his own tiny ideals about the pure and authentic. It takes a moment to realize it's only earbuds.

I would love nothing more than to drown out everything with something good and viciously electronic. Something from Berlin. Or, better yet, Iceland. Something cryogenic and rootless without any genetic-based point of view to endure. Something inhuman and sterile, incapable of decay or nostalgia. I am sick of all things verdant, fertile, and bosky. Even Eléonore's healthy scent bears too strongly on me now. I want the neutral tones of white noise in my nostrils. I want to empty, blank out, my senses. I whisper in Eléonore's ear that after I leave Romania I'm going to the North Pole. She looks at me strangely and laughs and then takes my phone and fiddles with it before pretending to whisper into the microphone, or maybe actually whispering something into the machine, while looking me in the eye with a cocked eyebrow, and I think it's sad because, of course, the recorder is broken so I will never know.

A new energy takes over the group when one reports that their friend Josif has died. His funeral is tomorrow. From the way they talk he was a great, legendary fiddler. Very famous in these parts. This man, Josif, now lost for good, was from Gherla, about thirty miles from Cluj. Not far, Bob says, just one county over from Maros-Torda, where BB had notated his two versions of the folk ballad "The Hunting Boys Turned into Stags."

Bob says we should crash the funeral, to honor the man, and so we drink more to that. Jake likes the idea. Eléonore thinks it's a little weird, crashing a funeral, but she's game. I've

personally had enough of this death cult of a nation, I don't want to crash a funeral. Still, I say, whatever, I'm game. So Bob raises a toast.

"Tomorrow we plant a gypsy!"

Then we leave the cellar, and go up the stairwell, the end of which glows a beckoning crimson. The walls, in the main hall, are a deep submarine shark blood red, painted with quirky, anthropomorphic cats. Some of the cats wear zoot-style outfits and hats. I feel good, better than good, in the dim arterial gloom. This is heaven, red in tooth and claw. There's another bar in the back, and I get myself a drink, and then fix myself in a corner, off to the side where the band is tuning, where I can savor the luminous shadow play of ice and scotch in my hand, red and black chiaroscuro. A few thick-torsoed men sit at the handful of tables with arms around their girlfriends. A handful more wander in from the next room, where there's a foosball table. Eléonore and Raoul stand together in the wide doorway between the two rooms while the band readies. The foosball handles glow emerald green.

Jake scrapes out a long opening high note followed by a trill almost monstrous in its quavering sadness. Then Florin and Bob step in with a heartbroken, off-footed march, and it stirs in me an immense grief. I hear something of Bartók's most lonesome ballad, something of the same pleading sorrow as duo no. 28, the driving thickness, the same rhythmic wistfulness. The ballad is so melancholy. A different longing, however, replaces it when I see Eléonore step out from the doorway, and I see her coming slowly toward me, walking across the floor, synched to the firm but doleful progression of the plowman's ballad, and then reaches into my shirt pocket to help herself to

a cigarette. She lets me light it. Then, as she turns to watch the music, I close my eyes to let the moment replay in my mind. The way you do when you love a song so much you must restart it over three bars in to experience it again from the beginning, to prolong it, and so, again, as Eléonore is released from the doorway, and steps across the planked floor in her chic stride, as if wading through a dewey meadow, moving at the pace of lament, as Raoul watches her departing figure with an ugly desperate expression, until she reaches again into my shirt pocket. After a drag, she says let's go play foosball.

First we get more drinks. Then into the other room where a few expats sit at a long table with a group of younger gypsies listening to the music and talking. I grasp the green handles, with their little skewered men, twitching in unison, opposite Eléonore who is playing for red. There's an Australian girl. A duo of German backpacker dudes with matching hypothermic blue eyes. We play a few rounds against the Germans, but then split in the middle of an unfinished game, agreeing by some kind of uncanny indirect communication to return to the music in the big room.

Jake and Bob are grinding down into it now, taking turns stepping forward, sweat dripping on their strings. The whole room is redder and darker, and a much larger crowd has emerged. A number of them are doing the old folk dance revival routine, full of its weird, kicky ritualistic motions. One young woman dances around, jerking her head as if there were snakes in her hair. Some of the youth have come up from the dungeon: here is a chance for the city children to try out the old authentic-style thing, kids whose own parents must have come down from the hills not all that long ago. The dance involves

much twirling and unsynchronous finger-snapping and violent knee and boot slaps that all come off a bit like a bizarre, perilous tic. Eléonore and I flail freestyle, and as we converge with the other dancers, and the spinning wrathful cat deities go streaming in the opposite direction, I see Raoul dervish past, grinning like an injured mutt, trying to do his own best hacking sideways kicks and leaps, though without the same flirty hip swivel and sharp boot smacks that only the lithest and most polyrhythmic are able to pull off.

Closer to the hurling center, where we have spun our way into the vortex of sweating faces and cherry-blur streak of cigarettes, where the orbit is at once centrifugal and centripetal, where even my crippled shoulder has surrendered to the competing weak and strong forces, I feel temporarily lifted from all my fear and grief and uptight shit. Eléonore and I have thrown off the weeds. We punch the air with fiero. We twerk. We do a little Soulja Boy, a little Can-Can, then a loose interpretation of the Swim. I can feel the flutter of her shoulder blades against mine as we shimmy back up. To think, one county over a man waits to be buried. But tonight we revel. We revel in the spinning sweating life-force. Sweating freely, sweating joy, our cells still rapidly dividing. I revel in the heat of the collective organism even if I am usually disgusted by it, by my own heat most of all, my own tendency to start leaking at the pores when I feel exposed in the presence of other conscious beings, other minds. That has always been the true terror. What triggers my greatest angst and shame and lack of composure. But now I want to merge with the pure *noise* of all the other minds, a chaos that cannot be transcribed, ordered, contained, tidily arranged in a circle of fifths. My cheeks are spattered and

flecked with the sweat of these strangers, and I can sense the tidal heat in the whirl of blood, and I can even feel the iron, in the blood, tugging me this way and that, as if the blood rushing to our skin, in lust, in shame, is trying to leap past the threshold of our membranes, to bind in midflight, commingle, recombine, to remix the sacred entangled molecules. In the swirling mass I feel as happy as if the crowd had suddenly turned on me, pinned me to the ground, and hammered a stake into my heart.

I am fixed—nailed—to the here and now for eternity.

And then, as Eléonore flutters up, and I go down for a solo cannonball, I am momentarily enthralled by the lower realm at knee level of stomping boots. Down here, the entire room above and around me pounds and vibrates. I recognize that I have taken a somewhat debased position, on my haunches, when I fail to return to the surface, but it has its own exhilaration, this new focalization, which I am not yet ready to abandon. I find myself mesmerized and lost in a forest of boots and legs, but then I get hit in the eye by a divot of flying dirt. It is alarming. But also strangely *arousing*. Above and around me the dancers bound and plunge, like fawns in the green-hearted woods, and for each reverse kick, or in some cases, a double leap and slap off the knee, followed by the hard open palm smack to the side of the boot, a fair amount of debris is dislodged at this level. When the next chunk nicks me in the mouth, even my own reaction surprises me when I part my lips to receive the morsel, to take in the profane sacrament. The taste of earth intoxicates as it dissolves on my willing tongue, and in the shock of the moment, ecstatic, with grit in my teeth, I snap at the air to catch each new bit of crud that flies from their boots.

But then when I stand to catch my breath, and rinse the

dirt from my tongue with a swig of scotch, the sweat on my face goes cold when I see what stands in the doorway. Nobody else stops dancing. Nobody else notices. It waits only on me. I look for Eléonore. But, I suppose predictably, she has vanished. No—she is with the band. Playing flute. I do not remember knowing that she played flute. The sheer will of the music has become unbearable. Bob reels and keens. Jake's hair is pasted to his beautiful forehead. Eléonore plays beside him. When did she leave? How long have I been here alone? I want to scream at her to stop, to let the beast in the doorway free, convinced it must be the flute that has bidden it here. Should I even report all this? How to convince the journalists among you? Dear reader, my own disbelief was suspended by meat hooks. By the vividness of detail, the clumps of mud and pine needles clinging to its hooves. Its dripping fetlocks. Clearly, it was trying to make its way over to this side of things but was stuck at the door, as if at some impenetrable barrier, and for some reason I cannot scream. I am muzzled by grief and terror, by the sudden clod of dirt that is my tongue, by the impossibility of facing this, any of this, except at the blasphemous remove of pure metaphor, and so it must remain there in the doorway, breathing heavily, with the hoary face of antiquity.

Such a feeling of pity overtakes me at the sight of it trying to force its mossy rack into the room, pushing and ramming it forcibly enough to splinter the jamb. The real problem, of course, the technical difficulty, for the creature, is that it's not just the antlers preventing it from passing freely through the door. It is what is impaled and bleeding on the antlers, and by this, I mean my old man, the preacher, swinging from the spikes. He is tossed up there like a sacrifice on the high dead branches

of some tree in heartless Thebes. Pierced to each hook is a piece of my father, a hand impaled here, a shoulder, one wasted and jaundiced buttock. His black robes are twisted, tangled, on the evil tines; caught like a trout by one hairy, droopy ear; a bloodied foot draped across the heavy muzzle; the tubing of his bile drain tangled up with a few ragged wisps of holy ghost and generational curse. When my father tries to raise his spiked hand to me, I can hear, under the pagan klezmer, the grate of bone against coarse antler. There is nothing I can do except watch helplessly as my father is banged against the frame as the stag tries, again and again, against hope, to get through. It tries to shake the preacher loose, stomping and swinging wild on the wide planks, and my father reaches out his one free pale yellow arm over the heads of the oblivious dancers. But the carcass won't come free. So my father is trapped, too, on the other side. The doorway is a closed bridge. The fjord is too narrow. I want to take him down. I want to unpierce his hands and feet, and to nurse him in my arms, to spoon out my tears over his wounds, to save him from this terrible fate, but I can only stand there, as disloyal a son as ever walked the Earth, mouth smeared with filth, knowing that this is the part where I am supposed to say something, that this is my last chance to speak before all is swallowed by loss, that if I do not manage to say whatever it is I will regret it as long as the sun burns in the sky, but nothing comes to mind, except maybe a silent vow, that, Father, I will bury your secret fears for you. The worst sins must be kept secret. I carry an exact replica of these secrets in me, a spare copy of the dossier, I know how grievous the nature of your crimes are against the spirit, I share them as well, so in this way I can remain loyal. I will let the orchard wither over your secret fears so

something else might spring up, even if it's too late for us in the desecrated grove. As if accepting the terms of this settlement, the stag, lumbering and titanic, at last gives up, and turns, with my father swinging out one last time over the dancers, before it staggers under its wicked burden in retreat. There is no passage for it here. And, yes, it feels tragic when the stag breaks away, a fiction renounced, and vanishes into the basement where God knows what the children will do to it down there.

17

AFTER I FINALLY GET A CAB, AND RETURN HOME, I CALLED
the number that Al Dove, the embalmer at Mann Funeral
Home, had given me for John Rosso. As soon as the prig an-
swered, I knew I was in trouble.

"He's alive but that's about all you can say," Rosso says.
"He suffers from considerable dementia. I don't know that
talking to him would be the least bit satisfactory." He's obvi-
ously irked by my call and disinclined to play liaison, whining
about how he was at the end of a "very trying semester" and
doesn't have time to introduce me to the priest now.

But he will be going to see Father Dorsey on Palm Sunday,
he says, a few days from now. "I am going to replace his piece
of palm, which he likes to keep fresh, under the crucifix in his

room. So I will explore his state of mind. But he is certainly not going to be a source for any additional information."

By his tone, I was clearly being cockblocked. But he is just foolish enough to tell me the name of the nursing home, Maplewood Manor, which is in Germantown, only one neighborhood over from me. He evidently realizes what he's done because he begs me to promise not to go over there on my own, so I promise. But as soon as I get off the phone, I put on a suit and tie, and then, on the drive over to Maplewood Manor, I rehearse how I will make it past the registration desk, in bombastic stride: *Well, good afternoon, I'm an old friend of Father Dorsey's, yes, I'm the one writing the book about the Philadelphia Musical Fund Society? No? Really? You mean the old goat isn't bragging?! How he saved the Bartók String Quartet? Always such a modest man . . . But, this time of year, he does get downright miserable if he doesn't get his Easter palm replenished on the regular. Etc.* And then, after I park, I yank up a bouquet of fern in the yard, which I carry through the sliding glass doors.

"Hi, I'm here to see Father James *Claypoole* Dorsey," I tell the receptionist and am just about to launch into my rehearsed bonhomie when she says, without looking up, that he's in room 417A.

"You can sign in. Take the elevator up."

When I'm let off at the fourth floor, my entire being is assaulted by the doo-wop turned up to an inhumane volume. That and the general stench of gangrene.

I walk purposefully past the nurses' station, and bravely past the grotesquerie of wrecked and reeking humanity that lines the corridor in wheelchairs, until I find 417A. His name is on the wall outside. JAMES DORSEY. The door is open, and

sunlight beams in, but the room is stark empty. I step inside and linger between the two bare beds. I take a few pictures, even though there's nothing to photograph. There isn't one solitary scrap of personality or human identity. Zero ekphrastics. Literally nothing but a plain wardrobe and curling poster on the wall that says, in the generic florid font of a greeting card: RESPONSIBILITY. I can't imagine for whom this reminder must be intended. There is no crucifix. Not so much as a withered palm leaf beneath the Styrofoam cup on the food tray, which makes me realize Rosso had been lying, or at least deliberately steering me off course. Then I think, well, that's it. I got here too late. They must have only just removed the body. It's a shame I was so close to resolving this chapter.

Before I leave, I quickly scan the surfaces for any pill bottles, and then leave the fern on the foot of the bed, but as I head back for the elevator I am stopped by a nurse who asks if she can help me. I say I was looking for Father Dorsey, but he seems to be dead. She points me toward the dayroom at the end of the corridor.

It turns out the dayroom is the source of the hateful doo-wop.

Bright saxophone and sun blare against the tiled walls. *Gow gow wanna dib-a-doo.* The TV blares as well. But the doo-wop has it in a reverse chinlock.

Hell fried ricky ticky hubba lubba.

Right away, I know who he is even though I've never seen a picture. He's the only white guy in the room. A taller than average man, even seated in a wheelchair, at a card table beside a sleeping woman. He's not dressed like a priest. He's wearing a brown, dandruff-sprinkled sweatshirt.

Did I actually think he would be dressed in priest's garb?

"Hello."

"Hello," he says. A sonorous, familiar tone. He looks at me expectantly. A stately old man with silver editor hair. His large hands are spread out in front of him like panniers.

"Reverend Dorsey?"

"I'm hungry," he says, giving me a minotaur's grin. The woman sitting next to him, asleep in her wheelchair, has a piece of bread clenched in the hollow of her fist.

Flummoxed, I say, "I'm Jay." Feeling terrible suddenly for my fraud and for having crashed the dayroom, I say, just as lamely, "I'm a friend of an old friend."

"Who is that old friend?" he says, mellifluous as all get-out.

"Otto Albrecht?"

"Oh, Dr. Albrecht. Yes. University of Pennsylvania."

"Yes, sir."

"Thank you!" He is smiling as if I've just delivered very good news indeed.

Day down sum wanna jiggah-wah.

"I'm so glad to see you," I say. "Happy Easter."

"Thank you, sir!"

"I'm working on the book about the Philadelphia Musical Fund Society." Though it occurs to me now that he might actually be the first member of this organization I've actually met. He is.

"The Musical Fund Society, yes. I was the archivist for a while."

"You were the archivist for quite some time, correct?"

"Oh, just a short time comparatively."

"Do you have time to visit?" I say.

"I don't have a son, I'm not married," he says.

"Let me find a chair and we'll talk."

"Whatever you say, sir," he says.

I drag over an empty chair.

Every time that you're near, every time that we meet.

"Here we are," says Father Dorsey, still melodious.

"It's such a nice day out," I say.

"Is it really?" he says, delighted and astonished, even though one wall of the dayroom is floor-to-ceiling window, and the sun crashing through the sycamores practically sets fire to the side of his face, a horror show of boils, encrusted eyes, patches of gray hair around bluish warts. Folded before him on the table are his decaying hands, the brown fingernails like claws. The woman slumped beside him, wearing a tracheostomy cuff, every now and then clenches the little wadded hoard of bread in her sleeping fist.

"Well, I was told you were responsible for saving one of the world's most famous string quartets of the twentieth century."

"Well, that's possible, yes. So many things were being thrown away. But I'm an old man now, and I'm retired. There's another archivist, I'm sure."

Another woman parked by the window starts to clap to the Belmonts. Very loud and not at all in rhythm.

"Did you care for Bartók? Was that your sort of music?"

"Oh, a little bit of everything, I suppose."

The woman clapping starts to shout.

"What is that noise?" Dorsey turns annoyed, brittle. "Stop that noise! Such a bother."

So I ask about his church.

"St. Albans, Olney, yes. I was rector. But I'm an old man now. I was rector when I was a younger person."

"To be honest," I say, "I didn't know if you were still around or not."

"I'm still alive," he says, cheerfully resigned.

"Were you a musician as well?"

"Oh, a little bit of everything, I suppose. I used to play as the piano accompanist for some soloists. But I don't do that anymore. I'm retired. I don't play anymore. I'm an old man in a nursing home." He laughs.

It is true. He's as old as a quasar.

After a beat, where I don't know what to say at all, I say: "My father was a Methodist minister."

"Was he really? And what is your name again?"

I tell him, wondering if, before I had arrived, Rosso may have gotten through to him to warn him.

"Kirk. That name is not unfamiliar to me. And you're working on a book on . . ."

"About the Third String Quartet of Béla Bartók."

"Bartók String Quartet—*yesss*."

"The autograph manuscript actually. It was missing for many years, and you returned it to Otto Albrecht."

A palsied man over by the window, whom I have been watching wrestle with what appears to be a peanut butter and jelly sandwich, startles me with a laugh.

"Nobody wanted anything to do with it," the priest says a bit defensively. "They thought it was just junk."

"Just junk?"

"Just junk."

"So what exactly happened to the manuscript?" I lean forward on the table, brushing aside some of the damp bread crumbs.

He's suddenly exasperated and takes a bitten-off tone with me. "It's in *good shape now*. It's been cared for and preserved. It hasn't been thrown *away*."

I say I was not accusing him of throwing it away.

"*They* didn't realize how important it is. But I guess it's been saved, and I suppose it's at the University of Pennsylvania Music Library."

I tell him how I was only there recently, and I assure him the manuscript is in very good condition.

"Well, it is *now*, I'm sure. It's in *very* good condition right now. Because it's been *saved*."

Jig-jag-jaw putty putty ticky woo.

"Was that music that you particularly cared for? Bartók...?"

Very irritated now. "I was the *arch*-i-vist for some years," he says, extremely irritated. "Of the Musical *Fund* So-*cie*-a-*tee*."

"And so Otto Albrecht had asked you..."

"He did indeed and I did my best! But I'm retired now and I've forgotten those things! You should speak with the current archivist of the Musical Fund Society!" He takes hold of the wheels of his chair and is starting to look really pissed. I glance around us nervously. Nobody seems to be noticing, so I lean closer to the old man and look him hard in the eyes.

"Oh, yes, I will." My tone is a little pissy as well. "But since *you* were the archivist when it happened, I wanted to meet *you*."

He drops the ballbuster routine and whines. "Well, they were going to throw it away! It was considered to be junk! Can you imagine?!" His horny claws fidget madly. "Well, I can't! I

don't know. But I saw to it that it was placed in the music library of the University of Pennsylvania, where I hope it is today."

"It is, I assure you."

"God bless you for telling me that. I'm glad to know that."

"Many musicians would be extremely grateful to you, sir." I revert to my more polite, if now less fake, self.

"Well, I'm glad they are. I'm an old man in a nursing home. I'm not an important person in the music world these days." He pauses and looks at the woman with the bread and whispers something I can't make out.

"My father's Bryce M. Dorsey at the University of Maryland," he says when he looks back at me, apropos nothing.

"Did he teach?"

"At the school of dentistry."

We sit in silence as the woman sleeps. The moist bread in her hand has rolled onto the table. It sits there, the inverted mold of the void of her uncurled fist.

I ask him how he ended up becoming a priest.

"Well, I certainly didn't want to become a dentist. I didn't want to keep poking into people's mouths. No, thank you, sir."

So you poked at their souls, I think. *Because you were afraid to look at your own naked dread. You thought being a man of God would protect you. You played the part to avoid your own bottomless pit of fear. To avoid what was truly sacred because what was truly sacred tormented you. Because it could only be perceived naked and you could not bear to look upon naked reality nor could you bear your own nakedness before it. So you dressed it all up with foolish ritual, needless fiction. Did you truly believe it was a cosmic felony to see your god or goddess nude? Burn your sermons, fine, but burn your robes and mysteries, too, and share communion with the fire.*

I say I felt the same way about following in my own father's footsteps.

"I'm a priest of the Episcopal Church. St. Albans, Olney, was my parish. Whatever happened to it? I thought Negroes took it over because they moved into that neighborhood and it became a colored parish."

I told him I was under the impression it was evangelical Haitians.

"Well, that's interesting to note," he says. "I have nothing to do with that building anymore. I don't live there anymore. I'm an old man, I'm retired. I'm living in Annapolis, Maryland, in the home my parents built for themselves for their own use, and I've moved into that place."

"Your parents built this house?" I look around the room. The palsied man in the corner has lost his fight with the P&J sandwich, which is now mostly scattered in shreds over his torso. He waves to me with a shrug, as if to say, you can't win 'em all.

"My father had it built for himself and my mother. My father was Dr. Bryce M. Dorsey, as you probably know. Professor of Dentistry at the University of Maryland."

I ask Father Dorsey if he took piano lessons when he was a boy.

"I did. I took piano lessons. I'm glad to be an old man now. I didn't like being a young person. I was unhappy. I was miserable. I'm glad to be an old man in a nursing home now, and I'm fed and housed and cared for at this point."

I tell him that he should be proud to be remembered as the man who saved the autograph manuscript of Bartók's Third String Quartet.

"Béla Bartók's, yes. That is correct. It was being thrown away as not important. But I realized that it *was* important, it *is* important, and it will *always be* important! Some people were not interested in preserving things for the future. Some people just were not interested in—anything. Just enjoying themselves." He makes a la-di-da gesture to dismiss the hedonists. "I remember if I hadn't suggested that it was *good*, it was just going to be thrown away with the trash. Can you imagine?!" He nearly shrieks. "Well, I can't. I couldn't at that time, and I don't now."

I take a gamble: "And so you snuck it out and gave it to Otto?"

He looks at me conspiratorially and his eyes light up. "Well, I did. I just took the box and gave it to him and said 'Take this, care for it, use it, and see that it is always preserved.'" He whispers, holding out the invisible box to me.

The significance of what he is saying takes a moment to sink in. "You saved it because they were actually going to throw it away?"

The horror of what he is telling me is unspeakable. If it is true. But I don't know that I will have the strength to investigate the full implication of what he's suggesting.

"Well, I'm glad I did it! It's good to know that I did something important." He is still holding out the box. "But I'm an old man in a nursing home now. I'm not an important figure in the music world."

I tell him that maybe he is, more than he or anybody else really knows.

"Well, I wonder, do they know that my name is Father James Claypoole Dorsey? My father was at the University of

Maryland. Dr. Bryce M. Dorsey, and—" He slaps the table. "August 21, 1932, I was born!" He is now giddy. "And what is my age now? I'm a shaky old man! Yes, yes, yes." Almost giggling. "I'm glad to be looked at with such kindness here. I get three square meals a day and people are good to me and refer to me as Father Dorsey, as they should."

"Is this your friend?" I say, looking at the woman.

"Who?"

"This woman sitting here next to you."

"Who's this woman next to me?"

We regard her for a moment.

"Who is this lady here?" he asks again. "Looks like she's asleep. Doesn't matter."

The cheering from *The Price Is Right* is deafening.

The woman in the chair mumbles.

"Whatever you say, whatever you say, dear child," Father Dorsey says.

That's when the man by the window makes some louder, garbled noise. He is trying to communicate something to me, clearly of the essence. Each time I glance at him, he tries again, to communicate whatever it is, but I can't make it out, and the harder I try to decipher his meaning, as he mumbles and points at the priest, waving the flensed crust of his mangled sandwich, the more confused I get.

But finally I understand. He wants me to know he is Dorsey's roommate. That's all. I tell him that I hope they take good care of each other. He gives me a jittery thumbs-up, then rolls back to the window, in the sun, where the pieces of broken bread gleam on his chest.

"Pardon?" Father Dorsey says.

"I was just saying hello to this gentleman over here."

"And what is this gentleman called?"

"I don't know," I say. "He's just waving at me."

"Is something good to eat coming?" Father Dorsey says. "I'm hungry."

"He's having a peanut butter and jelly sandwich," I say, pointlessly.

"C'mon, Sheila. Come on down!"

"Well, now what?" Father Dorsey says.

18

WE WERE IN THE CAR TRYING TO FIND THE DEAD GYPSY'S house, the fiddler Josif Ghement. Everything felt like it was moving faster. The moments and the spaces between were moving closer. The metronome at 160 bpm. A very precise and unletting tempo. As we bumped down the road, and around the ever-expanding potholes, I was trying to read a text from Darren. Details about a charter flight from Oslo to an outpost called Longyearbyen, home to the northernmost ATM machine on Earth, Darren said. "Gobsmacking fjordage up the ass!" *Was I in?*

Eléonore was annoyed with me because the night before the Germans we had been playing foosball with had begun taunting her at some point, about what she didn't say, but she had evidently tried to get me to help, to call my attention to

her harassment, calling my name repeatedly, she said. And even though I was standing right next to her, I had only looked at her dully and said, "I'm not here." I had no memory of this. But the way she quoted me back to myself, in a mocking, dumb zombie voice, *I'm not here,* let me know that I was little more than a disappointment to her now.

We had no idea where the funeral was, outside of knowing the town. Gherla was an hour east of Cluj. But once we get to Gherla we just drive in circles, passing the same castle wall three or four times until Jake suddenly shouts, "Hearse!"

And then we turn down a street where I see the spangle of accordions.

A brief, extremely slow chase ensues as we drive behind the hearse until it joins the mob scene at the end of the street. We park a little ways back. Bob had to take a crap and decided the only course of action, without any better options, was to knock on the first door, where he was warmly welcomed. Jake and I meandered into an empty lot to piss, carefully stepping around what seemed like a lot of used glass syringes that looked like fat cartoonish hypodermic needles. Then we walked down the street and stood off a little with the other bystanders.

There must have been more than a hundred people crowded on the street, far too unruly for a church or funeral home. There's a local news crew there, some local politician types, and a mayor, or the like, with a retinue of minor dignitaries. All waiting for the body to come out of the house and into the hearse, the hood of which was heaped with plastic flower corteges. This was an obviously much beloved figure.

There were thirty or forty village musicians in the street,

some wedged into the small garden plot beside the house. A mob scene from every village around, a small army of accordions, shiny and tarnished and dented horns and fiddles galore, and men wearing fifty-year-old zoot suits, wide lapels, short satin ties, and all the best hats, the best send-off a person could imagine. There were younger women on the decrepit side porch smoking and crying, and old women dressed in black milling about with little children dressed up like the old women, and thuggish looking younger men holding black medieval looking flags. They were ornately tattooed and wore tight striped pants and leather jackets and drank from two-liter bottles of orange pop called Malibu. One wondered what kind of music the younger men liked, but I imagined it something evocative of empty cargo containers and rusty gantry chains. None of the younger men were playing instruments. They stood around dressed like hoods holding the black flags with black tassels and gold crosses. Some of the banners suspended plastic bags of bread, an offering to the dead I assumed.

The house of the deceased looked the same as the other houses on the block, a cinder-block unit adorned with a sinuous wooden front gate and pimped-out tin gutters. The peasants put all of their bling into their gutters, which was something I admired. An oversize picture of the deceased playing his violin hung in front of the house, the blow-up half as big as the wall. Josif in a field beside a forest, in a soft green meadow looking straight at the camera, holding out his instrument, playing to the wind-rilled trees and the radiant world around him. The man has nobility, he wears a gold vest and has powerful thick hands and wild eyebrows, like the king of the forest, radiant

himself because he does not care if he is making the music or if the music is making him. In a church or funeral home the picture would have been on an easel.

After standing on the street for a while, we were surprised when the two sons of the deceased man inexplicably came out and ushered us into the house, into a dark back room, the only window covered with a blanket. The brothers join us. Jake and Eléonore and Bob and myself. All crammed together in a room mostly taken up by the pine box in the center. It was propped against a sawhorse, the lid leaning next to a dangling fuse box. The body was at a tilt. On one bare shelf I noticed a ceramic elephant figurine, Hindu, which I read as a reminder that the gypsy, the Romani people, come from India, from Punjab, Rajasthan, Haryana, but have now found their nationality in exile. The only other thing I saw was a twist of dusty cassette tape wrappers, though I do not see any tapes, but the Mobius loop connects me back for an instant to my own childhood boxes of tapes, U2, Billy Joel, Abba, the *Star Wars* soundtrack, and the carefully archived tapes of me endlessly talking to myself, sometimes talking to my future self with future self errands and vows that I no longer remember and have very likely failed to keep. I cannot connect the photograph of the radiant man to the shriveled corpse with cotton stuffed in his nostrils; how sunken the old man looks, as if he were both the stillest thing imaginable and yet visibly sinking before our eyes into his suit. All of it fails to connect for me, just as it also seems to fail to connect for one of the brothers, clearly the eldest, who is bent over the box, his begrimed, meaty hands gripping and clutching the white satin lining while sobbing, as if begging the dead man for something that the dead man refuses to do.

When we are back outside I can again feel how everything keeps accelerating. I want to describe the face of Josif Ghement playing in the meadow, so I ask Eléonore if she will videotape the musicians for a minute with my iPod. I scribble in my notebook as she takes a slow pan of the whole scene I am trying to describe—to decipher later—and then she says, "Oh, I am having déjà vu." When I look at her she appears stricken, like she wants to shake it, and she tries to laugh it off by saying, "I know I have never been to a gypsy funeral before." This just as the coffin is being carried out and the musicians start up a dirge, a collective power chord of lamentation, and Bob leans over to Jake to say how this is the first time he has ever heard this kind of dirge in its proper setting, in its rightful context. The most extreme part is that I, too, have a familiar feeling, I am also in the grip of déjà vu. Impossibly terrifying. It's as if we both got caught in the same inexplicable current, both stepped into the same time-stutter, but I don't have a chance to say that I feel it too before she pans back to my face. Speechless, I look straight into the chrome rectangle in her hands. The mirror of my little machine held between her fingers. But I only see the reflection of the white sun and glinting tin downspouts. The worst part was that the déjà vu had not yet even begun to subside.

19

BEFORE WE LEFT OSLO WE WERE ALREADY SCHEMING. We had come up with the idea while browsing the gift shop in the Edvard Munch Museum, a few hours before our chartered flight to Longyearbyen, the northernmost human settlement on Earth. From there, already eight hundred miles north of the Arctic Circle, we would board the *National Geographic Explorer*, the top-dollar eco-cruise on which Darren had finagled us a free ride under the half-legitimate guise of shooting a travel documentary. One he was making for whatever cable network he was currently counting on for his bread and butter. He wanted to call it *Holiday in the Arctic* and hoped to turn it into a series (*Holiday in Lithuania*, *Holiday in Rwanda*, etc.). But, now, since our sudden brainstorm in the gift shop, he was ready to upgrade our entire motive for being on the ship. We

had long wanted to collaborate on something. Since he already had all the equipment, and had brought along his own videographer, Mark, a thorough if sometimes fussy character by the way Darren spoke, here was our big chance to do something truly epic. Even infamous. And so, on a last-minute hunt for props, before heading to the airport, Darren had found the briefcase in a thrift shop down the street from the Nobel Peace Center, along with the pair of handcuffs that now lay between us on the bed in my cabin as the dock slipped away.

The briefcase was on the floor beside my unpacked bags. Its hasp glinted in the cold light streaming through the porthole above Darren's head. We sat cross-legged, facing each other like two degenerate monks, and hatched our master plan. A horror movie set in the Arctic. We had a good basic concept: one morning, our protagonists, a small documentary film crew, wake to find the ship mysteriously empty. All the other passengers and crew have inexplicably vanished. Leaving our heroes—who have come aboard the top-dollar eco-cruise with some serious emotional baggage—alone and floating off into the abyss. We would do the whole thing guerrilla style. Producing it would be simple. The unwitting passengers wouldn't even know we had made them our victims. Darren would still have to knock off the job he was being paid to do, but even if we only had nine days on the ship, we also had twenty-four-hour sunlight. If push came to shove, he said, he would shun sleep entirely. A chance like this would not come again, not in this lifetime.

I thought the premise alone was sufficiently unsettling that we didn't really require any big explanations. The psychological terror would carry the film as we witnessed the gradual

disintegration of our characters' minds, with maybe the ship left stuck in the barren ice at the end, but no real answers. I advocated for an atmosphere of unrelenting monotony and gathering silence. The audience would be left in a state of profound ambiguity, even a state of regression that mirrored our own fictional plight. But Darren said he wanted to make a movie, not a video installation, and sure as hell not some Terrence Malick snoozefest. A real horror flick needed a monster. If not an actual monster, though he seemed to prefer the idea of an actual monster, there had to be not just terror, but an agent of that terror, an author of that terror, a terrorist. A monster with its own sinister and knowable intent, providing a motive behind the terror we were experiencing. Otherwise it was just an act of pretentious sadism. He didn't buy my argument that the antagonist could remain unannounced. That reason had its limits, and in such an irrational scenario, the only rational response would be complete surrender of will.

No, he said. The monster was a nonnegotiable element for any horror movie. The audience demanded it. "The audience has to know at the end."

"People only think they want an explanation," I said, "but what they won't admit to themselves is when they find out the answer they only feel disappointment."

"Maybe," Darren said. "But at some point we provide a reason. A cause."

"No," I said after a moment. "No causation."

He shrugged. "We can figure it out later."

Regardless, the first critical question, aside from our next plot point, which we had not the foggiest, was how we were going to go about filming the ship, with 150-plus passengers,

as if it were actually empty. Our best bet was to take advantage of the midnight sun and stay up after everyone had gone to bed, but the only problem with that was we would have to do a lot of tiptoeing, and yet, in that actual situation, we speculated, there would probably be more freaking out and shouting and running around the empty ship in a panicked search for others.

As for the acting, we would be doing that ourselves. We would have to rely on our own meager talents, though Darren thought this was ultimately a plus since it would add to the grit and sense of verité. To get our heads into the right mind-set, into role, we would just channel our neuroses, which, between the two of us, were bountiful.

Darren and I had met in college. I'd acted in a few of his student shorts. From the first day we had been like brothers, the kind who are always trying to annihilate each other's ego, and so we knew each other's flaws and psychological fault lines to a tee. Of course, Darren would be the director, but I wasn't feeling his vision for the opening shot, which didn't feel organic to our premise. The opening shot in his mind being my frozen corpse, handcuffed to the briefcase, floating facedown and naked in an ice-rimmed cove.

"You'll be fine," he assured me. "I can shoot it in under thirty seconds. And we'll have whiskey and towels on standby and then medevac you back to the sauna ASAP." He put up a hand apologetically. "Right. No whiskey. I'll be standing by with a nice hot cocoa."

I appreciated that he remembered I had come aboard thirty days sober, and he was willing to support my choice to use the cruise as a way to clear my head after my recent misadventures in eastern Europe.

He was dangling the cuffs in such a way that the loops overlapped with the bright loop of the porthole, creating a sort of triple halo, or Venn diagram. Where they intersected, in the aperture that framed the logo of a heart impaled by a Gibson electric Flying V on Darren's tight-fitting tee (Tom Petty), in the steely hollow of this Celtic knot I now perceived my true motive for coming aboard the ship, and I knew I had made the right decision.

Especially since my brother was visiting my father this week, and they needed time alone to say their goodbyes. To be honest, it was probably best that I wasn't there anyway. Not only because I didn't think I could stomach being in the same room with the two of them together—but because I was afraid I would make it worse. It was better I wasn't there.

The other problem, Darren worried, covertly checking his pulse, would be getting Mark, his camera operator, or DP, as he evidently liked to be addressed, director of photography, on board, so to speak. (Mark was also a certified sommelier, Darren said, which I guess sounded better in LA than just being a waiter.) He wasn't sure if Mark would cooperate on our outlaw project. Mark liked things to stay fairly organized and predictable, Darren said, though he was paying him per diem, so in theory Mark was there to shoot whatever Darren told him to shoot. He was a hired gun. Still, from the way he spoke, Mark could be kind of particular, and he wasn't sure how he'd take to the change of plans. Mark and I were actually sharing a cabin, since Darren had taken the other for himself. I hadn't shared a bedroom with another guy since I was a kid and had to share a room with my brother who would stick pencils up his ass and try to trick me into sniffing them. I hadn't met Mark yet, he

was off exploring the ship, but I was acquainting myself with his things, which were already unpacked and tidily arranged on his side of the room.

"As for the plot," Darren said, dropping to the floor and positioning himself into a plank, and then speaking in measured tones as he executed a set of well-controlled push-ups. "There's no reason it can't be subtle. It doesn't need to be corny. So even if it's, like, a military experiment gone afoul, or a paranormal event, even if we don't spell it out in the film, *we should know*. And we've got to work out the story first. That way we can reveal enough for the viewer to figure it all out if they really want. Capisce?"

"None of that matters. It's all about the mind. That's it."

"Well, I can see one of us going crazy and hallucinating the whole thing. But not two of us."

"Well, it could be. A *folie à deux*," I say.

He gives me a quizzical look between push-ups. I had only recently heard the term myself and wasn't even sure I was pronouncing it correctly. I said it was supposed to be like a *déjà vu* except not really. It was actually nothing like a déjà vu. *Folie à deux* was where two people shared a common delusion.

I watched him test the unfamiliar phrase in his mouth.

"Like a déjà vu?" he said, standing back up.

"No," I say. "It's nothing like a déjà vu."

"Jesus!" He leaped up on Mark's bed with his shoes on and stuck his face in the porthole. "Just look at this! That's easily two million in location fees alone. Look at those icebergs! They're goddamned obscene is what they are! We'd be insane not to take advantage of this situation. No indie horror project could ever afford getting up here, let alone leasing a whole

ice-classed ship." He was taking tiny sips of the beer he had left on my night table. "I'm telling you, man, if a studio were doing this whole hog, getting a union crew up here, it would budget ten million just for starters."

Taking a seat on Mark's bed, still out of breath from his outburst, he slumped forward. "Can you imagine it?"

"What?"

"Right now. Just imagine." He held his hands up, vaguely boxed. "Actually being fucking alone on the ship. Look out the window. We're already moving." I looked out the window at the gargantuan wall of the fjord passing silently. "Are you sure we're *not* alone? Are you sure somebody's piloting this ship?"

He let the quiet sink in a minute before suddenly jumping up and opening the door to look out into the hallway, as if to assure himself he had not just wished it true. "Oh, hello, ladies, how are you?" he said to someone, before coming back in and pacing in circles.

"I don't know if Mark will even go for it. What do you think?"

"I don't know Mark. I haven't even met him."

"Right."

Then he started worrying all over again how to tell Mark. He could always just offer him an executive producer credit or points off the back end, he guessed. For a minute he got tormented. Maybe the whole thing wasn't a good idea. It could trash his relationship with the company fronting him expenses for the travel show. What if we got caught? Was there a brig on this ship?

Besides, nine days was hardly enough time to do the basic travel show, let alone to make a feature-length horror film that

didn't even have a full treatment yet. On the other hand we had twenty-four-hour sunlight. Nine nights of midnight sun. We were here. In a sense, now, we had to do it. He'd already purchased props.

"Fuck it!" he said. "We don't need anybody's permission. If we get busted, that'll only make for good PR in the long run. Getting arrested for being a guerrilla filmmaker? Bring it on! You only live once! I don't care if we have to work around the clock. I'll sleep back in LA."

He was sick of making cable shows about retired pro wrestlers and quirky profiles on self-storage-unit owners in Nebraska who were competitive karaoke kings on the side. Even the exotic travel docs felt pointless: there was nothing more bourgeois than travel. The fact of the matter was, he wasn't getting any younger, and nobody was going to remember him for the shows he churned out just to pay the bills. Those were a dime a dozen, he said. But a psychological horror flick set aboard a fucking cruise ship in the Arctic? Who else would ever get the chance to make a movie like this?

Nobody, he said, before I could answer. *That's* who.

Besides, Mark would love it. He could be particular, but he was pretty hip. Making guerrilla films was all the rage now. The edgiest directors were shooting illegal movies at Disneyland and SeaWorld and breaking down the barriers between the studio and real life. This was the golden era of pirate cinema. But who had even *thought* of misappropriating a sea vessel in international waters? Making a horror film on an eco-cruise at the North Pole? The metaphor alone was too potent.

I had to admit the whole thing made me nervous. It was a little sociopathic to be planning the heist of a once-in-a-

lifetime-experience for 150 paying customers. Then again, maybe anything worth doing in this world was supposed to make you feel guilty. But I was edgy enough that the moment Darren walked out, to go find Mark, I unlocked my passport safe and then stood there looking at the yellow pill bottle.

I had stashed it for emergencies only. It had only been an hour and a half since we'd stepped aboard and I'd implemented my latest plan to kick. To turn these nine days and nights into my own personal Ahabian rehab at sea, a chance to get clean once and for all, to readjust so I could learn to withstand the stimuli of life again. To face direct reality, however noisy.

This was the right place to do it. The stillness here was exalted. I wanted to purify myself for it.

At first, I had doubted the wisdom of going cold turkey in an environment of such raw elemental power. But when I saw the full luxury of the ship, the inviting library, the sauna, the premium wine cellar I wouldn't be touching, I decided it wasn't as if I were going off on a rusty Siberian freighter, nor even one of those moronic inferno Disney Cruises that would have been a million times worse. This was a midsize ship, with the serene vibe of a spa at a five-star ski resort. There was a sauna and a masseuse on the wellness deck—there was a *wellness deck*. They had afternoon tea. They had a Zodiac outfitted to deliver schnapps-spiked cocoa to day kayakers. The ship was replete with well-appointed, quality nooks and lounging areas. The menu featured terrine of reindeer with foie gras de canard, ptarmigan breast fillet with warm fennel salad and juniper foam, pan-fried Arctic char with toasted hazelnuts, and cloudberry mousse for dessert. We had turn-down service, biodegradable shampoos, and the sauna was always set to a perfect

80°C. If I had to put up with a tiny bit of discomfort while I thawed out my amygdala, this would be a safe place to tough it out. I would stash the pills for worst-case scenarios only. I felt good about my plan. Maybe I would even be able to return home to face my father, and stand by him in his death, my father who had only strung together a handful of sober days in his own life. I already felt elevated. I felt the grace of simplicity that I knew awaited me, the stirrings of a fresh start, new life, rebirth. I saw myself as a tiny sprig of wakefulness emerging, unfolding, springing out of the dark earth. I felt deserving of such platitudes.

And maybe making a horror flick would be good catharsis: to vent what I could not melt off in the sauna. I would channel my primal dread, sublimate my fear into the movie. What I couldn't burn off through a little acting therapy, I could primal scream out over the ship's wake. The irony, of course, was not lost on me that we were trying to make a film about erasing a whole ship of people while I was trying to un-erase myself.

20

NOT THAT NIGHT EXISTED HERE AS AN ACTUAL PHENOM-
enon, but on only our second night, we were woken by the
gentle disembodied voice of our cruise director, Lisa, murmur-
ing down on us from the speakers mounted just above each
bed, letting us know the date and time, 3:30 A.M., just a week
from the summer solstice, 78° north of the equator, and invit-
ing us to join her on the bow to see a mother polar bear just
now coming across the ice if we were so inclined. This was the
big prize, the most coveted of sightings, the most charismatic
of all the endangered megafauna, maybe even more than the
mountain gorilla, its main competitor on the experiential sta-
tus market, and here we were being treated to it almost pre-
emptively. It seemed like a good sign. A wholesome omen that
nature was smiling upon us, and maybe that I was in harmony

after all with whatever it was I needed to be in harmony with, that I had made the right choice to come, to reset my out-of-balance chakras, and purify myself in the land of the ice bears, and so I rolled over to go back to sleep, thinking, *how nice to call the universe home*, as I began to dream of white bears surrounding the ship like furry angels, but Mark was already fumbling with his pants and his camera equipment, and in another minute Darren came banging into our room with a skinny cappuccino in his hand, perfectly frothed. He snapped on the lights and threw some clothes at me, barking how it was time to pay the piper.

We found the other passengers already outside. Gathered in a collective hush. Pressed along the front of the bow and crowding every perch, spectators tiered along the upper railings of the bridge and veranda decks. We took up a position port-side, at the top of the stairs, a level above the bow, just outside the chart room. Squinting to look upward at the bridge, I could see a few hazy faces behind the glass, peering out, not just the captain and crew, but passengers, too, thanks to the ship's oddly trusting open bridge policy, one Darren and I would be sure to exploit. We were surrounded by an endless field of choppy white ice. Giant broken slabs piled against the prow like granite snapped off at the Earth's crust, shorn just above the mantle. Slabs tilted like massive white piano lids, cracked and split, as if we'd crashed into a piano factory. The tourists gazed out in awe at the horizon, in their Canada Goose parkas, and Tory Burch quilted boots, and new telephoto-lens-mounted Canon EOS 60-Ds held up to their faces, timidly, like prosthetics not yet fully grafted. The spectators in their reverence had dutifully turned off the automatic shutter sound effects, putting their

cameras on silencer mode, gray-haired yoginis with good investment portfolios readied for the money shot.

When my eyes finally deciphered the bear, it emerged as if breaking apart from the general whiteness, a piece breaking off from the horizon, one bear-shaped shard limned against the surrounding absolute. A faint suggestion of movement. A stirring of palest yellow on the bulging nape, the tint of seal fat in the bear's fur, then the coal black eyes, black snout, as it turned to regard our vessel, its round small ears tuning in our quickened heartbeats beneath our collective held breath.

All stood silent now but for the hum of the radar on its turret, turning slowly below the sun locked into its ecliptical slot, its fixed and unmoving right ascension and declination, and the intermittent *whisk-whisk* of synthetic fabric, sleeve rubbing sleeve. I gripped the taffrail with my oversize black mittens. The bear gradually became more distinct as it padded over one floe and then clambered onto the next block, pawing its way across the puzzle, feeling its way with massive paws, sniffing, its elongated skull down, and as I watch it getting closer I feel a tremor in the trunk of my body and realize that I have not thawed out enough yet, I am not prepared for this level of unmediated majesty and raw spectacle, it is too much too soon, and my automatic reflex is to break the glass, to break off half a milligram, to run interception, except my pocket is empty and I remember I had stashed my fix in the passport safe. So, against my will, I am forced to withstand the onslaught, and I realize what a very terrible idea going cold turkey at the top of the world was.

I start to inch away, to sneak back to my cabin, when Darren leans over and whispers, "If that bear could climb up here he'd

eat as many of us as he could. That's literally the only animal on the face of the planet that will go out of its way to eat human flesh. It's a legitimate fact. Read the literature. Watch some of the online videos. Just google 'polar bear attacks.' You'll have nightmares for weeks. See the way he's sniffing? He's smelling us like we're chicken-fried steak." He blinks, as if chasing away some of the disturbing things he's seen online.

I saw Mark a deck above us, wedged amid fifty other cameras, all the lenses positioned over the railing like the compound eye of a dragonfly with each photoreceptor horizontally untangled. So far, what I had learned about Mark was that he never spoke and spent all his free time—if he wasn't on the clock for Darren—either reading *The New Yorker* articles on his phone, thumb scrolling at an unwaveringly steady rate, glass of wine in hand, or sitting on his bed on his side of our cabin with his laptop and headphones on editing an exercise video.

Darren nodded up at the bridge. "When these guys go in for landings, you'll see, they bring a small militia. They've got snipers with twenty-aught-sixes, spotters on the ship with long-range scopes. Keep in contact by radio. I think they're trained as ninjas. No amount of insurance is going to save a company like Lindblad after one outing gets a front-row seat to a proper feasting."

"Maybe that's how everybody gets disappeared," I say, trying to distract myself by studying the passengers. How innocently they gawk. Mobbed onto the bow. "A massive attack. A whole pack of superintelligent bears sneaks on board in the middle of the night." How seemingly unperturbed all the others are, how much I would like to see them perturbed. "Not that night is an actual phenomenon here."

He crimps his brow, studying the passengers, clearly contemplating whether or not it was a workable premise. He shakes his head. "No Man vs. Nature bullshit. It's gotta be something with actual malevolent will or intention. How about a radical ecoterrorist with some kind of device who tries to reset the planet's temperature but somehow vaporizes anyone north of the Arctic Circle? Except somehow us. He gets it from a lab at MIT, steals the device, some secret DoE project. Or, even better, a breakaway faction of ISIS! One of them has been reading Bill McKibben in his downtime and convinces the others to declare a holy war on carbon emissions. They have a change of heart. They go green. A hit squad of ecojihadists. The reason they spare us is so we can film it. A mass beheading on the bow. Orange jumpsuits, the works. They need a professional-grade recruiting video to win over their fellow Islamo-fascists to the cause, saving the planet. On the other hand, I guess I don't really want a fatwa on my head."

This is when the fun-loving cruise director, Lisa, who wants to be sure we know that she is obviously fun-loving and loath to ever have us think the opposite, and yet really needs to let it be known that we should stuff a sock in it, says, in her cheeriest whisper, "*You guys!*"

We step a few feet away to continue conspiring how to hijack the ship. The first priority, the first trick, before we can worry about who or what is behind it, is filming the ship to look actually deserted. Darren says he took a look at the schedule on the way down and there's a landing tomorrow at a cove named Kongsfjorden. It's got active glaciers, nice fjordage. Lots of nice little trembly wildflowers, great for simple transitions. *Campanula uniflora. Cassiope tetragona. Saxifraga oppositifolia.*

He points each out to me in his cruise handbook. He needs to go on at least one landing, for sure. Reindeer and seal are obviously mandatory, but now since he's already got a polar bear in the can he's not too stressed.

If we stay behind, it will be our chance to get the ship empty, he says, even if we have to duck a maid or two. He thinks it's definitely our best hope, maybe our only chance to do it right. The only way to establish the spatial reality of the ship's emptiness in the viewer's mind. Nothing but silence and ice. As for me, I'm happy to skip a shore walk if it means avoiding polar bears. I am sure they would be able to smell my unmedicated fear.

To really sell the idea, Darren whispers frantically in my ear, to reveal the ship in all its unimpugnable emptiness, we'll need to show us searching it in one long epic tracking shot. Going deck to deck, really freaking out, down the hollow corridors, one level to the next, no edits, nothing faked, nothing fudged, nothing turned up but more confirmed emptiness, all in one unbroken sequence of Kubrickian elegance. Sustained, continuous, suspenseful, and ending in climactic dread on the empty bridge with Darren's character letting out a primal bellow.

"You guys!"

He still hasn't brought it up with Mark. He's waiting for the right moment. He's a little worried whether he'll go along with it. And for a second he starts to fret all over again about whether or not we should really skip the landing. At the very least he could get some eider or barnacle geese, he says. He looks at the polar bear, which appears to be growing bored. He shakes it off. He nods up at Mark. He'll be cool, he says. We've just got to remain committed. Focused. He says he'll talk to him right after this.

After the bear ambles off, and the volume of chatter comes back up, there's a general murmur of reverent approval in the jubilant afterglow, the feeling that, indeed, their money has been well spent, their expectations satisfactorily met. People are eager to give each other their reviews, and this is when Darren swoops in, donning the persona of amiable host, with Mark in tow, ready to suck up the songs of delight and deluded transcendence. I say this not because I am, admittedly, a small bit jealous of Darren's social ease, his ability to mingle and engage, how he can put it on at will, but because as the passengers point and laugh, trying to find just the right combination of gestures to convey whatever it is they feel they are required to convey, with withheld gasps, hands to their hearts, cheeks swelled out with incredulity, exclaiming "absolutely magical" and "experience of a lifetime." All basically to express how much they have been transformed. As if they have somehow absorbed a part of the bear's power, as if its power had somehow magically been transferred into their own flesh, as if such a thing were transmissible. At least a few must know the truth. That it is the polar bear who has taken something from them. The bear does not require fiction to remain intact. Its skull is uncontaminated by myth or questions of self-image, its will is pure, whereas our minds are almost entirely contaminant. The tourists have taken nothing. But the bear has robbed them of one more bit of the fiction that holds up the delicate construction of the passengers. It has robbed them of the *idea* of a polar bear.

Reason has led me to certain conclusions that I cannot abide.

21

THE NEXT MORNING, BEFORE MARK OR DARREN WERE up, I took my laptop out on deck to try and put in a Skype call to my dad who was back in the hospital and recovering from a procedure to unblock a bile duct. Now I wished I was there, and not six time zones away. It was midnight his time, and I had hoped to only have to leave a message, but to my surprise he answered. He looked doped and a million years old, but happy to see me. I wanted him to see where I was, so I held my laptop over the railing, and for an unsettling moment it felt as if I were holding my father's head out over the sea. His skin was Boris Karloff yellow, and he might as well have had bolts sticking out of his neck, the jaundice was that bad. I could see some hospital room machines bleeping. Apparently my brother was no longer there. He had left early so far as I could surmise. My father's

yolky, barely animate eyes gazed around at the frozen splendor
in the gray drizzle, as if he were right there taking it in with
me. He said it looked like I had really found someplace sacred. I
told him we had seen a few reindeer earlier. Eight or nine. All, to
be honest, kind of shabby. Not magnificent. So-so at best. I didn't
tell my father that—I wanted him to imagine them as magnifi-
cent and healthy—and I especially didn't mention how they
seemed to be trying to ditch the oldest one in their group, which
had come hobbling behind, straggling along the rocky tundra,
with long tufts of white fur like Spanish moss on its chest, and
that's when he asked if I remembered the time he'd gone to deer
camp with a few of the guys. One of his own true, sacred experi-
ences. I knew the story well. Since my father didn't hunt, he had
not taken a gun, only a camera, an old Nikon he'd bought in di-
vinity school. Nobody had given him a hard time about lugging
a camera instead of a gun, though if he had not been a man of
God they probably would have busted his balls, but, anyway, like
me, being prone to morbid hangovers and jittery predawn walks
to ward off the shrieks, he had woken early and gone out alone.
It was then he had his encounter with the magnificent stag.
Almost as if it had been waiting on him. Or so was my father's
impression. It had a rack like a tree. Sixteen points. Thirty-two
points. A rack that could have cradled a small exoplanet. To his
amazement it had not bolted. According to my father, he and the
buck had then had some kind of numinous exchange, a magical
transference, and he was left feeling empowered, overwhelmed
with the conviction that all in the world was forgiven. His hunt-
ing buddies, who never saw a single deer the entire time, accused
him of making the whole thing up. That is, until he had the film
developed. (Here, he licked his cracked, white lips with a deeply

furred tongue.) My father had the photograph blown up and put on an easel next to the pulpit as a visual aid for his first Epiphany week sermon. It is one of the few sermons of his that I can recall. Wherein he likened this buck to visions of angels, even quoting a line from Rilke, and how one must ready and equip one's mind to withstand the radiance of such moments, what he called the unbearable presence of the Almighty.

For a minute, then, we just lapsed into silence, me holding his teary head over the railing. I listened to the tiny bell of one of the machines in his room, or maybe another machine down the hall, in another room. Then he started crying and told me he was afraid of dying. He said he was going to miss me and my brother, who I gathered had left on a more or less perfunctory note. But how else does one bid farewell forever? I said I was going to miss him, too. I wanted to press my cheek to his against the screen but didn't. Then he told me he'd talked to his own brother a few days ago, my uncle. "He told me he hasn't decided whether he's coming to my funeral or not," he sneered. He made me promise, in the event my uncle did show, not to let him speak. "Under any circumstances." When I asked why, he said I must have forgotten what a fiasco it had been when his brother had spoken at their mother's funeral, and how he'd read an Apache blessing, which my dad thought was beyond as-inine, but I didn't remember that part, only the part about how my father had a crazy laughing jag in the car on the way to the cemetery, and how when my understandably perplexed brother had made the mistake of asking what was so funny, how my father turned on him, ferocious, had turned on my now grown brother, a man in a suit, and I thought for sure my father was going to clap him in the back of the head. You wouldn't un-

derstand, he snarled, unable to stifle his grotesque snorts. You had to be there, he wept, in tears of broken laughter. He was laughing because earlier, when the mourners had gathered at his cousin Rick's farm, before driving to the cemetery, my father's dogs, two ordinarily friendly and harmless labs, rushed the barn and in a frenzy killed what I gathered was a number upward of three cats. All of which struck him, on the drive to the cemetery to inter his mother's remains, as stupendously funny, and I guess one can only reasonably chalk up such reactions to the unpredictable nature of grief. But now a lewd grin crept across my father's greenish-yellow face, and he began mumbling about our mother, what a woman she was, how there was never a dull moment and so on, and I could tell he was on a pretty good load of painkillers. Truth be told, when I ended the call, I almost went and hit the passport safe myself, but managed not to cave.

———

I MEET BACK UP with Mark and Darren in the veranda deck lounge, midmorning, same place where the night before there had been a cocktail hour and lecture from the first mate on how to differentiate between sludge ice, brash ice, drift ice, pancake ice, pack ice, young ice (bad), fast ice (worse), "bergy bits" vs. growlers vs. full-on icebergs, and other notable conditions and species (all endangered) of the curious state of matter known as ice. I had tried to distract myself from the trays of champagne in circulation by watching the way the light wobbled on the daguerreotypes that hung on the walls. Black-and-white photos of Robert Falcon Scott, Sir John Franklin, Willem Barentsz. Portraits of the doomed astronauts trapped in the hard facticity of ice.

Darren is frustrated that the landing we were counting on, to film the ship empty, has been canceled due to weather. It was still drizzling and people were scattered about the ship, reading, napping, playing cards. Beads of rain jittered and babbled across the glass of the large floor-to-ceiling windows. Our plans have to be put on hold. We don't have free run of the ship as hoped. All that priceless emptiness right there, right under our fingertips, if not for all the people in the way. But if we tried to establish that categorical emptiness any other way, by stitching or cobbling together a composite of empty corridor shots and empty deck shots and so on, the viewer would know they were being manipulated. It could not be a montage. It had to be one continuous, unbroken shot. But for now we had the lounge to ourselves. It was a large empty space where we could at least work out the aftermath on our characters' minds, our rapid disintegration following the rapturing of the other passengers. Darren flips a coin to decide who gets to go first. He has to ask Mark for a coin. Heads he goes first. Tails I go. It's tails.

As we discuss this, Darren evidently notices the puzzled look on Mark's face and realizes he's forgotten to tell him we were doing a horror movie now. He gestures at Mark to follow him to the other side of the lounge, beside the grand piano, for a private conference. Darren does most of the talking while Mark listens, occasionally giving a curt nod. While I wait, I watch the streaks of rain streaming across the large windows, chasing after one another, mating, coordinating, forming temporary conjunctions, points of juncture, what look like alien sentence diagrams until breaking away into gibberish. By the time they come back, the rain has stopped.

"Great. Now the sun comes out," Darren says, as Mark,

without a word, begins setting up a new shot by the bar. Darren grins and gives me a thumbs-up behind his back. He stands at the window a minute. "What are the chances they'll go ahead with the landing now? Probably zero. Whatever."

He turns and studies me for a long moment. Looking me up and down.

"Okay. Let's do a scene. Something atmospheric. Just to kind of show you, uh . . . Okay, yeah, this will be like a shot that comes after. The quiet beat that follows the big panicked discovery sequence where we establish the full monty of the empty ship, in all its chilling vacated grandeur, where our characters verifying yeah, this is real, this shit is really happening, this can't be happening, this cannot be fucking happening, but, yes, it is fucking happening. So this is, like, a day or two later where you're letting the doom sink in. It's only a beat, but I want to suggest some element of transformation has begun. You're, like, in shock, still struggling to let it sink in, but you're no longer in complete denial. You're alone in this scene, so, introspective. No dialogue. We don't know where my character is—maybe I'm off taking an inventory or something, to see how many weeks or months of food we'll have to survive if the ship doesn't crash first. Okay, are you feeling this?" He looks around, chin in hand, and then walks me over to the bar.

"Let's start here." He pulls back a stool for me, as Mark goes about getting the windows and forlorn open sea over my shoulder into tastefully blurred focus.

"Okay. Great. We're gonna have to use as much of our own personal shit as we can to give our characters real depth. Are you feeling me? Your character is really struggling here, I think. So what are you able to bring to the table? You said you were,

uh, sober now, right? I mean, I can't keep track, but you quit drinking when you got back from Bulgaria, right?"

"Romania. It's been a month." And three days and forty-eight minutes.

"Congratulations. That's impressive. So . . . you want to make that part of your character's makeup? That's serious stuff. Your character's inner whatever, background, the given circumstances of his makeup." He takes Mark gently by the shoulders and moves him an inch to the left. "So you're already kind of struggling when we first meet you, right? We can read it on your face. Now that same guy—who's only a month sober—just found out he's basically the last man on Earth. So that's what he's bringing to the situation. Your character doesn't know if he's gone insane or if it's real, all he knows is this is not possible. Either way, it's guaranteed nutsville. Total waking nightmare. Reason does not operate here. Your mind is buried alive. You're trapped on the wrong side, and you can't find your way back, you can't wake up. The only time your character's ever felt anything even approaching this is maybe when he had the DTs so bad when he looked in the mirror his face looked like a writhing mass." He looked at me sidelong. "Ever been there?"

"Pretty much."

"All right. So name one single person on the face of the planet who isn't going to hit the bottle once they find out they might be the last man on Earth? That's *literally* the first thing any human being would do. I don't care if they're Mormon or if they've been sober thirty-five years and a day. They'd be, like, where's the fucking bar! So, yeah, just, whatever, it's only an idea. But if we want to make the whole existential abandonment plot believable, let's just feel our way through the scene . . .

Let's work out the given circumstances of your character: What's his baggage, his worldview, where do we locate his fault lines?" He gestures at the bottles that gleam like a stained-glass window. Ovals of crinkled light from the glasses hung overhead wobble on the bar's surface. "So, maybe, again, totally up to you how you approach this scene. But maybe you're feeling kind of torn now . . . I mean, look. Wow. Macallan. Chivas. Glenlivet twelve-year. It's all pretty top-shelf. Oh! Think about that scene in *The Shining*, when Jack Nicholson is talking to the ghost bartender . . . Lloyd, and ends up saying, fuck it, pour me a bourbon. 'Here's to five miserable months on the wagon and all the irreparable harm that it's caused me.'"

"'White man's burden, Lloyd, my man. White man's burden.'"

Out the window the passing ice fields look like thousands of unhinged white doors. Like a torn-up suicide note shakily reglued. Like the ruins of the sun. The lifeboats cradled in their davits look like comically pointless escape pods. And, in a way, the sumptuous emptiness of the lounge with its black gleaming Steinway is reminiscent of the ghostly ballroom in *The Shining*.

"Or maybe you don't take that drink yet. You're trying to keep your head. There's still a vestige of hope you can hold on to your principles and face the tsunami of cosmic uncertainty with dignity. That's your struggle. But, so, now, maybe we come upon you—you haven't reached the point yet where you say fuck it, pour me a stiff one and at least I won't have to blow my brains out today—but now we find you in a state of extreme paranoia. Panic maybe verging into catatonia. Just take a stab at that."

I put my head in my hands to try to look sad or at least lost in thought. I think about my dad, and our Skype chat, and

whether or not it made me sad. But trying to evoke or whatever wasn't working, so Darren took a second stab at trying to direct me into the right frame of mind.

"Just think, you are alone and cosmically abandoned. Nobody is on the ship. Not a single other soul."

But that image only gives me a feeling of profound serenity. I must smile, because he shouts at me.

"Dude! This isn't going to just be any movie. You've really got to put yourself in here, for fuck's sake. Look, I'm already coming up with blurbs for the poster: 'Disturbing, Mythic, Phantasmagoric, Surreal, Utterly Genre Defying.' So that's how you've got to act it."

I told him not to be ridiculous. Besides, I was unprepared. I couldn't do anything except keep thinking, blankly, *I'm in a scene, I'm in a scene, I'm in a scene.*

"I'll guide you. Tune into my voice. Just try to really put yourself there, okay? Start by relaxing your body. Now just, like, imagine if you took a nap at the wrong time of day and woke feeling weird, does that ever happen to you? Man, if I ever take a nap at the wrong time of day, or oversleep, I wake up feeling completely insane, really morbid, I really do. Trust me."

I said I didn't really take naps.

"Okay. Well, you can still get across the general vibe. If you just tap into something sad, disturbed. But the only sensible reaction to this whole scenario would be a full-on, and I mean *full-on* psychotic break. So if you can, tap into whatever fucked-up shit you've got."

He was fidgeting with his light meter, looking a little exasperated.

"Just think about a time you were scared to death as a kid. Think about a time you got lost in a department store. Remember the smell, the texture of new fabric, hiding inside the racks, the feel of being enclosed in a cocoon of women's dresses, the jangle of hangers. All that soft fabric draped around you. Maybe you were even starting to get a little erection, but then you peered out and realized the lights were off and you'd been left alone and you couldn't breathe and—"

I tell him I was the kind of kid who stuck pretty close to his parents, very uncertain of my footing in public spaces. I don't ever remember getting lost in a department store.

"Okay. Well, an equally terrifying, some time in your life that the universe forgot you existed. I don't know."

Then he snapped his fingers.

"What?"

"It's a method acting thing," he said. "A sensory exercise. This is what we're gonna do. So, like, think about Nicole Kidman. Say she were playing a character who had decided that she was going to take her own life. Right after she finished drinking her final cup of coffee. Imagine everything she would have to put into that cup of coffee as an actor. She would have to make it evoke *everything*. The decision, the final moments of her life, all telegraphed just in the way she's holding the cup. Maybe she's standing at the window over the kitchen sink. It's a beautiful morning, but she only has five minutes left. She's not going to just drink that coffee, she's going to telegraph all the emotion of making the decision to kill herself, and letting us know that we are inhabiting, with her, the impending moment when she will act, and where we will witness the conclusion of that decision,

via the experience of drinking that cup of coffee. Just by how she *savors* the coffee. She's going to make it real by summoning the essence, or the collective essence, I guess, of every cup of coffee she has ever drunk, to transmit the full power of that sensory data so you experience it too." He paused, picking up a mug from behind the bar. "But first she's got to eliminate anything that gets in the way: namely and number one, any *fear* she's carrying. That's the biggest, the most lethal obstacle. Fear really impedes flow. It's like cancer for actors. Only then can she rebuild the coffee cup, get to the essence of the mug, its tactile dimensions, the frequencies of its radiant ceramic heat, to summon and link all that critical emotional material, all the emotional research she's done, preparing for months, exploring every detail, aroma, the play of citrus and florals, whether it's a commercial roast, she knows the altitude the bean was picked, she knows its *terroir*, linking it to the immediate sensory data of the cup, so just to look at the way her finger is curled around the handle and the way her face profiles and contours the rising steam you know the decision is real. She's going to do it. Each sip is like an emotional Bitly that she can upload with a simple click of her mind. But the question here is, what's going to be your trigger, and how can we start to build a gun around that trigger?"

I looked at my hand, motionless inside a bright square of sunlight, and then lay my cheek on the bar. The marble cool contrast to the warm sun on the back of my head is pleasant. I feel serene. "Okay, great, turn your head to the left," Darren directs me. "I want to see your face." I turn to see the camera an inch from my nose, Darren whispering behind Mark, "Really get the crinkle around his eyes."

I murmur or splutter some words but what I'd meant to say

doesn't come out, which was *I think I'm getting some mental formations.*

These formations being at first a jumble, unconnected, but as I focus in on the warmth, the sensory data of the sun on the back of my head, with my eyes closed, the feeling begins to link to other suns my head has felt, streams of data both strong and weak, vying memories of suns, until an aggregate of all the combined memory hours and combined suns I have ever felt on the back of my head begins to gel, a lifetime composite of interconnecting suns blazing against my skull, and inside one of those brightly lit compartments I glimpse a patch of lawn. A lawn trepanned by an obstacle course of holes. And weaving between those holes is my brother's filthy dog, Clyde, pausing here and there to widen out one of the many ragged pits that aerated the dentist's Night Gladiolus.

Darren prompts me. "Home in on your skin receptors. Breathe. Explore. Don't be afraid to be vulnerable."

I see the bricky light of the mental hospital's smokestack, towering, over the summer trees, and at my feet freshly opened earth . . . I am in the scrubby field behind our house, a shovel in my hands. I look over at the green square of my mother's garden, the one shelf of life hanging from the quay of mud. She is there, picking Japanese beetles off her tomatoes and dropping them into a can half filled with kerosene. The breeze rustles her blue shirt. She smiles at me. But then I look again and she is not there. There are no tomato plants. No mother. I return to my shovel. Who had begun this ritual obsession of digging holes? Myself or the dog? Who was emulating whom? Which of us was only an imitator? A copycat? Maybe I had only begun the ritual after Clyde had been evicted, outsourced

to the asylum, a pet to sit with you between Thorazine naps. The upper ramparts of the hospital, in spite of the serene blue summer sky, now hissed and popped, emitting fizzing clicks and crackling feedback, its weathered bricks transmitting the blaring noise of the chaos imprisoned behind its high walls.

I have a sense of what feels like some force emanating from the asylum, one I suspected was generated between the poles of the church steeple and the smokestack. As if, aboveground, I were caught in its magnetic field. I feel the sickening waves of attraction and repulsion except when I am down in my hole.

I want to find my mother but instead I get another formation: I see my brother on the lawn, sprawled in the grass with his head inside one of Clyde's holes, laughing and kicking, yelling moronically, as dirt rained down on his face. My brother who inhabited a remote end of the spectrum, beyond the invisible ultraviolets, or far infrareds, beyond the impossible colors already blurring into sound, well past the frequencies that only canines could detect. Perhaps the same subsonic frequency the hospital used to communicate with patients out in the village on walking passes, when it was time to return to the castle.

"Think kinesthetics—think about the body attitude. Think grammar of gesture. Tension and discharge. Flow. Attunement to the given circumstances."

As I place a foot on the back of the shovel, the aroma of the earth is released, virginal and fecund as the smell of the cut grass wafting over from the well-tended campus of the asylum. The first cut was always the most satisfying. The first stab an exhilaration, even if a bit sickening. The visceral tear of roots. The stones that set your teeth on edge when scraped on the wrong angle. But the first slice across the Earth's crust: to cut into the

side of the planet itself. By violating it, who knew what treasures or blasphemies would bubble forth. To plunge and lift the spade, hoisting out each dark wedge, using the rim of the hole as a fulcrum, I had to pull back on the handle with all my small freight, like hanging off the helm under full gale.

A hole started out as a rough cone, as if I were carving a negative sculpture, an inverted pyramid, the growing mound beside the hole an obverse of the hollow work in progress. I could feel the sound of grit on the blade in my teeth. A synesthesia in my mouth. After a while you could detect the different textures transmitted through the blade to the handle. Granular gradations: coarse, fine, sandy, clay. The siltier dirt flung into the air in parabolic spumes. Sometimes flakes of dirt or some mineral, iron filings, clung in a way that made me wonder if my shovel were lightly magnetized.

Now I was knee-deep inside my foxhole. My legs decidedly cooler than my upper body. Every ten minutes or so I stopped to examine my work, making minor calculations, correcting for asymmetry. Shaving down the sides, not overly fastidious about circumference, but fastidious enough, scooping out every last bit. Sometimes you found a weird button or an old tractor part. Working around the difficult larger field stones until they were loose enough to heave out. Coming to the stones the sun may have never touched. Once I even dug up part of a deer antler. A dense, half-petrified claw, with six or seven points. I had gilded it with some leftover gold spray paint I'd found in the attic, where the life-size figures of the church manger tableaux hibernated off-season: the three kings, Mary, Joseph, and the Baby Jesus doll, along with a few chipped lambs and a donkey. The spray paint was left over from a retouch to

the star of Bethlehem. The antler had become one of my digging implements.

Here I pause to wipe my brow. Then looked up and saw the sailboat in the driveway, a sight that filled me with dread. I could hear the church organ coming from across the street. It was warm out. The organist must have been practicing with the windows open. The boat looked as if it had just been abandoned, parked hastily, half in the driveway, half on the lawn, the sail tied off and bundled haphazardly around the mast. The boat, its indigo sparkling hull, was dripping wet. As if just back from the lake, or as if my father had just given it a hosing. But why parked so weirdly? I try to recall if my father had included the lake in his miniature replication of our town, but I can only picture the book he had gotten from the library, *Basics of Sailing*, a book with clean simple illustrations, the kind written for a child with competent dreams.

When I hear the rattle of tiny wheels on gravel, I turn my attention from the disturbing way the sodden sail is clumsily wrapped around the mast, to see my father dragging the grill down the driveway. He dumps a full bag of briquettes into the grill, ripping off the stitched seam and emptying the bag in a cloud of black dust. Then he douses the heap with a full bottle of lighter fluid in its entirety, soaking the coals, and giving the bottle several futile squeezes so the plastic makes a crinkled gasping noise. Then he irritably tosses both empty bag and spent bottle onto the lawn.

When he drops the match, the fireball is so huge, even at this distance, in the far reaches of the muddy field, I can feel its searing heat, but that may only be the hyperbole of memory. It licks at the overhanging branches of the birch that grows

outside my brother's window. The window from which I now hear my brother wailing. He is no longer on the lawn, and the holes that had only a moment ago pocked the dentist's yard have been repaired, if not yet fully grassed back over. There is no sign of Clyde.

When I remember how Darren had warned me against tension rising from fear, and how it could compromise my acting, I take cover in the hole.

Sitting cross-legged I touch the solid walls and feel safely encapsulated. Down here is a stillness that precedes all noise and craving, before language or ritual, possibly desire itself. The hole is a pocket of emptiness where I am free to be disconnected. The barometric pressure is more forgiving. But eventually I have to stick my head back up, and there is my mistake, because when he sees me, from the far end of the field, in the tall grass, he turns and starts walking toward me briskly. Did he emerge from the woods? Out of the woods? He is coming from the direction of the asylum, obviously, one hand jammed in a floppy white pocket. I am too terrified to scream out for my father, but he would not hear me now over the roar of the fireball that he violently stokes into a frenzy with a golf putter. Clouds of brass sparks clashing like a cymbal against the dusk. The reflective droplets of water and sparkling indigo fiberglass swirl red in the grill inferno. My brother is still howling from his bedroom window, but I do not think it is because of the flames. Nor do I think he sees the man in the white coat, who is halfway across the field.

It occurs to me the man in the white coat might only be hunting some escaped patient, a murderous lunatic, a bug-munching Renfield. I hear Darren, "Focus your breath. Embody

the predicament. What do you see?" But then I see the man's scowling face and eyes flared like two dark nostrils that smell rather than see me, and now I scream, but it is canceled out by the church organ. A Bach cantata. Is it BWV 140? *Wachet auf, ruft uns die Stimme.* Sleepers awake, the voice is calling us . . .

It feels as if the volume has been deliberately turned up, maybe to cancel out my brother's howls. He was screaming like a victim of hypothermia, like he was being suddenly thawed out so all the sensations of existing came rushing back at once. Either that, or because, from his window, he can see the patient who has stopped on the sidewalk in front of our house, holding the leash that droops from the collar of my brother's former pet.

The man in the white coat, lunging across the field now on all fours.

His white jacket snaps like a sail, almost glowing in the fading summer light, and the field seems to whorl and shift beneath his feet, and when I hear Darren whispering to Mark about low batteries, this is when I make a run for it, fleeing the lounge, banging my knee hard on the piano bench, with Darren barking after me that he can't work with divas.

I'm so undone that I return to my cabin, unlock the safe, and pop two benzos, but then immediately spit them into the toilet and lock the pill bottle back in the safe and then spend the rest of the day trying to read *Frankenstein*. It was the one book I had brought. I'd packed it after vaguely recalling how part of the novel was set in the Arctic, where creator and monster come to fight it out in the end.

22

IT WAS JUST ANOTHER MORNING AT SEA, A FULL FOUR-
teen degrees north of that sorcerer's ring known as the Arctic
Circle. Almost a thousand miles north of where the world was
thought to have already ended, but things were just getting
started for world-weary traveler and documentary filmmaker
Darren Ray. He had a polar bear in the can, and some sound-
ups of passengers saying things that could pass for profound
and/or amusing. But he still hadn't nabbed that special some-
thing that gave a film its spice. So far, things were just a bit
too ordinary for his liking. Not even the caliber of hangover
he found himself nursing could be described as out of the ordi-
nary. But he knew, in the end, reality would deliver the goods.
It always did. It was a tenet of his faith. All he had to do was

keep the camera rolling, and at some point *it* would happen. But so far there just hadn't been a lot of *it*.

His feet hit the floor—seen from the POV of a dust bunny mounted with a procam—and slipped into his slim-line leather sneakers, at the ready next to one of his crumpled western snap shirts. After splashing water on his face, he glanced out the porthole to see nothing but nauseating gray ocean. Then stumbled around the disaster site of his cabin in search of his hat. He hazily took in the evidence of the night's debauchery. It all came back to him bit by bit. The strewn bottles. Napkins scrawled with some moronic idea for a documentary about, best he could tell, a buddy quest for the Holy Grail. The nine-inch kitchen knife pilfered from the galley impaled in the bathroom door. Or was he supposed to call it the head? They were on a ship, so the kitchen was the galley, but was the bathroom called a *bathroom* or *the head*? Whatever it was called it was where he had last seen Jay, barfing like a dying elephant seal. He only had a misty recollection of his friend ranting about the Holy Grail and, yes, dear Jesus, waving around a knife like it was freaking Excalibur. Somehow, when Jay was three tattered sheets to the wind, he always got his hands on a blade. That was his tell. Even in college. His mountain boy roots came out and he went full Daniel Boone. Then he would spend the next hour demonstrating his iffy knife-throwing skills on the nearest tree or dining room hutch. He knew people who literally hid their good steak knives if Jay was drinking. Darren, who hailed from Florida, had first seen snow when he'd gone home with Jay one Thanksgiving. All Jay had wanted to do was walk around in the woods with a bottle of vodka and look for deer skulls,

even though Darren had been freezing his ass off and was scared to death of mountain lions. It was funny to think how those same two stupid college kids were here at the end of the world now, looking for *it*, eyewitnesses to the Big Thaw.

When he stepped unsteadily out of his cabin he groaned when he saw the camera already trained on his bloated face. Mark, his laconic but ever present third eye, his DP, waiting bright eyed and restored as usual by a wholesome night's sleep, ready to capture the first waking moments on Day 3.

This was the price he paid. For being a witness. For being a filmmaker whose material was the real, the immediate, the immutable truth, hairy warts and all. Even when it was him who felt like the real wart. One big hungover wart badly in need of some bacon and eggs.

The camera followed him down the hall, which he told himself, on a ship, was technically supposed to be called a *companionway*, but he didn't really know why he knew that, nor why he was supposed to care. It was just one more damned corridor on a ship that at times felt like it was nothing *but* corridor. Quite frankly, right now, the wavy-pattern aquamarine carpeting was making him feel like he might have to hurl. He rapped on the door to cabin 329. Mark waited with the camera on his shoulder. He knocked again, but still no answer. An empty champagne bottle was cantilevered precariously on the railing outside Jay's cabin. He was probably passed out, and Darren felt a surge of guilt for letting his old college friend, sober one month, go ahead and drink half the alcohol on the ship last night.

Whatever. He would get breakfast and let the bastard sleep it off. He liked the idea of eating in peace without having to

listen to Jay's blubbering regrets having nose-dived his whole plan for using the trip as a five-star floating rehab. That had lasted all of two days.

As for himself, three or four cups of coffee and a plate of bacon and eggs would fix him right. Then he would check with the expedition leader, Lisa, to see if there had been any whale sightings and any breathless tourists to pump for sound-ups.

Dragging himself up the carpeted stairwell, Darren gestured for Mark to take in the high-end gift shop tchotchkes in the display case, a tastefully lit corner hutch with overpriced jewelry and framed underwater photographs of a polar bear swimming past a gargantuan iceberg that hung in the sapphire water like an upside-down mountain, like the root of a gargantuan extracted molar.

He had to admit, it irked him he didn't have a room with a balcony. If he had been Anthony Bourdain, they would have given him a room on the upper deck with his own balcony.

He came out into the main reception area and went to the front desk. He wanted to put money on his internet card. But the receptionist wasn't there, so he browsed the postcards, and then after another two or three minutes when the receptionist still didn't show, he peeked into the purser's office behind the reception desk, but nobody was there either, so he gave up and went into the Café Bistro.

He took a seat at the bar where a cappuccino was waiting on the black polished surface for somebody else. He snapped his fingers at Mark, who had wandered away to study the wine display, to come back over and zoom in on the cappuccino. Travel docs could never have enough classy food porn. The foam art jobber, or *crema*, or whatever you called it, was not a

leaf, but a fleur-de-lis, or what was it, the word, a weird word, he didn't even know where it was coming from now. *Thyrsus.* After another minute when the barista failed to materialize, he consulted the chunky pilot-watch on his wrist that had a bunch of cool-looking dials he had never bothered to decipher and that, when he thought about it, made him feel a little foolish. He wondered what kind of watch Bourdain wore. Was this display here supposed to be an altimeter or a barometer or what? He had no idea. He adjusted his hat in the reflective chrome of the espresso machine. It was 8:46 A.M.

Most everybody must be in the dining hall now. But, still, where the heck was the barista? On second thought, a little hair of the dog wouldn't hurt, he thought, looking down the bar at an unaccompanied Bloody Mary. That was the proper way to recalibrate. Especially if he had to play charming travel host today. If you were going to stick a camera in people's faces and wanted them to ejaculate all over the place about the Experience of a Lifetime in every painstaking, dull-as-dogshit detail, and look like you didn't want to cut your own throat out of boredom, a drink was not a terrible idea.

He reached for the bowl of goldfish crackers. Then looked sheepishly around, to check he was not being watched. Which of course he was not, because the lounge was as dead as his career if he didn't get a move on and start rolling something better than him waiting for this nonexistent bar service. Abruptly, he reached out and grabbed the celery from the ownerless Bloody Mary. But then instinctively dropped it as if repulsed. *It was room temperature.* The ice in the drink was melted. For all he knew, it had been sitting there all night.

As if afraid to know, he refrained from testing the cappuc-

cino. Then something caught his attention out the corner of his eye, and he got up and went over to the window that looked out on the deck, muttering "What the fuck?"

The wind luffed against the microphone, scrubbing out his more profane and distraught exclamations as he ran outside, with Mark in tow. The ice cracked as it scraped and split against the hull below. What had caught Darren's attention was a camera left out on the deck. And not any camera. A Pentax 645Z. Nobody would leave a camera like this one unguarded for a second. It cost close to five thousand dollars. But there it was, just resting on the gunnel, and he automatically scanned the ice, prepared to bellow, "man overboard!"

Then he noticed that the entire deck was littered with cameras.

They were sitting on lounge chairs, scattered all along the railing, far too many to count. Far too many to be real. He looked about in alarmed disbelief. Something about the haphazard way they were scattered, black and broken, looked as if a flock of disoriented, or suicidal, birds had collided into the ship in the middle of the night.

He now knelt and picked up a Canon EOS 5D, turning it in his hands. The lens was cracked. Setting it back down, he found himself pressing the sharp metal tong of his belt buckle into his thumb, as if to test whether he was actually conscious.

More than shaken, he quickly went back inside and started for the dining hall. But at the elevator he changed his mind and turned back into the café. At the bar he picked up the lukewarm Bloody Mary and downed it. Then stood looking until he finally allowed himself to admit what he had only let into the periphery of his mind earlier. The room was dead empty.

The silence was assaulting.

The only sound was the aloof hum of the ship's engine.

Usually there were any number of people in here, studying their Bradt travel guides, chatting, or just stepping in for a moment out of the cold. His eyes scanned the smattering of unattended personal effects. A book next to a cup of tea. An iPad with a John Grisham novel, 31 percent completed. The latest issue of *National Geographic*, with the cover story: "Searching for the Real Cleopatra" (ancient Alexandria now lay below the sea, and archaeologists were conducting underwater excavations, hauling sunken granite colossi and barnacled sphinxes to the surface in a search of her tomb). A pair of GORE-TEX mittens. Even a wallet, on the seat of an unoccupied chair. Several more top-end cameras he had not noticed before. Three. Four. No, five, there was another one on the floor. A mimosa, next to a cell phone in a sparkly pink case with a half-written text. The ice was melted, but he drank it now too. Then read the text. It was nothing. "Meet you back at the room in 5." He stared at the ghosting ellipsis until he knew there would be no reply, only the pulsing *dot . . . dot . . . dot . . .* until the battery went dead.

Darren was hyperventilating, you could hear it on the camera mike as they moved around looking at the empty space, and when he heard the *ding*, he strode quickly to the elevator and stood waiting for the doors to open with a look of immense and tormented apprehension—as if he would suffocate if the doors did not open this instant, which they did, with a gentle rumble, just as they again closed, a moment later, on the empty unoccupied box.

Abruptly he ran for the bathroom. Mark's camera caught up a moment later, to find Darren on the floor in a stall, retching.

While he retched, Mark filmed himself standing still in front of the bathroom mirror, until, after a moment, he panned back to Darren sprawled out on his belly, reaching under a locked stall. He was scrabbling after a cell phone in the next stall over, almost out of reach behind the toilet. After he finally managed to get ahold of it, the camera zoomed in on the cracked screen in Darren's hand. The unsurprising message: YOU ARE NOT CONNECTED TO THE INTERNET. Then the camera lingered gratuitously on the turd just floating there, unwiped, unflushed.

A minute later Darren stuck his head into the women's bathroom and called out, sotto voce, but nobody answered. Two stalls were unoccupied but one was locked. He saw no feet, and when he stuck his head under, nothing. On the sink was a handbag, an Orla Kiely, black-and-cream flower print.

He had experienced weird things when he was seriously hungover, and everything refused to make sense, when he saw things that weren't there, where he became overly suggestible, paranoid, and his mind could make too much out of altogether insignificant and entirely explicable things, but not like this. He knew this was far beyond the regular apophenia of a hangover.

As he banged into the dining room he was greeted by the sunny aroma of fresh baked rolls and coffee, and the heavenly smell of bacon, but he was no longer hungry, nor did he think that the issue here could be mended with a solid breakfast. He walked past the steaming buffet and stood looking at the surrounding empty tables dressed in white linen. By now, sweat was pouring down his face and his shirt was stained with vomit. Even if there had been a landing, people would still have breakfast first. There were full pitchers of orange juice and water by the pyramids of spotless drinking glasses and silverware bun-

dled in scabbards of starched napkin. But scanning the dining room with ever more frantic eyes, he looked like a castaway who had climbed out of the sea only to discover that the beach was a mere spit of sand already dissolving between his fingers. It was empty. Dramatically the camera pans across the room from left to right, until we spot, floating amid a sea of empty tables like a single buoy of grim despair, one lone figure in a corner booth.

It was Jay, with his head on the table, cradled in his arms.

Even at this distance he can see that Jay is mortally hungover, and Darren remembers the night before with a pang of guilt, for letting his friend drink, despite the fact that last night could easily have been a hundred years ago, five hundred years ago, a party in the Middle Ages, for as real as it felt now.

Jay looked up wearily when Darren sat down, but let his head drop back when he saw Mark filming. Until then Darren hadn't fully registered that Mark was still shooting, which he found unsettling, but at the same time he thought this was Mark's way of keeping himself tethered. A safety blanket he wasn't going to yank away from him now.

Darren sat and looked at the yellow pill bottle on the linen at his friend's hand. Jay offered it to his friend.

"Hits the same gabba receptors as scotch. Just to hold off the Bad Mamma Jammas. Want one?"

Darren waved it off. Then let a minute pass before saying, in a weak and almost inaudible voice, "Tell me you've seen a waiter."

Jay looked at him sideways, shrugged.

Darren got up and walked slowly to the coffee station, grabbed a carafe, and brought it back to the table. Taking the first sip and finding it lukewarm, he knocked it back, refilled, and drank the second cup in one swallow, before folding his

hands in his lap. He only wanted to wake up. Then, on second thought, he reached across and shook out one of the pills and let it dissolve under his tongue. Jay watched with an expression that could only be described as indeterminate.

"I don't think they're still serving breakfast," Jay said after another minute, letting another pill dissolve in his spoon before slurping the chalky coffee slurry.

Darren inspected the tines of his fork until he was sure he could see his own divided reflection. "I want to go up to the chart room and check the schedule. Let's go take a look."

"No thanks."

"I want to see if there was a landing."

"You go ahead. I'll catch up with you later." Jay put his head back down on the table.

"Look, we need to stick together, at least until we figure out where the fuck everybody . . . is."

Jay laughed and then clutched his head and moaned. And then looked around the room and rubbed his nose. "What time is it?" he asked.

Darren said about 8:30. He looked at his watch. "8:46."

"A.M. or P.M.?"

"You're not serious."

"How can you tell the difference? Yeah, I'm serious."

"In that case, it's A.M. And nobody's here."

"Didn't you just say there was a landing?"

"I said there wasn't one scheduled."

"We just slept through it. You can shoot another tomorrow. Today's fucked anyway. I'm just trying to stay as still as possible right now."

Despite a wave of genuine pity for his friend, Darren was

growing annoyed. "Like I said, nothing was scheduled for to-day. *No* landing."

"There's probably nothing worth seeing anyway. Just barren rocks and a few scraggy plants. Whatever."

Speaking in an overly enunciated tone, Darren said, "There was *no fucking landing* scheduled. And even if there were, if you looked out the window, you would see that there's no fucking land. So where the fuck, specifically, would there be a landing? Except, *like I said,* there wasn't one. And yet there's nobody on this fucking shithole ship is what I'm fucking saying."

A long beat followed where Jay slowly took in Mark. "Okay. Fine. You want to go check the schedule?"

Dragging behind as they went upstairs, Jay followed Darren who went first, more than a bit jumpy now, followed by the camera that registered the barf bags on the railing next to the elevator as they came around the corner, now on the veranda deck, following signs to the chart room, where the camera paused over a tin of shortbread cookies by the coffee station, which Mark's hand reached out to give a disappointed shake. The camera juked and the empty cookie tin banged on the ground when Darren shouted (off camera). He was in the cor-ridor at the bulletin board, with the torn-off schedule in his hand. Cursing, he crumpled it and flung it to the ground.

The camera patiently waited for Jay to pick up the crum-pled ball and flatten it out, then zoomed in on the wrinkled itinerary. The paper, held against the wall, looked at in a certain way, revealed a different kind of map, if one only carefully studied its seemingly random folds, adjacent creases, mesmer-izing grooves, intriguing dents.

Ignoring Jay who said maybe everybody else had just had

the good sense to do what he was planning to do next, which was go back to bed, Darren circled the large chart table, yanking open the drawers, pulling out random stacks of maps and hyperdetailed charts showing every grid of the deckle-edged archipelago that still presumably existed, and, if so, that they were still presumably circumnavigating. In a tantrum, he winged the charts across the room before banging open the portside exit to the bow.

The bow was deserted except for several more dozen cameras scattered across the steel gray deck. He gulped in the cold air, his eyes scouring the horizon in baffled disbelief. He continued to suck in huge gulps of air, not hyperventilating so much as infuriated, determined to shake off the sheer impossibility closing in around him by brute force of will.

And then he half strode, half lunged at the bow and braced himself before leaning out over the pulpit, where the wind roared in his ears. After a moment he dared to look down. The ship plowed ahead. The ice parting before the towering sleek prow. It buckled and snapped before the cataclysmic wedge of blue steel. How many knots, he couldn't say. There was nothing ahead but a field of ice, endless in every direction. No visible land. He dropped back down and stood there, stunned, under the small flapping powder-blue flag that snapped overhead. He had never noticed what was on the flag before, but now, when it could not have mattered less, he saw it was a polar bear. It looked stupid, as if a child had made it, and it made him angry, but then out the corner of his eye he caught sight of something else. A swoop of gray. He turned just in time to see the dart of shadow across the deck followed by a sickening thud. It had come like an incoming missile. A seabird had torpedoed the

windshield of the bridge. He looked up, shading his eyes with one hand, and saw a streak on the glass just beneath the turning radar bars where the bird had struck.

The glare prevented him from seeing into the bridge.

The bird was quite large, and after the collision its broken body bounced off the chain locker and came to rest at Darren's feet. Jay only stood there, hands in his pockets, leaning against a capstan. He seemed as indifferent to the bird as he did to the cameras strewn about the bow. In fact, Darren couldn't tell if it was a faint grin on his face, or a grimace. He hadn't even jumped when the bird hit.

Darren now flung himself up the metal stairs, Mark stamping after, and bolted down the veranda deck, skipping over more orphaned cameras. Nikon D610s and Canon Mark IIIs, Sony RX1s, and Olympus OM-Ds. Kicking them out of his way like litter as he ran.

He cut inside through the nearest door, into the lounge, where he slowed to let his eyes adjust to the dark hues of single malt and bronze. Gouts of sunshine splashed the wavy grain of the burled walnut walls. As Jay sauntered between the empty curvilinear seating, running a hand across the backs of the leather sofas, Darren stalked the room in irritable circles. Fuming. At the piano, he raised both fists and slammed the keys in a fit of helpless fury. An ugly din hung in the jumbled air. Other than Mark with his useless camera, the only witnesses to this outburst were the framed sepia faces of past explorers to this doomed realm. Haggard ghosts posing before the full-rigged grainy schooner seized in the fast winter ice: a final message home, burned onto a glass plate by the hideous uncompromising sun.

The camera jinked away from the daguerreotypes to catch

Darren moving past the bar and out the back exit onto the sun deck. After a moment, the camera rejoined him and scanned the slatted tables and folded umbrellas. An orange life preserver hanging from the rail. Fire ax mounted to the white-painted metal bulwark. Darren gripped the stern, looking down on the vast rearward view of chopped ice in the gutter cut out of the flat white horizon. No land in sight. Nothing but the midnight sun that had already murdered time and was now in pursuit of its next prey.

Darren and Jay launched up the stairs to the wellness deck. Outside the gym, when they heard a buzzing noise, they entered, and Darren stood looking at the leather benches, and empty yoga mats, then walked over and hit the stop button on one of the treadmills. When it wound down, and its motor fully stopped, another smaller sound, muffled, with an upbeat tempo, became audible. He picked up the earbuds dangling from the handlebars of the elliptical. The tiny pulse of dance music made an odd soundtrack to the ship's majestic gray wake, visible through the smudgeless floor-to-ceiling glass. A receding empty starkness serenaded now by a miniature, if overly autotuned, voice held in Darren's palm. Below the window was a spray bottle of glass cleaner. Unscrolled halfway across the floor, a roll of paper towels. Mark zoomed in on a magazine left propped on the treadmill. A photospread of celebrities caught breastfeeding in public in a place called California.

As they moved through the spa they skipped the sauna and massage room and spa suite altogether to return back out onto the open deck where they came to what Darren's eyes revealed he had most hoped not to find. The rigid inflatable Zodiac rafts. He went up and held out a hand as if uncertain if it were an appari-

tion. But they were all fastened in place, all accounted for, stacked behind the portside funnel. And worst of all, perfectly *dry.*

At the sight of the black boats, in their thermobonded finality, Darren lunged, and let out a pathetic roar, flinging himself bodily at the wall of black PVC, which, trampoline-like, bounced him back, repelling his attack as if he had run headlong into a rubberized force field, and landing him on his rear end in a moment of unintended slapstick.

Next, an overly gimmicky POV shot: focalized through one of the oarlocks, our enraged bewildered hero running off across the well-swabbed deck toward the bridge. Followed by an awkward/too abrupt jump edit. Our hero already halfway up the metal stairs.

Under the turning radar bars, he looked back, gripping the cold rail. He is just below the window to the bridge. He looks over the full rearward length of the ship, down on the observation deck and skylights and orange roofs of the life pods cradled in their davits, and farther back along the white superstructure of the ship with its bristling antennae, two low-rise exhaust stacks, and large spaceshiplike sphere encasing the main communications satellite dish.

He looked at the twin smudges of heat coming off the funnels. The NatGeo gold yellow rectangle and the Lindblad logo of a giant blue eye on the side of the portside funnel. Looking at the eye, Darren thinks, *What's with Cleopatra?* Then he slowly turned the handle to the bridge.

His veins didn't go icy. It was too late for that. But he did register the cavernous echo of an inward scream. As if the harsh chord he had banged on the piano in the lounge were still slamming around his blood cells. This despite the overall

appearance, or first impression, of an orderly, well-tuned command center under full sail. He stared at the quiet blinking lights and listened to the even hum of the electronic navigation systems. The complex array of knobs and dials, monitors that displayed a steady stream of data. Digital graphs plotting fin angle, yaw rate, rudder angle magnitudes. Sonar. Radar. On the chart table, a coffee mug rested on the corner of a map. He stood next to the captain's chair, which looked a lot like a barber's chair. A highly ergonomic, black leather barber's chair.

The only detail that suggested anything might be out of place was the phone. The direct analog line to the engine room. It was off its hook, dangling from a coiled cord. It swiveled, slowly spinning.

Disregarding the gruesome smear of bird on the glass, which had dribbled down onto the windshield wiper and begun to pool in the rounded corner of one of the riveted window frames, Darren looked down on the empty bow strewn with cameras. Jay, who had joined him on the bridge and still appeared nonplussed, peered through the mounted telescope used for spotting wildlife. Darren shoved him aside to look for himself—but it was focused on absolutely nothing. Maybe five or ten or twenty miles away, he had no way to measure such distances, he could see where the flat expanse of ice gave to open water, speckled waves, with rafts of broken ice like slabs of dry wall floating away from a demolished house.

In the little kitchenette, a cold black wedge poked from the toaster. He had noticed the burnt smell when he had first stepped onto the bridge. A butter knife was impaled in a jar of Nutella. Only now did he finally allow himself to fully register the radio playing, very softly, *Take me home, country roads . . .*

But, of course, there was nobody driving the ship.

The bridge was empty.

Radio reminds me of my home far away . . .

Darren fled the bridge. Banging back down the metal stairway. Unbridled panic now. Frenzied handheld, doors slamming open and shut on the wind. Now running through the library, sprinting through the observatory with its risible illusion of a cozy partition that could protect the passengers from the elements. A meek hovel against the ravenous wind.

At the elevator, Darren jabbed at the button and screamed at Mark to turn off the fucking camera, but, instead, the camera only turned back to the library where Jay, dawdling, lingered over the globe, patiently spinning it, as if lazily searching for a misplaced continent. When it stopped, he rapped the globe with his knuckles. It gave a hollow thud. But Darren was already screaming again—screaming at his friend and jabbing the elevator button—but then instead of waiting another second he shouted at Mark to take the stairs.

They went plummeting down. Bridge to wellness deck, to veranda, to upper deck, to main deck, level to level. Squaring corners, slamming and leaping, their banging footsteps looped in the echo chamber of the rectangular well. They plunged down the steps as if fleeing ahead of an out-of-control piano. As if pursued by the fear of madness itself. Fleeing from the horror of their irreversible discovery. Leaping half a flight at a time, hurtling the railings, hearts exploding. They staggered down the stairs in a kaleidoscope of slatted stuttering shadow and light. Shot from above, shot from below, shot diagonal, Dutch tilt, golden ratio, chiaroscuro. At last exiting at the main deck, no longer vertical, their fleeing became horizontal, hurtling and

caroming down the corridors, Darren in the lead, pounding on all the cabin doors, shouting "hello hello hello hello," thumping the walls with the side of his fist as he ran, Jay coming behind at an unbothered stride, clomping along in heavy winter boots, and as if egging him on, or mocking, joined in and pounded the doors as well, crying in a singsongy lilt, "hello hello hello hello?"

Until almost at once, they slowed to a dead crawl. As if suddenly aware they had been running toward danger instead of away from it. That whatever unknown they had been chasing was in fact stalking them, lying in wait, lurking around the next corner. But they kept going, instead of turning back, as if they were not moving entirely under their own control, as if drawn against their will, inching forward at a pace of absolute kinetic dread, the headlong sprint decelerated to an anxious tiptoeing crawl. It took the entirety of their collective will to put one foot before the other, moving now at an excruciatingly halting pace, baby steps up to and around the next forbidding corner, practically pulling themselves around the doorjambs, groping until they were no longer properly holding themselves up, sliding limply along the walls, merging into the wallpaper, pressing their ears to the walls to pick up any murmurs that might clue them in to what might lie ahead, and coming to each corner with such trepidation, moving so coyly, it is as if they are testing every possible way one could turn a corner, in this ritual of corners, how to turn it more slowly, then slower still, how many tortuous ways were there to turn a corner when one was moving though a labyrinth, coming to the endless bends, dead ends, passage after passage, dank interchanges, false connections, as if the corners themselves were refracting, multiplying, archivolt, a never-ending fractal doorway. This eternal rite, eternal hor-

ror movie ritual, edging around dark corners, as if they were the very sacrificial youths of Crete, fed each solar year to the labyrinth built to hold the queen's fey offspring.

Why did the minotaur need to devour so many children? So much blood of the innocents? To renew his bad self, of course. The slouching beast refreshed his blood with their fresh plasma, synthesized the healthy gristle of their childish peasant melodies, vitamin-rich songs of eternal innocence, into his own shriveled and scaly flesh. Without this steady infusion he lost all sense of equilibrium, all sense of purpose. And despite his divine lineage, the mutant son of the sacred bull was vulnerable to the most degenerate thoughts. Shut up in his claustrophobic universe with nothing but the stalest bits of brain matter to lick off the walls.

But Theseus, a moron who failed to appreciate the necessity of the ritual, which was to keep the scales of the sacred and profane in balance, went dashing in to put an end to it all on behalf of the selfish brat sister who only wanted her intellectually disabled brother out of the picture. It was *embarrassing*. He was so chromosomal! Her mom had fucked a sacred bull to get back at her dad for cheating and then, for good measure, put a curse on his prick so he ejaculated poisonous centipedes. And then Ariadne gave Theseus the clew, the ball of string—a thin thread of sanity to find his way back after he had put an end to her retarded kid brother who had been put in the labyrinth for his own good by the state. The state, in this case, of course, being her father.

But the never-ending creepy turns shattered the hero's nerves. Theseus could feel how the labyrinth, hot by day, was weirdly more intestinal than stone. Its twisted winding passageways. Slimy walls, cramped dark shafts. Feculent apses and

naves. Eerie chamber music echoed down the murky corridors. He could sense its hunger. How it craved, like a junkie, the sacred monster's profane appetite radiating from the center. The only thing that calmed him was to pluck the string wound taut around his fingers. A single, dull-timbered note, but to Theseus the clew had a lovely flaxen voice that sang him lullabies, which promised to dissolve the walls if only he would let go the string . . .

But now as Darren, our hero, came scrambling out onto the B deck, the lowest level, half expecting, even hoping, by now, to find a pile of bodies stacked like firewood, or at least a lot of blood splatter, a sign of struggle, maybe a pirate attack, or mass suicide, maybe this was when they discovered they had accidentally signed up for an apocalyptic cult's final cruise—any of these scenarios being preferable to what they found, which was, of course, not a single trace of the missing others. No explanations. Nothing. Only more emptiness.

This was the level with the mudroom. Where passengers boarded the Zodiacs for nature walks on the shores of cold rubble, where all egress and ingress took place in a most systematic way through the giant shell door in the portside hull. But all the life jackets, and expensive parkas, and muck boots were stowed in their proper cubbies. All gear accounted for, all dry as pocket lint. Not an item out of place. Not the smallest sign of a landing procedure. Here was final confirmation. Permission even, to now officially lose their minds.

There was no more resisting the truth. And yet as Darren's fear and rage combusted, he was still able to resist. He was unable to give up—he was unable to resist—resisting. Moving in tight jerky circles, and throwing his arms about, he demanded to

know who was behind it all. He knew Jay was in on it, obviously, and Mark, but who else? He knew this was all a punk, and a goddamned expensive and vicious evil punk, a punk that was sure to be remembered as a classic, a real epic fucking punk, but if they just came out now and admitted that it was all a hoax, he promised that he would not kill anybody, and that as soon as he got back from a nice week or two away at an inpatient facility where he could recover he was sure he'd be able to forgive.

But when nobody showed up to take credit, he threw Jay against the wall, grabbing his dumb redheaded travel buddy by his stupid black parka with the red zipper breast pocket where, several times a day, he would withdraw his little deck of index cards and scribble down something precious he had noticed or something somebody said that he thought was idiotic or amusing, and then he had a hiking pole in one hand and appeared on the edge of running it through him.

⸺ ⁓ ⸺

WHATEVER DARREN HAD TAPPED into for this scene, I thought, on the point of being impaled, he had clearly taken the same acting advice he had been giving me all along, either that or it was all already closer to the surface, or he had maybe been abducted by his own advice. "I'm going to break your fucking arms if this is some kind of joke," he screamed. "I'll rip off your head and shit down your neck." And then he looked at Mark and shoved him hard enough that Mark had to swerve and huddle to protect the camera with both arms. "If this is what I think it is, I'll make a human centipede out of every last one of you motherfuckers!" I think he's overdoing it a bit, but it's nothing we can't tone down in the editing room postpro.

23

IN SIX HOURS OF FILMING, THE ONE AND ONLY HITCH HAD been when we had run into one of the Filipino staff polishing the brass railing leading up the main stairway. Other than that, which Darren said he could easily edit out, just as he could edit in all the strewn-about cameras, with CGI, we had achieved our objective. We were now excitedly reviewing the footage on Darren's laptop, still in an adrenalized sweat, huddled on my bed. I had not come down yet from hurling myself around the ship. I could still feel a buzzing in my arms, my nerves vibrating under my skin. We had totally nailed the money shot of the empty ship, but Mark could not have cared less. Or maybe he did care. It was impossible to know what Mark thought. He was stretched out on his bed, working on his freelance gig, the exercise video he'd brought along for downtime and that he worked

on in every spare moment. Ensconced under his headphones, and tinkering with color saturation of the woman's fuchsia unitard, he was oblivious to our whoops of victory. I had grown to hate the sight of this anonymous woman and her toned legs and sternocleidomastoids. The rhythm of her extension to flexion ratios. The smile she wore while doing scissor kicks.

Darren was as exultant as if we had pulled off an actual coup. Mark, humdrum as he seemed, turned out to be a brilliant cinematographer. He had worked a feat of sublime horror magic. Each shot of the empty ship was so exquisitely composed it almost atoned for our wretched acting.

Since breaking character it's difficult to shake the illusion that we're not really suspended in some alternative B-movie reality. Even if, looking out the porthole, I can see the Zodiacs returning now, zipping back from the lagoon. I had become so immersed in our own physical performance that I am still in a kind of hypnopompic state.

Darren, sipping a Corona, is eager to "kick it into high gear" and gin up our plot. He's ecstatic with the footage of ourselves going Jason Bourne from deck to deck, but what is the underlying *logic* of our situation? We need to nail down the cause of the mass disappearance, organize our story, find some kind of satisfying rational explanation.

"Rational?" I laugh. "Your problem is you actually believe in causation," I say. "What if there is no ultimate cause? Who says cause needs to precede effects?"

He groans.

"Causation is always theoretical, never directly experienced."

"Yeah, well, I call bullshit. I also call bullshit on you buying that bullshit. You don't believe in anything."

"That's not true," I say. "I believe in the collective unconscious. I believe in the fourth state of matter. I believe in the power of ancient grains."

But I shrug because he's right. I don't find it convincing. But I wish it were true.

He moves on. "Like I said, a horror movie has to have a monster. The monster can be human, obviously, or not. It can be paranormal. It can be technology."

"I don't think we really need a villain."

"I said monster, not villain." He points the neck of his bottle at me. "Don't be hokey. It's Hollywood jargon. It can be anything, not necessarily a monster-monster, but the *monster* is a basic requirement. The monster is a prerequisite."

"Fuck causation," I say. "Once you give an explanation it's over. It's phony. Any attempt to explain *anything* is phony. The only thing people want and secretly crave is more uncertainty."

"There has to be a monster."

"Don't give the audience anything to *interpret*," I say. "No stupid fixed meaning. Just give them the immediacy of our fear. We're not pundits. We don't have to explain anything."

He looks at me. "I guarantee you if the audience leaves the theater without knowing *why* the passengers vanished, there's gonna be a riot. Trust me."

I shrug.

"C'mon. Let's brainstorm."

Brainstorming stupid horror movie ideas sounds like a reasonable distraction from the passport safe and its five-digit code that keeps purring in my head. So over the next hour we quickly rule out ice zombies, sea monsters, evil puppeteers, and all things ufological (though we repeatedly circle back around

to the idea of an alien slave-ship abduction), before we rule out, once again, some kind of mass cult suicide, or grand-scale flash mob mindfuck, and then briefly consider, in no particular order, mutant vampires, ghost Vikings, divine intervention and/or demonic manifestation, ice warlocks, blah-blah contagion, abrupt shifts in the Earth's orbit, and a not-half-bad idea from Darren where it turns out we are among the first victims of the singularity—the ship has fallen under the command of our robot overlords, so all the computerized controls are taking orders from the new AI master race and have wiped out all life-forms on the ship. The viewer wonders, as do we, why we've been spared, until the end when it's revealed that our characters were AI as well all along.

We wonder about a plot where we are being punished for eternity, à la *No Exit*, where we are alone, just the two of us, three if you counted Mark.

After two hours, the only line of script we have written down is: "No, no. This can't be happening."

We consider possible spooky clues we might stumble upon. Namely, when one of our characters, while aimlessly meandering, comes to the door of one cabin cracked open, lights on, and finds dozens of yellowed children's drawings taped to the wall: portentous scrawls, dark-eyed stick figures trapped at the bottom of dark well shafts, et cetera. Then Darren floats the (less convincing) idea about how the source of our predicament might somehow originate from something called the Oort Cloud, which accounts for the regular rhythms of major extinction events, he says, including the apocalyptic dinosaur-killing meteor.

We consider a plotline involving secret weapon testing over

the impending territorial war for control of the Northwest Passage. Mark, in a rare contribution, said he had read something in *The New Yorker* about recent discoveries of a crack in the Earth's magnetosphere. Supposedly caused by a giant solar flare. Such a breach in our protective shield would only naturally account for freak physics near the poles. Unnatural phenomenon and whatnot. Tourists going out in rapture.

"What is the magnetosphere, anyway?" I ask.

Mark shrugs.

Darren tries going online to google it but gives up after a few minutes. We can only get an internet connection during certain hours of the day and sometimes not at all.

After Mark snaps his headphones back on, we snigger, watching him, once again oblivious, zooming in on a gluteal shot.

"How about a wormhole?"

"Caused by?"

"A supermassive particle accelerator," I say. "There's a secret research base up here, operated by CIA-trained Esquimaux. A virus breaks out, high fever, and somebody forgets to move the decimal."

"You've gotta keep budget in mind." A distasteful look crosses his face. "Besides, there are no Esquimaux here. There was never an indigenous population in this part of the world. You're banking on the cultural naïveté of the audience."

He was right. There had never been any civilization built here. No empires. No ruins in the Arctic. It was one of the few places on Earth with more myth than history. I did not think it was so much the cold as it was the fracture of time, the illusion of stopped time, the frozen sun, and so there was no natural

rhythm, and without regular rhythms the human mind cannot operate, cannot locate the required patterns.

I, for one, had definitely set aside the user's manual. My new cold turkey regime had led to cycling through self states faster than I could identify them. On top of the slight tremor, irritability, vague throbby ache in my carotids, and stuttering hypertalk just trying to keep up with my thoughts, which had begun to jag out into the unchartered narwhal-infested depths, the one really notable side effect was a distinct *thaw* in the deep freeze of memory, complete with dramatic calving of cerebral bergs. I kept thinking of my mother and her garden. The can of kerosene she used to drown the Japanese beetles on her tomato plants. Just that morning Darren had come up behind me and clapped me on the shoulder and I had screamed out like an autistic child. The ghostly pain in my shoulder, pain that mauled my shoulder, was migrating wildly. First it was my right shoulder that was frozen, then my left. Things had started to come into unwelcome, unusual focus, everything just a little too *visible*. For instance, I beheld, embedded in each tiny pinprick of sea spray on the cabin porthole, not only the reflection of the intact sun but inside each globule a tiny grain of dark energy. That sort of thing. I was always on the verge of losing the staring contest with the face of what I had determined was the Infinite Real, but the thought of looking at it directly scared me so badly I thought I'd go blind, go insane, or turn inside out like a vampire caught in the sun.

What if, I said, what if the others were *converted into light* and shelved in a new slot of the electromagnetic spectral ribbon. Perhaps there is a mysterious rainbow visible the whole time we are drifting . . .

Darren took up another area of inquiry: the magnetic property of blood. Some evil genius had figured out how to isolate and manipulate the iron in our blood, harnessing the force that existed inside us in such large and diffuse quantities. If concentrated, you could probably fuck up a life-form pretty badly. I had to agree, though I also had to admit I had never taken the idea of iron in the blood literally and now felt a little stupid, realizing it wasn't just a vague vitamin called "iron" but an actual metal.

"It's what makes our red blood cells red! It certainly exists at levels capable of being manipulated, so if we could harness that magnetic force . . ."

"So yeah," I say, warming to the topic. "If our monster was able to alter the magnetic field, using some kind of giant magnet, whatever, maybe the ship passes through it, or maybe the magnetic field itself is hacked, but what if the effect on the blood of the passengers is so powerful and instantaneous that all the iron is spontaneously attracted and *fused*. Everybody, all 165 of our fellow ecotourists, are spontaneously de-othered. Bonded into a huge blob that then rolls over the bow in a final Arctic plunge. A giant clot, like a massive blob of chum sinking to the bottom and nipped apart by a pod of minke whales."

"You had me at hello on this one," Darren says, "but maybe it's a little too complex." It's a lot of exposition to get across, and hard to swallow our characters would have that kind of biomedical knowledge at their fingertips to solve the riddle, presuming the internet would be down during such an event.

I am thawing out way too quickly, as if, indeed, the walls of my cell membranes were dissolving, my blood in a state of meteorological crisis, a freak weather system that ached and

even itched. As if, after being frozen hard as iron for an eon, sensations I did not even know I possessed had returned in a bloom of agony.

I feel my own quarks splitting. My gluons coming unglued.

When I look at the woman in Mark's video, her neck and face flushed, midcrunch, I have the strange but convincing feeling, even through the screen, that her blood is somehow speaking to me, as if it is conscious, that is the word that comes to mind, as if it has its own mind, or will, and is somehow communicating with my blood, telekinetically.

We move on to consider the plausibility of some tech giant experimenting with photon communications. Working on the next level of quantum data storage. But it's only in beta and accidentally uploads humans into the cloud. Or, wait—even more sinister. An evil hacker uses it to hold people hostage! Actual, literal ransom malware.

"People fucking transformed into data, held hostage in the cloud."

"The monster is information. I'm intrigued."

Or a benign but covert operation to save the planet with some nanotech device meant to sequester carbon emissions but it goes amiss and ends up devouring all the carbon-based biomass on the ship. It happens while the passengers are all out on the bow during a beluga whale sighting, and we're belowdecks, on a tour of the engine room, which reminds Darren that he'd tentatively scheduled a tour of the engine room.

He looked at his watch. "It's only first dogwatch. We're cool."

"What if we find hieroglyphs in the engine room?"

"Jackal-headed priests, smeared in seal blood. Turns out

the Egyptians made an expedition here during the reign of Sekhemkhet in the Third Dynasty."

"You know the Mormons own Ancestry.com?"

"Really?"

"Yes. It's an established fact. You can google it."

"I believe it."

"They send you a DNA test kit so you can upload your DNA to the site, even though a lot of people are understandably freaked about how the Mormons are going to use all that information. What if it turns out everybody on the ship had unwittingly licensed their DNA to the Mormon Church?"

"No more uploading ideas. No more cyber shit."

"Oh. I got it. A time machine."

"Time machine?" Darren says.

"Why not?"

"What, like fuckin' *Back to the Future 3*?"

"Sure. The flux capacitor."

"The flux capacitor? But the internal engine runs on ordinary gasoline."

"It always has."

"Great Scott, there won't be a gas station around here until sometime in the next century."

"Without gasoline, we can't get the DeLorean up to 88 mph."

"So what do we do?"

"It's no use, Marty!"

Darren recalls the seed vault in Longyearbyen. We'd seen it on a brief tour of the town before embarking.

"What if one of the seeds is a mutant strain? A radioactive GMO. Or an ancient kernel of maize with a curse put on it by an Aztec priest a thousand years ago. We show all

that in prologue. It's the priest's revenge for his daughter being sacrificed. We show the girl, the knife, the grieving enraged priest doing his witchcraft. Then cut to present day, you see the young, telegenic scientists hacking their way through the rain forest, bagging a sample for the seed vault." He mimes a tweezer and vial. "The curse thaws the permafrost and releases some kind of Mesoamerican kraken that's been frozen in the Earth for the past million years. But I guess that doesn't really account for missing passengers. Maybe the seed just opens up a wormhole."

Maybe. But, meanwhile, I can feel my own thaw accelerating. As if the cursed seed had fallen into one of my crevices. A splayed labyrinth of fine cracks, a webwork that has already begun to melt at the core, the capillaries running deep, turning into rivulets, widening out in a slurry of rapidly thawing muck, chunks breaking free, bits of gravel coming loose, all the filth and little shark-eyed polliwogs rising to the surface in pools of foamy scum.

"What if we were *meant* to survive?"

"A targeted experiment. We're the subjects."

"Yes! Subjects chosen well ahead of the cruise, recruited unwittingly. CIA. FSB. It doesn't matter who. Cultivated and monitored for years. Carefully groomed. Nothing left to chance. Everything in our lives leading up to this—but we don't suspect a thing."

We both slip into a paranoid lull.

Darren goes and stands in our tiny bathroom. At first I think he's examining himself in the mirror. Then I realize he's examining the mirror. "Do *they* have agents on board?" he says, trying to pry one of the light shades free.

"On the boat?" I smirk at Mark, who remains oblivious under his headphones. "What if it's the DP? He's a plant."

"On the *ship*!" Darren shouts. "*Never* call it a boat." He gives up dismantling the mirror and storms back and for a second I think he's going to cuff me. I step to the door and cautiously peer out the peephole.

I stand there a good long time until I'm ready. I have prepared a scene.

I unbolt the door; then turn around and stand in the open doorway, one hand coquettishly placed on the frame.

I look into the room as if I have just entered, and hold his eyes for a beat, but in such a way to let him know that he is not there, that he is invisible. My gaze trails across the bed, the nightstand.

Then, as if drugged, I take a few reluctant steps into the room. Not as if I expect to encounter anyone, or anything, but as if I have the room to myself. I have been on the ship for weeks, maybe months. I take idle inventory with my sleepy eyes.

"The moment before. In the corridor. The camera drops in on me wandering," I say. "Aimless. I move with no purpose. In a state of spiritual decomposition. The camera follows me down the corridor. At a leisurely pace. I have a drink in one hand. You can hear the ice cubes clinking. I move slowly to keep it from sloshing. You can hear the slam of ice battering the hull."

"That's good. Nice touch," Darren says, one leg crossed at the knee, leaning forward, studying what I'll do next.

"But I look completely unfazed. Almost as if I don't notice the ice, which sounds quite violent and dangerous now. But keeping my equilibrium is just an automatic function now. I'm

oblivious to the grinding ice against the hull. I do not even look capable of fear anymore, not that I'm numb, but more that any will I might have once possessed is gone. That a part of my will has been absorbed or reunited with the sacred wilderness that encircles us in rings of ice and rock. You can sense that. I am not the same as you found me at the end of Act 1. Not numb. Not exactly surrender, but there is a new process at work. We've been on the ship so long, we've lost count. It could be months. We have no idea. But it's still summer, because the sun still never sets. Or maybe time really is stuck. That no time has passed at all. And then you watch as I stop outside this room."

"Right," Darren says. "By now, obviously, we would have found the master keys I think."

"Exactly. I am exploring the ship. Unlocking rooms. Moving down the corridors, going door to door, as if I have all the time in the world."

"Not rushing at all."

"Not rushing at all. You see me maybe stop in one room. I find a bra draped over the shower curtain and hold it to my face. You see me going through these left-behind personal belongings. As I pick up each object, everything is pregnant with repressed feeling and loss. Intimate objects, now orphaned. I'm like a tranquilized Judith to your Bluebeard. You are up in the tower of the ship's bridge. As I move about the ship in a trance, searching the forbidden rooms . . . But, now, I enter this room. There is nothing special about it. It is just one among many empty rooms. I stand in the middle of the empty room and take it all in. It's exactly as it had been left. It looks occupied, but of course, it is not. Abandoned suitcases, et cetera. I glance

at the clock. It reads the same as all the clocks on the ship. 8:46. But by now the audience knows that time no longer has any hold on my character."

"How about my character?"

"You're still preoccupied with time."

"Good. Okay. Very good."

"Now I go over to the nightstand. A glass of water is left from whoever last slept here. An unmade bed. A book."

I pick up the book. It's my copy of what everyone on the ship is reading, one of the titles on the recommended list that came in our travel packet. *A Woman in the Polar Night*, by Christiane Ritter. It's actually a very good read; I read it on the plane. Ritter was a well-to-do Austrian *hausfrau* who joins her husband in the 1930s on a yearlong overwinter to the northern tip of Svalbard to hunt fur. Mostly for white fox, which was all the rage then in Vienna. They live together, with her husband's weird Swedish friend Karl, in "a small, bleak, bare box," where she bakes a lot of seal pies and struggles to come up with adequate words to describe the frenzied gloaming of the northern lights. At first she compares them to a Berlioz symphony but then says the bewildering strangeness was more like witnessing "a serenely smiling man commit murder; murder everything that comes within range of his smile."

I go into the bathroom and bring back my toilet kit and dump it on the carpet.

For this, Mark actually pauses editing his exercise video to watch, as I kneel before the contents. He looks to Darren as if to ask if he should be filming, as I begin to compose the assortment of pills into a mandala, but Darren shakes his head.

I suspect he is too afraid of interrupting, curious what divinations might come as I arrange my concentric rings of Zoloft, Benadryl, ibuprofen, valerian, Preparation H capsules, tablets of melatonin, using Q-tips as rays. I consider going into the safe to create another ring, but refrain.

Once satisfied that it is symmetrical, I stand and go to Mark's closet and look at the clothes hanging there. "Now I take out a woman's dress," I say, as I take out one of Mark's blue checked shirts.

"A blue dress," I say, laying it down on my bed, almost ceremonially. Darren stands up to make room for me and now watches from the corner with arms crossed. I patiently smooth out the wrinkles, flattening the shirt on the bed, stroking the fabric as if I have all the time in the world, as if each desolate furrow deserves my entire and eternal attention, and then I lie down next to the empty shirt, as if trying not to wake it, and gently put an arm across its waist.

Then I close my eyes, and after a long moment when I don't speak, Darren says, "Okay, well, that was interesting, but we still need a plot."

With my back still turned to him and Mark, staring at the wall, I feel my face burning. I suggest maybe he would be happier if our monster were the ghost of some doomed whaler or Victorian explorer. I hiss: "Every time we sense his presence—a cold, malevolent gust—we can smell the rum on his breath and you can see icicles of frozen snot in his beard and his gums black with scurvy. He leaves a trail of blackened, frostbitten fingers everywhere he goes. At one point he breaks off his dick and hands it to you as a gift."

When I turn over, Darren looks at me, trying to decide if I'm serious. Mark retrieves his shirt and hangs it back in the closet. I assume he will reiron it later when I'm not around.

"What if it's your father's ghost?" he says.

"My father's not dead yet. He's dying."

"I know, but just, like . . . the idea of it." Darren looks at Mark's screen as if he's getting bored. "You bring him onto the ship, his spirit, like a curse."

"Seriously fuck off now."

He suddenly wags his finger. "Holy shit!"

"What?"

"The briefcase! Maybe *we* brought it on board. What's in the briefcase?"

"We brought it on board?"

"Without knowing, somebody swapped it on us. The old switcheroo at the boarding dock. Whatever. The nanodevice. Or the Aztec curse. What's in the briefcase?"

"Wittgenstein's box," I say, sitting up now, and trying with difficulty to ignore the passport safe: the only box that is calling my name. Its five-digit code unstitching my head at the seams.

He looks at me, expectant.

"Wittgenstein's box," I repeat. "His mind experiment. Inside the box is a beetle. The beetle is a metaphor for the mind. And yet it always remains invisible to the other. You can't see mine, and I can't see yours, so how do we know for sure that the other really even has a mind. I personally don't know which is more terrifying, the idea of being the only one with a mind, and finding out everyone else really is a zombie, or the idea that everyone else has a mind that's more or less identical. Making for a great redundancy of consciousness."

I wonder if there is a name for the phobia of *other minds.*

"Dude. Jesus. I fucking hate bugs." He shudders. "The idea of a giant beetle, *Jesus*, that gives me the fucking willies. If you ask me, that's gonna be the worst part of global warming. People don't think about that. Rising floodwaters, spread of disease, unbreathable air, fine. But what people don't realize is bugs. Giant bugs. I'm talking late Carboniferous monster bugs. That's the kind of thing that makes me want to blow my brains out before it's too late. Quick. Please." He swigs his beer. "Give me something else to think about."

But we have run out of ideas, and so he turns and punches Mark in the arm. Mark removes his headphones and looks up from the woman mid side-plank. "We should go do some interviews, Marko. Get some sound-ups."

Mark starts putting on his shoes.

Darren gives me a malignant look. "You can come, too, if you can maybe start to pull your own weight. Interview a few passengers without looking like you want to kill yourself for once. Actually. Forget it. I think we're good. You stay here and have a nice read or something."

"Why bother with sound-ups," I say. "Let's just dub it. The Arctic foxes were AMAZING! It was all so INDESCRIB-ABLE! The *Campanula uniflora* was EXQUISITE AND DELICIOUS! The landscape was PRISTINE! As if you could describe something rotting before your very eyes as FUCK-ING PRISTINE! The hot cocoa they gave us when we got back was an EXPERIENCE OF A LIFETIME!"

I am left behind shouting at the door.

24

WE WERE STILL WAITING FOR THE IDEAL MOMENT TO
shoot on the bridge. There was almost always a small group of
tipsy passengers, usually older men, many who likened them-
selves captains of their own respective hedge funds or tech firms.
They loitered on the bridge with gin and tonics, peppering the
captain with questions about stabilizers and gross tonnage, and
then, like little boys, demanded that their wives take their pic-
ture in the captain's chair. I felt embarrassed for the captain. I
had no idea how he put up with it. It seemed degrading that
his job required having to put up with that kind of nonsense
on top of just having to keep us afloat. Wasn't it enough to be
competent at your job without having to put on a spectacle?
Either way, we would take over his bridge and get what we

needed when it was sufficiently deserted. It would have to be one day soon, when the captain was at lunch.

We had staked out the bridge enough to know that half the time he left for lunch he only left behind a skeleton crew of one. In the meantime, Darren said, we could get a few more moody shots of me in my fey state of crumbling surrender.

Since his directing, last time, he had honestly helped me to dislodge something I felt curious about exploring more, and so now he had set me out on the deck where I could be exposed to the elements, weakened by the cold and overwhelming sublimity of passing fjordage. But after a few sensory exercises, he said I looked too uptight.

He liked the work I had done the day before. I had really done some top-notch evoking that had majorly triggered his peristalsis; I had reached right in and given it a good squeeze, really telegraphed my psychosis, and made him feel like he had witnessed something almost unspeakable. But now he wanted to know if I could go for something a bit stronger. The obstacle, he thought, was my inhibition in front of the camera. He felt if I could just let that go that we could unleash a real eruption of primal terror.

The key of course to staying relaxed and not letting my anxiety, that is, fear, get in the way, and block me from evoking the requisite dramatic fear, was to remember I was merely an acolyte in the service of a higher art. He told me to remember the relaxation exercises. This was one of the big catch-22s of moviemaking, he told me. I needed to eliminate fear in order to purely express fear.

"Let all that tension go, Kirk. You can't act when your chi

is all clotted up." He guided me through a body scan while I got into position stretched over a life jacket chest and he took his light meter readings.

"We've got to eliminate any involuntary nervous energy that interferes with your total expression," Darren says. He had me locate the greatest areas of tension, and then visualize letting them go. "Fear is the enemy of your instrument. You need to find the fear, yes, but you must relax first to concentrate. And you must concentrate on relaxing. You can't find the fear unless you're fully relaxed and fully divested of actual fear. It's a major paradox, I know. But this is exactly what all the great acting coaches will tell you."

He did some kind of qigong thing on my forehead, lightly brushing my skin with his fingers, or maybe his fingers did not come into actual contact, even though I could feel a tingling sensation, and then stood back.

"Okay, now for the crushing incomprehensibility of it all," Darren said. "*Really* get in there. You're on a ship. No one is here. This is what, Act 2, Scene 1? Doesn't matter. We're just pantsing it now. We can resequence everything later. But this is a beat well after we've discovered it's our basic situation. This is where you're struggling to let it sink in. Reality is breaking down. After our situation becomes *irrefutable*. Can you do irrefutable? All the others have vanished. Just *poof*. You're drowning in the deep inexplicable. You're about to hang it up. Maybe you've just gone through all the cameras that were left behind, scattered around the deck. You've gathered them all up into a giant heap, looking for any kind of clue. You've just finished going through every single one, one after the other, toss-

ing them aside. Don't worry, I can put that in postpro. Just act like they're there. Show me how you hold a camera."

I mimed for him best I could turning a camera over in my hands, forwarding through the pictures, fiddling with the lens.

"Great. But as you go through them, maybe you discover that every image is blank! Every picture mysteriously erased. Most likely some kind of magnetic surge. *Marco, write that down!* But, yeah, you've reached the point of utter hopelessness. So, okay, let's do take one. What I want you to do for me now is I want you to communicate a sense of ultimate horror with your entire being. Nothing less."

The lens of Mark's camera was two inches from my face. My eyes were tearing up in the wind. Darren gave my shoulders a quick rub, then stood back. "You've been left behind. You're on one side of a canyon and the rest of the world is on the other. All you know is you're stuck on the wrong fucking side, like *forever.*"

I went for the hole again.

Briefly I get blocked, but then try to summon, for starters, a clump of dirt. When I have the dirt, cool in my hand, I can feel it dribble through my fingers. I see grains of sun-flecked quartz and microspecks of leaf and organic detritus. I can smell its dirt smell. Frayed bits of gossamer rootlet. I even get a worm half started. The aroma has a kind of electric charge, a cold smoke scent. When I hear cursing, I look up toward my house, the parsonage, and see my father dragging out our hobbled, three-legged grill from the garage, the plastic wheels sputtering across the gravel driveway. He pulls it violently, as if dragging a prisoner out to be shot . . .

The sailboat is still hitched to the car, its trailer parked at an odd, haphazard angle. It is the newest, nicest thing our family owns. We are not in the habit of new, nice things. I think my father bought it for Mother's Day, or her birthday. I see colored streamers? Red and blue. Flags? Not sure. But the boat. I am pretty sure my mom had not expressed any desire for a sailboat. Not to say that my father had been devious, that he had used the pretense of a gift for my mother only to buy himself a boat. I'm sure he sincerely believed she would enjoy it, since she had grown up on the water, her family had owned a boat, and perhaps that would have been the case—fun—had it not so quickly cursed our family.

It was, I recall, and I can see now, from the low vantage of my hole, a resplendent blue, glittering indigo. The most mystical hue on the visible spectrum. The fiberglass hull gleamed as if crushed mirror had been stirred into the epoxy. In the driveway, still glistening from what must have been a morning sail—a vague memory itch here makes me squirm uneasily on the cold deck. The sail itself was sodden, heavy with water, clumsily wound about the mast, like a shrouded corpse bound to a horizontal stake.

After he dumped out the dusty briquettes in the grill, tossing aside the crumpled bag, my father went back to the garage to get lighter fluid. He came back with two bottles, limping and grumbling like a castrated bull. One of the bottles was nearly empty and he wheezed out the last of it, tossed aside the empty, and tore off the plastic ring of the second before thoroughly soaking the briquettes. His whole being expressed a kind of disgraced demented fury. As if every inanimate object in the world had declared war on him alone. I was glad to stay

out of his sight, hidden half buried in the field, but it is now a
flash of white catches my attention, in my periphery, and I turn
to see, at the far end of the field, coming from the direction
of the asylum, WNW, the figure of a man searching through
the weeds, whacking at the tall trash grass with a stick, maybe
an orderly trying to flush a patient. But when he sees me, he
abruptly drops the stick and starts moving purposively in my
direction, one hand sheathed in the pocket of his coat. His
jacket is blinding white. He gleams like an angel. This time I
will wait, I decide, to see what he has to say, or at least I will
wait until I can make out his face. But then, before I can clearly
make out his face, I start to panic, and I try climbing up out
of the hole. But I have dug too deep this time. I have outdone
myself. I shout out for my father but he doesn't hear me, he is
too busy trying to light a match. When it finally strikes, the
veins of glittering indigo swirl crimson. The fire bursts upward
and the birch in our yard recoils. But despite the furious blaze,
and billowing smoke, my father continues to douse the flames
with prodigal gushes of lighter fluid. As if daring the flame to
piss back up the stream and explode in his hand. He continues
squirting until the whole bottle is empty and he tosses it aside.
I can hear my brother screaming inside the house, and I watch
my father clearly counting to ten. Then my father stalks off,
looking ready to kick the dog if he hadn't already committed it
to the mental hospital.

I still can't climb out of the hole, and the man in the white
coat is now almost upon me. I can see a little round mirror bob-
bing in his breast pocket. It sends off slender daggers of light.
Each time I try to get a foothold or grapple my way out I only
bring down another avalanche, so there is nothing to do but

crouch down in my cool burrow and hope he loses my scent. My father has returned inside the house and I hear a window slam and my brother's crying is muted. The next time I peer out of the hole, however, the man in the white coat is half-way across the field; he pulls something from his floppy white pocket—*A bone? With pincers?*—just as an announcement crackles over the PA.

A walrus sighting off starboard. Darren shouts, *"CUT!"* I am yanked up out of the hole as we rush to the bow.

We can smell them before we see them—the blubbering burly monsters. Turning somersaults, thumping the water, tusks swagged with seaweed. The stench wafting off their play is an atrocity. They are nearer in size to elephants than any large bovine, and something in the collective fetid body language suggests that the walruses must be brothers. I still feel dazed, fazed, in a swoon. This will be great for the TV show, Darren says, as they carol us with triple-throated barks. But I know there's no way this spectacle will ever translate to the screen. This kind of thing never does. The walruses not in the water laze on a barren gravel spit, voluptuous and rank as dying fertility gods. They bore of us before we bore of them. That's the way it goes with the so-called charismatic megafauna, the ones who get top billing for these so-called experiences of a lifetime. Even in Rwanda, when Darren and I had paid through the nose to see mountain gorillas, we were bored in thirty minutes, ready to head back to the resort to start drinking.

When we return to our spot on the deck, it has been usurped by the half-dozen teenagers who have come along with their rich grandparents, not so surreptitiously sipping tequila spritzers, and they hector Darren to film them, to document

the spectacular slutty fun they are having, but Darren doesn't feel like negotiating and tells them that's what selfies are for, and we go in search of a new spot, which is how we end up on the empty sun deck, just below the window to the gym. I can see two women bobbing on ellipticals. They stare out at the gray wake. It will be easy to frame them out of the shot, since Darren is going for a close-up of me, anyway.

Since we have to start over, and he has to light meter everything over again, et cetera, and make a number of other minute compositional decisions that seem to take forever, by the time he's ready for me he's impatient and tetchy.

"Okay, let's go for harrowing." Darren tells me to lie on the deck.

"It's wet. No way. It's too cold."

"Do it."

So I lie down. After all, he is the director.

"Okay. Go fetal."

I go fetal.

He kicks me in the hip to bring tears to my eyes.

Curled on the deck, I stare sideways at the ocean, the hypnotic swells, dark green rolling cold, a heaving maze of ice lobbing upward and slabward, lifting and falling. Darren does not bother to have me go through the relaxation exercises but only pushes Mark closer in as I attempt to refondle the handful of dirt I had begun to conjure before the walruses had interrupted. All I get is a choppy field of puke green. When I look for the hole, it's not there. My attitude indicators are all over the place. I can't tell pitch from yaw as I scan the horizon, looking for one of those black calving bergs, the sudden thaw of memory. And yet, with the cold deck against my cramped

side, and my eyes pressed shut, I feel something small and pebbly cave inward, a thin trickle of dread, a gust of wind down a funnel of black, at the long end of which I catch a glimpse of glittering indigo, indignant indigo! IRIS SHOT IN: fiberglass hull lapping the waves, on a wind-tossed mountain lake. The blinding white of virgin sail, snapping violently in the breeze. I see my brother's turbulent face, his collar flapping spasmodically, as if his head were stuck in a wind tunnel. I see my father cleating the mainsheet. A crisscross of taut rigging and convoluted, baroque knots. All showroom gleaming. My parents' new sailboat, a fourteen-footer, emphatically *not a ship*. Not so much as a cabin to take shelter from the sun, just a cranny to stow the life jackets and beer-stocked cooler (and a few bologna sandwiches) under the bow. It was the kind with a removable centerboard, not even a proper keel. My father was from the Midwest. A landlubber. He was the preacher child who had emerged from a million-acre maze of sun-scorched corn set aflame with the Holy Spirit. He had never seen a body of water larger than the Wabash River until he met my mother, who had grown up digging for clams on the weekend with her supremely competent father. Sundays on the Great South Bay. Her family had a small yacht named the *Happy Hour*. Perhaps my father bought the sailboat to show that he too could command a vessel like his more commanding, industrialist father-in-law, or, just as likely, to keep up with his yuppie parishioners. Maybe snag a membership at the marina where the hooch was top-shelf.

With a heaving sensation in my stomach, what my castrating midwestern grandmother would have called the collywobbles, I can see my father gloating, one hand on the tiller. I

remember the wind seething over the ropes. My mother wears a matching red white and blue T-shirt and shorts hideously spangled with the American flag. Oh dear God, the Fourth of July! I look back at the shore with a mix of terror and envy at the other families who had heeded the small-craft warnings. I see colored bunting tacked up to one of the picnic shelters tattering in the near gale. Scraps of grill smoke shredding westerly. A flag on a pole clanking and luffing, also westerly. Dogs running up and down the beach. The sky a rapture blue. Fathers with the day off and nothing to prove except their better judgment. As far as mine was concerned, the warnings on the marine weather band were only meant for the likes of the meek parishioners he despised and whom he only pretended to love when he was elevated above them on his pulpit. I picture him now at the helm in his robes. Billowing like black sails, snapping westerly. I see him gently easing out the mainsheet, the blinding white line in his hand, the same hand he raised above us during the benediction, the best part of church since it meant it was over. However silly, to picture him *attired in his divine garb*, for this nightmare day on the lake, what, thirty years ago, I still childishly wish this were how he were garbed instead of in his shabby day-offs T-shirt, grungy shorts, behind the tiller with his blotchy scrotum clinging to the molded fiberglass. Even as I look on from this memory hole I have burrowed out from under the Arctic Sea, I resent him for too comfortably inhabiting the profane, for letting himself be sacrileged in my memory, for bringing the wrath of Yahweh down on our heads. Well before this day, I know that the idol of my father had begun to tarnish in the corrosive acid that leaked from my queasy child's heart. Even if I could not have explained it, then, I can put it quite simply

now. I had begun to fall out of love with my father. I had begun to hate and detest him for his falsity, for denigrating his sacred calling, something I myself wanted more than anything, a calling. How could he squander his own calling? How could he choose to give in to his basest instincts? Whose only apparent motive was to nurse his delusions, to shield his easily wounded ego, just to protect his central defect—the scabbed-over hollow at his core—and to malign anything that might inadvertently expose him. For instance, Exhibit A, his own faulty offspring, we lame counterfeits, who by only breathing divulged the flaw. We were the visible reminder, the glitch he could not mask. But even then I knew, somehow I knew, that to bear one's humiliating wounds with purpose, even *virtuosically*, was part of the job description, the calling of a real minister. A true priest ministered to his or her own wounds by letting them breathe in the open, letting them stretch wide their suppurating mouths to sing, to transmit the sacramental pain to the ears of the unsaved. A good pastor showed his flock how one's secret wounds must be exposed, loved, held up to the sun, not kept in the dark to fester. But instead of performing the ritual correctly, by showing off his own wounds for the doubters to probe—even, if necessary, *to be the hole that fit the nail*—my father had filled his own with bluster. He should have attired himself in the hole, draped himself in that sacred empty space that encircled the nail. But he had turned his shame on us, his sons, whom he blamed for our visibility, and with whom he was as vengeful and erratic as the wind that now caught us off guard and forced him to abruptly change course, to tack, hauling on the tiller without bothering to alert us so we barely avoided being

knocked overboard by the boom when it swung and we came about, the sail lurching from port to starboard.

We had been sailing close-hauled, on a starboard tack, WSW, and I remember feeling happily enchanted, spacing out on the sky, staring at the top of the mast and out the corner of my eye the sun, a star, I was realizing, our sun is a star, wondering, mystified, as I forced myself not to look straight at it, how strange that we should be forbidden from looking directly at the thing that gave us our very existence, as if it were taboo, when my mother shouted for us to duck and all had gone spinning as we scrambled from one side to the other, to shift our weight, as we were now going on a port tack, WNW, but the boat immediately began to heel. That is, we were flung in this new direction, at terrible speed, riding on an extreme and unwelcome diagonal. A most menacing tilt. We had already scrambled to get our weight up onto the side, out on the very edge, to counterbalance the severe heeling, even as my father was barking at us to hike our weight out farther, to stick our butts over the chasm. Even with his own weight, equal if not in excess of the combined weight of his wife and two feeble-bodied sons, we were no match for the force that pressed the mast near parallel to the blur of water. My mother was shouting at him to trim the sail, this being the quickest and most obvious remedy to our predicament. If he only let out the sail, spilled off some wind, we might avert certain disaster. But in his senseless haste to turn about, and his general disdain for protocol, he had stupidly left the line cleated on the other side, when he should not have even let it out of his hand. An amateur mistake. The rope was out of reach. He had left it tied off on the starboard side.

And now in his angry-fool confusion, as my mother shouted *John, we're going to capsize! John, ease the mainsail!* he was too overwhelmed just trying to control the tiller, which he strained and pulled with all his clergyman's strength, as if he were plowing a field of fast-drying cement.

My mother could do nothing, as we tilted higher and continued to plummet onward at this absurd and cataclysmic slant. I can still see dirt under her fingernails, from working in the garden, as she grasped the fiberglass. The three of us hung out over the edge like ballast. My brother was caterwauling, less a scream than haggling sound, as if his head were slowly being removed with a handsaw. My heart was beating so fast it felt as if the spikes had flattened into a single quivering string. The whole ordeal felt like a carnival ride gone haywire. We were on a horizon gone sideways. My mother was between my brother and me, both of her strong hands clamped to the side as we rose, not just to anchor herself but because my brother was climbing up her like a cat climbing up the sinking conning tower of a submarine. She held on as rigidly as if she were turning herself into a tree. It was at this point, as my father yanked on the frozen tiller, and roared at us over the rushing wind that sheared away all sense to cantilever ourselves farther out, that it became clear to me that his real intent for bringing us out on the lake was to murder us. I suddenly understood this as clearly as I had ever understood anything up to this point in my short life. Obviously, it had been his plan all along. A premeditated plot to rid himself of his sons. To destroy the evidence. I readily accepted this as the only possible explanation.

When my mother yelled again for him to untie the mainsail, over the now outright monstrous screams of my brother,

even though it was hopeless, and she could see that he couldn't reach the line, at least not while he was engaged in his battle with the tiller, he only gave her an irate and hateful stare. As if it had been she who had stupidly tied the line out of reach.

It was then she turned to me, and somehow spoke through or over or maybe around the wind, as calmly and clearly as if we were alone, just the two of us, sitting in a patch of sun on the lawn, enjoying the stillness of a lazy afternoon, and as if my brother were not shrieking as if he were being dragged to the chopping block, so that I could plainly hear the critical important immediate thing she was telling me that I had to do.

Since she could not remove her own weight to go after the line tied out of reach below, she needed me to go down to retrieve it. It was up to me, the eldest son, to make this perilous excursion. I would need to swallow my terror and rappel down the steep face of the canted deck. But that meant somehow first prying myself loose from the hoisted top-end of our flying virgule. The cleat, from where I clung, looked like fangs.

As I began down, I inched backward, using the rubber grip of my sneakers and bare elbows for traction, concentrating my entire will on not falling and going tumbling straight over the plunging starboard. I only glanced up once to see my mother, looking far away to me now, haloed by blue sky, watching me with a look of mortified alarm, while my oblivious brother clawed at her rigid body. Holding on to the juddering tilted deck felt like clinging to the side of a massive gull that was banking with one wing, the keel, slicing through the water. I half slid, half clambered down. Hugging the deck, I could feel the surge against the hull thunking in my chest, the demonic gurgling of an ancient glacier-carved lake just inches below.

As I crawled beneath my father's knees, I glanced up to see him locked in his contest with the tiller. His shirt rippled like an ugly dead skin trying to slough itself free. He was using both arms to wrestle the tiller now, and the strain of it had him lifted on his toes, off balance, clearly overpowered, as if for sure it would snap off in his hands.

When I felt my feet touch bottom, against the starboard gunwale, I carefully turned myself around to face the shock of water speeding by in extreme proximity. It rushed past as if we were circling the inner wall of a maelstrom. Caught in a monster whirlpool pulling us down into the core of the Earth. I could feel the sucking force of it already starting to break apart the boat. The tensed sail, tipped against the waves, was like a great disembodied tympanic membrane, straining to receive the unthinkable transmission originating below.

I set to work on the knot. Instead of a proper cleat hitch my father had tied a clumsy blood knot. A knot more apt for joining a halyard to a shackle or block, harder to untangle since wet. After a minor struggle, however, it came free, and, at once, with a violent shudder, the sail launched in my hands. As if I had pulled the ripcord without being fully prepared; for an instant I thought for sure it would jerk me from the boat, but at the same time the boat leveled, equilibrium was restored, and my brother stopped screaming. When my father shouted at me to hand over the rope, however, as the sail fought against me, as if I had lassoed a flying horse, I found that I was not ready to let go.

The elemental force in the leashed sail tugged, but I was no longer afraid. I realized I could hold on to the rope without fear of being ripped from my moorings. We were equally

matched. The sail bulged like a silent instrument gathering up the full emptiness that surrounded us, the same simple full emptiness that my father, perhaps, should have garbed himself in from the beginning, instead of his stained and unhallowed T-shirt and shorts. I could hold the rope as long as I wished, for as long as the sail wished, it would not overpower me, we were in harmony, and I was not about to surrender that yet. I was so very awake now, so tremendously awake, splashed with the cold fresh lake. It dribbled from my lips, dripping from my eyes, which had been rinsed clear, repurposed with a vision of annihilating joy but one that I also knew had come at the cost of usurping my father. I could see how he had aged, how old he had suddenly become, and when I placed the rope back in his hand, at last, I saw the surrender in his eyes, I saw defeat, and I saw that he knew, as did I, that a transfer of power had taken place. The transfer was complete. I could also see how he wished he had just killed me when he still had the chance.

25

It was possible we were done with the horror movie.

Personally, I had sworn off any more sensory exercises and holed up in my cabin to read *Frankenstein*, with the flat-screen above my bed tuned to Channel 5, which showed the blustery view from the crow's nest camera. Darren, in the middle of his own minor crisis of confidence, had gone back to doing interviews for his travel show. He'd decided he was getting too old to be goofing around on anything that didn't speak directly to his bottom line. But, yeah, personally, the day before had touched the cold root of something I was just as happy to forget. Which was probably why I had ultimately lost the staring contest with the passport safe before wandering outside onto the empty sun deck.

At least I had it to myself. A warm spot in the sun, sheltered from the wind below the funnel stack. A chaise longue with a view of the herringbone wake. It was once I settled in that I took the pills from where I'd cached them in my zippered breast pocket, four in all. Four times what I had got myself titrated down to before going cold manic turkey. Stacked between thumb and forefinger, and held close to my eye, they blocked the sun like a miniature dolmen.

The mind cannot bear it, I thought. *That was the real reason nobody would ever settle this far north.* It wasn't the cold. It was because humans could not endure such relentless light. Perpetual darkness would be a billion times easier to endure. The sun is a horror because permanent wakefulness is a horror show. I had read someplace that the most ancient fear, the most primal anxiety, was the fear of the sun setting and never rising again. The world's first neurotic thought. But, for me, if the sun came up *and then never set again* would be a far worse scenario. The subconscious itself would wither and die. Only raw unmitigated consciousness. It would be unbearable. Permanent daylight. No more refuge in dreamworld. No more midnight quiet. Especially terrible for us humans, who were, at bottom, a burrowing and underground-minded species, a primarily symbolic-minded species. Such levels of undiluted consciousness would guarantee planetary suicide. *That could have been our monster*, I think. Fixed in the sky, the monster is a sickly halogen orb, with its own twisted motive, its own perverse will, hidden in plain sight the entire time. The evil of eternal recurrence, permanent solstice. I make a mental note to pitch the idea later to Darren.

While I let the pills dissolve under my tongue, I return

to my book. I'm at the part where the creature is holed up in the hovel outside the cottage, where he can eavesdrop on the family through a chink in the wall. It comes as a real relief for him to discover there are other sensitive souls in the world, after being chased from one hostile village after another, beaten by the mob, forced to fend off stones, pitchforks, the spittle of crones. At first we think, along with the creature, that they are just kindly peasants, but soon enough learn that they are really French nobility in exile. They have come down in the world. Like him, they have suffered banishment. They have joined the march of global refugees. Still, he is timid and too afraid to approach them, he fears rejection, and so night after night, from the asylum of the hovel, he watches as Agatha or Felix take down the guitar and put it in the blind old man's hands (only later in the movie versions does it become a violin). And while the creature listens, he is overcome by the gentle kindness of the old man and his children, by these good souls who treat each other with understanding and love rather than stomping each other's egos any chance they get. Moved by this surprising lack of dysfunction, and the sweet, beast-soothing strains of the guitar, he longs to be taken into their fold, sure that they will perceive his own goodness—they will see the truth beneath his hideous exterior. What the fiend wants more than anything is to break free from the solitary trap that is his own existence. To prepare to surrender his heart into their custody, he slowly pieces together the art of language, eavesdropping on their conversations and prayers, reading whatever books he can get his hands on, painstakingly deciphering the words he will need to bridge the chasm, but when at last he wins a brief audience with the old man, who's as blind as a prophet, just at the minute you

think he'll get the surrogate father he needs to mend his bricolage heart, it all goes to hell when Felix and Agatha burst in and Felix gives him a beating and then tosses him back out into the wilderness, hurling him back into his lonely exile, and so, bent on revenge, the creature goes and strangles Victor Frankenstein's kid brother . . .

This must have been the point where I began to drift off, but I was soon roused by voices.

"'We human beings are only instruments over which the song of the world plays. We do not create ideas; we only carry them.'"

"Oh, that is neat."

The voices trickle down from above, from the top of stairs that go upward to the wellness deck. Oddly enough, I actually recognize the quote.

It's from Christiane Ritter's *Woman in the Polar Night*. I had placed a sturdy checkmark in the margin next to it in my own copy.

The woman above me reads another line as if it's a Hallmark. "'Perhaps in centuries to come men will go to the Arctic as in Biblical times they withdrew to the desert, to find the truth again . . .'"

"Mmmm."

The two women above me were especially moved by the part where Christiane's husband is forced to keep her under house arrest when she starts to lose her mind and can no longer "dispel my fancy that I am myself moonlight."

Which makes me think, dreamily, of my old friend Otto Albrecht. His poor wife locked away in Byberry State Hospital. Did she ever believe that she was made of moonlight? When it

came in through the bars? It occurs to me that I miss the moon. Then, glancing up at the ship's stack, with its dual-logo gold rectangle and blue eye that looks like the great Eye of Horus, I picture it pointed at the night sky, funneling up the cosmic music some astronomers say emanates from the planets; I heard it on NPR, each planet cooing its own unique "song"—I remember I had braced myself when they said they were going to play a clip of Saturn, expecting some great and overpowering song of origination to come out of my radio, a Vedic hymn, but it only sounded like a microwave straining to cook a baked potato.

Thinking of this naturally leads to remembering that awful memoir I had read on Bartók in Vermont, written by Agatha and her cat, Felix, and how one summer night, on one of his last nights in Vermont, he had sat out in a wicker chair on the balcony of his room, wrapped in a flannel robe, mesmerized by the northern lights. He had never been that far north. He had never seen anything like it. But what if he had had his phonograph, I think, and had pointed its funnel at those bands of greenish-silver light undulating over the hills? What beatific tones of celestial fusion would my ancient astronaut have picked up and folded into his own final compositions, or would it have been a bliss beyond notation?

My view of the water is encircled: framed by the orange life preserver hanging from the taffrail. An iceberg passes. A faceless molten sphinx. Blocks of ice like bobbing white suitcases and cracked white pianos. *Life preserver*, I thought, *so much meaning everywhere, and it can all be measured circumferentially . . .*

Just this morning I felt I would never again be able to see or feel beauty. I was a sad little ape, an imp of the perverse, con-

vinced all beauty in the universe had expired. That my heart was sewn in on the wrong side. I felt beyond repair. I did not want to be here. I did not want to be anywhere. But now my rudder has come up out of the drag. The wake is a silver mane. The white painted bulwarks, the ship walls, are actually radiating.

However pharmaceutically achieved, I feel purified, released, with maybe even a twingle of genuine redemption. And yet the beauty is something I do not now know how to put my eyes on exactly. Not directly. It has a kind of intolerable clarity. If I focus on the foamy wake, I can see all the excruciating details inside the roiling froth, the writhing spray, filaments freed on the wind, as if the ocean were breaking down into string theory before my eyes.

(1) If Dostoevsky's starting point is that consciousness is the cause of suffering (2) and we accept the tenet that suffering is undesirable (3) then perhaps consciousness itself is suffering (4) and not simply a means by which we observe suffering? (5) Or perception is character a'iight?

Oh, relapse is bliss! They make me glad, my little gladiators. My instrument feels tuned. My brain lined with fur, a sleek pelt like sealskin, impervious to cold and pelting reason. It is the bliss of showing up for your own farewell party. A hero's send-off, date of return unknown. At last, an exit from the maze. A way outside the dialectic, free from the straits of cause and effect, the freaking bliss of connection and detachment at the same and simultaneous once. I feel it at the nano level. The pattern of air molecules is less random, less noise pushing against my skin, less pressure inside my ears, it could all be attributed to barometric change, I think, it is the cold, the physics of thermodynamics as much as it is the drugs, for

sure, because the air molecules are less agitated now on the sun deck, outside, and with the air molecules settled down there is literally more space, more room for my own molecules. The feeling of my carbon connections being loosened up is very real, of being unlocked, there is loads of space between the atomic bonds or whatever, more commas, more room to move about, unburdened, from the usual heaviness I attribute to the persistent need for things to add up, piling up, to all the endless unsolicited solutions, evaluations, analytics, to the heavy craving for more connectivity, the world's one and only pursuit, the pursuit for greater *connectivity*, the word itself tastes like actual shit in my mouth, like electrified shit on my tongue, I no longer have any will to interface or interconnect.

All that is obviously required is formlessness.

More of that hora lungă shit.

Why did I ever think my thoughts *belonged* to me? Why did I let them pester me so? These are not my ideas. We do not own these thoughts, not any of them, and it's a relief to remember that, to keep that *in mind*.

We are, as the hausfrau said, only instruments. Ideas, thoughts, pass by, they pass away, they pass muster, comma, they are like mustard seeds flitting in the wind, comma, they catch in our teeth. With my eyes closed my face feels like a hole in the wind: an empty space surrounded by the seething wind. A hole of stillness surrounded by a fiery mane of noise. As if my face is the hub at the center of a many-spoked wheel, and as I steer it into the wind, now standing at the portside rail, as I turn my hollow face to the wind, like a butterfly net, I tell Jesus that I think I may have arrived at my final metamorphosis, because he's got his hand on my shoulder, and he tells me he knows all

about my little scheme, my secret plan to reunite with the wilderness by running off on the next landing, my plan to sneak off from the group, to vanish like a naughty boy, but he says he does not disapprove, that it's my choice when to reabsorb with the wilderness, and despite what they say in his name, he's never judged suicide, but for now, he says, I should just listen to the voices in the wind, and so I listen, and after a minute he says, see, those were old voices, people move on, people forget, people forgive, at least most of the time, he said, checking in with his vast and limitless access to global databases, but even when they didn't, it didn't matter, I should get over it, I should move on with my bad self, especially since, you know, it was all only an illusion anyway, the idea of self, it was just one of those floating ideas, old voices, in fact, he said, ideas themselves, taken as a whole, were bad; *ideas are bad*, Jesus said; for instance, he said, he was going to let me in on a secret, that whole thing about the sins of the father? It was just an old wives' tale. That wasn't how it worked at all! We had a laugh over that. I don't know why, it just seemed funny. I guess because all along I did think I was carrying all those humiliating sins of the father. But Jesus said, you consumed your father's ego like a Communion wafer the moment you took the rope from him on the boat, so you're the priest now. After Jesus put it that way, I felt more relaxed about things. And then he pointed to a polar bear in the distance, or what we both agreed was a polar bear, and he grinned and said, those fucking bears are gonna be just fine. Nothing a few hundred thousand years of adaptation won't sort out. It all shakes out in deep time, baby, that was something he said that he and his vampire friends had always understood. He thought he might even genetically modify the bears to make them more

reflective. To increase their albedo, which Jesus explained was how reflective power was measured, on a scale of whiteness, fresh snow being a 0.9, and new concrete having a factor of 0.55. (Albedo means *white* in Latin. Think *albumen*, think *White Album*.) New concrete had a really good albedo, Jesus said, but dropped rapidly as it got dirty and weathered. If you wanted to halt global warming—since the world's two biggest mirrors were melting—you had to jack up the albedo. Ice was nice but it was only 0.5. It was lower than good cloud cover (0.8), which was why he said he might have to schedule a few supervolcanic eruptions. Turn down the global rheostat with a couple million metric tons of volcanic dust in the atmosphere. Like the Hekla 3 eruption, in 1159, but that mother triggered an eighteen-year freeze. Same as Mt. Tambora, in 1816, which wiped out crops across northern Europe and made everyone think the sun was *actually dying*, but at least gave your gal-pal Mary Shelley good reason to stay indoors and write. Contrails from airplanes in heavily trafficked flight paths actually pumped up the albedo pretty well. Forests (0.03) were just about worthless, he said. Asphalt (0.12) bounced way more rays. Your average suburban lawn clocked in at 0.18–0.23, much better than forests. Polar bears were obviously way up there, at least 0.7–0.8, but genetically modified, Jesus said with a smirk, he could bump them up to an 0.88, the equivalence of a brand-new white, heavily chromed Maserati. Or why not turn the bears all the way up to 1.0. Turn them into disco balls. Start a breeding program. Motivate the bastards. Hell, this was their home! It was either that or start building giant space mirrors.

26

After a few days off, we were back to it. The captain and his officers were at lunch now, so we were finally going to get the bridge shots while it was mostly deserted. Darren was getting into the zone in the gym, having converted it temporarily into his personal green room. We had a platter of strawberries and cookies from the dining room and half a bottle of warm prosecco. He stood before the mirror limbering up. He rolled his shoulders and did a few lunges. He palped his face with his fingers, massaging his scalp around his ears. Feeling for tension spots, giving extra time to his neck and jaw, working the hinge, pouting his lips, making motorboat noises, even massaging his pouted lips. With hands flat to his chest he hummed in a reverberating basso, and then, with palms tented over his nose, made midrange nasal chantlike vocalizations.

He dated an actress once, he said, that's how he knew all this stuff. You wanted to feel the vibrations in your chest and nasal resonators to get your whole instrument as relaxed as possible. It was all about remaining open to moments of discovery that might arise. He didn't want to be locked into the script, he said, though, of course, we didn't have a script, it was all just notes on cocktail napkins at this point.

As expected, we had the bridge to ourselves, all but for the navigation officer, an indifferent Filipino with a penchant for John Denver who was quietly checking wind and sea forecasts on the internet. It wasn't going to be hard to make it look like Darren was on the bridge alone. The N.O. was out of sight, behind a semipartitioned workstation, and Mark could fix the camera from any angle. I was paranoid about the whole thing. But Darren was probably right that we had already established a familiar, if dubious, enough presence that the officer would just ignore us.

I didn't realize how hungover I was until we were actually on the bridge. I was drowning in panic and dread and shame and regret. Without giving it too much thought, the night before, or maybe it was two nights before, night always remaining the least certain thing of all here, I had stumbled off the wagon. It was during the Captain's Reception, in the Veranda Lounge. I had snapped up the first glass of champagne that passed my way. I guess the whole unmitigated consciousness thing had become too much. I was going snowblind. I could no longer endure my own internal midnight sun. I needed to draw the shades, wind down the rheostat. And, anyway, I had already freed the pills from the passport safe, so having fallen off one wagon only made it easier to fall off the next. But now my eyes

felt like two bleeding keyholes, the sun looked jaundiced, and I feared my body was exuding the fragrance of rot.

Our plot had progressed to the point now where our characters had turned on one another and retreated to separate corners of the ship: me holed up in the library, with a dirty blanket, a few crusty dishes for props, wallowing in my makeshift hovel, spiritually and psychologically decaying in a semiferal state of lyrical but torpid regression, and Darren camped out on the bridge, rising to the challenge, the dogged survivor, intact of will, determined, charged with rational vigor, unwaveringly driven to wrestle the ship into submission, to fight his way back to civilization, to return to his wife and kids and his favorite Starbucks on Wilshire, the faith in his heart unextinguished, otherwise, in the abbreviated semiotics of Hollywood, striving to overcome fate, to become master.

As I watched Darren and Mark getting a few lockdown shots of the Siemens console with all its incomprehensible knobs and blinking indicator lights, I felt sure we were only moments away from getting caught. The N.O. was probably only pretending to ignore us, even as he was, I imagined, now texting the captain to inform him what we were up to and how it was obviously not pertinent to any supposed travel documentary. Once we were busted and they reviewed our confiscated footage and saw Darren's hijinks in the engine room—when we had gained access on the pretense of the documentary and gotten the naïve Norwegian brute at the helm of this deafening dungeon realm to let Darren and Mark creep around unchaperoned into the very inner sanctum of the ship's controls, to get shots of Darren tapping gauges, jerking at random levers, prowling through the arcane maze of panels and snaking cables,

while I played decoy, plying the man with questions about shaft generators and reverse osmosis water filtration, even if I was unable to make out the answers over the roar of the turbines, let alone the sickening thuds of ice pounding the hull as if we were passing through an asteroid field, many orders louder belowdecks than observed from the bow—we'd probably get brought up on terrorism charges. I wouldn't be able to make it back in time for my father's funeral. I felt sure the captain would storm in any second now. To dial down my panic, I quickly slipped another milligram under my tongue on top of the half I'd already taken with breakfast to defang my hangover.

The main trick, given we had twenty-five minutes at best, was to try and compress all the bridge shots we would need. Ironically, several meant to telegraph a significant passage of time. But Darren had clearly been crafting his beats. I was surprised at how deftly he entered the first take, leaning over the chart table, clenching the protractor, as if we had come upon him many hours sunk in agonizing thought. He stretched, rubbed his eyes, and went to glance at the sonar. Pausing to check the Doppler log and position displays. Then seamlessly repositioning himself for an entirely new shot: grabbing the captain's binoculars and scanning the horizon with a look of grizzled determination. That followed by a fluid transition, totally different energy, for an out-of-sequence berserk outburst where he pitched back his arm to hurl the binoculars across the bridge, then a mimed routine of his character gripped in catatonic terror, slumped in the captain's black leather chair, before shifting to yet another, more resolute and commanding mode, all the while shadowed by Mark who took his cues with the spooky intuition of a golden retriever.

With casual ease, Darren transitioned from one beat to the next. From one sweat-popping moment where he seized the very actual and very real throttle with a dead-ahead gaze that completely sold the illusion that he was driving the ship through the buckling pack ice, followed by a drastic and nihilistic key change, the hero gone pensive and melancholy, staring at the barren horizon as if he'd been stuck in this loop for centuries.

Then, with Mark crawling underfoot for a low-angle shot, Darren went to the shelf of operation manuals, pulling down one of the thickest binders from the small library, and sat cross-legged with it in his lap. Flipping through the laminated pages, speed-reading with one finger, getting up to speed on ballast water settings, stabilizer control systems, and other complex instrumentation he would never understand, like the slow kid faking absorption of new and difficult material with impossible celerity. It was when he stood, pretending to go through some kind of checklist, that he first heard it.

He stopped dead in his tracks. Dropped the binder with a clatter.

Making a violent, startled motion, he staggered back from the radio. But then rushed toward it, hungrily. This was his moment. When he first hears the voice. His moment of panicked discovery. His greatest moment as an actor so far, completely improvised. Though unexpected, and conveyed without a single word, every nuance was made clear through the lucid, gripping eloquence of his performance.

At first, of course, he does not know for sure it is a voice. And we are not sure ourselves what to make of this mysterious signal he has apparently detected. He hovers over the radio, uncertain if what he is hearing might just be random noise.

Given his expression, if it is a voice, it must be either too faint, or foreign, or deliberately scrambled. Something about the tense way he listens tips the scale toward encryption. Perhaps it's the unnatural position of his body that gives the impression the object of his attention is itself unnatural. Bent over the voice, he tests various expressions of rapt attention. He scowls. He tilts his head for optimal receptivity. If it is a voice, is it friend or foe? Help from the mainland? Did the mainland still exist? If it is a voice it must mean possible rescue. But what is its source? Is it even a *human* voice? It could be a machine gabbling to itself, the black box of another doomed ship murmuring from the bottom of the ocean . . . One thing he knows for certain, with some relief, and some terror, is that the source is not inside his own head. He can sense a formidable will coming from the radio much greater than his own. His own mind cannot be generating this voice. How can he be so sure? Because he is too familiar with the vagaries and stratagems of that particular onslaught. This was far less erratic than his own internal tauntings.

Suddenly, he runs to the chart table, grabs a piece of paper, and hurries back, pen in hand. He has made out something. Something vaguely *delineable*. A single intelligible note. Even if it is only a syllable, a lonely phoneme, it is a start. Now if he can decipher the alien tones.

As he listens, the rhythm of his body, the tempo of his listening, suggests that whatever it is, is on repeat, a recorded message perhaps. That it is a relatively short sequence. With beginning and end. And you can tell when the loop makes a full circle by the way he sits up, refocuses, gathers his resolve to listen again, to make out the next fragment. If it is a code, then

it can be cracked, at least theoretically, and if it is on repeat, then it will give him ample opportunity. The stakes could not be higher. Only by cracking the code is there hope of escape. And so Darren must now also act out the passage of time, days, maybe weeks, hours and hours of endless excruciating listening, studying the secret voice, craning his entire being into it, forgoing sleep and food, growing pale, as if each hour he listened took a year off his life. As if his soul gets fried a little each time.

Sometimes a sleepless week or sometimes only several hours will pass between signals. When the broadcast goes silent for days at a time, he doesn't dare so much as step out on the equipment deck for a breath of fresh air. But when it returns, he tests out every notational system he can devise. He stabs out anything that comes to mind on a pad of stationery with the ship's logo. He tries Morse code. Stick figures. Pseudoglyphs. Exploded diagrams of crypto-malarkey and alphanumeric grids. But despite the intense effort of his listening, the tortured concentration on his face as he wrestles with this voice, this angel or demon, tells us that it is obscured, not only distorted and scrambled, but as if muffled under a mound of earth, pings so remote and indistinct they might be transmitting from a long deceased star. Over weeks of intense eavesdropping, as piles of stationery grow, and as the ship is crushed in by the ice, he has become as familiar with the sound of the transmission as a child's lullaby, but it remains impenetrable, nothing that he can connect to any fixed meaning of hope.

As we left the bridge, he looked like he'd been through the wringer. He had obviously worked his way into an intense emotional state, and having failed to decipher the signal, he looked

depressed. I wanted to know what he had been thinking about to get to that place, where had he put his mind to look so defeated.

At first he didn't want to say.

I nodded. It's private, I said, understood.

But then, after a long pause, he said, yeah, okay, if I really wanted to know, he was thinking about the time he and our friends from college had gone with me up to Vermont one Thanksgiving. That was the first time he'd seen snow, I reminded him. True, he said, but that wasn't what he had been thinking about. He asked if I remembered how we'd spilled some red wine in the guest room? He thought it was one of our girlfriends who'd actually spilled the glass, but it didn't matter, that had nothing to do with it. Before we'd had a chance to clean up my brother ratted us out, that was more to the point. And then how my mother had chewed me out, and probably justifiably so, since even by then it was obvious I had a serious drinking problem, worse even than my father—but right after that, did I remember, I had cornered my brother, thrown him down, and clipped clothespins to his earlobes and nose and dragged him around the house by his arms kicking and screaming and cursing me out through his tears, until he was covered in carpet burns, and Darren and my other friends had looked on, appalled at how I got off on torturing my younger brother, especially since he wasn't, you know, Darren said, the kind of kid who could exactly defend himself . . . Sure, he was a weird pain in the ass, he said, but it was a nauseating spectacle all the same. So, yeah, that's what he had been thinking about while acting out that last bit, he said, at which point I cut him off with my own fun fact. Did he happen to know—I thought

he might be curious, I really did—that the word *nausea* shared its etymology with the word *noise*? *Nau* was where you got *nautical*. A pretty intriguing connection, right? From *nau* you got *nave* and *navigate*. Because *nau* meant boat. And nausea, I guess, was a kind of noise. The kind you felt deep down when you were about to turn your insides out.

27

TO PUNISH ME—TO PUNISH THE CHARACTER I'M playing—Darren had come up with another improv sequence I wasn't too crazy about, but which he said was essential to advance the story. Camera rolling, he had frog-marched me down from the bridge and handcuffed me to the railing on the quiet, carpeted forward stairwell, near the fresh water machine, doing it all in a pretty violent homoerotic way, with my hands pinioned behind my back where I can only teeter on tiptoes. But the shot had gotten blown when an older couple wearing matching fleece vests from REI appeared to refill their Nalgene bottles.

The idea was that I had taken a fire ax to the radio—while he was momentarily off the bridge, steeping a cup of tea in the chart room—to cut him off from the voice, convinced as I am

that the voice only bears us ill will, and because it is my character's belief that the only thing that will save us now is to trust in the encircling sleep that is slowly reabsorbing us, the sleep that surrounds, that is pulling us back to the unconscious jungle realm of formlessness.

The axing of the radio takes place off camera, but he wants to add some sparks and electric flashes later postproduction.

After the handcuff scene, we go back up to the observatory deck and library to get a cutaway of me in the rat's nest that we had made for my deteriorating character between the bookshelves, and then after Mark and Darren leave, I stay behind in my hidey-hole to finish reading *Frankenstein*.

When I set it down, I automatically reach to grab another book off the nearest shelf, without bothering to look, and, no huge surprise, it's a musty tome on polar expeditions. Because the introduction to my copy of *Frankenstein* had tried to draw a meteorological parallel between climate change anxiety today, and the year Shelley and her proto-goth friends had held their famous ghost story contest, in 1816, aka the Year without a Summer, I flip through the index to see if there's any mention of Mt. Tambora, the Indonesian supervolcano whose massive spew had triggered the global chill. I find a passing reference, as well as several more, in a few other books on the shelf, a number of which in fact do mention *Frankenstein*, which is, of course, bookended by the creature's final exile to the pole . . . When my attention is turned to other quasi-scientific faddish topics that fascinated Byron et. al., like galvinism, and electromagnetism, I want to read more. Though most of what I find, given the nautical bent of my source(s), pertains more to early questions of navigation. Electromagnetism clearly still mystified

these early-nineteenth-century scientists; for instance, they were flummoxed by what caused magnetic variations in the compass. (I read how garlic used to be banned on ships because sailors thought it might account for these odd disparities.) Which, in turn, aroused questions pertaining to the composition of the Earth, and a general planetary curiosity. But it was a hundred years before Shelley that Edmond Halley—while trying to calculate for these variations in the Earth's magnetic poles, and working loosely off Newton's new conclusions about gravity and planetary motion—proposed his own theory of a Hollow Earth. By this point, nobody had any real idea about the actual internal structure of the Earth, what lay beneath the crust. What was a planet anyway? Halley proposed that it was only a shell. A geode. We were only living on the fragile crust, like birds on the roof of a more opulent, more hospitable mansion. Anywhere from one to three moon-size spheres, or miniature subterranean planets, orbited within the shell of this Hollow Earth, Halley concluded, an undeniably cinematic hypothesis, and one that, Halley believed, accounted for the magnetic fluctuations picked up on an ordinary compass. Halley devoted the better part of his life to this theory until it was taken up after his death by an American crackpot named Jeremiah Reynolds, who garnered support from Congress during John Quincy Adams's presidency, to outfit an expedition to the South Pole to find the opening to Hollow Earth (later nixed by Andrew Jackson). It was Reynolds's lectures on this mystical hole in the ocean that acted as a portal to Hollow Earth that inspired Edgar Allan Poe. You can see it in his very first published story, "MS. Found in a Bottle," as well as "A Descent into the Maelstrom," and in his one and only and truly bad novel,

The Narrative of Arthur Gordon Pym of Nantucket, where the narrator finds the rocky entrance to this inverted upside-down realm inhabited by demonic minstrels.

I look around the library for a volume of Poe without luck, though there is plenty of Mary Higgins Clark. I can't recall who recovers the bottle with the manuscript, tossed from the deck of a ghost ship before its author is sucked into a whirlpool or what the recovered manuscript says exactly, but for a fatuous moment I picture it as the manuscript of Bartók's Third String Quartet, scrolled up in the bottle, with its accelerating loops and spirals, a frail maelstrom winding the turbine, but I do not think this without rebuking whatever part of my brain insists on making these idiotic connections.

Still, I keep looking over the shelves trying to find anything I can about Reynolds. A generic encyclopedia gets me there. It turns out Reynolds had only been working off the ideas of this even more unhinged guy named John Cleves Symmes. Symmes had popularized Halley's idea in a kind of utopian sci-fi travelogue, a trip he purported to have taken himself. To my amazement I find a copy in the ship library. *Symzonia: Voyage of Discovery*. It's tucked behind a more dour section on arctic tundra plants and wildflowers. A tattered, clothbound edition. Written under Symmes's pen name, Captain Adam Seaborn.

It turns out it was Symmes who first surmised that the entrance would be near the poles and that, of course, occupying this hollow sphere would be a heretofore unencountered and advanced civilization. In this inverted world, Symmes reports, in a style that is admittedly a bit of a slog, some of the animals were half plant, half bird. Pods of telekinetic dolphins frolicked the seas. Bears grew to the size of elephants, and there

were Koonsian sunflowers half a mile wide. To stand on the surface of Hollow Earth was to experience the strange convexity of an internally inverted world. You perceived the horizon, distant landscape, whitecaps on the inner sea, canopies of vast primordial forests, appear to *rise* as it gained in distance, rather than *drop off* as it does in ours. When you craned your head on a clear day, beneath this enormous curvature, the zenith was not sky but a distant continent. Best of all, living in this subterranean womb, the inhabitants were protected from the awful face of the sun. They only received its rays indirectly, diffused and filtered, somewhere between bright moonlight and a late fall afternoon.

The Internals themselves, as Symmes dubbed the chaste inhabitants, were large-statured albinos who spoke in a shrill birdsong and bopped around on magnetic-powered aerial yachts and a public transit system called the "sacred locomotive." They were a refined, intelligent, music-loving people who enjoyed wholesome pursuits such as gardening. They only required three hours of sleep a day, lived to be hundreds of years old, and money was nonexistent. They were strict teetotalers and vegetarian except for oysters, the shells of which they used to stucco their homes. Highly skilled in math, statistics, geography, botany, geology, mineralology, zoology, ornithology, ichthiology, conchology, and entomology, they not surprisingly came up short on astronomy—understandable, given their limited if not entirely occluded view of the celestial bodies.

They were lovers of the arts but held a dim view of fiction, which they considered a vice. Untempted by the trappings of

vanity, the Internals dressed alike in durable unisex tunics spun from the silk of a cave spider native to their world. One saw no monuments to the flamboyant egos of dead heroes. Their cities, almost eerily, had no slums.

At the very center of this inverted cosmos was a strange, pulsing orb. A loud clacking dwarf planet, mock star, that chuffed oily pink smoke and sometimes shot off dark bluish sparks. Its charge vitalized the blood of the Internals. Nobody was sure why it was there, their ancestors had built it thousands of years ago, some believed it must have been a weapon built in less enlightened times.

War was no longer in their nature.

Nor did they believe in capital punishment, and yet, to stifle deviancy, those who indulged in certain pernicious habits were banished. Those with cravings and filthy impulses that could not be put in check, those who were too enmeshed by the gears of desire, who did not have the willpower to master their beastly hungers, were cast out. Hypocrites, masturbators, pill-poppers, and all breed of degenerates were exiled to the outer world, with its extremes of howling cold and endless months of permanent midnight followed by endless months of the midnight sun. A hellish exile for the albino Internals, left to perish on the frozen crust, hunted by ice bears.

It was Symmes who learned that we surface dwellers were the descendants of these exiled addicts, sentenced to wander far outside the comfort of the hole from which we had been evicted, a contaminated race of delinquents doomed to forever pine for our lost Elysium. Living on the outer shell, the scabby *crust*, always on the run, never satisfied, stuck with our

impaired minds, and with only the company of other craving craven lunatics, we were the offspring of those original losers who had inherited the sun-baked rind of the Earth.

Ironically, our puritanical inverted ancestors would have granted the same fate to Poe if he had actually been an Internal and not just a beatified tosspot who dreamt so much of their world. It was then, thinking of Edgar Allan, whirling down the maelstrom wall, trying to time it just right with only one chance to pitch his bottled manuscript, that I look to the bottom shelf and see a tattered copy of *The Aeneid*.

This one final connection snowblinds me.

Unbelieving, with shaky hands, and a horrible sense of portent, I turn to Book 6, opening to lines 968–969, right after Aeneas arrives in the World Below, in search of his dead father, Anchises, and seeing the swarms of beelike souls drinking from the river Lethe, asks his father what it means. He explains that they are drinking to forget their former lives in order to prepare to inhabit their next body, and, horrified, Aeneas cries: *The poor souls, how can they crave our daylight so?*

28

WHEN I SIT AT THE BAR, COMING STRAIGHT FROM THE library, Darren says nothing as I drop two Ativan in my wine, and he watches the bubbles until the pills dissolve, then holds up a finger to silence me before I speak. "Listen," he says.

He points at his phone on the bar. An audio file titled JokhangWheel.mp3. After a dramatic pause, once he's sure he has my full attention, he hits play. It sounds like loose-staved barrels tumbling down a grassy slope. Maybe an octagonal barrel, or a tin army tank trundling through a meadow.

"Cool," I say. "What is it?"

"At the Jokhang Temple, in Lhasa. About a ten-minute walk from the former palace of the Dalai Lama before he was forced into exile. Giant prayer wheel. A massive copper cylinder made in the seventh century. It's basically a religious technology for

mass dissemination. The monks wind the mantras around the spindle with very thin paper. The new prayer wheels use microfilm, so you can pack a few million into a wheel this size. Purify billions of their negative karma in just a few hours, rid them of their obscurations on the path to enlightenment. It's the equivalent of ten million monks chanting, in a fraction of the time."

He plays the file again.

"Very soothing," I say.

"No, you don't get it. This could be our sound. The encrypted voice I have to decipher on the bridge. Slow it way down, put the signal through a compressor, or fuzzbox, it will sound spooky as hell."

He plays it again. The giant barrel, or cylinder, rumbling on its sacred vertical axis. It is a fundamental sound, one I find myself involuntarily leaning toward.

"Nice," I say. "So guess what? I found our monster."

"No shit. Does it sound like this?" He taps the audio file. "Because, executive decision, I've already made that call so it has to fit."

He shakes the pretzel bowl at the bartender, who comes over and refills it.

I nod. "Sure. Definitely."

"Good. What is it?"

"Our causation."

"The source of the voice?"

"The source of everything. The vanishing. Everything."

"Lay it on me."

I start pitching him the whole thing. A summary of everything I'd been reading on Hollow Earth. I can see he is taken in by the whole rock opera of it all.

"That orb thing," he says, mulling his olive suspended half-way between martini and partly open mouth. "So that could be the source of the voice."

I nod.

"So somehow the ship crosses over this area and everyone is transported, vaporized, down into the . . . what is it?"

"Hollow Earth."

"Right. What makes us so special that we don't get vaporized too?"

I shrug and try to mesmerize him instead with the weirdness of the crossing over, or at least how Symmes and Poe had described it. How nobody ever notices the real moment when they actually cross over. It's a seamless transition. How even some contemporary Hollow Earth theorists think the aperture could be as much as a hundred miles across or more. The transition is not immediately registered except as a change of barometric pressure. One might not even realize, for days, that one had even passed over into the internal world, except for a somewhat milder climate. The crossing, according to Symmes, was not necessarily that dramatic. One wouldn't even notice if they happened to be in their cabin lightly napping, might not even notice until they stepped outside on the deck and saw that things had gone concave, and that the sun was no longer there. The compass might go a little sluggish. I told him everything, even how the Internals spoke in song, like birds, in a dialect that sounded, to Symmes, like Sanskrit. How they all played the harp and sung in symphonic choirs.

"Albinos," he says. "I don't think that's the PC term. I think it's just 'people with albinism.' But otherwise I like it. No spendy special effects. Really eerie." He is nodding now, mulling

it over. "And if we're the only ones left behind, then it just takes place while we're sleeping—maybe we miss a midnight polar bear sighting, when everybody else comes out on the bow. Whatever!"

He asks if I want another glass of wine, recommending a pinot noir that he says Mark had turned him on to from Paraguay.

"And think about it," I say, taking a sip, trying to measure his readiness for more. "We could totally kick it to the underworld genre."

"Hell yeah," he says. "I'm surprised we haven't already bounced around anything demonic." He points at me, suddenly inspired, leaning back on his stool. "*Hellraiser.* Forget the techno paranoid stuff. Go straight for the deep religious superstitions."

"But bring in the old-school underworld, too," I say. "Hades. Virgil. The whole classical resonance of the thing. Ulysses. Even bring in the Nibelungen. Take it to a whole extra level."

"Nibelungen?"

"The Ring Cycle. Wagner. Yeah, the fucking Nibelungs!" I feel my head fizzing, tachometer humming. "Think about it. The hunter-priest's cave paintings flickering in the sooty firelight. We can push all those primordial triggers."

I gesture too wildly and splash a little wine on my pants. "Fucking Orpheus!" I pound the bar with my fist. "Fucking Orpheus who had a lyre that gave him power over all the other animals, not just foxes and reindeer, but ants, tarantulas, giant African millipedes, even the rocks, real horror stuff—there's your monster!"

I look out the window.

"What?"

"How many days until the solstice?"

Darren looks at his phone. "Three. Three days."

When an iceberg screeches against the hull we both stand and waddle with arms spread and glasses held aloft, making slight corrections to our yaw and pitch until the turbulence subsides.

Darren picks through the overturned pretzels. "Remind me, what's a lyre exactly?"

"A lyre. You know . . ." I make a curving shape with my hands, as if stroking an antelope's head, with accompanying plucking motions. "He used it to navigate his way down to hell, to retrieve Eurydice. It's a stringed—wait, total déjà vu moment—wait a minute—whoa—you know the violin the old man plays in *Frankenstein*?" I waggle my empty glass at the bartender. "In the movie, all the movie versions, it's a violin. Well, in the book it's not a violin. It's a guitar."

"Never read *Frankenstein*."

"How about Poe?"

"Sure."

"Okay, well, Shelley and Poe share a certain source."

"Don't tell me Hollow Earth."

"Have you read 'MS. Found in a Bottle'?"

"Never read that one."

"At the very end the narrator gets sucked down into this maelstrom that's the entrance to Hollow Earth—a theoretical vortex Poe plays out more than once—and hurls out a bottle with the manuscript *sealed inside* before going down the hole."

"So he never actually gets to Hollow Earth," Darren says.

"Well, no, not in the story. Majorly tentative ending. Same as 'A Descent into the Maelstrom.' But what's more interesting is 'Fall of the House of Usher.'"

"I've read that one, I think, but get back to the orb, man. You think it could be the source of the voice that I pick up on the bridge?"

"Definitely. But wait a second, get this. 'Usher' is basically a retelling of the Orpheus myth. Roderick Usher is Orpheus. References to all the motifs are clearly coded. Just like Orpheus, Roderick is the bard of grief. The guitar is obviously the lyre. He plays these wild, unhinged dirges—again, on a guitar—in his gloomy-ass study. Poe says he could only bear the sound of *stringed instruments*. Madeline, his dead sister, is Eurydice, locked in her coffin down in the basement, the dungeon or whatever—oh and whoa, *whoa*, what about working in Monteverdi's *L'Orfeo*. The opera? That could be our soundtrack. The voice of the lyre, like the voice you pick up on the radio on the bridge, it guides him down into the underworld. *Possente spirto, e formidabil nume.* Monteverdi was totally avant-garde—an early adopter of polyphony, it blew people's minds. It expanded consciousness itself—the idea of twisting together separate parts, multiple melodies, rival voices of the mind, speaking all at once, contradicting and harmonizing simultaneously." I stop to close my eyes for a moment. "My chakras are really starting to burn here, man. I'm gettin' a visual on my third eye. My pineal gland is pissing its pants. Can you see how this is all fucking related? It is *all* connecting."

"Yeah, but I hate opera."

"Dude, the aria, the *voice* of the oracle—who guides Aeneas. In the *Aeneid* she's the one, the Sibyl, who guides Aeneas down to the underworld to visit his dead father, Anchises. . . ."

He looks at me uncertainly.

"In the *Aeneid*, on his way to found the ultimate civilization on Latium's shore? Where they would one day lay to rest the bespoke bones of Marcello Mastroianni? The oracle, Sibyl?" I hear myself speaking mincingly, and it annoys me even, but I can't stop. "Aeneas begged the oracle to reveal the entrance to Hades? If Orpheus had done it, if Hercules had done it, Aeneas argued, why couldn't he visit Anchises, his father, in the underworld? And so Sibyl lit a fire, and grilled up four bulls to Apollo, and as the cave filled with choking smoke, and the priestess shouted out some wild prayers to Mother Night herself, the Earth shook, yadda yadda, the rocks parted, and then he enters the underworld with the golden bough the Sibyl had instructed him to buy his way in . . ."

"Now you're starting to lose me."

"Stay with me. Once he finds his father on the banks of the Lethe, he tries to embrace him but his shade slips away. And, oh, but wait—this will completely melt your face. The Greeks said *Apollo* had a spiritual retreat, a place where he could go and do yoga and meditate, in Hyperborea. Hyperborea, which is—guess where?"

He shrugs and stabs the fresh olive in his drink.

"The Arctic motherfrickin' Circle. It was their conception of the North Pole. This according to Hecataeus."

He turns to me, and curling a finger over his upper lip, speaks in wavery falsetto: "This, uh, according to Heck-a-taeus."

"Hecataeus of Abdera, not Hecataeus of Miletus. But Hyperborea was where Apollo had a temple—it was spherical, so maybe an *orb*?—on an island in the Arctic Circle."

"But that's only according to Hecataeus," he said.

"You are seeing the points of resonance here, right?" I am

starting to feel pissed off. "They're vertical and horizontal at the same time, man. So why not work in a little subtext? Do you have something against subtext? The fucking point is, the origin of Western literature is the horror story. Forget the *Iliad*. That's just a warm-up. Real Western lit starts in Mycenaean Greece."

"I think I'm gonna head back to my cabin now."

I pat his hand. "The point of greatest terror is always a *recognition*—a wake-up call to some irreversible thing. Some unbearable, inescapable realization the mind cannot digest."

"So, for instance, Chucky, *Child's Play 2*."

"Chucky's noble lineage begins with Oedipus plucking out his eyes. Then there's the House of Atreus and its legacy of serial child murder. Tantalus chopping his son up into pieces to test the gods' omniscience. Thyestes realizing he's been served the savory meat of his own sons by his vengeful brother. Agamemnon sacrificing Iphigenia. It's a generational curse covered by Sophocles, Aeschylus, Euripides. It's Poe reading his 'forgotten lore' in 'The Raven.' Because the bird is perched on—what?—a bust of Pallas. His lost Lenore is Helen of Troy, a French mutation of the name. A variant of the name. *Elena*. Eléonore. Leana. Ileana. *Lenaea*. Guess what's on Usher's reading table . . . ?"

"The Bhagavad Gita."

"Nope. This." I drop it on the bar. *Niels Klim's Journey Under the Ground*, by Ludvig Holberg. "Mary Fucking Shelley mentions in her diary that she read *Klim*, too, while she was writing *Frankenstein*. Insane, right?"

"Is this your book or the library's? You've completely defaced it."

"I just underlined a couple of things."

"Look. I like the orb. Let's stick to that," he says. "It must generate some force. The gravity would be immense. It would account for all kind of bizarre phenomena. It could totally be our cause."

"That's what I've been trying to say."

"I think it really could be. The orb could be our monster."

It cheers him up so much he orders a shot of tequila.

"And of course, *Frankenstein*, you know, at least in the book, starts and ends at the Arctic," I add, a compulsive footnote.

"Right," he says. He knew that—he can picture shirtless Kenneth Branaugh slogging along a snowy cliff.

"Yeah, well, I don't think he was shirtless in that scene."

I'm starting to feel slack, the downshift of the benzos dropping me back a few gears, as if somebody had adjusted the gravity in the room, or perhaps we have already crossed over.

"Sure he was, he was shirtless through the whole film. He didn't put his shirt on once."

"Or it's you . . ."

He looks at me.

"It's all garbled. You can't make it out. But then at some point it becomes clear."

"I decipher it. The voice on the radio."

"Yes."

He leans in. "And what does it say?"

"We can finally make it out," I say, "who it is."

He looks as if he might be trembling. "Who?"

"The voice . . ."

He stares at me hard.

"You receive the oracle. You untangle the string. You hear the voice . . ."

It occurs to me that Darren is an anagram of Ariadne. Or close enough.

"Right . . . I'm totally feeling you, but, actually, not really at all."

"You're the captain. The one in control, right? So . . . it's *you* who must steer the ship back out of the abyss. The hero threads the needle back through the maelstrom, out of the bowels of hell itself."

"So we're in the mirror world?"

"Right. Not the others."

"So, fuck, wait, I'm confused. The passengers all get left behind in the real world. Oh wait! I get it. That's major. So it's a total flip? A reversal? Total mindfuck! Yeah yeah! This is fucking bardo shit right here," he says. "So we're stuck on the other side. I like it. I get it." He likes it enough he orders us both a shot of tequila.

I set my empty shot glass on the bar. "Except it's not both of us."

"Sure it is. *Folie à deux.* Right?"

I am suddenly, inconsolably, bored.

"No. It's just you," I say. "You're alone. But it's your voice. Small and barely detectable. It's you on the other end of the radio."

He looks horrified.

I glance across the room at the piano, where there's a couple of men and a woman trying to tipsily riff out some melody they can't remember. The piano looks black as a new moon, reflected in the window or, rather, no, that's not right, and I must revise my optics, it cannot be reflected in the window, it is not dark enough outside for there to be a reflection on the glass, though

it feels as if there ought to be since it's two in the morning, but clearly I have let my desire, my hunger for darkness, wishful thinking, superimpose a reflection where there is no reflection.

"I think I like the passengers getting uploaded into the cloud by the North Koreans better." He looks at the bar snacks, trying to make his face inscrutable. "Okay, so how do I get back?"

"You don't get back. But we can *hear* you. Or more precisely, *you can hear you*, calling for help, on the other side."

"Well, I get back somehow."

"No. You can't cross back."

He fumbles with his drink and accidentally upends the snack bowl, then looks at the spilled pretzel nuggets numbly. "Yeah, I get back. Maybe the ship gets destroyed. But I get out. At the very least I can stick myself in a torpedo chamber. Escape pod."

"The ship doesn't have a torpedo chamber. This isn't a submarine."

He slowly presses down his thumb on a nugget, crushing it, twisting, until it's thoroughly pulverized, and then he flicks the crumb matter in my direction.

"Right," he says. "Of course not."

"You lost the golden bough. You're trapped in the underworld. The hero must harrow hell. You're the hero, right?"

"You're being like a total fetus, you know that, right?" He turns to the bartender drying glasses. "Does it smell like fetus in here to you?"

"Look. I don't know who's on what side, okay? But think about the crossover, like what I was starting to say, in the *Aeneid*—"

"Nobody gives a shit about that."

I clench the stem of my wineglass. I need him to get the important part here, how the shade of Anchises greets his son over the wailing infants, and *as tears wetted his cheeks* (line 920): "Have you at last come . . . ? Am I to see your face, my son, and hear our voices in communion as before?" And then preaches his dead man jive about eternal recurrence that I think could be a real clincher for our own script. The whole trippy aspect of how time may have skipped a groove for us, but then another underworld meeting between father and son comes to mind, another thread warps my woof, as I recall a more apocryphal tale I had read when the internet had come back on in the library. A piece of fanfic that picked up where Shelley had left off, with the creature on the ice—where instead of immolating himself, as Captain Walton had reported in his last letter to his sister, the creature, half frozen, stumbles upon the entrance to Hollow Earth.

In this version, death rejects the creature. The bricolage man cannot even die at the end of the world. He must continue his forsaken adventure. And so he wanders, wincing against the subzero winds, blowing on his frostbitten fingers, hands that he knows do not really belong to him any more than the intruding thoughts that crowd his mind, concerns that are only the residue of impressions and experiences made by the brain occupying his skull prior to its current tenancy, and so he went on, clambering around and over towering icebergs, seracs, and wall-high pressure ridges, kicking at the rat-faced ringed seals that snapped at his ankles, until he steps into a hole in the side of a glacier. The cavern, surprisingly, drops off, and he finds himself going farther and farther down, and for a long time it is

nothing but treacherous climbing, until, after miles of this hard descent, he comes upon a wreck, an old sunken ship. Huddled in the fo'c'sle, he discovers an ample stock of frozen biscuits and chews on one while contemplating his long deathless eternity ahead, in what he thinks will be his final hovel. But then he finds a blunderbuss and decides to continue exploring, but soon gets lost in a system of ever more descending, confusing tunnels. Farther down he encounters giant reptiles and dog-size stag beetles that he hunts and eats, even if the explosion of the blunderbuss tears apart his tender eardrums in such a tight space. Whatever poor sod's hearing he had inherited must have been very fine indeed. He can still recall, all too well, the painful screeches made by little Billy Frankenstein, Victor's younger brother, when he was crushing his windpipe. Even farther down, where the light is murky, and the walls oozed a kind of licheny mucus, he encounters ugly apelike creatures that frighten him worse than the giant bugs. He survives on the wormy meat of these underground apes, however, and stitches a cloak out of their stinking skins.

When at last he comes out upon a glittery beach on the great internal sea, and beholds the vast curvature of the white-capped ocean sloshing against an inverted horizon, like a massive brandy snifter, he stands there in his hideous robes and feels something akin to wonder and hope. That it is his own sense of wonder and hope, and not the residual capacity for wonder and hope from his mind's former tenant, he is confident. He stood in awe on the shores of this antiworld. Mirror Earth. His heart only softened the more by the atonal hum of the orb, which has a calming effect on his soul, whereas to most outsiders the subliminal music of the chthonic sun would only

trigger primal alarm. It reminds him, albeit unconsciously, of the soothing dissonant murmur of the iron womb where he had floated, between life and death, in Victor Frankenstein's cold laboratory, the amniotic tank the mad scientist had fashioned out of the boiler tank of a steam locomotive, soldered for leaks.

His feeling of joy only enlarges when he comes to the first village and sees the smiling naked children, and dogs come up and lick his black-spotted hands. The cockles of his lazarus heart melt. He is reminded of the cottagers whom he had spied on from his hovel, aching for their sweet companionship. "It isn't right that I should be alone," he thinks, ready, if necessary, to be fooled-me-twice—maybe this had been the road that fate demanded he take, a frozen jagged path to where he belonged, at the center of the Earth, where he could be himself at last, or at least so he thought until he saw the Internals returning from some kind of raiding party. Drunk and shouting, the men were celebrating over the vile trophies they had returned with—a heap of severed heads, chopped-off hands, and genitals—and this unmends his heart, or whomever's heart it had originally belonged, still scarred by passions he would never know, and recalling again the painful education he had received at the hands of the perfidious cottagers, he knew the system was rigged against him, and so he made a decision and took immediate and preemptive action by blowing a hole in the ground with his blunderbuss. Natural abject cowards that the Internals really were, within an hour of his arrival he had pacified the local population. But, after a few months, he found that he had grown lonely in power and decided to demand their love as well. At first he fell for it, because they were skilled flatterers

and yes-men, but ultimately he could tell they were only faking, it was not true love, only groveling fear, and so, in a move he knew would consolidate his power, and also show that he could be a benevolent dictator, he led them in a campaign to destroy their enemies, other tribes of Inner Earthers, countless factions and subfactions, branches, and theologically sworn enemy sub-subfactions, divided by language, dress, competing origin myths, all of whom he wiped out, village after village, building larger and larger slave armies after absorbing each fiefdom and city-state, he conquers Inner Earth. As a gift to show their gratitude to their new warlord, one of the chieftains gives his own daughter to the creature in marriage, a blind girl who cannot see his ugly face. She was the only woman he had ever seen naked. And it is during the middle of their first clumsy hump that the ghost of his father, Victor Frankenstein, materializes at the foot of the bed, to mock his efforts.

"Even in this respect you are a travesty," said Victor, pointing at the creature's flaccid penis. "You remove the beauty from all human functions." The creature, ashamed by his own impotence, bitterly howled: "The sin is with my maker!"

But then Victor liquefies his bride in a pool of gore.

This is when the creature wants to rip out his own brainstem from the stalk. He wants the horror of the mind to end. Instead, he goes active shooter and tears down the new world around him in a rampage of disembowelment, sabotage, and rape, killing anything with a heartbeat. As the bodies pile up around him, what drives the creature's blind fury is not only that he has been robbed of finding love or peace, but that he did not know why he cared, or more to the point, *who* it was that cared, because where exactly was the location of anything

that he could call his self? Especially since anything that could be characterized as identity remained unfixed for the creature, he being nothing more than a mashup, a remix of other dead men's parts, some other man's finger that pulled the trigger, another man's larynx that screamed in grief-stricken murderous rage, and another's transverse colon that tightened in spasmodic rapture as he cut a man in two and blew the head off another. His speeding thoughts were nothing more than an overdue loan of other dead men's dead ideas. Recycled opinions and misperceptions knocking about in his head, a polyphonic shitstorm of other voices that he received, more involuntarily than self-generated, looping and recombinant, voices arguing and pleading, conspiring against his own best interests, perhaps even his conception of love nothing but a pitiful bootleg. But then when an insurrection mounted a coup, and assassins of the deep state push him back toward the water, in a scene I see as very much parallel to Virgil, just before Aeneas returns to his men and his ships, the creature, in the middle of one of these stupendous firefights, comes to a docked barge, where the shade of Victor Frankenstein, again, like Anchises, tells the creature that his curse will never be lifted. *We two are joined at the soul, monster, and our destinies run parallel to each other.* After the grief-enraged creature rips apart the ghost of his father's corpse and tosses the dismembered disembodied pieces into the bay, there is nothing left to do but set fire to the inner world and jump aboard a raft that takes him away from the smoking ruins, down an underground river and through a series of caves to the chancel of Hollow Earth, where, at the very center, in a chamber that smells like motor oil and snuffed candles he finds a strange machine with levers and dials and

regulator valves under the operation of leather-winged tentacled insects with eyestalks and . . .

Darren looks at me. "The orb?"

"I'm getting there," I say.

"What does this have to do with anything?"

"It's just something I found on the internet." I look into my wine. "But think about the parallels, the *mise-en-abyme*, it really bounces off the stuff we want to hit. The encounter between the creature and Victor is like Aeneas and Anchises meeting in the underworld—"

"Dude." He plunks down his credit card, then starts to stand. "You've been reading too much Wikipedia."

This is when I smash my wineglass against the bar. Not against the edge, like a beer bottle, as I did on one other night with Darren twenty years ago in Boston, when it had actually felt much colder, far more *arctic*, but straight down, base first, so the stem breaks off in the meat of my thumb. The snack bowl goes flying. A thin lasso of my blood spatters the bar. My anger feels like trying to hold on to a jerking goat that had bit my thumb—a kicking, writhing goat whose stinking head I want to shove in a vise. There are slivers of glass in my knuckles, blood on the bar snacks. We glare at each other, his eyes gone slitty, my teeth bared. It is not exactly a Queequeg moment.

But it isn't Darren that makes me so furious. It's that he is right.

Looking at the jagged glass I consider the possibility of my own liberation, and how easily I could fix it by plunging the stem into my jugular. To feel the hateful pressure fling out in a flying buttress, arc across the floor to ceiling windows, in a lovely extrados. At least then I wouldn't have to listen to myself

attribute significance to the shape of the blood splatter. I would not have to decipher the distorted spew my mind projects onto every available surface anymore. If I bled out now, under Darren's hateful gaze, I could quit rooting out all the fatuous bits of synchronicity, all the *meaningful links*, as if I were only learning, again and again, that, yes, the world was contained inside the world. I would no longer have to endure the eternal horror show of connectivity. The never-ending hum of the pattern machine. I could finally trade in the noise of meaning for a little meaningless peace and quiet. After all, my own patterns were now far too clear and hideous. What at first gave such a rush of elation, the discovery of new junctions between each intertwinkled globule of passing information, the epiphanic points of proximity, adjacent folds, intriguing dents, transcendent creases, always ending in the letdown of realizing it was little more than the automatic operative conditioning of my internal hardware. No different than a robotic, drug-sniffing dog. As if the mind were meant to do anything other than correlate, notice, and receive what it was programmed to correlate, notice, and receive. It is for this reason that I sometimes find myself hating music. That I find it suffocating. All I can hear is the composer trying to break out of his box. Trapped like an escape artist inside an eight-sided coffin. Twelve at most, but still, a limited set of combinations. There is ultimately no escaping the puzzle except silence.

29

SOMETIMES IT IS BEST JUST TO TREAD WATER. AS I DO now. Kicking to keep my head above, the water is tranquil and only looks mussed, its surface lightly raked. Treading now, I feel pleasantly formless, the barrier between the lake and my skin indistinct, as if the bonds of my molecules have dissolved and are intermingling with the molecules of the water. Suspended in pure and spacious silence, a most reassuring emptiness. I do not see my brother or my mother or father but the boat is not yet out of sight. It has come to rest in the middle of the lake, the water nipping at its hull. It rocks gently, sails down, the mast still. It would not be that long a swim, but I am fine treading, I prefer to remain inside my pocket, this hole in the lake, where I only need to wag my arms and feet to keep it from closing around me. I do not have any desire to return.

And anyway, like I said, the other passengers, my family, have vanished.

One must tread as calmly and rhythmically as possible. Even so, when I grow tired, it becomes harder to stay inside the circle, to keep from falling, to keep the hole from closing around me, but then again all I have to do is reach with my feet until I can feel bottom, the reassuring solid ground, and then my nose is even with the sill of the hole, where I can peer across the field, my gaze at bug level, and see my mother weeding.

Remember, this scene is supposed to be your final disintegration, before you take a fire ax to the radio on the bridge, before my character can decipher the message. Because you think it's evil or something or you're trying to cut us off from civilization.

The boat looks bedraggled, parked at a violent angle in the driveway, still gleaming wet, the sails sodden. I had come back to the sanctuary of my hole, I now recall, as soon as we had returned home from the lake.

I had not even bothered to change, but went straightaway to my hole. We had not capsized, but so much water had swamped the boat, I was soaked. Now, back in the hole, I had dug so deep that I could only see over if I stood on tiptoe. When I peered out I watched my father over the grill, angrily spouting lighter fluid into the open flame. It was both wonderful and terrible to remember that I had taken his power, which meant, of course, that I had killed him.

I was still shivering in my wet clothes but felt the inward heat of humiliation as the sun was blocked by the shadow of the dentist. Our next-door neighbor. He stood far above me, the dying strands of the sun flaring around his white coat.

What do you see? What do you see? Remember, atune to the

given circumstances. Grammar of gesture. But give me anguish. Give me weeping. Weep! Weep you pussy-ass motherfucker!

When I look up at him I feel something erode and collapse. Before coming over, he had been out in his own trepanned flower beds, filling in the holes dug by Clyde, before our family pet had been hauled off to the funny farm, and though my mother had offered to help fill them in, he had refused.

He stood above me with his own spade, studying my work. There were smudges on the pockets of his coat. I didn't think to wonder why he was doing yardwork in his doctor's white coat. He had a mouth mirror in his breast pocket. The dentist looked at the sailboat and wheel marks on the lawn where my dad had skidded to an angry halt, nearly capsizing us a second time that day. "Where's Captain Ahab?"

Then he squatted down and picked up my piece of antler.

My pagan, kitsch handspade.

"Very cool," he said, turning it over in his hand. The gold paint picked up jags of the fading sun. "Did you know antler is the fastest-growing form of animal tissue? It kinda looks like a tooth, but it's nothing like a tooth. A tooth has marrow. A tooth has enamel and nerves. Structurally, it's completely different from a tooth."

I looked up at him dizzily and felt the water squishing in my shoes. I still had the lake and wind in my ears.

"Don't worry, I'm not gonna steal your amulet." He watched me watching him fondle the antler. It glinted as he turned it over in his soiled hands.

"With a tooth, you drill past the outer wall of enamel, and the next layer, dentine, then you come out into the pulp chamber. The nerve runs down into the root, and if the drill

slips it goes all the way into the jawbone. Your alveolar. The root is buried in the jawbone. The alveolar is where the marrow is, where your red blood cells are made."

He sniffed the antler.

What did he mean by this intrusion on my solitude? Why did he not leave me to my work? He came to probe me, nothing else.

Taking out his little round mirror and kneeling, he pretended to examine the cavity I stood inside. "What do you do down there? I bet you eat earthworms when you think nobody's looking. You eat bugs I bet. You eat worms. Next thing you know you'll be on to birds. Then cats."

"I don't eat worms," I mumbled.

He watched me another minute. "Digging farther down, that's your first mistake. You need a ladder, my little ginger-haired man, not a shovel."

I gave a rock a halfhearted scrape.

"What *are* you doing, digging a foxhole?"

"Why would I dig a foxhole?"

He looked around. "Oh, I don't know. Maybe to shelter in place from all the psychic fallout from the asylum. You can feel it in the air, can't you? All the radioactive waves of mental anguish?"

He saw that he had struck a nerve. "Listen. No need to worry. Take it from me, folks who worry too much end up with receding gums." He smirked. "Or end up like that dog of yours." He laughed lecherously. "Maybe they'd let the two of you share one of those nice rooms? The ones with the pink bars and the rubber walls?"

The dentist's hands flapped around his white coat, searching the floppy pockets for his cigarettes, but once he found them he only dropped the crumpled packet back.

"A person's sanity"—he tapped his skull—"comes with no guarantees. It's chipped as easily as the enamel on your tooth."

On second thought he retrieved the cigarettes, lit one, and waved it over my hole, the antler dangling in his other hand.

"I always see the things people can't hide. The things people think they can hide show up in their teeth. Don't forget, I've seen inside your mouth." He cleared his throat. "I've seen people actually grieve, *really grieve*, after a molar extraction. It's the separation. They really believe their teeth are a part of them."

He held up the antler and cigarette like prosthetic air quotes. "'You can run, but you can't hide.' Ever hear that one? That's why you're digging these holes, right?" He let the smoke seethe slowly through his dull-yellow teeth. "Cuz if you're digging to China you're making crap time."

"I'm not digging to China."

"Then maybe you just have separation anxiety. Not the way that's usually meant. Most people are *afraid to be separate* from all this crap." He waved his cigarette. "They don't feel connected enough! Oh no, I don't belong! Well, guess what, it's not even an option. It's called ecology. But you, my friend, you can't stand the thought that you might actually be a *part* of all this, can you? That just gives you a case of the cosmic upchucks. Well, I've got bad news for you, kid, you're here for the duration. Take it from me. You can't dig yourself out of this place."

Saying so, he dropped the antler in the dirt.

—⟋⟍—

IT WAS LATE, WELL past my bedtime, by the time I took my dinner, a paper plate of blackened, reduced-to-ash chicken parts, out on the kitchen stoop. I was grimy from sitting in my hole, and I was still damp and cold.

It was eerily windless, and with no stars or moon in the sky, the field fell off in complete darkness. I could hear the clamor of my parents and their friends, a few select alcoholics from church, floating around from the front porch, punctuated every few minutes by a firecracker tossed over the railing by my father or one of his buddies as the wives ran back inside the house. The boisterous guffaws and inebriated shrieks suggested that our disaster on the lake was forgotten, as if nobody had ever tried to murder anyone that morning. I could hear the TV coming from the living room, my brother watching his favorite infomercials. Through the window the blue light faintly illumined the scuttled boat, the sail swaddled around the mast. The trailer's safety reflectors barely registered the decomposing fire in the grill.

For several hours after my encounter with the dentist, I had been stewing over how I might not ever succeed in tunneling out, infuriated with how he had exposed my mind, and its frightened thoughts, and that it was all such easily penetrable marrow. He had read me as if he'd taken a crowbar and opened my skull. And if he could, then any other stranger, any *other mind*, might do the same.

I had sat in the hole until well after dusk, watching my father go back and forth, angrily tending to the fire, until he abandoned it. I hated him more than ever for letting the fire die out.

Wait. I really dig this. Get lower, Marko, you gotta get this handheld. He's totally trancing out. Mark, get down on the frigging deck so you can get this—lock in that mist and fjord action behind him! Okay, keep on it. What do you see, Jay, what are you seeing? Take me there, baby.

I had left the porch steps to repair the fire, which had petered to a dull glow. When I tossed in the first handful of pine needles, its incense reawakened the harmonic feeling that I had achieved before surrendering the rope to my father on the lake. When I had still been synchronized with the wind and sail. I could feel Mark's camera there, of course, as I went around gathering up invisible twigs and branches on the cold deck outside the Café Bistro, feeding the sticks which I carefully angled, tepee style, until the fire drew life back upward in a trembling cone.

This will look insane! It's your character after you've gone completely over the edge. Day 495. It's evoking genuine pity in me—so deranged and pathetic! I feel genuine pity. I can tell you're really in the zone. Don't stop now. This is gold, pure fucking gold.

As I coaxed the dormant embers, building up the piddling flame, gradually kindling its drowsing hunger, the fireworms wriggled forth and began to gnaw at the coals, and then sent me out in the dark hunting bigger branches. I tried to build it up as symmetrically as possible. The cone, as it increased, required many small corrections, tweaks to keep it from wobbling over, and I kept having to add to avoid lopsidedness. I made many trips, dragging larger, half-rotten branches and slug-flecked logs out of the bushes until what had only been a bit of scant leftover heat quickly grew into a tottering, midsize inferno. But I had only just begun. My anger was a hunger that ached

all the way into my teeth. I would burn off the scab, my secret wound, which I had been unable to bury out of sight, unable to conceal. The hole had been my only escape. I craved its stillness but knew I could never go back now that it had been defiled by the dentist and the thoughts he had put into my head. It was as if he had flushed me out onto the inhospitable surface. Evicted me from the cool safety of my hovel.

I was nowhere near done. I was soon scavenging the garage for stray scraps of lumber. Tossing in the odd fallen shingle, even an empty paper wasp nest the size of a football that I had found behind the garage. Once the conflagration had grown large enough, its gravity concentrated until it was pulling all available air into its vortex. The sound of sucking oxygen spluttered. In the wide cast of roaring light, I could see the shovel handle stuck in my pile of dirt like a tiller, steering the field at a long tilt into the outer dark.

I suspected the lunatics were now watching from behind their grated windows, the stabbing light of my bonfire—fractal and toothed—mirrored in the unhealthy jelly of their eyes.

The fire had transfused its power into my veins. The flames peeled away at the bits of wood, unloosing the dumb matter in jagged gibbering ribbons as it was converted back to the invisible end of the spectrum, where the hem of space and time folded, hissing and popping like a convenience store radio tuned between stations, and appeared as if moving in reverse, falling upward, played backward. The sensation of smoke in my nostrils and eyes was ecstatic. I was its mindless acolyte, lugging anything I could find to feed the inner geometry that spoke from its center. I was the sibyl bent over smoking entrails, the first brahmin-priest to dab abstruse signs on their forehead in

ash. The blue fiberglass hull of the sailboat was lit up so unnaturally bright now, unveiled from the dark, that it appeared to levitate as apocalyptic flakes wobbled down from the sky onto its deck. This, my preposterous fire sermon, was a rebuke to anything that challenged my power to define my own consciousness.

Great jibs of flame licked at the lower birch branches, nipping at the boughs that swayed in the gusts of heat. The grill was so overfilled, already in danger of toppling, but still I jammed in every combustible thing I could lay hands on. I yanked up a garden stake and kicked it in two against a stump before adding it to the bonfire. Same for an old broom I found in the garage that went up in a splash of sparks, bristles and all. I lugged out bundles of newspapers and *National Geographic*s and watched as the dire-eyed faces of lemurs, Amazonian jaguars, Arctic foxes, and baby polar bears crumpled and turned to lint. In my frenzy I fed an oil-stained hymnal from under the workbench into the flames. I even tossed in my antler and watched as the gold points blistered and blackened into the grotesque pincers of a beetle. The fire was heavy and sagging in its cauldron now. And my power felt infinite. It would only enlarge now as the flames continued to devour and synthesize everything that I could find to feed its endless hunger, all the worthless bits of the world, and I believed this right up to the moment that I howled out as the back of my neck was seized by a freezing cold smack of water, and a blast of steam scalded my face and palms as the fire hissed out.

At first I expected my father on the other side of the cloud that had seared my lungs. The reverend come to punish me. I expected the worst. Now he would have a legitimate excuse to

finish me. I would run forever into the dark and live off wild rabbits and fiddleheads down by the river. But it was my brother who stood there clenching the hose.

I had been soaked, asperged, and there was the aspergeroid himself, grinning like a gloating mooncalf. A simper on his absurd face, looking haughty and snide and idiotic at the same time. Satisfied he had done what needed to be done to restore balance to the universe, that is, specifically, by extinguishing my bliss.

The dipshit dropped the hose with a smirk and started to say something—to chasten me, no doubt—when I lunged. He managed to eke out one strangled bleat before my hands clutched off his air and he went down on his knees. He didn't even have time to scream. I began to wring his neck, indifferent to his clawing hands, the look of petrified agony in his flared pupils.

He had pissed on my cloak of flame. He had tried to take my power, just as I had usurped my father's that morning on the lake, only to have the dentist try to snatch it from me, and just as I had nearly succeeded in coaxing it back from the dying coals. No more than a feeble twig himself, my brother had snuck up and tried to take this power for himself. And now I would annihilate the golliwog. My fury was the most dangerous kind. An annihilating rage that was the fury of self-pity. I would never surrender to this stupid world, nor let any feeble worms touch my golden power. It was his feet scrabbling in the gravel and the guttural bellows of rage that issued from my own throat that brought my parents and their inebriated friends running to the scene. If they had waited a second longer, I would have crucified him for sure. Once my father pried

my fingers from his throat he crumpled to the ground, eyes bulging like a drowning dog.

Jay, man, where are you at! That's amazing! You look like, Jesus, you're even scaring me! I'm TOTALLY there. That was amazing! You look like fucking Harvey Keitel at the end of Reservoir Dogs!

I found myself now in Darren's arms. Cradled à la Michelangelo's *Pietà*. Darren was beckoning me back, cooing in my ear. "We thought you were gone for sure." Mark was filming down on his stomach. A small audience had gathered a bit away, near one of the orange lifeboats, cameras limp about their necks.

"I think I found it," I say to Darren, weeping. "The source."

"There, there," he says, wimpled by a halo of solar effluxion. "There, there."

As he rocked me, I whispered in Darren's ear. Mark moved in closer.

"The radio on the bridge," I said.

"Yes," he said. "On the bridge."

"The encrypted message."

"Go on."

"It's me. I'm the monster."

"No, no. There, there, brother. I'm here for you."

30

WE ARE LIKE ASTRONAUTS GETTING SUITED UP FOR AN evacuation. Wrangling with our stowed cold gear, everybody crowding the lockers down below on B deck. This is the one frills-free area of the ship, aside from the engine room, that isn't all recessed lighting and quiet carpeted corridor. It is painted metal, diamond plate flooring, bare bones. No polite distractions from the basic fact that we are merely encased in a vessel: a husk separating us from oblivion. A mean wind blows through the truck-size opening in the ship's side, where crew in orange jumpsuits help us down into the waiting Zodiacs that then transport us, eight at a time, toward the island and towering cliffs ringed by mist.

The noise of thousands of seabirds nesting around the rock face grows louder as we approach. Darren and Mark are at the

bow, filming the impending island of doom. Hans, our guide, who sits wedged between two Texans across from me, says the ride will take no more than five minutes. There's a rifle on the galvanized rubber floor at his feet, a Springfield .30–06. Powerful enough to take down a polar bear at three hundred yards. The island is called Gnålodden, he says. Nagging point. After the birds that nag and nag. He speaks with a thick, pulpy accent. Even over the engine buzz, the squall and clamor of birds is as loud as if the cliffs were a giant wall of amps. While studying the screeching island, noting what might be caves or different hideaway spots in the rocks, I find I am content with the decision I have made. The decision not to return. It is an honorable plan. I'm pressed between an older couple, butt perched on the port side of the raft's edge. As we go swerving in and out between slabs of ice, I can feel the floor bulging and swaying beneath my feet.

As the fog-cloaked monolith grows closer, I realize if I'm really going to make it official, I should probably compose a note. I feel certain of my plan now, tired of the stale brain matter stuck to my own walls. I am tired of my own walls. My rage is burned out. I know it might be ugly, especially if a bear gets me before I succumb to exposure. Even more reason to leave behind an explanation, for why I've decided the only thing to do now is separate from the others and slip away when they're not looking. It will only be a matter of time then. Extreme as it sounds, death by bear is something I've given a good amount of thought. Even if it's only remained fantasy until today, something outré to say at cocktail parties, even though, of course, people think you're only joking when you say your heartfelt demise of preference would be to be torn apart and devoured by a bear. Maybe it did begin as a joke. *Exuent, Pursued by Bear.* Or maybe it was

always an unconscious thing. Either way, it's something that gradually made a dent in my conscious mind. What more wide-awake way to go? Reincarnated directly into the bloodstream of a superpredator. Instant metamorphosis. To be the ecstatic blessing, the hot ejaculation of blood across the spongy tundra. To have one's skull liberated by the crunching tearing jaws, to enter the labyrinth of the bear's own walls, our souls conjoined respectively. To make sure the offering is pure and that I am wide awake for my final act of atonement I have left behind the pills. I want to be clear when I pay the piper. And God knows I want the bear to be awake too! If the poor thing ended up tranquilized, then they would only track it down faster and kill it before I was fully digested, and then where would we be?

With my notebook perched on my thigh, it dawns how I have the opportunity to actually contribute to what I've always thought of as the purest nonfiction genre. The suicide note really is the best shot you get . . . Your best chance to absolutely slay everyone with the truth without getting all inhibited about knowing you'll have to live with the consequences of what you write down, or end up having to answer to some talk-show host when they reveal your grubby lies. ("And how much dialogue did you *enhance* again?" "Quite a lot, really.") Though, now, I can't think what to say. The insufficience of words is suffocating.

I notice Darren and Mark surreptitiously filming me, since Darren has decided any time I pull out my notebook is a good time to try to get a sound-up.

"Look, ahoy!" Darren shouts over the engine. "The writer in the midst of Experiencing His Surroundings!"

Mark has the camera trained on me, grinning.

"Kirky, yo, how would you describe where we're headed?

Look at that friggin' island. Any reaction for the people back home?"

I look at the looming cliffs. A great crevice, like a giant granite vulva, draws the gulls as if they are caught in its magnetic pull. The approaching ring of birds appears to me like the origin of all fear, a chaotic blur that is the blind dumb will of the world.

"It looks like the album cover of Mahler's *Kindertoten-lieder*," I say. "*Songs on the Death of Children.* Lorin Maazel conducting the Vienna Philharmonic, paired with the Third Symphony."

"Thank you for that manly observation."

I reconsider. "Or the ruins of an ancient Zoroastrian temple."

"Skull Island," Mark shouts over the engine buzz.

"I think it looks like the island where Cyclops would live," Darren says.

I assess the rocks. "I can go with that."

Or maybe the final lair where Frankenstein's monster would have hidden in wait for his creator.

"What were you scribbling?"

"A suicide note."

"Ah," Darren says.

The elderly couple on either side of me look at us, then spot a bird of interest.

"Skua!" the woman says.

"Skua! Skua!" Darren caws, cracking up Mark.

Realizing they're being mocked, the couple ignore Darren while passing the Zeiss glasses back and forth. No doubt they are somebody's parents. Empty nesters who go on thirty-thousand-dollar birding junkets.

When we scrape over a hump of ice, everyone clutches the

sides of the boat but after another few ass-clenching moments we make our landing, skidding up onto the gravel beach. Mark splashes out in his knee-high muck boots, camera hoisted, already rolling. Darren throwing off his life jacket and heading up the beach toward a photogenic and solitary dilapidated hut. While I find myself helping out the elderly couple, who I like to think will later recall me and make an effort to tell my mom what a nice man I seemed to be, no doubt biting their tongues about some other things.

We're in a cove, at the foot of a fearful slope. Above us the jagged column of rock, a dizzying goblin castle, and the unearthly shriek of a million birds who circle like bats, in and out of the high fog that rings the precipice. The birds wheel as if turning a massive cylinder. A massive, bird-inscribed prayer wheel. Their bones crunch beneath our boots, thousands of skeletons, skulls, wings, birds fallen like pieces of brittle ash from the dark cyclone that burns overhead. I stuff my notebook in my pocket and trudge after the others and our guide, Hans, who struts up the bone-littered beach with rifle slung over his shoulder, a short way to the cottage.

With a jokey doltish expression, outside the hut, Hans turns to us, cranes his head at the noisy cliffs, mouth agape. "All the time when you look at birds, don't do like this! For obvious reasons, *ha ha*, because you might get droppings in your mouth."

It doesn't get much of a laugh.

With hands on hips, he takes in the coastal view with a slow panoramic gaze, dramatically waiting for us to turn and take it in with him. We look out at our abandoned ship. The sun gleaming black on the funnel. He says the fjord is called Hornsund. "The story is they found an antler here, which gave

name to the fjord. Hornsund. And *horn* is from *antler*. It's a very beautiful fjord."

As we each duck under the doorway of the hut to get a quick tour of the absurdly cramped interior, he says how this was obviously not a Norwegian hut, considering its inferior construction. Most likely built by a group of excommunicated monks from Novgorod who had come here in the mid-seventeenth century.

"Did you see in the corner here? They have huge logs to make corner, and they carve out the groove here, and then just drop it, the wall element. We call this dropwall. All this was prefabricated in Russia."

Evidently, this group of apocalyptic monks, known as the Old Believers, following a schism over some liturgical reforms in the Russian Orthodox Church, had come here to hunt. They would rather have died at the frozen end of the world—those who had not already immolated themselves—than give up the old rites and folk-pagan rituals. Or, worst of all, adopt the modern polyphonic form of chant. It was dissonant, too Western, heretical, music of the Antichrist. One can imagine during the blackest hours of winter, when the birds were silent, the monks gathered to chant in worship before the morning hunt, and the droning baritone of their voices, locked in monodic unison, deep and bottomless as if rising from the Earth. The acoustics of the cliffs must have been stupefying.

Our guide goes on a bit more about the inferior hunting tactics of the Russian hunter-priests, and how the more ingenious and crafty Norwegians would spread out over a wider area, with strategically placed satellite stations and pack dogs, while the priestly hunts were more what sounded like a mob of escaped mental patients on a lynching expedition. He points

out the beefy rusted nails poking out the side of the walls: for-tification against polar bears.

A woman asks why the monasteries sent trappers? She seems truly shocked to hear about monks clubbing baby seals.

The guide shrugs the rifle on his shoulder and fingers a fresh, splintered claw mark on the door. "For money. Their main thing was blubber from walrus. And they caught foxes and polar bears as an extra hunt."

When the group wanders away from the cabin, following Hans toward another point of interest, I linger behind, pre-tending to take notes. The spikes jutting from the cottage walls give me a chill; there may as well be garlic around the door. I eye a large boulder up the slope where I figure if I can reach it without being seen I can hide out until everyone heads back to the ship. They'll realize I'm missing, of course, and send back a search party, but by then I'll be long gone.

To give the group time to move ahead, I sit on a rock and continue to scribble in my notebook or at least keep pretend-ing to scribble. The crackle and soft pops of ice in the lagoon is tranquil. For a moment, the squalling Saturn ring of birds over-head even seems muted. Remotely removed. There is a stillness. A presence that is an absence. As if all the world's noise down to the electrons whirling in the quiet rocks at my feet has gone still. All I register now is the murmur of the thawing ice.

The spot where I have sat is by a small stream. A Zenlike brook, embanked by mossy tundra. It meanders out to the la-goon, one spangled thread in a freshet that has brought the warming glacier trickling to my feet. A half-molten iceberg floats in the inlet, an emerald-blue, dripping, biomorphic sculpture. I look around and see that the thaw is really on. It

reminds me of spring in Vermont. So-called *mud season* (I hear it is called *schlammzeit* in Vienna), when only patches of snow were left on our lawn and the thaw came in shimmering rivulets down from the mountain. It was always my favorite season as a child. Using my mother's well-worn garden hoe, I would carve labyrinthine canals, complex systems of sluiceways, burbling troughs, throughout the field behind our house. I unclogged leaves and broke up stubborn chunks of frozen muck at the bottlenecks. To control for direction and flow, I patiently engineered the network of dams and locks, extending branches, or closing off tributaries that were only a drag on the overall systolic momentum of my monster as it came to life, grafting new arteries around difficult stumps or roots. I loved the cold glisten of mud. The feeling of something wonderful coming into being. That jubilation of the rushing cold bright flow, as clumps of frozen earth calved away, coming unbound, unglued, disintegrating into the current. It is the same epiphanic unstuckness I now experience as I prepare to sacrifice myself to the island. Just as the muddy ice dissolved in clouds of shimmering constellations, I feel myself dissolving, as if the points of my own constellation are fading, the stream gone clear, the meaning of my self seen for what it is, a mere snag in the rapids, but the bright twig is now set free back into the drift of meaningless bliss. It is all as clear as you can easily see that the sunlight prancing on this Arctic brook is in fact only trillions of tiny mirror duplicates, each sun an individual sequin, trillions of tiny perfect reflections of the star that is our master, riding the riffles, photon-thick. The only sane thing is to join the thaw. Let the frozen crud of my soul dissolve in the stream. The transformation is already under way, the thaw welcomes

me to hit the pause button of deep time, and I find myself comforted by the thought of a world preparing to revert to jungle again. I welcome it. Even the soft give of the permafrost underfoot makes me glad, and the scattered bird bones, the crunch of skulls, is a comfort. I embrace the thaw. There is a sense of vernal ecstasy in my chest. I can breathe easier now. Separation is a deceit. I am *unseized*. Let its heat loosen all the tangled odious connections.

I glance up at the semicircle of tourists who've stopped and gathered around something I can't make out. Halfway around the curve of the lagoon, they look absurdly tiny. When I turn back to my notepad, and my note, I am more certain than ever, but I cannot think how to put official language to the business at hand. It is all I can do to get down, in a quick and joyous scrawl:

It is then that Darren's gesticulations catch my eye. I should have run when I still had the chance, but now that he sees that I do see him, he is frantically waving. I give him a thumbs-up and point at the pretty stream that has detained me. He shakes his head and points at the ground where he is. The party is across the way, on the other side of the lagoon now. The guide turns to look at me too.

Spotted, I have no choice but to rejoin them.

"This is heavy," Darren whispers. They are gathered around an old foundation to a root cellar or something. It's a narrow, collapsed rectangle in the Earth. Some ancient planks of weathered wood and rocks are tumbled over the top.

Mark is filming the hole.

"They would go just up below the cliff where you get most nutrients," Hans says, pointing toward the light green slope below the cliff. "This is the place where scurvy grass grow. That's what makes it so green up there. And scurvy grass contain a lot of C vitamin. So people would, a hundred years ago, would go up here, collect as much of the scurvy grass they could ever find, and use it as a salad throughout the whole winter."

I look at the caved-in ground. Purple saxifrage and yellow buttercup grow in the crevices around the rubble. I decide to take a picture. I crouch down and try to zero in on one pale butterfly-shaped rock. It calls out to me. The ground is spongy and cushioned enough for kneeling. The guide yammers on but I'm not paying attention. "Maybe died from scurvy . . . and they had scurvy grass few hundred meters." Everybody, including the guide, seems to shrug at this fatal irony. "Didn't know it."

The stone is the size of one of those huge rain forest

butterflies. A Blue Morpho. Only it's not blue, but the color of unbleached silk. On one smooth wing, there's an appealing perforation. Really, the object looks like a fossilized Rorschach but fails to transmit any perceptions my way. I want a closer look, so without really thinking about what I am doing, I take my pen and gently slide it into this small hole and pick it up. The pen is a perfect fit and allows me to fetch it out from its resting place to better ogle. I am doing just that, dangling it before my eyes, when Hans abruptly stops talking, and says, mildly, "We do not prefer to desecrate the dead while we are here, okay?"

Paused now, I realize everyone is looking at me.

At this level, I am eye to eye with all their boots, under which, the carnage of bird skulls. The beaks scream out. The guide is staring coldly at the object that I now realize is not just any object suspended from my pen. Darren looks mortified, but it doesn't stop Mark from filming me down on my knees with what I now realize is a human bone. By its size and shape, the pelvis of a small child. A tiny sacrum.

Now it's transmitting all sorts of perceptions.

For instance, that the grave, this grave before which I am kneeling, the grave that I now see is in fact a grave, is so shallow because it was hewn out of permafrost. Barely a hole, but none-theless, a hole, a grave, and inside the bones of a small child. I'd missed the story if there was one. Did the monks bring families? Did they bring children as acolytes? Catamites? Or maybe this was a child who had come later, after the monks departed, and the child's father was a hunter, and they were just squatting in one of the old hunter-priests' huts. Whoever they were must have been crazy or crazy desperate to come. To

overwinter through four months of permanent darkness, fifty, sixty, seventy below, an eternity before any ship would be able to return for them come spring. Come the thaw. What kind of reckless, insane father would drag his family to such a desolate brink? Trapped on the ice in a spiked box, living in constant terror of bears, leaving your wife and child for days at a time, to check the traps, to bait the traps, to hunt the walrus or seals for bait, and then to return one day to find a bear had gotten through your meager defenses. That your son had been eaten in front of your now insane wife. Or did the child just succumb to fever? Or maybe the boy had drowned before winter had even come. Or maybe it really just wasn't enough vitamin C.

Either way, the child in the hole is long gone. So what depraved if unconscious part of me insists on picking over his bones? Because they still cry out for vengeance? Or, no, it is a crying from overhead. A sound like a wailing turbine. The others don't seem to notice it and only stare at me. I can see my reflection in reverse down the long bore of Mark's lens, crouched like an animal on the edge of the hole. Holding up my vile trophy on the tip of my pen. I am a defiler. A scavenger. Profane. I see that as clearly as I have ever seen anything. Ashamed, I let the bone slip from my pen, and then, as the rest lose interest and begin to walk away, moving on to the next desolate point of interest, I cannot get up off my knees because I have already made the fatal mistake of looking up to see the ring of birds and find myself caught between the hole and this turning whirlwind.

It is a cyclone, a halo of burning wings. It is a churning in the air that makes a terrible unholy song, a circle of squalling black notes, funneling, chanting in infernal unison, all merged

into one blasphemous voice, into one great psychopathic hymn to the thought of thoughts, a black current in eternal recurrence, and it is all I can do, caught between, to clutch at the earth, to seize the edge of the shallow frozen hole with all the feeble strength my hands can muster as the world goes capsized. As it does, I summon my last measure of will to look straight into the vortex, which is the entrance to another world, one that has not yet gone under. I keep my eyes fixed on the center. The bright empty hole at the center of the turning wheel. The still blue hole. Like a pulsing orb at the center of this dark wheel of noise.

About the Author

JAY KIRK is the author of *Kingdom Under Glass*, which was named one of the *Washington Post*'s Best Nonfiction Books. His widely anthologized award-winning essays and nonfiction have been published in *Harper's Magazine*, *GQ*, and *New York Times Magazine*. He is a recipient of a Pew Fellowship in the Arts, a Whiting Award in creative nonfiction, and a finalist for the National Magazine Award. He teaches in the Creative Writing Program at the University of Pennsylvania.